DRAWING
CLOSER
TO
NATURE

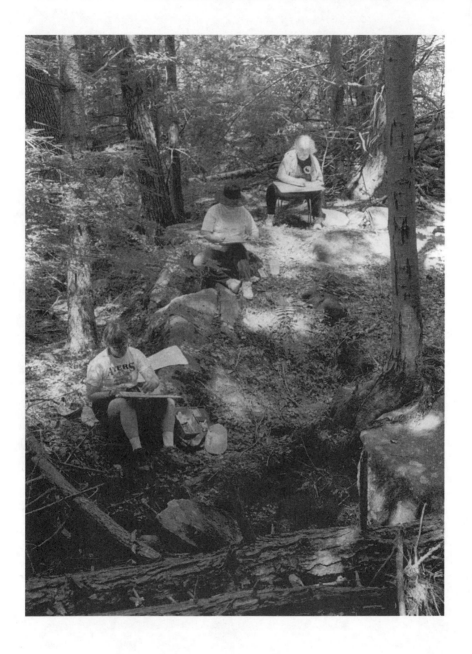

DRAWING CLOSER TO NATURE

MAKING ART IN DIALOGUE WITH THE NATURAL WORLD

Peter London

SHAMBHALA
Boston & London
2003

Shambhala Publications, Inc.
Horticultural Hall
300 Massachusetts Avenue
Boston, Massachusetts 02115
www.shambhala.com

9 8 7 6 5 4 3 2 1

First Edition
Printed in the United States of America

Book design by Ruth Kolbert

∞ This edition is printed on acid-free paper
that meets the American National Standards Institute Z39.48 Standard.
Distributed in the United States by Random House, Inc.,
and in Canada by Random House of Canada Ltd

Library of Congress Cataloging-in-Publication Data

London, Peter.
Drawing closer to nature: making art in dialogue with the natural world
p. cm.
Includes bibliographical references.
ISBN 1-57062-854-8
1. Art—Psychological aspects. 2. Creation (Literary, artistic, etc.)—
Psychological aspects. 3. Nature (Aesthetics) 4. Inspiration. 5. Spirituality.
I. Title.
N71 .L5967 2003 700'.1'9—dc21
2002009074

CONTENTS

———

PART THREE

THE STRUCTURE OF AN ENCOUNTER

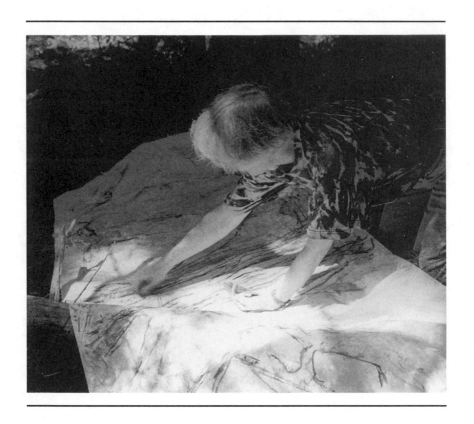

PROLOGUE

SEE FOR YOURSELF

Suppose Genesis misspoke.
We never left Eden.
Nature, just as it is, is Eden,
And we are still there.
We remain in our first, our only, our exquisite home.
But we have been told otherwise,
And we behave otherwise.
We must awaken to where we are,
And thus who we are.

But how?

Just as Eden was and remains our first home,
Art was, and remains, our first language.
Baby babble-sing, whole baby wiggle,
everything cry, everything laugh.
Artless art.
One road cobbled equally with
dreaming, seeing, imagining, reasoning.
Inner, outer.
First mind, final mind,
Art, we call these ways art.

We can learn—again—to art/live this way.
We can learn to art and to speak and to be
the way Nature does in all that it does.
Nature: where everything counts, nothing is left out, nothing is left
over, where everything is closely fitted,
draws, erases, then moves on.

Drawing closer to Nature
we come home
and learn how to feel at home and be at home.

Art is the language of meeting, of intimacy, of closely fitted things.
Nature, of course, is exactly the same.
We can learn to draw up our lives and our art
close to the ways Nature draws up the world.

See for yourself.

DRAWING
CLOSER
TO
NATURE

Introduction

THE PERSPECTIVE

Our culture's profound separation of humans from all the rest of creation has produced a deep, diffuse, pervasive loneliness, disorientation, sense of loss, and fragility that is played out in all our relationships and through all our means of expression. Rejoining these two aspects of the original whole, the Self and Nature, is the great task each one of us faces, the great requirement of our civilization at this pivotal moment in time. To the degree that we are able to draw closer to Nature, to heal this broken primal relationship, our lives—mind, body, and spirit—take on a harmony, a grace, a wholeness, and an endlessly resourceful, gentle, and indomitable power. Our art becomes that way too.

As we rediscover our rightful place in the world, break through the barriers of hand-me-down ideas and customs that have kept us from our ancient, infinite, dazzling family of origin in Nature, we newly experience ourselves and our world. The closer we draw to Nature, the more we experience everyone and everything as family. In *this* world we are never lost, never far from home. Two not incidentally linked consequences follow: fuller, deeper, richer, more authentic art and, more broadly, a fuller, deeper, richer, and higher life.

In order to accomplish so fundamental a task, a fresh language is necessary to perceive and name the world anew, for our prevailing

language stems from a worldview that accepts the schism separating human nature from the rest of Nature. The artistic processes that shape art offer the power to create a worldview and a view of our Selves that are in accord with the necessary and inextricable symbiosis of humans and Nature. Nothing less than an effort of mind and body and spirit is required to assert a new worldview sufficiently credible to create a replete and durable sense of being in the world. Art is such an endeavor. Art is a holistic language that is uttered from the mind, body, and spirit. In this way, art is a perfect form of expression with which to imagine, investigate, propose, and engage in a new worldview. Employing this power of art, *Drawing Closer to Nature* offers a wide range of readers—artists and environmentalists, veterans and novices, students and teachers—a practical guide by which to forge their particular reconciliation with Nature.

Because art and the creative process are seen as an entirely natural and universal method of forming meaning, the book aims to help readers cultivate a simple, authentic, firsthand way of seeing Nature as it is and as we as we are. As we draw closer to Nature, two profoundly important and powerful qualities are experienced. One is that the entire world takes on new degree of poignancy, luminosity, preciousness, subtlety, mystery, and intimacy. The other is that we increasingly experience ourselves in just the same way: as poignant, luminous, precious, subtle, mysterious, and intimate. For as we draw closer to Nature, we simultaneously draw closer to our Selves. This movement reconceives Nature, redefines our Selves, and reframes our relationships within the universal web. When I speak of the Self throughout this book, I most emphatically refer to an experience of being distinct and unique but not separate. This Self is always understood as an inextricable partner in the infinite corps de ballet that is the world—all of it.

The generative force behind the artistic impulse of humans derives from the generative forces that animate the entire creation. Humans being a product of the larger creation, where else could our particular powers come from? The artistic process—in which elements are joined in such a fashion that their new union creates a more meaningful, satisfying whole than any of its constituent elements—is the perfect instrument for drawing our Selves toward a more satisfactory union with Nature. The artistic process is not merely a vehicle to represent our current state of mind and affairs; more significantly it is

a powerful practice by which we can work toward the achievement of desired states of mind and work.

As we employ the artistic process to draw closer to Nature, and begin to establish a more perfect union, our inner nature grows richer and deeper and becomes more articulate. Our willingness to reach, our daring to dream, our coordination of effort in the service of high ambitions, all become elevated to a higher degree. The composition of our lives takes on a greater unity. How we compose our page, how we express our Selves through any artistic endeavor, correspondingly becomes equally graceful, rich, full.

Fantastic claims? On first reading it may seem so, and I have paused long over these assertions, asking myself if this is indeed the case. Does drawing closer to Nature by employing a holistic approach to the creative process actually produce the resulting artistic behaviors claimed? Having taught this approach for more than twenty years across North America, in colleges, art schools, holistic centers, and teacher institutes, to thousands of students ranging from teens to octogenarians, to "art phobics," naives, professional artists, and art teachers, I am convinced that it *does* help us attain such states and degrees of artistic achievement. For everybody? Just about.

Drawing Closer to Nature presents practical employments of art to enable the practitioner to both draw closer to Nature and draw closer to their inner nature. This in turn enables the creation of an artistic voice that is rich, profound, subtle, and brave. Brave enough to say how it is when I encounter the world firsthand, saying nothing more and nothing less. This same healing of the schism between the Self and Nature has the power to bring about an even greater good; indeed it is the good that we all seek: a richer, profounder, more subtle, braver, and more graceful life.

READING THIS BOOK

The experiences that led to the ideas that in turn led to the writing of this book came about in a manner similar to an unhurried walk through fields and forests on summer's day. Some tree in the distance catches your eye, and you head for it. Along the way a weed with a pretty seed head that you haven't seen before in just this form causes

you to stop, bend down, and look more closely. A bird in a nearby thicket calls, and you go over to investigate. You wait again for its call, and a black fly enters your ear. Scooping it out, you notice a burr clinging to your sleeve, a quite interesting one. It goes on that way, and only upon taking your shoes off before bed do you miss that distant tree that you never got around to.

From a distance such meandering might seem without order or purpose, much like the fluttering of a moth or firefly as it appears to us: now here, now there. However, it is a rewarding way for me, eventually (and apparently for moths and fireflies too). But perhaps it is no way for readers intent on getting somewhere as a reward for their attention, and so I have organized my essays, images, and poems into a particular sequence intended to develop ever more revealing and satisfying perspective and detail. However, this order derives from my conjuring of an imaginary reader and not any actual reader, you. And so I welcome you to scan the contents and, if you wish, enter them at a place that suits your own interests and proceed accordingly. In other words, you might wish to take the same privileges as I did and create your own path in drawing closer to Nature.

With that invitation in mind, the order I have imposed on the book is as follows.

Part one consists of essays that broadly stroke in the argument for drawing closer to Nature by exploring my own personal experiences of doing so. They are quite common types of experiences: a walk along a beach, a dream, a reading of a well-known book, an account of someone touching the earth with their eyes closed.

The essays in part two are addressed to readers interested in drawing closer to Nature through art, offering practical advice on the use of creative methods. The theme running throughout this part is that by observing the infinite, exquisitely made, successful ways Nature creates the world, we may be able to discover similar ways that are amenable to the creation of the harmonies, textures, and colors of our personal lives and artistic expression.

Part three introduces the Encounter, the term I use to describe the pivotal method of my approach to art. It describes how a single Encounter and a sequenced program of Encounters, based as they are on the structure and purposes of rites of passage, enable practitioners to draw closer to Nature.

Part four presents a number of Encounters, each designed to explore a significant quality of our inner nature and a corresponding revealing aspect of outer Nature.

Part five addresses the media and techniques of art from a distinctive point of view. The claim is made that for the purposes of drawing closer to Nature, any substance can become an art medium if taken up with care, as if it contains an inner life, and employed in a partnering relationship.

Part six consists of a series of essays on teaching the art of drawing closer to Nature from a holistic perspective and to a wide range of learners. The student-teacher relationship is presented as critical to the purposes and effectiveness of such teaching and most closely resembles the I-Thou relationship that Martin Buber proposed.

"In Another Voice," a series of poems interspersed throughout the text, portrays the region mapped by my own efforts to draw closer to Nature, which appeared to me in a form in which the cadence of the lines, the compactness of ideas, the sound of the words and phrasing, contained meanings best preserved in their original form of verse.

A Note on Vocabulary

I have taken the liberty of capitalizing certain words that are key understandings for this text in order to demarcate them from their common understandings. *Nature* is always capitalized because to me it is alive, knowing, and always speaking. I believe, with Pierre Teilhard de Chardin, that Nature at all levels of complexity contains a "within," some form and degree of awareness. Similarly, I accept with Martin Buber that all creation is endowed with a quality he terms "Thou," independent of anyone bestowing this quality but unknowable to me until I call to it from the depths of my "I." Common appreciation of Nature contains no such connotations. To refer to this *more* of Nature, I have capitalized its name. *Self*, as in "my Self," connotes a synthesis of mind, body, and spirit in one being. Although this is not an uncommon appreciation of human beings' prime elements, by capitalizing the word I remind the reader of this ineluctable complexion in a time of frequent forgetting.

ON THE ILLUSTRATIONS

Readers of a book about cultivating artistic processes are apt to be visual as well as textual learners. Since this book intends to offer both theory and practice to a wide readership, I thought it imperative to offer the material in a number of literary and visual formats. The images of my students at work engaging in differing phases of Encounters with Nature are offered to provide readers who wonder, "What might these ideas actually look like in practice?" The photographs were mostly taken by David Allen, a friend and colleague who joined me in a two-week period of "Drawing Closer to Nature" workshops in the summer of 2001. Other photographs were taken by participants in the programs and by myself. They are offered to provide a sense of the ambiance, the emotional and intellectual climate that characterizes the dedicated quality of artistic and interpersonal work of people drawing closer to Nature.

Images of my paintings and drawings are included to illustrate where my artistic efforts have led me as I tread my own way of drawing closer to Nature. Often the work on these led me in directions

that preceded my conscious thoughts, mapping new grounds for me to consider later as I looked at and wrote about them. They were created over the same period of time as the writing of this book. Their materials are simple: paper, charcoal, oil and chalk pastel. Like Nature, like me, they are a way of speaking not easily translatable into words.

DIFFERENT VOICES

I have come to believe that the various literary forms—poetry, essays, novels, plays, memoirs and the like—may have first arisen as a consequence of how their authors originally "heard" their ideas take form. Certain ideas about art, Nature, and teaching that appear in this book emerged within a particular literary structure, and I have retained those original structures rather than converting them to one single format, for a number of reasons. The prime reason is that the idea is most clear to me in that format, and I am best able to examine and convey that idea in that same format. Also, I retained the original formats because doing so seems to complement the principles concerning art and Nature championed by this book. That is, in Nature as in art, there are many structures that viably resolve the problems of how to thrive in this world. No form in Nature exactly replicates any other; each occupies and exploits a particular genius of endowment, moment, and place. Each, examined, provides the observer a distinctive lens through which Nature manifests a different aspect of itself. Each form is coherent, expressive, and coexistent with all other forms. In each of the literary and visual forms I have employed, I have attempted, as every author does, only to say what I know full and well. I hope the reader will understand that the several voices in which this book is composed are nothing more than this particular form of Nature—me—practicing what the rest of Nature is doing all the time.

❧ LISTEN TO THIS

Listen to this.

I was reading *Orion* magazine,

an article about orchards, tuxedos, money, adolescence, and such.

I was sitting by the edge of our pond, on a plastic lounge chair.

It was early September, still OK for a swim.

I was reading this sentence: "There was picture of him standing
with his Filipino friends."

When out of the *i* of *him* walked a creature.

It was, I'd say, one-fifth the width of the *i* and about one-third
of the length.

It was how small it was that got my attention.

Then I saw that it had a head.

And from the head it had two antennae about one-fourth,
maybe less, of the length of its body.

I'm certain it had a mouth with all the things insect mouths
have, but I couldn't see that.

Then I saw that it had wings.

The wings were transparent, but you could still see them
because they were bordered by a very thin black line.

The wings also had veins or inside borders.

After this I saw that the insect had legs.

I'm not sure how many, at least four, but there could have been
more.

Each leg bent at what must be its knee.

The ends of the legs were a bit darker or bigger than the shaft,
so I suppose it had toes,

or things like toes.

That's all I could see of that.

It began to walk up the page from the *i* to a *w* just on the line
above.

Not more than halfway there the insect bent its body in an arc
and disappeared from near the *i* and reappeared about a sixth
of an inch away, near one of the bottom arrows of the *w*.

I thought he must have jumped there, but the truth is what I
saw was here then there.

Nothing in between.

Then I saw him (it could just as well have been a her) wiggle his
 antennae.
Then open and close his wings.
Then arch his back again.
Then disappear and reappear.
He (or she) headed up the page like this.
Of course when he landed on a letter he disappeared too.
Landing on a letter was not the kind of disappearing I was
 referring to above.
At some point I began reading the article again.
I hadn't gotten past "They wore suits with double-breasted
 jackets that tapered at the waist" when my interest returned
 to the insect.
But he wasn't there anymore.

—————

PERSONAL ENCOUNTERS WITH NATURE

On Horseneck Beach

FIRST SIGHT OF DRAWING CLOSER TO NATURE

———

On A DEAD-COLD DAY in January a few years back, I walked alone along a broad-backed beach. The sky was a weak yellow, the kind when it's this cold around three in the afternoon. Not a cloud. A low, icy wind blew in from the west. A day or two back, a storm at sea caused the waves to well up way out, break, then in great arcs seethe toward the shore. The water was gray, so was the sky. It was low tide and still receding, creating a great expanse of glassy sand between the last riffle of the sea and the quilted drier sand. I walked into the wind on my way out so that I'd have it at my back returning. As I was walking west, it being late afternoon, the sun, not far above the purple horizon, dazzled the skim coat of water and wet sand before me. Nobody else about. No sea gulls flying—they had nestled in bunches here and there into the sand. Pointing windward, they didn't rise as I passed. The wind froze my face, burnt my cheeks, pained my ears, caused my eyes to tear. My thighs burned with the cold. My scarf, wrapped around my neck and face, turned stiff from my breath and drippy nose.

I needed to go on that walk. I needed to be by myself. I couldn't let these winter conditions turn me back to the car and home. I'd been cold before and a long time and a far distance from warmth. When this happens I do what I imagine other creatures must do: slip into a rhythmic pattern of breathing and moving, much like a meditation. In fact, for me it *was* a meditation. With the elements as overwhelming as

they sometimes can be, the way I endure is to give up resisting what feels like Nature's intentional onslaughts, and slip into an enclosed frame of reference, a retreat from surface engagement with the world. Thus cocooned, I withdrew my attention from what the elements were doing to my body and instead turned my dim lights to some other, less remarkable events around me; the sound of my footsteps in the sand, the tears running down my cheeks and freezing in the corners of my eyes, the changing patterns of light on the receding waters. Ceasing to notice individual things, including myself, I became increasingly aware and fixated on the fading light, the wind roaring across my ears and the rhythmic crunching of my steps. It was still cold, I was still cold, but it didn't matter as much.

Why I went to the beach in the first place.

I had come to the end of a number of things in my life, not the least of which was a ten-year theme of paintings. I felt as if the map with which I had been steering my life and art rather suddenly and unexpectedly had certain of its main features lifted. It still had the places where I had been, but the places I thought I was heading toward no longer appeared. My maps never prove as predictive as I would have them. I have never studied a topological map that prepared me for the actual terrain underfoot. Whenever I get to wherever it is I finally get to, the way is far steeper, wetter, rockier, more impenetrable, wider, and deeper than the map promised it would be. Ruefully, I have come to trust the dictum "The map is not the territory." The missing elements from the map I had been using at this phase of my life's journey were the distance scale, the compass orientation, and some destinations I thought were permanent features of the territory; not a very useful map. When I did refer to the map for guidance, it frightened the dickens out of me because the absence of these critical features confirmed my own feelings of uncertainty and disorientation.

For more than ten years I had been working on a theme that, as I now realize, had even earlier antecedents. The theme was based upon the complimentary forces of yin/yang. I had become increasingly intrigued by how much of my life experiences could be subsumed by the relationships represented by the forces of yin and yang. It seemed to me, and still does now, that the infinite variety of forces the universe comes in displays the characteristics, in varying proportions, of just two qualities: yin and yang. The universe seems to break down into an

infinite number and variety of these binary systems; light/dark, hot/cold, wet/dry, male/female, ascent/descent, subconscious/conscious, earth/sky, dream/waking, moonlight/sunshine, and on and on. For more than a decade I explored in graphic language my experiences with these complementarities. At first it was as exhilarating and as challenging as any new love affair that seems endless in its possibilities and delights. I used this dyadic lens to examine the world and explain my relations to it and in it. It provided me with a revealing and comprehensive view of my world, which I naturally took to be *the* world.

There came a time, however, when I became so satisfied with the apparent repleteness of this way of thinking about the world and expressing those understandings in painterly ways that it was hard to have any ideas or even perceptions that were not made apparent by way of this powerful yin/yang lens. The vessel and its contents became (more or less) one. That was OK, but as I began to realize, only if the fusion were a momentary phase of a much more complex and intermittent system. When the vessel is full and fixed, uniform throughout, there is neither vessel nor contents: nothing to pour in, nothing can pour out. With this degree of fusion, the vessel can no longer serve its function of temporary container, and the contents become unacceptable because of the growing staleness of their permanence. Both vessel and container require that each submit to a temporary relationship. I had raised the best questions I was capable of raising at that time. I explored them with whatever talents I had available. I drew out responses that were commensurate with the direction and degree of my questions, and explored all the territory on the map *that I had*. I followed this map for more than ten years, traveled many places, saw many things. Now it was over. The map I had been using covered only a small fraction of the actual territory of the world, but it *was* all the map I had, or more precisely, would allow myself to have. If I had been gifted with greater resources of mind and character, my map would have been proportionately enlarged. But I wasn't, so it wasn't; neither was my art.

The feeling that I had accompanying this ending was one of emptiness and drifting. I viewed the last years as a fascination now run its course, and I began to notice that my studio experiences became more studied performances than unselfconscious "work." The world

seemed as interesting and inviting as before, but with no one item or issue any more compelling than the next, my attention wandered everywhere and settled nowhere.

To compound my feelings of dissociation and disorientation, as a consequence of themes run dry, was my growing unease with painting itself. Or at least painting as I had been taught it in the rather classical tradition in which I was schooled. I had been trained in New York City, at Queens College and then Columbia University, during the late fifties and sixties. It was a period of the ascendance of abstract expressionism over figuration, and the majority of my instructors adhered to that abstract canon. I was soon disabused of my own naive notions of personally significant figurative imagery and replacing my own shoddy system with something more up to date, more correct, more within the mainstream of the prevailing discourse of art. Something that would demonstrate the proper respect for the picture plane, the integrity of paint, the optimality of surface. In this way I entered the arena of discourse, and although initially I found its territory studded with features that seemed at first glance rather bland—thickness of paint, problems of corners, the push and pull of certain colors in juxtaposition—I soon found myself engaged in heated conversation with my fellow students about the push and pull of their color systems and the degree of thickness of my paint. I couldn't have known it at the time, but I was going through one of the several rites of passage so characteristic and necessary in everyone's life. I began to die to my maternal tongue and learned the ways of my betters, the Society of Men. At the time I was glad of it.

This is how I came to embrace, with no apparent regrets, the look and attack and philosophic premises of abstract expressionism. Thus equipped and empowered, I made quite a few decent-looking works. I had been painting and drawing in this general frame of reference for more than thirty years, and it is was no longer foreign to me; it suited how I lived my life in general: improvisational, somewhat abstract, gestural. The insufficiency of the yin/yang metaphor for life, the severity of its juxtapositions in a world that I now saw as being multifarious, graded, more subtle and paradoxical, brought me to the conclusion of my yin/yang series. The daunting hole thus left in my cosmology unraveled a thread from my conception of painting itself, and to the question that every artist must be firm and positive in response to

"Why do you paint?" I could now only muster, "I'm no longer sure." With that thread left dangling, the whole fabric of "Why paint at all?" began to unravel. Why paint on canvas? Why apply the paint with brushes? Why use paints to form images? Why a square or rectangular format? Why images without texts? Why work on this scale? Why these galleries and these prices and these clientele? Why these themes? Why these techniques? These strategies? These canons of good form, of craftsmanship?

So deep was my increasing dissatisfaction with what I was painting and how I was painting that I began to approach the bedrock issue of making art itself. Why do it at all? Being a man in the world, and not dwelling solely in the studio, I was keenly aware of how damaged the world was becoming by the way people were treating it, and how damaged *people* were by the way they were treated by other people. How could art serve to address or redress these wounds? Wouldn't I better serve my time by repositioning myself in the world and differently employing my talents and resources than by what I was currently engaged in doing: painting pictures? I was familiar enough with the literature and activities of other disciplines such as community-development organizations, social activism, ecotactics, art as therapy, et cetera, to have these doubts about the efficacy of my own path put more in question. The route that my brush had to travel between my palette and my canvas was becoming longer and more uncertain.

If I was to reidentify myself as an artist, it would have to be on new terms, ones that I would have to create myself. I needed to proceed in a new direction, perhaps inwardly, off the path I was on. Wherever it was I was going, it now had to be toward a place that had no map, at least none with which I was familiar. Being this uncertain about myself, the net worth of my past and my preferred destination, I felt I needed my equipment to at least be sound and trustworthy, to possess an integrity that I myself lacked. Not being a preplanner by nature, and at this particular moment of my life not having a definitive plan at all, I would have to outfit myself as I went along. Each piece of equipment, each material and strategy needed for this uncertain journey, I would have to test and find true. Each item would have to be come upon singly in turn, leaned on, shaken, its breaking point found, its possibilities measured. I wanted equipment that suited me, the way I happened to think, to move, to be built. Equipment that

would keep me honest, force me out of hiding. I hadn't started out wanting to acquire gimmicks, sure-to-please marks and color schemes and all the deceits that artists have in common with conjurers. It just seemed to turn out that way.

There was only one firm spot in my world at that moment, one solid, endurable thought; I did not wish to go on the way I had been going. I did not want to paint *pictures*, I did not want to use familiar media and employ my conventional techniques, I did not want to compose my work along classical canons of good form and traditional strategies, and I had had enough of yin and yang for the time being. Quickly the whole edifice of beliefs that supported my behaviors as an artist disassembled. The topics, the questions, the vast and glorious traditions of Western art had thoughtful and ready responses, but for me they now seemed weakened by their very source: received news. Earlier on, the fact that these were received truths made me feel that I was on the right track; after all, I was shoulder to shoulder with the worthies of my clan. Now the same fact, conducting my affairs with received instructions, would no longer do. With each connection severed between the tutored me and the original me, who I sensed was still somewhere here within, my slate became ever more clean until the slate itself seemed to disintegrate and I was left walking alone along a broad-backed beach into a weak sun of the new year.

To return to that walk on the beach and what happened next: The beach is about a mile long from where I began to the point where a great tidal river opens onto the ocean, cutting the beach off from the rest of the shoreline. I had been walking for almost an hour and by this time, about three or three-thirty, the sun was an hour away from setting. Although the weakening sun was probably colder still, the slackening wind no longer bit so deeply. I was cold, exhausted physically and emotionally, and glad to be approaching the turnabout point of my walk. I had set out to do a simple thing in a confusing phase of my life: taking a walk to the end of a beach. I felt somewhat satisfied in at least accomplishing that. I stuck the tip of my boot into the sea at the end of the beach to mark the completion of this small but distinct act.

With a final look sunward, as if to a departing friend whose companionship has not been without its difficulties and rewards, I turned around and looked east, where the evening was already well under way. The colors were now reversed; the sky was a deep blue gray, the

ocean a fraction lighter, and the sand russet streaked with violet. With the wind now at my back, it would be easier going; still the cold was penetrating, and in front of me lay a long homeward leg. To put an end to one thing and before beginning another, I sat on something facing away from the wind, letting my eyes adjust to what they would be seeing for the next while.

My first impression of this new vista was that the place was a mess. The beach was littered with a wild assortment of things thrown up from the sea storm a few days earlier. At first my eyes wandered from item to item, and I amused myself noticing the random juxtaposition of disparate things: fisherman's glove, skate egg-case, rope, clamshells, toy shovel, splayed magazine, twisted blanket, wooden crate, zillions of different-sized and-shaped pebbles and shells and seaweed and drift-wood and bottles. Woolworth's after an earthquake. No rhyme, no reason, but fascinating. Not much to think about here except what the environmentalists keep reminding us: the ocean has become the final refuse dump of ignorant and profligate people, and we'd better mend out ways soon or else. As wrought up by this as I usually can get, it seemed now to be other people's business, a problem to be rectified by others more zealous and engaged with such matters than I. I only wanted to finish the day, get home, be warm.

With a determined heave, I got up and began my homeward jour-ney. Having walked along the water's edge on the way out, I returned along a route somewhat higher up the beach to see a little different terrain. The last flood tide had not reached as high as this for a day or so. What at first appeared as a random scattering of debris began to re-veal a certain low level of order. The sun, now quite low to the hori-zon, was casting proportionately long shadows from every item on the beach. The debris was strewn across the beach in random fashion. When the sun's single light source touched any piece, it converted this wild inconstancy to a precise geometry: each shadow raked the beach at exactly the same angle. And no matter the variety of shapes, colors, and textures of the debris, all were reduced to one color and textured shadow: deep violet. Things that existed on the third-dimensional level in splendid difference, with no apparent familial identity, when cast upon a two-dimensional plane (the beach) produced a remarkable singularity. Their distinctive colors, textures, and form dropped away, revealing their common quality: opacity.

Musing along these lines, I noticed something else. The debris it-
self no longer occupied any meaningful place on the temporal plane.
Torn from their original place in time and purpose, the objects were
now all disengaged from their vital role in the organic scheme of
things, in the same way that cultural artifacts which play a vital role in
one society find their way to the museums and dining rooms of an-
other. Here, strewn on the beach, this jumble of items uprooted from
their original functions and places from around the world were now
being subject to new and common forces: gravity, air, water, earth, and
fire (the sun). No matter what individual history each one arrived
with at this common place, at this point in time these heretofore
strange bedfellows would inscribe their common fate in the same
sand. Every glove, shell, rope, stone, or strand of seaweed was now sub-
ject to the same evenly distributed forces of nature: water washing up
and down a constantly pitched plane (the beach); puffs of wind; angle,
mass, and velocity of rain; and the quiet but indomitable forces of
gravity and temperature. Differences of color, shape, texture, and pur-
pose mattered not; here, only the common feature of mass counted. A
higher tide would soon erase their lightly written history, the story of
a certain portion of the continent of North America, telling what
happened in a span of a quarter of a day when a twenty-knot wind
out of the north by northwest blew over them and the rain in millions
of small, wet explosions fell upon them, and the ocean's insistent
pounding pushed and shoved them here and there to settle, finally, in
heaps and rows. Every single item an inadvertent and incorruptibly
honest witness to this small but (who knows?) critical piece of the
earth's history.

Warming up to this kind of seeing and thinking, I cast about for
what other kinds of order there might be in the midst of all this hurly-
burly. I began to look past the gaudy and strange debris—the nets,
great logs riven with rusted hardware, shattered morsels of boats and
birds, grotesques of seaweed, a perfect beach chair—and noticed more
subtle things, such as the patterned arcs of beach pebbles and the
somewhat more irregular ones of slightly larger stones. With increas-
ing fascination I observed that every pebble acted as a cap protecting
the sand immediately underneath it from the erosive effects of rain
from above and wind from the side. Here, on this quite ordinary
stretch of beach, the same exact forces that created the giant rock-

capped spires in Zion and Bryce plied their trade on a comically diminished scale, the tallest spire here achieving a height of a quarter of an inch. Although these structures were not easy to see from above and from the distance of my eyes to the ground, the raking angle of the sun cast shadows twenty times that length across the sand. Lying down to examine these mini-mesas I noticed more fully the force of the wind. The spires were not simply symmetrical pedestals upon which the capstone, much like a mushroom cap, rested. Instead, they were aerodynamically shaped, something like the cross-section of a wing or a teardrop. The wind had been blowing for a couple of days, at varying velocities and from a number of directions. From time to time the velocity of the wind had been sufficient to pick up enough fine sand to sand-blast these tiny pedestals and form them in such a manner that to windward the pedestal was blunt and to leeward, pointed. As the wind had changed direction and velocity over the course of the last few days, it had left its telltale markings of lighter and darker sand (heavier and lighter particles?) by the shifting tail.

I had the growing sensation that I had been witnessing a number of instances of a more revealing understanding of how Nature makes manifest its ways than I had appreciated before. It was not as if these phenomena were new to me, I must have seen it all before. It was, after all, all there *was* to see. And, like everybody who attended school and paid even a modicum of attention, I had been taught about the patterns and the meaning of the patterns I was now observing. However, and here again this is not uncommon, the instruction I received in science seemed to be about one entire and complete category of phenomena, and the instruction I received about the history and techniques of art were about another entire and complete set. And my own existential jumble of experiences comprised yet another set. The last, my own, seemed for the most part entire and complete and *distinct* from the other categories. As a consequence, it never occurred to me to purposefully seek in the ways and means of Nature an alternative to the ways and means of art. I was on the verge of seeing how Nature, at least in this portion and at this level of the universe, did things: how it carved, built, drew, colored, selected, destroyed, recombined, salvaged, yielded, composed. Unlike the schools I had attended up until this point, I felt like a comfortable, competent student in this larger school, employing this form of instruction. I loved the way Nature

seemed to be teaching. Here's the lesson. Take your time. You have your lifetime to learn it. You didn't get it today? Come back tomorrow. You missed last week's assignment? It's still on the board. No, there will be no final exams (you simply die, and then it's the next person's turn). No, there is no front row in this school. It has no front. You don't speak English? That's OK, neither do we. You are a slow learner? What's a slow learner? You are talented and gifted? Oh, your *mother* says you are talented and gifted—that's nice. When do you graduate? You don't really want to know. How much is this going to cost you? Everything. What will you get out of it? Everything.

I continued further along the beach. The lengthening shadows and my increasing appetite for seeing revealed yet another level of order, another display of how the world works. As the tide retreated, an exquisitely crenellated line was left where the highest and next-to-highest waves and the next and the next and the just-this-very-moment came to rest. These lines were the complex resultant of the forces of the gravitational tug of the moon upon the earth, the viscosity and surface tension of water, the direction and velocity of wind upon the surface of water, the slope of the earth relative to the angle of the ocean's surface, the topological subtleties of the earth right here at the water's edge, and the resistance of water running over a particularly textured and porous surface. In short, these lines were the resultants of the forces of the sun, the moon, the earth, and the stars. Gravity and temperature, these great silent things, working in tandem upon the denser stuff of the universe, drew these exquisite and delicate lines.

Not just any lines. These lines perfectly fit the occasion. An absence of any one of the contributors, the slightest variation in the degree and kind of participation by any one of these colossals, and the drawing would have been different, must be different. These colossals don't only find their expressive outlet in drawings on the sand. They draw on everything, they sculpt everything, they destroy everything, they create everything. Deep in the core of me, I felt drawn toward a level or order of perception that I had heard about and read about but not personally witnessed. The infinite number of things of the world that appeared to me before as jumbling about and bumping into each other spasmodically now appeared to be a subtly and necessary chore-

ography, in which every item in the universe was dancing and also *playing*. I was not then, no less now, under the false pretext of grasping the entire melodic line, nor could I follow all but the most rudimentary and obvious steps. Nonetheless, it came crashing in on me that what I had taken to be Nature's mess was only me looking through my messy lens at quite an exquisite thing. Buddha was right. They were *all* right.

Hurting, and preoccupied with the throb of my own wounds, I initially saw only a random scattering of litter across the beach. A dump shaken out and kicked about. Is this what *they* mean? Is the world not only a stage upon which we strut and fret, or, in a more contemporary idiom, a screen upon which we project the story of our lives and take what we ourselves create as our received portion? Or was there indeed a sacred geometry to the whole affair? Was it only I who was littering the beach, steering by a bum map and compass, thus bumping into a finely made web whose complexity and grandeur eluded me?

This ascetic walk along a "deserted" beach allowed the murkiness of my own mind to settle out a bit. To the degree that my seeing was now less obscured by the confusion of litter in my own perceptual apparatus, I could begin to observe the many levels and magnitudes of ordering that make the world and are the world. I began to notice that things were not distributed randomly from the water's edge up toward the dunes. Farthest up the beach, where the highest tide had reached, the objects were generally larger, more irregular, and more buoyant. As I walked down to the water's edge (this was, you may remember, a walk taken at low tide a few days after a storm at sea, at a phase of the moon's relation to the earth where the difference between high and low tide runs five vertical feet), the objects were smaller and denser and more regular. Why this was so has to do with the ratio of surface to volume and density.

This is what I saw. What I *thought* was, "Here is a principle of composition that the universe employs under certain circumstances; things get to be where they are as a consequence of their internal constitution and the external circumstances they have been subject to. Things are in the company they find themselves, not necessarily because they share similar attributes (a glove and a shell) or even similar

histories, but because the resultants of these two equations, each with distinctive variables, happen to work out to have, not identical, but similar quotients:

$$27 \times 18 - 221 + 2^2 = 269.$$
$$9 \times 11 + 158 - 2 + (3 \times 5) = 270.$$

I loved this mix of indeterminacy and constancy at all levels and moments of creation. This seemed more empowering, expressive, freeing, yet also more responsible, than the system for arriving at aesthetic orderliness as taught to me by my studio teachers. Their system of instruction was simple and useful but proved hollow in the long run. As I faced an accumulating host of life's challenges and opportunities, received truths and means no longer felt sufficiently trustworthy to adequately deal with them.

The advice given to me by the Great Men (at that time there were no Great Women, though there are now) seemed to improve the look of my paintings. They offered such insights as, this doesn't work, try more orange over here; or this area is too large and holds the eye too long, make it smaller; or there's a hole in the picture plane created by this form and that color, warm it up, and get rid of that angle. As I followed these admonitions, my paintings began to "work." *Work* here meant that my painting engendered serious discussion among my companions, referenced as it now could be with what other artists considered serious, and in the system of discourse employed by art critics, art historians, and aestheticians. Increasingly pleased with my progress and being admitted into the community of discourse, I realized several years after leaving school that how they came to make these acute observations and recommendations had never been explained to me. I and my fellow students were only provided with the news report, never allowed to see the scene itself, and never explained the system of thinking our elders employed to generate their insights.

I do not believe our instructors purposefully hid the vital source of their wisdom from us in order to make us dependent upon their monopoly of deep information. I'm not sure they themselves could generate their insights afresh. More than likely they were deriving these finely tailored interventions from a stock they in turn had inherited. My training in art prepared me not so much as an artist but

more as a painter. These need not be different from each other, but in the main they are. The resourcefulness, creativity, playfulness, apparent daring and courage, focus, finely honed skills, sweeping vision, and bold intuitions that characterize the efforts of the artist must derive from deep, close familiarity with the basic nature of the materials and organizing principles of the universe itself. This more fundamental level of understanding was neither made available to me nor, as far as I can tell, even alluded to. As far as seeking within oneself for mean-ingfulness went, this pursuit was considered the domain of therapy or spiritual life, and there was no room in the art studio for them. In ret-rospect I think we had been had, not intentionally, just had. We had taken the messenger for the message, not knowing that underlying each was yet an even deeper source, *and that one could access it*. We were not the first to be dazzled by the illusion.

I was a good enough student; how was I to know at the time there is a fundamental difference between what is required of the successful art student and what is required of a good or successful artist. Follow-ing the classical canons of good form—catch their eye in the lower right corner of the piece, conduct their eye about two-thirds up and toward the right center, then bring their eye toward the left and down-ward, leaving off with a return to the beginning; more is less, less is more; keep a dominant value system throughout your color scheme, if you keep the same value scale throughout, you can expand the range of your hues—I made some nice paintings.

There was still another canon not made explicit by our instructors but known by all the students: don't follow all the rules all the time; break at least one rule in each work. Obeying this one demonstrated your creativity and courage, very important for art students wishing to catch the favoring eye of their instructors and, subsequent to that, for entering the annals of Art History. Once you got the hang of this rule, completing the assignments became, if not fun, exciting. It was excit-ing in the same way that going fishing is with a highly touted new lure in an old hole; something may just happen.

Before I could allow myself to relinquish these canons of good form, I required something, even the promise of something, to take their place. What made the possibility of such alternatives outside the realm of *my* possibilities was a notion also taught to me as a funda-mental of my preparation for entering the community of artists: that

art proceeds from art. That is, the history of the canon of art proceeds along a logic distinctly its own, and those who would be part of its community of discourse must familiarize themselves with the canon and the values that determine its content and boundaries. Ultimately, one's own work ought to acknowledge its indebtedness to the canon, with, of course, the necessary degree of disrespect.

The particular events of my private and social life could not help but shape the look of my work, as did the general thoughts and events of the times and place: New York City in the 1960s. Then, art that mattered, art that might be taken seriously, could not derive from a private vision; it had to reference other "serious" art and must exhibit some freshet of novelty in the direction of the general trend in the river. The art that I was being introduced to was becoming ever more self-referential. Styles evolved as a consequence of the internal discourse among key artists; Kline, de Kooning, Guston, Rothko, Newman, Reinhardt, Motherwell, and a precious few others. I found myself in the position of being married into a family whose incestuous practices were not at all to my liking. As with many dysfunctional families, it was the only family I knew, and no one in the family suggested that we may have certain problems or, if I was truly unhappy, that I might try elsewhere. There was no legitimate elsewhere. Or so I believed.

Besides, letting go of these and other canons of good form would be to lose the means with which I formed my identity as an artist, organized my work, steered my budding career. Such a leap of faith might be just the thing for mystics who unflinchingly let go of everything and fly into the void only to be caught in the loving arms of God. At the time, I was not so sure about that, feeling that if I leapt, the Master of the Universe might be at work in some other corner of the world, helping some more deserving soul.

When I took that walk along the beach, I was not looking for another way to satisfy my inclinations to create. I knew that other peoples did create in entirely different attitudes and strategies. But they were tribal Africans, Australian aborigines, Native Americans, folk artisans of Asia, naive fabricators of hinterland America, and I was none of these; I was a guy from New York. So when I took that walk along the beach many years later, I simply took a walk.

But something happened along the way, and as a consequence it

seemed to me that there was a way of organizing chaos into an expressive canvas that did not arise from the tradition I was schooled in. I had witnessed Nature in the act of creating the universe and doing so in a most conspicuous fashion right beneath my feet—in fact, in my feet themselves, in everything. It's impossible to say this without a high degree of irony, but Nature's creations "worked" at least as well as the art with which I was familiar, and worked on a scale and to a degree of an entirely different magnitude.

And there was the politics of it that appealed to me: Nature's creations weren't faddish or enslaved to stylistic moments or prevailing opinion. Nature's novel permutations were unconstrained by concern for their reception. Nature didn't fawn, pander, or posture. Nature's amorality exploded morality altogether. Nature's indifference troubled me greatly in matters of human life, struggle, and death, but not in the realm of sheer creation itself. Here Shiva's eternal dance of destruction and re-creation were instead a source of solemn and terrible wonder. And having glimpsed the barest outlines of some sublime order, one that was as red as white, I could only muster, with Job:

> *I had heard of you with my ears;*
> *but now my eyes have seen you.*
> *Therefore I will be quiet,*
> *comforted that I am dust.*[1]

When I started my walk along the beach, I walked right through this very same classroom, stepped right upon the same text, chapter by chapter, glanced over the illustrations, and I saw nothing and learned nothing. On the way out Nature was an obstacle; on the way back it was my teacher. On the way out I felt alone; on the way back I felt at home, embedded in an infinitely extended (and functional!) family. On the way out I felt vulnerable, assaulted by a hostile, uncompromising Nature; on the way back I felt attended to, as if the world were showing me the things I needed to know in order to feel at home and behave properly. On the way out nothing seemed to excite my intellect to action, nothing I saw teased an idea to form, I had barely enough juice running through my brains to keep physically moving, to keep from stepping on things and keeping my feet dry. On the way back each item in my view appeared as a single example of a more

general principle, and what first appeared as chaos now revealed not only an orderliness but universal organizing principles. Every item was not only its own palpable form but a pointing to something else and something more. Everything took on the powers of metaphor. Before, nature looked fascinating—at its best, beautiful. Now, less absorbed by my own paining self, which clouded my vision, I believed I witnessed the outlines of a far grander Something. It seemed at the time as if this great Something was permitting me a view of itself, to learn how it works. The great Jewish scholar Abraham Joshua Heschel says of such a vision, "Under the running sea of our theories and scientific explanations lies the aboriginal abyss of radical amazement. . . . While any act of perception or cognition has as its object a selected segment of reality, radical amazement refers to all reality; not only to what we see, but also to the very act of seeing as well as to our own selves, to the selves that see and are amazed at their ability to see."[2]

As I continued on my return, walking became more and more interrupted with seeing. Then seeing itself became so full and rich I could hardly continue to keep on seeing and instead began to allow my eyes to just rove along the horizon or into the cloudless blue sky and to shake my head back and forth, making a sound with my tongue and palate, beneath words, my cipher of radical amazement: tssk, tssk, tssk, tssk . . .

This was turning out to be a strange walk indeed. It began with the intention of finding some broad prospect to afford me solace from a cramped schedule and a bruised psyche. I needed uninterrupted time and space to reflect on my life and unwrinkle the creases in my spirit. The unanticipated severity of the weather forced me to abandon such higher thinking and revert instead to a more primitive source of solace, rhythmic breathing and moving in a manner quite detached from this or any time or place.

My habitual walks are punctuated by casting about for things I might use back in the studio. At the conclusion of an innocent enough walk, I arrive home, pockets bulging with small trophies, my head full of images and phrases with which to compose my next piece. This time it was different. I felt no need to acquire, to manipulate, to improve the world. I wanted, really, nothing. Heschel reminds us that "a mercenary of our will to power, the mind is trained to assail in order to plunder rather than to commune in order to love."[3] I didn't con-

sider my acquisitive journeys as plundering or my acquisitions plunder, but I did go out to seek and take, and I did not go out in or for love. I sought nothing but some wild and empty place, but quite unexpectedly a series of events brought about in me a state of "radical amazement." Heschel goes on to explain this condition in this way: "Where man meets the world, not with the tools he has made but with the soul with which he was born; not like a hunter who seeks his prey but like a lover to reciprocate love; where man and matter meet as equals before the mystery, both made, maintained and destined to pass away, it is not an object, a thing that is given to his senses, but a state of fellowship that embraces him and all things."[4]

Embracing myself and all things was the way I now experienced my Self in the world, as a simple but quite present member. A role more familiar to me was that of an awed guest welcomed by a noble family, or as a relative at some distant cousin's affair. None of these relationships with the world now fit. All made too much of the distinction between me and the world. I felt none of this. I felt instead a quiet and sufficient sense of wonder. The great sweep of the horizon and the tiny, syncopated fault line of sand-flea casings were equally astonishing. The ornate tangle of seaweed lush with wet greens and purples delayed my eye no longer than the pink and simple curve of the razor claw. The creature that I was, this outrageous construction of positive- and negative-charged particles that could *see, think, die, live!*— all this made me shiver and be still.

Heschel, who must have had his own fair share of such epiphanies, describes it this way: "The soul of a man is an urge to sing for all beings about that for which they all stand. All things carry a surplus of measuring our being—they mean more than what they are in themselves. Even finite facts stand for infinite meaning. It is as if all things were vibrant with spiritual meaning, and all we try to do in creating art and in good deeds is to intone the secret strain, an aspect of that meaning."[5] The sky shifted from blue to green to a pale lemon, then from pale orange to maroon, coming to rest on the deep blue of the earth with a final purple. The day had run its course, everything was either black or indigo, everything was shadow, and I left the beach.

Back in my car I turned over the engine but stopped just before engaging the gears. Something happened out there on the beach that I didn't want to be separated from. I was back in my car, surrounded

by glass and steel, settled comfortably out of the wind, with the heat slowly making its way from the engine and even more slowly through my many layers. Something had happened to me, and I did not want to leave it there and return empty-handed. I sat a long while staring straight ahead at the deepening night. I felt the world of things had drawn aside, for a moment and by only a sliver, the veil that hid meaning from appearances. Now I needed to reciprocate in some tangible way to this forthcoming gesture, with something from my Self. It was too soon to assimilate such radical news into some clear course of action. I knew from prior events in my life that it takes a long time for me to derive implications from major events, no less to chart a new course. Although I had no plan in mind, I felt, by way of some semi-magical thought process, a need to make some stab at assembling meaning from this little excursion before I returned home and the force of the experience became diluted and confused. I felt that if I didn't make some reciprocal effort, what had been shown to me might be withdrawn. After all, weren't mythology and religion replete with instances of human ingratitude invoking the wrath of the gods?

Who knows how thoughts arise, how they form themselves into words, and how words with seeming spontaneity align themselves into coherent sentences expressing thoughts? How is it that sometimes, as we pronounce these thoughts and send them out via language, we are amazed and even chagrined, as if the person who is speaking and the one who is hearing are two different beings inhabiting the same body? However thoughts are formed, a number of propositions about these and other aspects of Nature quite literally popped into my head, or rather out of it. Their novelty to me was initially startling, but I felt compelled to put them down while they were flowing and to make sense of them later. They opened an entire new category of Nature's attributes beyond the one I had been using to see, to make sense of the world, and to make art, beyond the category to which I had previously assigned Nature: Aesthetics. Once the initial proposition appeared, its logic pulled others out as corollaries. In the order they appeared:

- Nature is infinitely wise; it knows how to do everything that is possible to do.
- Everything we need to know and know how to do, Nature knows and does.

- Nature does not lie, does not know one thing and show another.
- Nature always and only means exactly and only what it says.
- Nature is constantly displaying everything it can do.
- Nature is guileless.
- Nature is shameless, shows everyone everything.
- Nature is infinitely layered; the more an eager observer prepares for the seeing, the more Nature reveals of itself.
- Nature uses only what is required to manifest its potentiality, not one thing more nor one thing less.
- Nature is never frivolous or shallow.
- Nature can be understood as a sacred way of speaking, because its content is always a matter of life and death, and what is says is always true.
- Nature appears beautiful to us because we too are Nature, and what we take to be beauty is only like meeting like and celebrating the congruence.
- Nature is always speaking, but in a language that we have not been taught because those traditional peoples who knew how to speak the languages of Nature we have either ignored or killed.
- The way Nature conducts its affairs is the way I want to conduct my affairs.
- The way Nature creates the world is the way I want to create art.
- We have cut ourselves off from Nature in our minds, our hearts, and our bodies. Our religious traditions, political policies, and social conventions, despite the protests of many, have reinforced this schism, separating humans from the rest of creation. This schism is killing us. All of us.

These were, for the moment, assertions of belief without benefit of study or further reflection. Now, however, I had an agenda to pursue, and satisfied that it was a fresh one, one that emerged from my own engagement with life, I felt a new optimism for my Self and my art. I would use my art not to make pictures but as a further inquiry into the meaning of the above propositions, about how I might draw closer to Nature. Now I could start my engine and head for home.

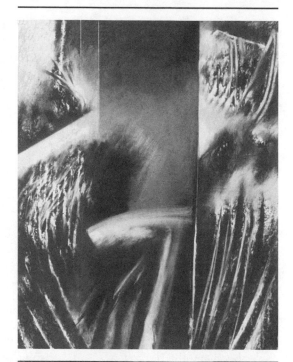

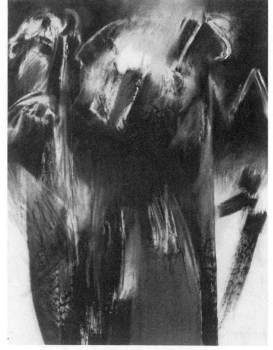

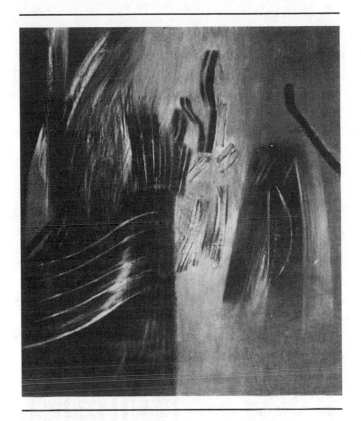

It is impossible to forget what we know, a fact that is a source of both anguish and power. My task of creating art out of an entirely new premise would have been made vastly easier if I could have stemmed the flow of memory into current action. Of course I couldn't do that. Yet I wanted to learn to draw from the beginning, again. How I might go about accomplishing this sleight of hand/mind came upon me in full resolution: I knew how I constructed my art, I would tease out each segment of the process and *not do that*. I imposed a series of restrictions upon myself that would prevent me, as much as possible, not from remembering what I knew of art but from using what I knew. This was my retreat into the desert.

I would observe these restrictions for one year:

I would not use any material that I had used before: no paint, no brushes, no solvents, no canvas, no stretchers, no gesso.

I would use the least expensive and most common of materials (I settled on charcoal and excess stock from a local printer).

I would use no color (I was a color-field painter) and would work only in black and white.

I would not make shapes that resembled the shapes I had been making.

I would not hold the marker in the way I had been used to holding the brush.

I would use a set of materials that were new to me (at least ones that I hadn't used for art in more than twenty-five years).

I would erase only as a form of marking.

I would stop before the image jelled—or became meaningful.

I would not repeat, build, or consolidate.

I would begin my markings with my eyes closed and keep them closed for as long as I could throughout the session; when I did open my eyes, I would try to remain in the same sightless frame of reference in which I had begun.

After each session I would put the work away, not to see it again for a week or two.

I would show my work to no one for a year.

On the anniversary of this strategic retreat, I would assemble all the works in the order they were made and see what there was to see.

I wanted to sink down so far beneath the art that I knew and did that I might find a bedrock of primal effort, so rudimentary that it was on the borderline between what animals do when they mark their territory and what dawn humans would do when they marked themselves. I simply wanted to draw closer to Nature.

Eden Revisited

———

THERE IS A STORY SO PERVASIVE, so deeply sublimated, therefore so powerful, that it is disabling our grace and ease in this world, the grace and ease with which we mostly conduct our lives and create our art. The story is Genesis, the Ur-story at the center of all our stories. It is in Genesis that we learn the reason for our current state of exile from Nature. Uniquely created and endowed (thus unnatural), in a world that is neither our original home nor our ultimate home, we have been cast as aliens into an opaque, often dangerous world, a corrupted form of something earlier, something higher. These observations on human nature, and on Nature itself, shape our forms of upbringing, the dynamic and moral structures of our entire civilization, our schooling—and in particular our art education.

To create a new, more deeply satisfactory story, one that will enable a healing of the schism between humans and the rest of creation, constitutes the great task of this generation. Because this story is as primary as it is, invasive as it is, the task of creating a new story, Genesis II, requires an effort that our minds, bodies, and spirits find satisfactory. The artistic enterprise, when full and sincere, is just such an engagement that calls upon these powers, making the arts well-made instruments for this daunting and necessary creative act.

Our Ur-story, Genesis, has portrayed human life as one of fundamental alienation from all the rest of creation. It is a story of the

human condition as a state of exile; we have been cast out from our original home (Nature) and our original state (members in good standing of an infinite family). Exiles from Eden. But, suppose we never left Eden. Suppose *this is* Eden. And suppose what we yearn for, we already have, but hidden.

And suppose that living in Eden, but dissuaded from recognizing it as such, we have come to despise this place (Eden!), seeing it instead as a place of exile, a place where what is gained is gained by the sweat of our brows, a place where pain is the reminding price we are forced to pay for our eternally spoiled nature.

Whatever credence we afford Scripture, we live in a world of ideas, values, laws, and social structures that bear the imprint of the Genesis story, which presents our world as a place of exile, and the face that Nature turns to us as the face of a severe, awesome, remote, indecipherable, overwhelming parent. From this telling we learn that from now until the next and final coming we must live and toil in a lesser land. Now we live in a world that is made to exact a severe toll for every morsel of sustenance we are required to wrest from it, for every child we bring into the world.

Few today believe in the literal truth of this primal story; yet how to explain the strange attraction the story holds on our personal and societal attitudes and behaviors toward Nature? The story of the Garden of Eden has particular powers to shape subsequent stories and lives because it was and will forever remain our *first story*.

The Garden of Eden is not only our first story; it is our only story. That is, although scientists have provided us with other dynamics of evolution, they have not provided us with another story of creation. Science has not and cannot provide us with a story that includes any characters with any lines to say, with any characters at all, just trends and forces and principles twisting and pulling at each other over insufferably long periods of time. Science may have given us a more accurate account of how things got to be the way they are than Scripture offers, but it is less of a story, drained as it must be of the elements we find compelling in the structure of a story: heroes and antiheroes, grace and fall from grace, plotting miscreants, gullible saps, justice and injustice, fall guys and vengeful agents, forbidden fruits, shattered innocence, supernatural forces, and so on. We have a better record of events, but we do not have a better story.

What is told to us in our primal story of Eden, our first impression of Nature, and humankind's place in it? Eden was a place that is not like "this" place. If we make an account of Eden as given to us in Scripture, then subtract those qualities of Eden from the world we now have, we should arrive at a conception of the world as we now take it to be. What, then, was Eden? It might be said that Eden was a place that contained qualities we deem valuable but do not currently have—that is, whatever we yearn for. For desert dwellers, Eden is a place of gushing springs, cool breezes, trees heavy with bountiful fruits. For the temperate agriculturists who plow the earth, Eden is a place where the soil runs deep, where rain and sun are in a necessary balance, where the seasons are predictably regular and seeds turn always to crops. For the spiritually hungry, for those who yearn to be close to their God, Eden is a place that God visits in the cool of the evening, open to conversation. Eden is what we love most, desire most, and never have enough of. More than what we do not have, Eden is the place that we no longer have. The sense of having lost a most precious thing through no personal fault of our own compounds our dissatisfaction with its substitute.

Thus held in our minds: Nature as exile, Nature as trial and as tribulation, we treat it accordingly—shabbily. We bruise, cut, burn, poison, break, tear, desiccate, suffocate, eviscerate, strangle, and bury all forms of animal, vegetable, and mineral. There is no news in any of this. These behaviors have become common and easy for us to exercise because what we are killing in these many ways is a wild, a lesser thing than we should have. We do these things rather automatically, because we are not injuring Nature, we are doing just quite ordinary things to "Not Eden." And why shouldn't we? This is not our first home, nor our ultimate one.

In the scriptural account of Eden, we are given a tantalizing view of our first, now lost home, and a life we no longer are permitted to enjoy. A description of *that* garden will provide us with what has been denied us, leaving a description of what we now have. A garden is quite a different affair than Nature at large, and these distinctions are of particular importance for the thesis of *Drawing Closer to Nature*. A garden is created with intentionality, and constantly groomed to maintain that intention. It requires perpetual care because the rest of Nature is constantly invading the garden, "grooming it" as it were, according to

quite different criteria. Whereas the purposes of Nature are complex, vast, and seemingly inscrutable, our purpose in the creation of a garden is relatively simple: to please ourselves. We like pretty colors and shapes, we like things of a manageable scale, ease of maintenance, tidiness, perhaps a touch of mild adventure and tiny surprise. We like our gardens to work on our behalf, with colorful flowers, well-sculpted and well-behaved trees and shrubs, and fruitful veggies. We are pleased with the performance of some, disappointed with others. We tinker with the place until we get it just right; then we change our tastes or grow bored and go to grooming again. If we are not pleased with the performance of our invited guests, we yank them out and try something else. It is marvelously recreational, even therapeutic, a source of many satisfactions for ourselves and our admiring guests.

Nature, raw, is quite another thing. Nature is fickle (or so Nature's inscrutable ways seem for us); the gardener needs constancy. Nature is so much more vigorous and expansive than we are, or at least with the modest requirements we have for our gardens. Nature is persistently invasive, always trying to reclaim our tiny groomed spot for its insatiable self. Nature is so abundant that we can never manage to schedule enough of our preciously apportioned time for trimming, clipping, and plucking. Nature has endurance, quantity, and unpredictability in far greater measure than we are willing to devote to our gardening efforts. Nature undoes everything we do. No matter the magnitude of our efforts, the very moment we break the earth for some new project, Nature is already at work at the micro- and macro-levels disassembling the enterprise, be it a garden or anything else. The order that Nature employs in the creation of the world's biomass is distinct from the order we use in the design of our gardens. Nature's order is infinitely fine, intertwined, and mostly hidden (at least from our casual eyes). Nature often appears to us as unruly, crowded, smelly, unkempt. We don't like these attributes in people, clothing, homes, art, anything of human device, and we don't very much like them in Nature. However, the saving grace of gardens, in contrast with Nature, is that gardens are more civilized, more like us.

A garden was our first home. Our first home was divinely provided. Our first home was a garden within which we had a dignified

responsibility: to dress and keep it. Our first home was pleasant to look at, had good and ready food, had a tree of life, and had a tree of the knowledge of good and evil. Our lot, however, was not to remain in Eden, because the root stock of our kind, Eve first, then Adam, broke God's first admonition: to not eat of the tree of knowledge of good and evil. And for their indiscretion they, and their offspring (us), are severely punished. For Eve, He has this to say: "I will greatly multiply thy pain and thy travail; in pain thou shalt bring forth children; and thy desire shall be to thy husband, and he shall rule over thee" (Gen. 3:16). For Adam He has another thing in mind: ". . . cursed is the ground for thy sake; in toil shalt thou eat of it all the days of thy life. Thorns also and thistles shall it bring forth to thee; and thou shall eat the herb of the field. In the sweat of thy face shall thou eat bread, till thou return unto the ground. . . ." (Gen. 3:17–19). To ensure that His wayward creations are not further tempted to go against His will and return to the garden, "He placed at the east of the garden of Eden the cherubim, and the flaming sword which turned every way, to keep the way to the tree of life" (Gen. 3:24).

This is the image of Nature bequeathed to us by our Scriptures, an image of what we once had and have now lost. From here on in we will know Nature as the perpetually distant and enigmatic "other": other than the place we were first given, other than a garden planted for our sustenance and pleasure by a divine source. There is enmity between our seed and the rest of Nature. We must labor hard for the crops that sustain us; we must bring forth our young in pain. Our current pain and sweaty efforts are constant and perpetual confirmation of the verity of our wayward past and their consequences in our present condition. If we cut down Nature, use it mercilessly for our own devices, so what? Why be circumspect in a place of exile?

And yet. And yet most of our personal experiences with Nature would have us believe otherwise, and ought to have similarly instructed our behavior. When we go out into Nature just as it is, for a little walk along the beach or a day in the country, or spend a bit of time looking at the sky, day or night, what we actually experience is quite another thing. We like the experience; we feel refreshed, cleansed, made somehow whole. On occasion, we even experience an

elusive mystery, the sanctity of the place and moment. Grand vistas will do this; so will majestic waterfalls, sunsets, daybreaks, mountains, brooks, and snowfall. But we do not require such dramatic displays of Nature's charms to feel refreshed, even transformed. A single pebble will do, or any leaf picked at random, the inside of any melon, or its outside. A cat, a dog, a goldfish, a baby's fingernail, any bird, every feather. Every entity and pattern and iota of Nature, witnessed with care, can refresh and transform us. Sunlight itself, moonlight itself, starlight, firelight, can comfort us, refresh us, make us whole.

Our personal history with Nature is quite literally, wonder-full. But we have yet to collect all these current and actual accounts of Nature into a new Story of Creation. We have yet to compose a story in which humans are entwined with the rest of creation in a new mutuality, in a story that has us still at home, still living in a garden, in the midst of an infinite web of life, more gardenlike for its intertwining patterns that continue to reveal themselves the closer we look.

The creation of a story that is credible and that bites as deep as the one we were given in Genesis requires a heroic act. Although the imaginative leap is substantial, and the perceptual acuity necessary for the task is within our capacities, the credibility that this story must have, sufficient to act upon in the world of concrete operations, must be sound enough to withstand the pervasive and dismissive powers of our received and sanctioned story.

If we are to extract ourselves from the grip of our present story, and thus release the hold this story has upon our worldview and our consequent behaviors, we must begin as simply as possible in concrete experiences with the natural world. We must begin before the construction of a story; we must begin with an archaic frame of mind, one that has the least abstraction, and metaphysic, one that is rich in primary experiences. Not surprisingly for the thesis of this book, this is just what artists do: have primary encounters with the world, then say what they know, not a thing more, not a thing less.

This book intends to guide the reader to experience a series of firsthand encounters with Nature and, aided by the process of creating imagery from deep within our being, to form a new image of the world and a new us within it. The new world that will come into focus as a consequence of these close encounters will have radiance, a depth, a richness, and an embracing familiarity; so will you, and so

will your art. By drawing closer to Nature, we discover that *we* are Nature. We were never, could never have been, exiled from our home. So "returned," we experience ourselves as natural, as family, and our lives take on an ease, grace, and fullness. Consequently, so does our art.

Do Not Be Afraid

———

IN THE FOURTH DAY of a week-long course in Drawing Closer to Nature for artists and art teachers, I brought a group of twenty adults to a woods not far from our campus. A few hundred yards into the nature preserve, we stopped at a pretty place underneath some giant pines; a stream nearby could just be heard over the hum of the breeze through the arched boughs overhead. A sunny summer day, in the companionship of now dear and trusted friends, we sat awhile and spoke of the history of these woods and what our task would be for the afternoon. It would be the Encounter I call "A Blind Walk" (see page 253). It is the one in which two people form a partnership, each taking a turn, with eyes closed, being introduced to the surroundings through the careful guidance of the sighted companion. I demonstrated with a participant how I might hold the other, ever mindful of the responsibilities now entrusted to me. I indicated that the duration for each portion of the experience would be about five minutes, and that no one would wander farther away than seeing distance from where we now stood. I then invited participants to select a partner with whom they felt comfortable in engaging in this process. The blind partners would establish the pace of the journey and how close they would like to be held. The sighted partners would introduce their charges to what might be a particularly rewarding series of tactile encounters with Nature. I would remain sighted and would wait at our

starting point, to which the pairs would be returning. It seemed straightforward, carefully prepared, safe, and promising to me. To me.

The invitation was initially met with nervous titters, tentative partnerships, firm holding on by the unsighted ones, hesitant baby steps by all. Every one of these competent adults, who had faced and survived the truly terrifying worlds of childhood, adolescence, marriage, raising families, driving in traffic, working in offices or classrooms, and who were thoroughly acquainted with trees and brooks and summer, became self-conscious and clearly frightened when asked to walk into raw Nature stripped of their sense of sight. The invitation to hold on to a sighted partner as close as they felt necessary, to move as slowly as they wished, walking in a place they had just walked through, for a prescribed five-minute interval—all these safety precautions were not sufficient to allay their tentativeness about being in the world—or, more precisely, of being in Nature—deprived of their early-warning optical systems and the great computational banks of their minds to make sense of the vital data they gathered.

One otherwise quite able woman, a fearless art teacher of junior high school students, sat where she was and decided not to engage in the process. I approached her and asked if I might be of assistance. She looked rather crestfallen and after a while said, "I can't do this. I cannot close my eyes in the out of doors." I replied as I always do that she needn't participate in the Encounter as I presented it and might modify it to her own thresholds of comfort and for the particular rewards she preferred and felt capable of achieving at this moment. More silence, then: "I would like to feel comfortable enough in Nature to be able to just sit here with my eyes closed for a while." I affirmed her choice and left to sit a few yards away. A short while later, she called me over and said, weeping, "I can't do this. I can't close my eyes sitting quietly, even knowing that the teacher is right by. I can hardly breathe thinking that without my eyes open to warn me, something from the forest will come out and—I know this is juvenile—hurt me." Silence. "This is no way to be! Please sit by my side, hold my hand so I'll know that you are still there, and then perhaps I will be able to close my eyes in this goddamn Nature." I sat by her side, I held her hand, she sat awhile trying to breathe calmly. After a while she put the other hand first on her heart, then on the earth; then, watching her breath, she closed her eyes. We sat there for a while; she rocked lightly

back and forth, wept quietly. After some time she stopped weeping and a calm came over her face. Instead of being hunched over, she straightened her back, released my hand, said thank you, put both her hands on the earth, said thank you as she lifted her face to the dappled light filtering down through the pines. She said thank you to the handful of earth, twigs, and pine needles that she brought up to her face to smell and touch. She slowly breathed in the aroma of the forest, then she exhaled long and slow and full. She lay face down on the soil, her arms wide out, her fingers caressing the earth. Her face became muddy, her tears mixed with the earth. She stayed there while all the others were finding their own rites of return. She made little lines in the ground, like a lover almost absentmindedly caressing the fabric of the beloved's shirt while looking at the still-astonishing features of his or her face, its pits and pores and hair, and the endless colors of even their irises. She made tiny piles of things, straightened out some pine needles, sprinkled a bit of humus on the arch of her foot, rubbed it in. She lay down again and put the side of her face against the earth from her temple to her chin. Then she sat up but did not brush herself off. She remained quiet while the other pairs arrived back at our place of meeting, chatting enthusiastically about their own encounters. As we gathered around to exchange the news of our forays, this woman was attentive to the triumphs of others but chose to remain silent. On the way back, several people remarked what a pretty face she had.

Do not be afraid.

Despite what may have been told to you about the nature of Nature, trust in your own experiences. See for your Self.

This is your home. The world as it is, is your home. The entire planet is where you live. No, that's too modest—the whole universe is where you live. *This* is it. This is what all of creation has been fifteen billion years in the making, making you and making It. *This* is the great place of meeting. All of this. Look around you; you are in the sticky mess of family from first breath to the last. What a mess, what a divine mess.

You have been told of a place called Eden. This is it.

Now close your eyes. Now open them. Say what you see, not a thing more and not a thing left out. The news is vital; saying it well and full is your art. The title of your story? Consider, "Genesis II."

I Awoke from This Dream

———

Lovers seem able to commune with Nature more readily than those not in love, at least not in new love. Accounts of a speaking world coming from children, lunatics, and artists also appear in our literature. But for those of us possessed only of ordinary consciousness, our ability to understand the languages of Nature is far less developed. So much so that we (not children, or artists, lovers, or lunatics) believe Nature cannot speak at all. Nature may be beautiful but is, unfortunately, dumb, without speech. Of course the central thesis of this book is quite the opposite: Nature is not dumb; it is we who are not listening, not listening because we conceive of Nature as being dumb. A fatal syllogism.

If we listen carefully to the language of lovers, children, artists, and lunatics, we may observe a revealing similarity in their apprehension and expression of language; all of them seem to be able to "read" the musicality of language, its tone, pitch, volume, texture, color, melodic line, rhythm, form, dynamics, pattern. It is the pattern that connects, Gregory Bateson tells us, the pattern wherein the news resides. That is after all the essential difference between an encyclopedia and a dictionary, the pattern of the chromosomes on the gene that differentiates you from me, the order of events that tell the story. The order of the words, the musicality of the order, the pattern's tone, color, texture, and so on, that tell the news with us and with Nature—but without benefit of words.

What artists look for, listen for, in Nature are not words: a talking dog, or even whispering pines. We listen for the poetic line, and not only are we moved by the beauty of its melody and the allure of its form, we are instructed. Instructed? Instructed because Nature is always about life, procreation, growing to maturity, courting, parenting, and becoming a member of a community, surviving adversities, meeting death. And so are we. Nature knows how to do these things well, having practiced this trade for several billion years. Our kind has been trying to get these same things straight for a long time too, but not quite as long.

The following dream is recounted as an example of the way Nature speaks. Employing the very same vocabulary and grammar of Nature, the things of this world; sunlight, hills, wind, stones, gravity, and the grammar of common sequence; morning followed by afternoon then evening, the dream presented a map of the world that I continue to study.

I awoke from this dream changed, although at that time I could not have known just how or how much. In retrospect, my dream seemed a resolving coda to many uncertain fragments that had emerged from time to time throughout my life in general and my art in particular. I awoke shaken, not yet refreshed. It seemed a slight shift at first; over the ensuing years, however, my sense of death—or, if you like, life—has taken on a different frame of reference and meaning: how could it not have affected my art? Although this account was written fifteen years after the event, I believe that I have neither added nor deleted anything from it, so vivid was my experience and so often have I reviewed that night's journey. This is what occurred.

THE DREAM

The time is late summer in the early afternoon of a sunny, mild day. I am me (in some of my dreams, the character, "I am" is not entirely the me that I take myself to be. But in this dream, I am). The field that I am standing in is knee high with wild grasses that wave lightly from a breeze gently blowing from the east, which is on my left. I am looking south out onto a series of rolling hills. I have no destination in

mind and am not aware of any antecedents to my present surround-ings or circumstances.

Soon, however, the dream begins to "play," and I find myself walking through the grasses toward the distant hills. The field that I am walking through, stretching indefinitely on either side of me, east and west, is the general color of a lion's mane. In front of me, south-ward, the closest line of hills are a warm green; they cool and fade as they recede in overlapping waves toward the horizon. The sky is cloudless; it is a rich summer's blue overhead and pales as it descends in all directions.

I walk without effort or purpose. My progress through the land-scape seems more like a slow, automatic glide with the scenery passing by, as if I were not walking at all but in a train, pulled along by a silent and distant engine. After a while I become aware of a number of changes in my surroundings. It now appears to be early afternoon, for the sun is in the western sky and lower toward the horizon. Although the hills are still at a substantial distance from where I stand, it seems I have come quite a ways, for they seem a bit higher, more textured and more steeply rolling. Their colors have shifted to cooler, softer shades of blue green; the most distant ones are now a gray blue. The sky re-mains cloudless. It is an intense blue to my left, toward the east; it warms and lightens overhead, and as it arcs to the west and descends to the southern hills, it pales to robin's egg.

More pressing on my attention is my awareness that I am no longer in an open field. Instead, I now find myself in the center of a broad valley, the sides of which are made up of the gradual slopes of modest-sized hills. The twin hills rise equally to my left and right. Al-though I take note of my new circumstances with care, my attitude is one of detachment, as if I am a passive observer of some curiosities that by chance I happened upon. And so I continue on my way, walking-gliding toward the hills to the south.

Some time must have elapsed, for I am next aware that the day has passed on to late afternoon. The hills in which direction I have been walking are closer still, for they appear now steeper than before, fill my southern view more completely, and have taken on a dusty blue cast, paling to a gunmetal gray in the farthest band. The sky too has become a deeper blue, with overtones of violet and purple. I can no longer

discern where the sky leaves off and the hills begin, so close are their adjacent colors. Here again, the circumstance that most compels my attention is the fact that I now stand in the center of a deep and narrow valley, walled in on either side by two quite steep and massive hills. The one on my right is in shade, the sun having passed beyond its crest toward the west. This hill is a rich mosaic of emerald greens and magenta. The hill on my left is golden on top as it still receives the sun, while below, it is in shadow cast by its twin. Warmed by the half-light of the hidden sun, its colors are shades of ochers, sienna, and chrome green. Being in the cleft of the hills, I too am in shadow and feel a slight chill in the air. I am dressed lightly and not prepared for the cool of the evening.

Some more time passes as I continue on my purposeless glide-walk toward the hills that still occupy the southern horizon before me. It now is dusk. The far hills are various shades of blue but blend together in a somber band that seamlessly joins the sky. Directly above me the sky is a deep indigo, still without a cloud. It is the aspect of the hills on either side of me that again impresses itself upon my attention. The two hills have become decidedly taller and steeper. They rise abruptly, forming a narrow V in which I now stand. So close are they to one another that I am able to touch each of their flanks by extending my arms to the sides. The hill on my right is in deep shade; it is composed of indistinct masses of dark green, blue, and purple verging on misty black. The hill on my left is remarkably different. The declining sun still shines on its uppermost reaches. The lower portions of this now quite massive hill, to the very base at which I stand, are in a diffuse warm glow. The hill is covered by a growth of rough scrub interspersed with rocks and outcroppings of silver, ocher, and rusts. By craning my neck, I notice that the upper ridge of the hill glows bright gold.

Standing as I do in a narrow chasm beneath two imposing heights that rise sharply to either side of me, constricting my view of the hills that I had been traveling toward all day, a mild sense of foreboding comes over me. (It is the first time in the dream that I am aware of "feeling" anything at all. Until this moment, I have viewed the conditions that surrounded me dispassionately.) At this same time, I also become aware that I desire something: to climb the hill on my left, the one whose summit is still in daylight. I feel I must accomplish this be-

fore the setting sun no longer falls upon the height; thus it is with a sense of urgency and desire that I turn in the direction of the eastern hill. And so for the first time I no longer walk-glide toward the ever-receding southern hills in front of me; instead I purposefully turn and begin to climb toward the sunlit summit. Although I am not aware to what end my ascent is aimed, this change from being an observer of my journey to now being a factor in its determination somehow quickens me, and I begin to feel more alert, alive.

With the first step onto the flank of the hill, I immediately become aware of its robust texture. I feel the dry stones, the thorny scrub, the gravel underneath my feet. (Before, I experienced the circumstances of my journey solely through the portals of my eyes, seeing the world as if in a movie theater. Now I have entered the world of sensation.) The going at first is easy; the slope presents a definite challenge, but it is doable. The ground is made of scattered boulders, outcroppings, broken shale, and stiff, brittle scrub. I make my way up at a slant to reduce the angle of ascent and my degree of effort. I continue to climb steadily until I am forced to pause in order to secure a firmer handhold on an outcropping.

My body pressed against the rough hill with my arms around the rocks just above me, I hear—or rather feel-hear throughout my body—the earth begin to tremble beneath me. The earth is groaning and heaving. The rocks above me give way and tumble down by me and on me. The hill not only trembles and creaks, it is as if it has become somewhat alive. Quite distinct from these earthy upheavals, I hear, less through my ears and more with my entire frame, pressed as it is against the earth, a deep and solemn utterance: "Where do you think you are going?" It is said in a stern, somewhat cautionary manner. But the utterance also has an indifference to it, as if no matter what my answer, it would not be sufficient reason for my doing what I am doing. (I take the utterance as coming from the ultimate source of reality, familiar with but not identical to Jewish and Christian formulations.) Although I have witnessed, most emphatically and unmistakably, something that I take to be the source of all sources, and the earth trembling all about me, nothing happens to me! Nothing at all. I am the same now as before. Nothing is made clear, nothing is revealed, nothing is settled. Although my circumstances are dire, I feel neither threatened nor deterred. Somehow the gravity of my situation and the

fact that I have just witnessed a direct communication from Head-quarters is lost to me. I remain where I am, ready to continue my climb as soon as things settle down a bit.

The quake over, and no further news from above or within, I continue my ascent. The going now becomes more difficult because the rock face has become quite sheer. I have to work to find foot- and handholds. I climb this way for a while, making my way up. The steepness of the hill requires me to have the front of my body scraping along the hill from my shoulders to my shins. Working my way up in this fashion, I reach above me to secure my next leverage point when, with a concussive spasm, the earth cracks and thunders all about me. The mountain (the hill has now become a mountain) heaves and trembles in great spasms. The earth crenellates, crushing and splintering the surface of the mountain, causing fissures that cave inward. The mountain is imploding, sucking the surface inward toward its core. Suddenly the mountain reverses itself and bursts outward, hurling rocks and tearing chunks of earth skyward. The air is choking with rubble, and rocks rain down upon me. The entire mountain is cracking underneath and all around me. My own body, subjected to the same chaotic forces, is being wrenched this way and that. With each implosive and explosive pulse, the atmosphere also pulses, in blinding greens alternating with searing violet and magenta. The very density of the air also convulses with crushing density, then with splitting vacuum. From the very core of the mountain I hear another utterance, now deeper, more accusatory: "Who do you think you are?"

No answer is expected. Rather I am once again put on warning, which at that time I took to mean: Go no further, this is not meant for you. Not simply for the likes of me, but for me in particular. Although I do not feel falsely accused of low worth, and the evidence is clearly mounting that I had better go no further, I make no such decision. I make no decision at all; I do not stop to weigh the consequences of going on or retreating. I am profoundly shaken but strangely un-harmed. I have a sense that the next portion of my journey will bring about great, more than likely dire events, but I attach no correspond-ing emotion to this, and when the world grows calm once more, I pro-ceed on my way up the mountain.

Looking above me, I can now see that the sun is shining on the top few feet of the mountain. I am only a few yards beneath this point and

again begin to inch my way up toward the rim. Here the going becomes quite vertical but still climbable by wedging my hands and fingers and feet into cracks and hauling myself up to the next hand- and tochold. Finally, I am less than an arm's length away from the sunlight and the very lip of the mountain. Securing my foothold, I free up my right hand and bring it from shadow to sunlight.

At the very instant I complete this act, the entire mountain shudders, groans, and simply blows apart. First with an inward convulsion, followed immediately by a purging explosion, the mountain bursts and flies apart. The entire sky alternately pulses neon green and magenta. The light is strong enough and hot enough to feel as if it is roasting me. Within this wrenching maelstrom, as if the entire world is pronouncing it, comes this: "Who do you think I am?" With the shock wave of that utterance, my body bursts and in slow motion flies apart. Without pain, I feel myself being ripped into large chunks: arms, legs, torso, head. Feeling myself irredeemably broken and severed, actually seeing the various parts of me tumbling through the sky several hundred feet above the valley floor, I say, "Shit, I'm dead." I say "Shit, I'm dead" with the same chagrin and mild self-disapproval I have felt on other occasions in my life when I committed far lesser transgressions, such as slicing my thumb with an X-acto blade or forgetting a book that was due back to school. Now I've really mucked things up. Once again I did not listen to good advice (this time from the source!), and now I have paid the ultimate, irrevocable price: my life. Now I am dead. Shit.

This feeling of disappointment once again quickly gives way to a dispassionate interest in the expanding arc of me in space. As I continue to fly slowly apart, the "I" that is still me and still conscious looks down at the landscape several hundred yards beneath me. I can see a house with a nice garden in the back. It is my house, my garden. I see my wife and my two children, who are nine and eleven at the time. I can see the children playing and my wife saying something to them. The thought comes to me: "I am never going to see my family again. I am never going to see my son and daughter grow up. I am never going to see my wife again. They are never going to see their father again. They are going to have to grow up without their father." I have these distinct thoughts but no accompanying feelings concerning these terrible losses. I want badly to feel something, to feel loss, and I

try to feel the way I should feel and want to feel, but I cannot. Gradually I find that not only can I not feel anything about my dreadful circumstances, I become detached and uninterested in my circumstances, my family, my house, my garden, my world.

I continue to drift further apart in ever-slower motion, dissipated by a steady breeze blowing from east to west. The pieces of me fracture into ever-smaller fragments until I become a thin cloud, then a slight haze. I am losing all care, all concern, losing consciousness. As this undifferentiated consciousness (me!) drifts upward and westward, it catches the final rays of the sun. As the sun shines through the mist, each particle of "me" acts as a prism, creating an incandescence of rainbow-colored light. The light begins to wane, the glowing mist dissipates further, becoming indistinct and melding with the rest of the darkening sky of evening. Everything becomes quiet, soft, one, nothing.

It was from this dream that I awoke.

———

∾ I WAS THINKING ABOUT DEATH

I was thinking about death
the other day.
Do I fear it or don't I?
I don't think there is a subtle, middle ground on this.
I probably do,
just like everyone else.

The topic came up the other day when it was snowing.
It had begun the night before
and there was already a foot of snow on the ground.
Everything horizontal was white,
everything vertical was black.
Just before we went to bed
the snow began again very casually
as if it really didn't care.
Very light, no wind, tiny crystals.
They just drifted around,
eventually taking their place somewhere on the field,

the stone walls, the trees.
In the morning, the same thing.
When I went out after breakfast,
the snow kept drifting down,
in no hurry to finish its trip from sky to earth.
Now it thickened somewhat,
the crystals became large enough to be called flakes,
a bit of wind imparting order to their fall.

I shoveled the walk again and you could see that
at least another six inches had fallen since last night.

My wife joined me and we went for a walk in the snow.
We decided to walk through the woods
rather than along the road.
It wasn't that cold, but it was less windy in the woods.
The snow got thicker, larger, and you could see
the whirls and streaks and dots and cross-hatchings
of the white flakes against the black stationary trees.
White dots, black streaks.
After about an hour, we walked back to our place.
It was really coming down now.

There is a small bench some yards from our house.
It faces downhill back toward the forest
where we had just come from.
Only the seat was above the snow
and the seat had a nice pyramid of snow on it.

My wife said, Let's sit here for a while.
She didn't want me to brush the snow off first,
just sit.

We sat on the bench.
The snow fell and fell.

I said to her, If I were to sit here and die,
just like that, I wouldn't mind.
You would think that she hadn't heard me
because she just kept looking at the snow drifting across and
 down the black bands of trees.

Eventually she did look at me
with the expression she reserves for these occasions.

Then she turned so she could see the snow again.
After a long time sitting on the bench
watching the snow
we got up to leave.

I asked her, well?
What do you think?
Halfway to the house she said:
I don't know.

———

PART TWO

NOTES
TO AN
ARTIST

General Considerations

———

ON SEEING

The creation of art is not some esoteric activity of a gifted few; it is the natural way of forming meaning whenever important issues are addressed sincerely. As such, these notes to an artist are offered to anyone, at any level of familiarity with artistic expression, who is sincere in their desire to draw closer to Nature.

Perhaps a reason that so many find the making of an articulate and full artistic expression as difficult as they do is that they have not prepared a foundation commensurate with the building they have in mind. If you seek to create a graceful, fearless, expansive, articulate, tuned work of art that evokes an intimacy with Nature, how can such a structure be built—with any integrity and reward—from any source but one made from the same stuff? If you wish to center clay on a wheel and you have not bothered to center your Self, tuned your body, focused your attention, steadied your hand, strengthened your will, and also practiced the art of allowing the world to slip gently through your fingers, how can you expect to form anything that is centered, focused, steady, strong, and graceful?

The artistic process holds the transformative potential not merely to decorate our life as it is, but to *elevate* our life, and do so by drawing ourselves closer to the Great Reality, closer to Nature. In order for this more substantial use of creativity to secure its foundation, we must

first have direct encounters with the actual, alive, untamed world-without-end. In short, we must *see*.

The challenge of seeing is this: with respect and appreciation for what has been given to us, we must see for the first time this soul-smacking, heart-rending gift of Nature—see it directly for ourselves. Can we summon the inner fortitude to disallow even the wisest and the best to stand between us and our direct contact with the world? Can we free up our mind from memory and rumination enough to give us access to raw, unnamed things in the world, permitting them to stream over us, immersing us as if for the first time? Can we awaken from casual viewing of a once-in-a-lifetime stupendous show? Do we have the temerity to say fully and clearly, to anyone who asks, what happened to us when we encountered Nature neat? Even if no one asks? There are certainly times when we must permit others to position us, offer the legacy, bring us to ripeness. But in the final portion of our journey, we must take leave of them all and step forward into Nature just as it is, just as we are.

To see something firsthand is to finally meet the thing, to break through the myriad veils of secondhand stories we have heard about it. These stories may have been initially offered only as a way of introducing the world to us, but these introductions have now become the world itself. To see a thing directly is to experience it not merely with the eyes but with all the complexity of bodily sensations and associated thoughts, to be shaken by the presence of the thing in the world. To hold a beloved, to feel the warmth of skin against skin, to breathe in each other's aroma and hear the rhythm of two breaths, is to be caught up in the ephemeral nature of their life and our life.

When so much of the world comes to us through the media, we imperceptibly come to believe that we are still living in the world of people, places, things, and events, when in fact we are living in a virtual world composed of words and pictures, newspapers, electronic blips of light and sound. Like the denizens of the cave described in Plato's *Republic*, we have taken the shadows on the wall for the objects that cast them. We talk to and about shadows while the actual world glides unobtrusively by. In art, imagery generated from experiences that refer to the world but are not themselves the stuff referred to can hardly be compelling.

Annie Dillard, in *Pilgrim at Tinker Creek*, speaks of meeting the world in this way:

It was sunny one evening last summer at Tinker Creek; the sun was low in the sky, upstream. I was sitting on the sycamore log bridge with the sunset at my back, watching the shiners the size of minnows who were feeding over the muddy sand in skittery schools. Again and again, one fish, then another, turned for a split second across the current and flash! the sun shot out from its silver side. I couldn't watch for it. It was always just happening somewhere else, and it drew my vision just as it disappeared: flash, like a sudden dazzle of the thinnest blade, a sparking over a dun and olive ground at chance intervals from every direction. Then I noticed white specks, some sort of pale petals, small, floating from under my feet on the creek's surface, very slow and steady. So I blurred my eyes and gazed towards the brim of my hat and saw a new world. I saw the pale white circles roll up, roll up, like the world's turning, mute and perfect, and I saw the linear flashes, gleaming silver, like stars being born at random down a rolling scroll of time. Something broke and something opened. I filled up like a new wineskin, I breathed an air like light; I saw a light like water, I was the lip of a fountain the creek filled forever; I was ether, the leaf in the zephyr; I was flesh-flake, feather, bone.

But I can't go out and try to see this way. I'll fail, I'll go mad. All I can do is try to gag the commentator, to hush the noise of useless interior babble that keeps me from seeing. . . . Instead you must allow the muddy river to flow unheeded in the dim channels of consciousness; you raise your sights; you look along it, mildly, acknowledging its presence without interest and gazing beyond it into the realm of the real where subjects and objects act and rest purely, without utterance. "Launch into the deep," says Jacques Ellul, "and you shall see."

The secret of seeing is, then, the pearl of great price. But although the pearl may be found, it may not be sought. . . . I cannot *cause* light; the most I can do is try to put myself in the path of its beam. It is possible, in deep space, to sail on solar wind. Light, be it particle or wave, has force: you rig a giant sail and go. The secret of seeing is to sail on solar wind. Hone and spread your spirit till you yourself are a sail, whetted, translucent, broadside to the merest puff.[1]

Let us suppose the universe as a place not of things but of events, the sum total of which is a swirling bankless river, rushing inexorably past and around us. We do not create this stream; it is already here and full to bursting. This stream is the universe, made up of a zillion teeming events, endlessly, unpredictably, tumbling and whooshing by. We can do something more than anxiously thrash about in it or passively allow everything to float past us. To use the term *suffer* in its ancient sense, we can suffer the world to come to us. And surprisingly, it does. Never in the way *we* would have it, but come to us it will. And it is the openness of our body, mind, and spirit that enables us to "catch" it, catch the flow that draws us deeper into the full current of Nature.

Allowing Nature to appear just as it is, at the confluence of the spontaneous activity of our mind and the natural, inexorable flow of the universe, night comes in due course, we find that the moon rises on schedule. Spring with its billions of expanding things follows on the crystals of winter. Life hisses, buzzes, and pops all around us. Whether we seek it or not. On schedule, though not ours. Nature is already most emphatically here and happening. Nature is always present, large and unhidden. It is the limitations we have placed upon our minds that obscure Nature and close off our access to what already is here and ours.

How to see? I mean, how to see the real world, the living, immense, stunning world so cleanly that you experience yourself as being seen? Can you get just a glimmer of what that would be like? Has that ever happened to you? Have you ever experienced yourself as not alone in Nature? Have you ever sensed that you were seen not by other people but by something alive in the universe, and that it accepted you just as you are? Has some untamed animal ever come up to you, touched you, and not fled? Have you ever lain down at night in an open field—no tent, no fire, no companions—and slept easily under the star-spangled sky, cushioned only by the patient earth? Have you ever felt unafraid, as if you belonged here, as if you too were as natural and wild as a deer, a stone, a pine? Perhaps you have; perhaps when you were a child all this was common knowledge, layered over though it now may be by the numbing effects of adult cosmologies and accepted practice. Paul Shepard writes that for most, childhood is a time of enchantment with Nature. Thus, he says, something of the undifferentiated sense of self and world "remains in the adult memory, bathing parts of the environ-

ment with the colors of paradise. In these special places . . . he will always remember with peculiar reverence. . . . The landscape to the child is animated. . . . The rhythm of being with and being apart from, coming and going, joining and separation in games is a dynamic recognition of the livingness of nature."[2] Do you know the grace of expression, the range of imagination that this sense of belonging endangers—the deep source of creativity that is tapped when this union occurs?

The ways of Nature are not self-evident. Nature is deeply layered, just as we are. At any one level Nature seems to be complete—but it is not, in the same way that we are not. Prejudice of every stripe—sexual, racial, religious, ethnic—observing only the superficial qualities of a thing and not bothering to notice the vast differentiating qualities that reside within individual members of any group, begins exactly where this is forgotten. To access ever-increasing layers of Nature, both inward and outward, we must prepare our Selves. The artistic processes—which we now employ mostly to make aesthetic amenities—can be employed to prepare us first to *see* and then to know the adjacent and subsequent levels of Nature, with which we are barely familiar.

Now it is difficult to know Nature, when so much of our days are lived within a veiled room of our own manufacture. Now light and shadow are numbers on a clock. Seasons are outfits and tasks. Fauna are pets and amusements. Flora are viewed through a window on a planted garden, or as decorative chic on a windowsill or table, relief for our weary eyes. Food is neither hunted nor grown.

Our domestication of Nature—of all the world of plants and animals, the land, the waters, the seasons—presents us not with tamed Nature but with a new Nature that is less tamed or wild but mostly "other." We take this drained, reduced, defanged virtual reality for original Nature. Doing this, we of course are tamed in our turn. For now it is we who must live by the clock or die. It is *we* who must walk the dog, water the flowers, mow the lawn, paint the house, wait in traffic, breathe, drink, eat fouled things, and die too soon.

Paul Shepard writes in his revealing book *Nature and Madness* about the connection between man's taming Nature and in turn being tamed in mind, body, and spirit. He observes that the hunter knows that he does not know what is going to happen, thus he needs 360-degree

attentiveness. The farmer has one degree, expectant observation. The city dweller—wanting for nothing—has no point of attention, actually expects nothing but desires everything. What is desired—their entire scope of imagination—is consumed by what they have made over in their own image. Thus we see only ourselves, we desire only ourselves, we imagine only ourselves. This preoccupation with the solitary self— especially that aspect of the self which resides on the surface of that self—keeps us forever away from and oblivious to the actual world in which we live. This collapsed awareness acts also to compress our concern, which *should* be spread evenly across the universe, crushingly upon the pinpoint of our solitary self. Thus preoccupied, we deep down feel alone, apart, estranged.[3]

There is impoverishment. And from this impoverishment, this hollowness of the mind and spirit, flows an insatiable hunger. We go about our days feeling that somehow this can't be all there is. Our joys seem fleeting and partial, the answers we have seem thin and unconvincing. We have much, yet require much more. Not able to savor the world, we remain famished. And in this way we savage and consume each other and Nature. Broken off from the great patterns, pulses, people, things of the universe, we in turn break everything. Deaf to the great music, the grand dance of Nature, we experience a small universe, domesticated and without ultimate meanings.

Because it is so rare to have made firsthand contact with Nature, we have little personal experience of being a necessary member of an infinite family, in either time, space, or kind. We have little experience in being and feeling natural. As a consequence, we often feel small, vulnerable, and frightened. Trapped alone in an uncertain place, we take this inherited view as: "This is my life. This *is* life." Intent on being creative, how can we ever succeed past the manufacture of superficial novelties if we have never "seen" Nature firsthand? If we have never fundamentally met and conversed with Nature, what original sources for our creativity could we possibly draw from?

Much of what is taken for creativity is really the juggling of secondhand material, which itself consists of shadows and rumors of some remote original observation. Art becomes fascinated with art; literature with syntax; dialogue with rhetoric. Spiritual appetites are appeased by religious dogmas; the gifts of imagination and dexterity are turned into privileged commodities for sale to the highest bidder.

Much, perhaps most, of current civilization derives from the legacy of prior generations and contemporary cross-cultural exchange. Ours contains a deep flaw in the information given to us about the relationship of human origin, Nature, and destiny with that of the rest of creation, requiring, as noted earlier, a way out of our prevailing confined worldview and the frenetic foraging that comes from our abysmal hunger for contact with the actual, full world: Nature. It seems fair to say that we must shift from experiencing ourselves and behaving as privileged if dispossessed interlopers and learn to stand in open relationship with all others. *Here* is where we "creative types" may finally employ our gifts more substantially. For the creative process does exactly this: it forges a relationship between entities that illuminates the nature of each entity while at the same moment revealing not only the pattern that connects them to each other but, in truly satisfying works of art, the underlying relationship of every pattern to every other pattern.

The creative process is at root a procedure the human mind employs to establish relationships and to elevate entities out of their ordinariness, revealing their essence. And this same process, revealing ever more subtle and generous relationships, is exactly the same process we require to achieve identical results: to reveal the pattern that connects us with the rest of the world, and to illuminate the special qualities that make everything in the world simultaneously unique and related—more succinctly, sacred. What is creativity if it is not combining elements in such a manner as to bring them into more revealing relationships?

The transformative potential of the creative process is realized when we plunge through the world of secondhand news and personally place our finger on the pulse of the live, wild universe. When we make this plunge through the veneer of chatter and received truths, we encounter a nude world, not hiding yet mysterious. All one can do here is to bear witness, to savor and celebrate that great privilege of "seeing." Passing beyond the familiar, we finds ourselves in yet another, deeper level of being and of the world. Here everything is encountered as if for the first time, and yet there is an uncanny feeling of returning to our original home. The moment we see Nature for the first time is the first time we feel at home. This in turn emboldens our resolve to bear witness more fully, in our life's work and in our artwork.

BEYOND CREATIVITY: AUTHENTICITY

In examining the factors that prevent us from drawing closer to Nature, we must look very critically at our attitude toward that darling of the arts, "creativity." Just as our long-held concept of "progress" has revealed its limitations and costliness under reexamination by thoughtful evolutionists, environmentalists, ecologists, macroeconomists, sociologists, and cosmologists, so too should our assumptions about creativity be reconsidered to determine if there isn't a hidden price exacted upon its practitioners and the world upon which we have so abundantly heaped our creations.

It has become axiomatic in technological societies that there is a constant need of creative solutions, new patterns of behaviors that improve upon earlier formations. However, when we carry this perceived mandate to "improve things" over into a compulsion to improve the world or Nature itself, we establish a way of seeing Nature as inherently defective and in need of repair. This misappropriation of our energies is costly for both us and the world, and ends up all too often disfiguring both Nature and our Selves. Contrast this notion with the traditional Jewish concept of "repairing the world" (*tikkun olam*), a marvelous call to set our human affairs in order, chiefly through social action. Busying ourselves with this noble task, we generalize our calling to the repair of the natural world at large.

Our attitude toward creativity presupposes a condition of lack, a perceived insufficiency that might be rectified, or at least improved upon, by our well-intentioned efforts. Much good comes from this attitude—most if not all of what we call civilization: a poem, a quartet, a judicial system, a subway system, a soufflé, the Internet. These and other things people think and do that create civilizations arise from the capacity to think and then to invent a better way to be in the world.

Without the capacity to come up with novel solutions, richer, more satisfying variations, more explanatory theory and finely made practice, the human state of affairs would be unrecognizable. How then to find fault with the capacity for creativity? Not fault exactly, but the limitations of creativity, particularly in the arts, will be our inquiry. For it must be remembered that creativity is not the goal, it is only a

means to desired goals. It is with that portion of the urge to creativity—the desire to improve upon the given world—that we take issue. The problem lies in viewing the world, viewing Nature, as not simply incomplete but also as insufficiently resolved and something that our superior powers of mind might rectify. This attitude places us in a rather exalted position as critic and judge of an inferior Nature. Anointing ourselves with the robes of authority, we remove ourselves from the thing being judged in order to gain a position of objectivity and impartiality. But it is not even the enormous difficulty of achieving this superior position of enlightened neutrality that is the problem. Rather it is the very act of distancing oneself from Nature, removing oneself from Nature in order to better judge Nature, then acting on that judgement to *improve* on Nature.

In contrast to this view of Nature as glorious but wanting, and human beings as the chosen creators of a better, more resolved world, we have this view of Lao Tzu found in the *Tao Te Ching*.

> *Do you think you can take over the universe and improve it?*
> *I do not believe it can be done.*
>
> *The universe is sacred.*
> *You cannot improve it.*
> *If you try to change it, you will ruin it.*
> *If you try to hold it, you will lose it.**

If one cannot improve upon something or change it without ruining it, and cannot hold it for losing it, won't this apparent complacency with things as they are lead to a state of enervation and inaction? And isn't this state of nondoing the very antithesis of creativity?

We begin our response by asking another question: Is it possible to engage in something or with someone without the desire to improve that someone or something? When you love someone and you are doing a loving thing together—taking a walk, dining, making love—

* From *Tao Te Ching* by Lao Tsu, translated by Gia-Fu Feng and Jane English, chap. 29, p. 82. Copyright © 1977 by Jane English. Copyright © 1972 by Gia-Fu Feng and Jane English. Used by permission of Alfred A. Knopf, a division of Random House, Inc.

is it not possible, even better, to celebrate the mutual delight in your differences and commonalities than to use the occasion to improve upon your loved one's gait, table manners, or lovemaking?

Placing ourselves in the self-appointed role of improving upon, creating a better version of our partner, divides our attention from our partner as they are, into a number of subsidiary concerns *of our own*. To create a better version of our partner—whether that partner is a human lover or Nature itself—we must step back in order to see the other against a backdrop of everything they are, everything they are not, everything they could be, and everything they might be that we would like them to be. Then, given the gap between what we take them to be against what we would prefer them to be and our assessment of what they are capable of achieving, we must devise a strategy of getting them from the place they are to the place where we want them to be. Then we have to enact that plan, constantly assessing the hopefully diminishing distance between what we have (what they are) and what we want (what they are not, what we don't have). This elaborate series of mental processes requires a great deal of cognitive activity, constantly shuttling between our desires, our opinions, our plans, our assessments, our satisfactions, our negotiating skills, and our needs for love and comfort that preceded this relationship. These consuming self-centered cognitive processes must of necessity dim the light that remains available for us with which to see the other as they appear before us. We thus distort the very other who had some initial appeal but now has been reduced and transformed into a creation of our superior intelligence and taste.

Perniciously, the way in which we perceive the other is what they come to resemble—if only in our own mind's eye. The resemblance is not necessarily to our model or plan for the other, but to the way we have perceived them as being before we graciously took charge: wanting, unresolved, rude, in need of our superior attention. So perceived, our partner appears even more deserving of our good intentions, and so on goes the cycle until we end up exactly where our civilization has come to: trenching the river's meandering, leveling the mountains, turning up the thermostat unmindful that the windows are open. It is not only the advanced technological societies that have this creative penchant, who have cared so much for the world that they feel com-

pelled to touch it up just a bit and end up by losing what they held dear.

"If you try to hold it, you will lose it." There is an additional dimension to Lao Tzu's warning. If we try to change Nature, we may indeed end by ruining Nature, but we will certainly ruin it for ourselves, for our Selves. Thomas Berry tells us:

> The outer world is necessary for the inner world; they're not two worlds but a single world with two aspects; the outer and the inner. If we don't have certain outer experiences, we don't have certain inner experiences, or at least we don't have them in a profound way. We need the sun, the moon, the stars, the rivers, and the mountains and the trees, the flowers, the birds, the song of the birds, the fish in the sea, to evoke a world of mystery, to evoke the sacred. . . . Humans become religious by joining the religion of the universe. Apart from that, our souls shrivel and our imagination is dulled.[4]

When we draw away from Nature and substitute our own tamed, diminished, created versions, we cut our selves off from the information Nature contains about how the world works: inclusively, exquisitely, fearlessly. It is at the same time how we work, how we must work: inclusively, exquisitely, fearlessly. This information we are clearly not yet in possession of. We also cut our Selves off from the benefits of being knowledgeable and in accord with the rest of the universe: a sense of belonging, of legitimacy, of sanity, wisdom, health, peace of mind, graciousness, joy.

If you try to change it, you will ruin it.

When we cut our Selves off from Nature, the within of Nature is obscured from our vision. What remains for those romantics still capable of being captivated by Nature's handsome features is exactly and only that: the handsome outer features. Nature—fat, juicy, mysterious, sacred, seething in permutations, thick with interiority—collapses before our distracted attention into a pretty face, into the picturesque. Paul Shepard documents this collapse of Nature under our weighty stare. He describes how the subjugation of Nature may be chronicled over the last two thousand years by the way Western

artists have portrayed Nature: from one more element in an endless frieze of life, through the sacralization of Nature, the banishment of Nature by the creators of the Semitic bibles in reaction to being banished from a fruitful land, to our current reduction of Nature into the picturesque.

Is there some third way to be in this world, among and within Nature? Something more than contemplative regard? For surely we cannot commit ourselves to such hermetic living knowing what we do, accustomed to what we have, and conceiving of ourselves in the way that we do. Something less than our urge to make over Nature in our own image? Some way to draw closer to Nature without ruining it and us?

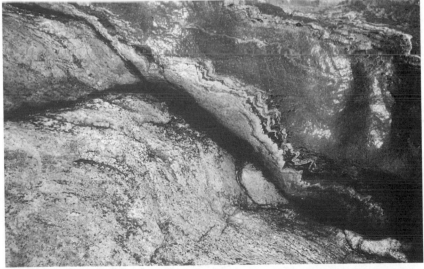

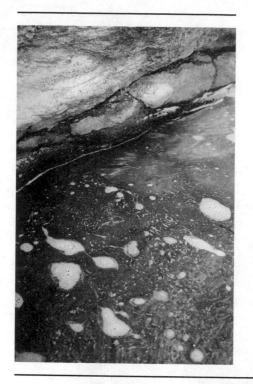

The third way proposed in this book—a way to be in the world as artists, to draw closer to Nature without damaging it by our advances—may be described in terms of Martin Buber's concept of the "I–Thou" relationship.[5] Buber portrayed this distinctive relationship as having the power to elevate both parties, to reveal the mysterious divine residing at the center of all. The I–Thou principle may be stated thus: If we call to an other, who initially appears to us as an "it," from the depths of our own "I," evoking the possibility of its hidden Thou becoming manifest, the "it" will reveal the "Thou" residing within. I wish to suggest a corollary to Buber's axiom: If we call to Nature as the "Thou" it already is before, during, and after us, Nature as the eternal Thou will be revealed to us, and the force of this newly uncovered

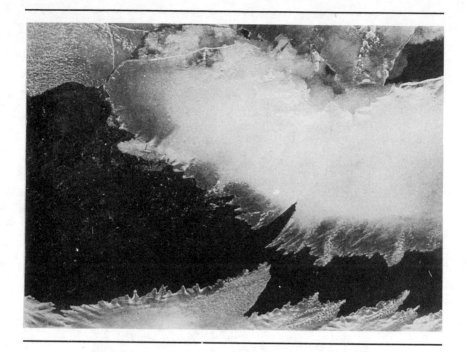

presence in our lives will break out and reveal the Thou residing within *ourselves*.

Art's history is replete with such sentiments. To quote only two:

> I seek to strengthen my feeling for the organic *rhythm of things in general, to identify pantheistically* with the trembling and the flow of blood in nature, in the trees, in animals, in the air—to make that into a picture with new movements and with colors that pour scorn on our old easel painting. . . . I can think of no better means than the animal picture of achieving what I would call the "animization" of art. That is why I have taken to painting animals. In the pictures of a Van Gogh or a Signac everything is animal, the air, even the rowing boat which floats on the water, and especially the painting itself. These works bear no resemblance whatever to what used to be called "pictures."
>
> —FRANZ MARC[6]

What my art probably lacks, is a kind of passionate humanity. I don't love animals and every sort of creature with an earthly

warmth. I don't descend to them or raise them to myself. I tend rather to dissolve into the whole of creation and am then on a footing of brotherliness to my neighbor, to all things earthly. I possess. The earth-idea gives way to the world-idea. My love is distant and religious.

Everything Faustian is foreign to me. I place myself at a remote starting point of creation, whence I state a priori formulas for men, beasts, plants, stones and the elements, and for all the whirling forces.

—PAUL KLEE[7]

We do not transform Nature by our efforts; Nature transforms us by our efforts. When we draw closer to Nature, the sincerity, the fullness, the desire, the tact, the patience, the courage, the vulnerability required to draw closer to Nature transforms and elevates us to the status of a Thou in the world. And we conduct our lives that way, and we create (yes, create) our art that way: courageously, patiently, fully, sincerely, openly, gracefully.

ALL THERE IS, IS CREATIVITY

In the many courses and workshops I have taught over a career of forty years, the greatest concern, shared by neophyte and advanced artist alike, is the fear of being seen as uncreative. Most people can bear the embarrassments of being unskillful or uninformed. These qualities are to be expected in an educational setting, and their very lack is the reason for the student and the teacher being present in the first place. But the trait of creativity seems to be held as a matter of character or intelligence or both. To search our inner self and come up with something that has been on the shelf for quite some time is seen as a sign of fundamental lack in our basic makeup—bad enough in general company, devastating in the company of artists. More skill and more information will not remedy this damning condition. As a consequence, our attention is distracted from the real task of art: saying what we know and how it feels, nothing less and nothing more. Instead, we are forever furtively looking at the work of our peers, measuring the distinctiveness of our marks by what other people seem to be doing, though they are

more probably measuring their marks against what we seem to be doing.

Since everybody has a life that is unimaginable to anyone else, it looks as if everyone else is being incredibly creative, in contrast to our own work, which looks incredibly familiar. (As of course it *must* look, because if it was not familiar, how could we possibly have been its author?) Making the fatal mistake of taking "otherness," or distinctiveness," for creativity commits us to a competition impossible to win. And we do not win, but instead end up with pale and brittle false things that satisfy no one. The look of our work may have visual appeal, but its failing lies in the heart of its maker (us), who knows the work was fraudulently come by. Now we are really in a pickle; we seem to be creative, but in fact what others take for innovation we know as shoplifting bits and pieces of others' accounts in others' tongues. Cut off from the only authentic source of art—firsthand conversation between the Self and the world—we are consigned to look over our shoulders forever. Others may catch us smiling at openings of our exhibitions, pleased at the turnout and the compliments tendered between sips of pinot grigio. But do we sleep well knowing that when we had the opportunity to say what we know about what happened when we met the world, we used it to portray a conversation overheard?

If we are an advanced artist, our fear is not being creative *enough*. The self-imposed burden of conceiving of ourselves as an artist advanced in our studies sometimes results in an opinion we have of ourselves of having to be the *most* creative in the group, or at least in the eyes of the teacher. We feel obligated to set an example or perhaps to set ourselves off from the duffers in the group by our creative daring. This presents a frightening spectacle to the other students, particularly the neophytes, who, taking the measure of the competition, quickly despair of ever achieving the apparent sweep so effortlessly exhibited by their betters. But it is a form of display that soon rings hollow, unsustained as it must be by the authentic groping and probing of a sincere investigator of the infinite facets and mysteries of the world. We sleep, I *know*, no better than the neophytes, whose company we thought we had left behind.

What *is* one to do?

If creativity need not be the nimble state of mind prerequisite to

artistic endeavor, what is proposed in its stead? In a word: authenticity.

Every artist of serious and sustained commitment knows that our quarry is not the novel solution or the creative response in and of itself. It is much simpler and much harder. It is to show up, prepare, and open ourselves to the world as it is, let the world bite as deep and as long as we are able to bear, become infected, not be too quick to seek a cure, try as best we can to keep our eyes open, try not to fear that we will die too soon to have said all there was to say, leave nothing out, add nothing more.

Creativity? Don't worry about it. It is the only thing you are and can ever be. Time's arrow coursing through the thick stew of an unpredictable universe can *only* generate novel outcomes. It is the way of the world. You and every last damn thing in the universe can't help being a first-time event. It's a first-time universe. You say that lots of things look the same and do so time after time? They do only to those who don't look carefully enough. Gertrude Stein was right, you simply cannot repeat yourself. The second time is not the first time. This is not only a central truth of the creative life. It may be said to be *the* truth of artists. Every dancer knows this, every musician knows this, every actor knows this, every close reader of literature knows this, every careful looker at art knows this, every lover knows this, every snowfall and snowflake knows this. It is the way of the world.

ART AS A SACRED CONVERSATION

Creating art is self-conscious, affected, and precious when as artists we experience ourselves as the only creature in the universe who is singing and dancing and making fantastic stuff, revealing inner truths and hidden beauty. And all alone in an insensate universe, we alone must give voice to this beautiful but dumb place. This pompous attitude imposes a heavy burden. Our thesis of drawing closer to Nature proposes otherwise.

We propose that the world, all of Nature, is engaged in a sacred conversation, speaking about everything there is, everything there was, and everything there will be, leaving nothing out (thus sacred). All of human history can be understood as an attempt at comprehending

that speaking and becoming conversant in word and deed with it. All disciplines of knowledge have employed their particular ways of knowing to break the code and bring the news to bear upon the affairs of man. How as artists do we learn to speak Nature's language? The way any other discipline does: listen and look.

Nature, having been here first, provides the initial speaking. You, coming in on a conversation that has been going on for billions of years, listen to where the conversation has gone so far, allowing the intricate patterned information into your own only somewhat less grand system. Now there are two receiving, interpreting, and patterning systems—big, fat, juicy, ancient, and forever-young Nature, and eensyweensy forever-young but oh-so-clever you. In some ways you and Nature are stunningly different, in other ways marvelously the same. As in a holographic interference pattern that assembles two partial and seemingly incoherent patterns to create a new coherence that subsumes the information embedded within each, the harmonies and dissonances of deeply grooved but ever-young Nature, and those of your Self, create the forever-new conversation.

Creative? How could it be otherwise? Original? How could it be otherwise?

However, if you withdraw from the arena of discourse, if you fail to listen, then *for you* Nature becomes silent. And you are left alone. Deaf, you think that the world is not speaking, not singing day and night, not bringing news about everything that ever was and is. In the billionth movement of an opera of an uncertain number of acts, with a cast of zillions, you, quite alone, wait for the music to begin.

As every meditator knows, in order to perceive the subtle dimensions of being and world, the first thing we must do is allow our perceptual system to become as quiet as possible. This may be achieved by limiting the kinds of external stimuli, limiting the necessity to respond to those that are picked up by our perceptual equipment, and routinizing necessary stimuli like breathing and muscle tone to such a degree that the mind, no longer required to be on alert/alarm status, slips into a more diffuse and open state of consciousness. Sitting quietly, doing nothing, taking a solitary walk along a quiet beach, a pond, a woodland path, having a nice night at home by yourself, lying on your

back looking up at the stars, or at the ceiling lit by candlelight—meditation in any of its many formal and informal techniques, if practiced with sincerity, allows the busybody chatty mind to disengage with life-buzz and to quiet down.

A quieted mind within a body at peace prepares us for perceiving that portion of the talking universe that speaks softly and at a pace beneath and beyond that of ordinary consciousness. Wait. Be unhurried to do and to say what you know. Wait while the chock-full-of-ideas mind that you bring on your visit to meet Nature turns its attention away from telling Nature what it knows and starts attending to what Nature might have to say. Artists might not ordinarily proceed in this manner, but it is commonplace among anthropologists, hunters, anglers, birders, and of course good farmers and gardeners. Gertrude Jekkyl, the great English landscape architect, called it discerning the genius of the place. Nature is always engaged in a complex conversation with absolutely every entity in the universe. The way of Nature can be said to be the sum total of this universal conversation. What is being said, how it is being said, and by whom at any moment in time is the consequence of what has just been said, how it was said, by whom, and how it was received. To enter this complex, tightly interwoven conversation without being an absolute boor (something verging on the impossible), we must first listen to the drift of the ongoing conversation and only when we get the feel of what's going on and find that our observations may enhance the discourse, have our say.

Just like our own body, the entire atmosphere in which we swim is teeming with patterned information. The signals sent from every sending generator throughout the planet are wafting across our little receivers all the time. Every radio and television broadcasting network, every microwave, every ham operator in every language, every wireless phone, all are babbling away in a din thankfully beneath the threshold of our normal perceptual acuity. Every conversation creates a disturbance in the field that is discernible at distances from its source relative to its amplitude. Some would have us believe that the disturbances in the fields of our brain giving rise to thoughts, even without being transformed into an audible voice, can be "heard" by those of more finely made and or polished equipment. I believe that it is possible for

everyone so determined to perceive and read that speaking of the world.

A quiet, polished, and patient mind is able to perceive the voices of Nature and read that speaking, but not necessarily first or best through normative cognitive channels. It is my experience that the hand as a supersensitive extension of the entire sensory self, a tautly strung web of mind, body, and spirit, is often able to register the incoming signals as they impinge upon this fantastic web of awareness that is our Selves. Singers would say it is the breath and the voice, dancers would say it is the entire skeletal-muscular system, seers and prophets would say it is something else. The point here of importance is that the rational verbal associated mind, the frontal lobes of the cerebrum, is not necessarily the first or the most acute system of listening to Nature and responding in kind. The midbrain, the cerebellum, an older brain associated with the limbic system, is quicker to respond to qualities as subtle as slight variations in temperature, touch, smell, and nonlinguistic noise, then in microseconds exquisitely orchestrate the entire body for appropriate reaction.

In the visual arts it is the hand that is the ambassador of the rest of the aware Self, and is the first to register the Self's return of conversation. And something else: the hand cannot lie.

SENSORY AND IMAGINATIVE SERIOUSNESS

Artists, like anyone else in our society even modestly aware of the strategies and knowledge base of science, draw closer to Nature by dint of their scientifically tutored intellect and perceptually honed mind. But it is not scientific attitudes or strategies or representational means that are particular to the artist's preparation for drawing closer to Nature. If you go into the world in order to draw closer to it, not as a naturalist or scientist, but as an artist, what special attributes might you bring that especially equip you for this grand enterprise?

The primary question raised within the scientific community is "What is that?" Artists ask a question that starts out in the same direction but make a critical turn by adding another dimension to the query, the artist's primary question being "What is that *to me*?" Science is interested in the nature of the world. Art is interested in the

nature of the world *as it impinges upon the experienced state of being in the world.* What *do* artists take as preparation for drawing closer to Nature, allowing a firsthand, deep witnessing of Nature's nature, permitting them to answer their particular category of questions? There are several qualities of mind that artists possess that most others also possess. The discriminating factor between people who address life in an artistic mode and those who do not is that artists raise certain common mental attributes to a threshold of concern that few others are inclined to do.

Artists live in the same world as everyone else, with more or less the same mental and physical equipment, but they take certain things *seriously.* One such attribute is what I term "sensory seriousness," another is "imaginative seriousness." First a description of what is meant by the term "sensory seriousness" and what distinguishes an artist's degree and kind of this attention to perceptual events that flood the life of everyone.

Visual artists take color seriously. Consequently, when we speak in color, the domain of color opens to us its vast, nuanced vocabulary of hue and tone and value and tint and shade. A red apple in the bin of a hundred red apples at the supermarket transforms itself through the eye of an artist into that glowing orb that Chardin or Manet or Cézanne or Renoir or Giacometti, each in his own way, set so carefully on a dutiful table, arresting our attention, causing us to pause long enough in the course of completing the ten thousand tasks of our day, setting those things aside while we, with our inner and outer eyes, savor the universals and particulars of this red apple.

Visual artists take the quality of line seriously. Where every object ends and something else begins, creates a line of demarcation. We are very concerned about that line and what it implies about the nature of the surface of each thing and also about the relationship of two adjacent things. Just as a musician composes a line of sound and silence in such a way as to convey an infinite range of human emotions and ideas, and writers can do the same with a string of words, visual artists require nothing more than a similarly nuanced vocabulary of line— just dark-then-light—to portray everything that is knowable about "what that is" as well as "what that is to me." So we know the relationship between van Gogh and Dr. Gatchet, by the line with which van Gogh touches the good doctor's face. Similarly we know Annette,

Diego, and Genet in the mind of Giacometti by the signature line of Giacometti as he attempts to place their fleeting aliveness in a timeless web of creased light and shadow.

Although everyone lives in a world consisting of transparency, shape, mass, texture, pattern, rhythm, order, space, density, interval, scale, for artists these universal and ordinary qualities that all things possess, free themselves of the entities from which they arise and take on semi-independent status, allowing their savor and employment in our own creative inclinations. Think Arp, Picasso, Calder, Caro.

Musicians take sounds seriously, and take silence seriously. When musicians place a sound over here of a certain pitch and volume and duration, and a silence before and after it, to be followed by another sound of a calculated pitch and volume, the sandwich created, for those who are fortunate enough to be in the vicinity, opens a doorway into a universe parallel to the one we gab and barter in, but with newly perceived formations and special pleasures. Listen to Verdi build a mountain, chord by chord ascending to God's ear via his *Requiem*. Hear how Mozart brings us from here to there via a silver scaffold reaching as high.

Poets pick from the same pool of words that we all use to order fries and a burger, to say I love you or I don't love you and sometimes mean it, tell our stories over and over simultaneously with everyone else telling their story over and over. But listen to Gerturde Stein lift words from the same dictionary to be found on the desk or in the bookcase of any indolent high school student:

> Then there are articles. Articles are interesting just as nouns and adjectives are not. And why are they interesting just as nouns and adjectives are not. They are interesting because they do what a noun might do if a noun was not so unfortunately so completely unfortunately the name of something. Articles please, a and an and the please as the name that follows cannot please. The name that is the nouns cannot please, because after all you know well after all that is what Shakespeare meant when he talked about a rose by any other name.[8]

Listen to Ozick, Milosz, Whitman, Rushdie, Dillard, Pound, Berryman, Paley, Snyder, Saramago, Gould, Gordimer, cummings.

The physical gyrations and antics that we employ brushing our teeth, walking to get the paper, driving the kids around, dancers take seriously. Dancers take seriously the movement of water spilling out of the glass, splashing the sides of the sink, going down the drain. They watch aspen leaves quake, tadpoles wiggle, fires burn, clouds evaporate, swans mate, boys strut, girls strut. They look long and hard at such things. They also look long and hard at themselves and their bodies, and they ask, What is that *to me*? Then they move and then they don't move, making another kind of sandwich. For those of us fortunate enough to be in the vicinity of such gyrations and antics, it is as if the human body has just moved, spoken, become alive in a new way. It is as if our own body, the container that our very own being has been poured into, shrugs off its torpor and awakens to its possibilities to speak and take flight. See Twyla Tharp droop and fall, Mark Morris march, snap twist and bend, Merce Cunningham stand walk sit, Graham stretch, Nijinsky fly.

Having just used the word *serious* to connote the degree of attention an artist devotes to *sensory* impressions, let us turn our attention to the issue of *imaginative* seriousness. Although all people are gifted with the capacity to imagine, not all people seem to take the products of their imaginative processes seriously. Insights flash across the mind of most people throughout the day and night as they see things, hear things, feel things that are the products of their mind's inner intelligence. But most people dismiss these presentments as *imaginary* and consign them to the dustbin of inattention. As one is sitting quietly doing nothing, or running around quite frantically, things pop into one's head unbeckoned. All sorts of memory fragments, tunes, fantastic images, snatches of dialogues that happened and did not happen, tastes, titles of stories that will make you famous as soon as you get around to writing the rest of it, you as a baby, God telling you something about what not to do, what you left on the table, the line that will turn the corner on the poem, the color that will lift that dull area to its proper station, the camels and whales that appear in your mind's eye when your eye tracks a cloud.

How these mental events occur and come to attention is a mystery. Moses, Jesus, Muhammad had their ideas, Freud and Jung had theirs, neurobiologists have theirs. It will be sufficient for our purposes to

note the ubiquity of such inner events of mind and call them acts of imagination without assigning them their origination. My contacts with artists and nonartists over the course of my life convince me that artists experience no more such inner events than do people who are not, or do not take themselves as, artists. What does distinguish the two seems to be this: whereas others mostly dismiss these (spontaneous?) inner events, these acts of imagination, artists take them seriously.

We look, without timing, at the ten thousand shades of green in a field of corn. Think Rousseau. At thirty, we noodle in front of the mirror for hours, still discovering the possible movements of our fingers to our palm to our wrist. Think Merce Cunningham. We pluck at a single G string, toying with the irrational number of its variations. Think Bach. We weigh the effect of punctuation. Think of nouns and adjectives, think Gertrude Stein.

When we bring our capacity for imaginative seriousness to bear upon the task of drawing closer to Nature, we equip ourselves with a powerful instrument for so doing. Thanks to the superb efforts of our community of scientists, we are doing so. If reason alone were sufficient to extract oneself from a universe of misconceptions and bad habits, then what science brings as news would be sufficient. But that is not how we are made; reason, as necessary as it is, is not sufficient. To hurl ourselves out of this fix, to draw closer to Nature, we must employ the *entire* array of mental attributes we—most thankfully—come equipped with: our imaginative capacities for dreaming, fantasizing, intuiting, wondering, visualizing, *and to take them all seriously.*

What might the practice of imaginative seriousness look like? In part four, "Encounters with Nature," I describe a pivotal phase of drawing closer to Nature wherein the reader is invited to just sit quietly (or stand or walk) in the midst of a chosen place in Nature with a particular key question in mind, such as "What powers of the North do I liken to my personal powers?" And holding to the belief that Nature is not only comely but wise, articulate, always speaking, and never lying, I ask the reader to take seriously the thoughts and feelings that so arise, in an unhurried and attentive frame of mind, and to guide his or her hand in the exploration of the emerging subsequent image.

Meditators tell us that when we sit quietly doing nothing,

thoughts arise, and we should allow the inner chatter of the mind to continue on its way until the mind becomes still and eventually lucid. When the inner noise abates, the undisturbed mind, like a polished lens, not only sees more detail but resolves larger and more subtle patterns. And, as Gregory Bateson tells us, it is the pattern that connects. So, in a way, cosmic consciousness emerges from behind the obscuring noise of local chatter.

Although the frame of mind suggested in this text is still and quiet like that offered by meditation, it may differ in one way. My experience has been that the thoughts and feelings that appear when we are in the midst of Nature, *genuinely and devotedly seeking its counsel,* are not solely the products of disturbances of our own neural network, our greedy, clinging ego, but are also emanations from Nature that, like any other evidence of the outer world that come to us by hearing and seeing and smelling and touching and tasting, are real and carry news of importance. To consign all imaginative material to the noise of monkey mind is, I believe, to misassign that portion of the sacred conversation between humans and Nature that arises from Nature and to locate the "noise" at the doorstep of our own chatty self.

Nature does speak. Taking that speech seriously provides that listener with news that has been central to many societies and to many artists who have drawn guidance from drawing close to Nature.

> I trust the landscape; it tells me what to paint each day, and I believe it. I go out and set up and look at the landscape. I don't wait around pondering or looking at it. It speaks to me and I paint.
> —SAM GELBER[9]

> In a cornfield as the sun set—brilliant yellow sunlight . . . with the bright afterglow came the first autumn chill. The smell of corn added to it. My hands grew numb—I came home in the electric air intoxicated with the new feelings . . .
> —CHARLES BURCHFIELD[10]

In the Carlos Castaneda series of interviews with Yaqui culture, Carlo's informant, the sorcerer Don Juan, constantly urges Carlos to pay immaculate attention to all the perceptions that enter his field of

attention that arise from the "other" dimensions. Carlos maddeningly interprets these presentiments as ordinary phenomena, denying himself appreciation of a world far more extensive, intricate, complex, and interrelated than the one he is familiar with. In these "other" dimensions, time, space, and substance are more mutable, with greater interpenetrability than we are accustomed to. These other characteristics of the world that don Juan is at pains to introduce to Castaneda are remarkably similar to the way the world is perceived during what Abraham Maslow termed "peak experiences." They are also similar to the state of higher consciousness arrived at through religious experiences as described by William James, or meditative, contemplative states achieved by spiritual adepts, *and similar to those experiences of artists in the midst of their artistic process.*

Nature speaks. The pivotal act of drawing closer to Nature is to learn how to listen.

Informed by that degree and quality of listening to the outer world as well as the inner imaginative one, the artist says what it means to be a witness to the world: nothing less, nothing more. All too often the common impression of artists is as people who have the temerity to say what is on their minds. But the portrayal portion of the artistic process is preceded by a sustained and attentive *listening* phase. This is the phase of the artistic process that informs and shapes the subsequent production of work with which the spectators are most familiar. It might even be said that an artwork—choreography, a musical composition, a novels, a painting, architecture—is the artist's portion of the dialogue he or she is having with Nature.

The highly polished sensory equipment of artists allows them to perceive the infinite facets, the exquisite detail, the micro and macro interpenetrating patterns, the subtle and complex voices of Nature, the "other" dimensions of Nature that lie just beyond the threshold of ordinary awareness. The reason why artists always seem to be "talking" is that there is so much to say about what they hear and see. That is why Monet painted that same bunch of fat and dopey haystacks dozens of times. Not because he was a poor draftsman or weak colorist, but because even fat and dopey haystacks have so much to say about the infinite facets, the exquisite detail, the micro and macro interpenetrating patterns, the subtle and complex voices of Nature. It is why Cézanne, when painting the portrait of his longtime art dealer,

took dozens of sittings over several months to finally arrive at a rendition in which he could admit to not being entirely dissatisfied with the front of his suffering sitter's shirt. Or why Giacometti, a consummate and graceful draftsman, worked day and night across the years without humor, trying to *see* the appearance of his so very familiar sitters, his wife, his brother, his mother. Or why the peaks, valleys, tints, and shades of his own face would occupy the attention of Rembrandt throughout the course of his long and arduous journey through life. Or why Brancusi hand-polished the surface of his *Bird in Flight* so that it was no less finely made than a bird in flight. Or why Turner sneaked his paint box into the home of his dinner host and, at a break in the meal, went into the room where a newly acquired Turner painting now hung, to work on it just a bit more, getting that sea mist to marry just a bit more subtly and intimately with the steamer's own heavy breath.

METAMORPHOSES

All things evolve. How they (you, me, Nature) do so is more telling than how the thing ends up. The story of how it all comes about is writ all across the face of Nature, adding depth, resonance, and meaning to its complexion. Learning to read the marks Nature leaves as it goes about its business of evolution commensurately allows us to understand the evolution of our own marks as we go about our business of creating art.

For many years we have had a small cabin on a few acres in the hills of Massachusetts that we visited a few times a year, staying a week or so during summers. It was a one-season cabin; no running water, no heat, no electricity, a shell really with built-in bunk beds, benches, and table. It looked out on a rolling meadow bordered by stone walls, great maple trees, and blue hills some forty miles in the distance. We would sit for hours looking out on this modest Xanadu, read, snooze, dunk ourselves in a spring-fed pond, have a bite to eat, take a walk, and then go off to sleep in our tiny shell perched lightly on a meadow beneath the stars.

A few years ago we decided to build a year-round home there, moving the cabin a few yards off to the side. Now we are in our

beloved land all year long. Hot water at a turn of the tap, cold water without first priming and pumping and pumping, light that goes on with a finger's flick, cold food that remains cold, heat when you want it, enfolding beds at the ready—none of these capitulations to technology and accommodations to our advancing age has, frankly, compromised our love of being on the land. In truth, it has enhanced it beyond the contributions of what a warm shower provides, and a meal without a hat and mittens.

Now that we are on the land across the entire year, in every season and weather and time of day, the seamless, complex, intricate, shimmering, aging, birthing, and dying world has begun to dance before us and with us, as we too shimmer and age.

Before, we were avid tourists returning to our favorite vacation spot, reuniting with old pals, seeing if everything was the same from when we last saw it, catching up on the news of the intervening year, and then settling into the comforts of familiar routines. Now the stream of time and circumstance that carries us inexorably if uncertainly forward is the same stream that enfolds all the rest of Nature. We have begun to care differently about the way things are and what might have brought them to their present circumstances. We have deepened our personal history with the world as only those can who experience themselves in the same lifeboat as the rest of the world. We are becoming entwined. We want to know what happens during the coursing of the day. We look forward to the face and touch of the land that has now become more than a memory or a longing. Vivid as they may be, memories and longing are abstractions and are *my* abstractions, they are not what they remember or long for. The trees, the rocks, the grass, the wind have now become a constant beat, a rhythm of our lives, like thirst, fatigue, continuous breathing.

When I was a sometime visitor to this same land, I understood and experienced the stream of time that my life bobbed in as different from that of the trees the sky the pond the earth that I came back to from time to time. And so the art that I created spoke as best it could about the affairs of an occasional visitor, someone more than a tourist but also different from a man who beds each night with the one he loves. Then I looked for signs of constancy (inconstant me!). I looked

for peaks, for quintessence, for something to show the folks back home. Consequently my art was of dramatic peaks and valleys, showy stuff. Now, having done time together, having seen the day roll out of the night, moments of nothing in particular, having sat in the midst of a whole day's slow dance across the meadow stitched now and then by black crows and a trotting pair of coyotes, a breeze from the north and then from the west, me perspiring by noon, ants shopping—now the art I create follows that same puzzling path. Now I point here, here, here.

You would think that plopping yourself down just anywhere in the midst of Nature's stew might lead to surface perceptions and shallow work. Not necessarily. If there is little prior engagement with what is out there, then there is little of interest that can flow from such minor terms of acquaintance. But when you have united your interior world with the Great World, wed the world in a ceremony of a continuous now, then the work runs as deep as you allow yourself to be soaked by the stream within which you both must swim.

In *The Spell of the Sensuous*, David Abram makes the scholarly and poetically put argument that it is our sensing body, in all of its array of sensing apparatuses, that finally knows, understands, comprehends, appreciates, feels, empathizes, and lives accordingly. Reading is not enough. Seeing is not enough. Hearing, tasting, touching, seeing, smelling, under many circumstances, together with emanations of our inner life, finally make up what we know, what we are, how we live. For us to draw closer to Nature, nothing less than an all-inclusive effort, engaging all the senses and qualities of mind, must be mounted. By way of example, I tell a story.

Our country home is adjacent to dairy and maple tree product farms. Traveling up the dirt road to our land for a stay of a couple of summer days or weeks, we would on occasion pass the local farmer at work in his fields. We would howdy, he on his John Deere, cutting or plowing or trenching or winnowing or baling, I in my Subaru station wagon crammed with kids, Coleman stove, ice chest and lanterns, sleeping bags, boxes of food, and fishing gear. The farmer looked rather picturesque to me, doing farmer things in the fields near our own place. I do not know what I looked like to the farmer. I knew his father and his grandfather in much the same way. That

image of him served as a perfect icon for our country vacation. This is as much of the farmer and farming that I knew for almost thirty years. It was, however, sufficient for me to believe that I knew this man on the tractor and what he did. I saw his cows in the fields. I saw his barns and silos. I saw his children and dog. On occasion I smelled the freshly manured cornfields. That is what I knew of country life, of farming.

This last year, frankly prompted by the writing of this book, it became increasingly clear to me that I actually knew next to nothing about country life, or about farming, or about this man. As I was trying myself to draw closer to Nature, it also became clear that my neighbor, the tenth or more generation to run the family farm, was a great deal closer to Nature than I was, and knew things that it would be good for me to know. I decided to volunteer my services to work on his farm for a couple of weeks, doing whatever was needed. When I tested this notion out with several friends, they all said the farmer would never go for the idea, too much risk of my getting injured and his being liable. When I asked the farmer, he said, "Fine."

I got up when they did, 5:30 A.M., helped with the morning chores of milking and feeding and mucking the milking parlor, spreading sawdust in the stalls and alley when milking was done, had breakfast around nine, back to work fixing fences or bringing in the maple sap apparatus, sawing wood, delivering or gathering bales of hay, then lunch around one or two. After lunch, more things to do: set fence, load and unload logs, fix stuff, move stuff, lift stuff, dig, carry, feed, clean, shovel, cut. A coffee break sometime in the late afternoon, then evening chores around six or seven of bringing the cows in, opening and closing gates, feeding the yearlings, feeding the newborns, running the conveyers from the silos to the mixing bin to the feeding troughs, feeding the milking herd, then cleaning the stalls for the lame ones, and cleaning the milking parlor when all the milking was over, spreading a new dusting of sawdust over the stalls and alleyway. I left at this point to go back to my place at about eight or nine, to shower, make and eat dinner, and flop into bed. The farmer and his wife still had lots more to do around the farm as well as tend to their three school-aged children and household chores. We did this seven days a week. I did this for two weeks. They have been doing this for over twenty years.

What did I learn? What did Claude Lévi-Strauss or Margaret Mead or Oscar Lewis learn when they entered the life of the people they sought to understand? That these people have an intact, whole, viable life that is different from the one I have. That the farmer on his John Deere whom I saw from the window of my Subaru lived within a society that was different from the society I lived within. That we looked the same, spoke the same words, knew of each other, shared in fact many values, beliefs, activities, styles of doing things, dispositions, but had different life experiences, and from these, we each constructed distinctive webs of life. I learned that when he said the word milk, as in "Please pass the milk," it meant something quite more and different than when I said "Please pass the milk."

What did I learn about drawing closer to Nature? The first thing to emerge that I learned, I had no intention to learn, nor was it learnable. I learned to love these people, this family. I came indeed to learn something about what farmers know about Nature, given their special relation to Nature. I did learn something about that, but I was first taken by the tender and playful and respectful and intelligent and loving contact that was the constant of their days. In the midst of milking or sawing or whatever they were engaged in doing, there was always time to stop to talk, help a neighbor, play with a child, have a bite to eat, take a snooze, drink some coffee with the children or their parents (who also lived on the farm) or their cousins or nephews, sisters, brothers, or friends who might show up. Smart people. Decent people. Busting their chops three hundred and sixty-five days a year, fourteen to eighteen hours a day. Doing the ten thousand things a farm requires and doing each one of them thoroughly yet lightly, with expertise and high finish. (Too costly and dangerous otherwise.)

I worked on the farm in the beginning of April, and there were still several feet of snow on the ground. Toward the second week the weather turned warm and the snow began to melt. During the course of the year, out of a herd of some one hundred and twenty-five cows, a tenth might ordinarily die or be sold off, being replaced by an equal number of newborns. During the winter, if a calf or cow dies, the ground is too frozen to bury it in, and so on this farm it is placed within a great pile of snow until such time as the snow melts, the ground thaws, and it can be buried. Such a time happened that

April. Working with a giant tractor with a bucket loader up front, we went over to the mound of snow where three cows and four calves were buried. Over five months of placing the animals and dumping more snow in this huge mound, it was not clear just where they were. The farmer took his time, taking just a bit of snow away until he came to an animal. Carefully, as if he were working a hand scoop instead of a cubic yard bucket on the end of a ten-foot boom, he gradually released the animal from its temporary bed and placed it on the tines of a forklift. Going slow, we drove the animal over to a nearby field for permanent burial. Upon arrival at the place, the animal was gently let down. With a backhoe, the farmer then dug a burial pit for all seven animals. Finished, it was about twelve by twelve and ten feet deep. Then, working the forklift, he hoisted the animal up, brought her to the edge of the grave, and slowly lowered her in. Tipping the tines, she slipped off easily and lay on the ground. He went back for the other cows and calves, doing the same thing for each. When he lowered each animal into the grave, he made sure that one did not lie on top of another; each rested on its own ground. When all were interred, he went back to his bucket loader and took a scoop of dirt and, lowering the boom until it was just above the animals, tipped the bucket as you would tip a spoonful of sugar, and covered the animals. He covered them with earth, layer by layer, until there was five or six feet of earth over them. Then, using the bucket as a plow, he covered the remaining depression and smoothed over the mound, and we left. He buries his dead like this every spring and a half dozen other times a year.

A few weeks later, I passed a herd of cows in a field and, as was my habit, noted what a pretty scene I had come upon: cows grazing in the foreground, a farm and fields in the midground, and the gentle curves of pale blue hills giving over finally to a pink sunset. How picturesque. The picture was abruptly shattered, however, when I recognized one of those cows in the scene as a cow I had fed and led and cleaned and milked. That wasn't "a cow," that was Beth! Having spent just two weeks leading the cows in from the pasture, setting out fences for the new season, finding a just-born calf in the just-thawed pasture, with mom and surrogate moms hovering about, lifting the calf through mud and snow drifts, carrying her to the barn nuzzled by

overprotective mom and surrogate moms, bringing her to the calf
hutches, teaching her how to take the nipple of the bottle filled with
still-warm milk, carrying the eighty pounds of milk for the calves a
hundred yards at seven A.M. and again at seven P.M. through snow and
muck, finding a day-old calf dead in her stall, selling off a lame cow
that we couldn't get healthy again, feeding the milking herd hay from
the loft, silage from the several silos and protein pellets from buckets,
cleaning out their water bowls and getting the water to flow in them
and not all over the stalls and alleyway, scraping the stalls during milk-
ing every few minutes so the farmer wouldn't kneel in crap when
cleaning the udders and attaching and unattaching the milking ma-
chines, having torrents of pee splash up on me, having loose crap
splash up on me, walking in inches of manure in the feeding pens,
bringing the herd in from the holding pen to the milking parlor, get-
ting them settled in their stalls, fastening them into the stalls, unfasten-
ing them again when milking is done, having one or two cows crush
my hand or arm or leg against a post or something, herding them out
again to the feeding shed, running the feed conveyer, bringing in spe-
cial pails of feed for lame ones in special stalls, fogging my glasses with
cow breath, cows pushing me aside in the feeding shed or knocking
over fences we just put up, conducting a final mucking of all the stalls
and alley-way and dusting the entire milking parlor with sawdust—
having, I say, spent two weeks at this and completing the morning
with a bowl of cereal soaked in their still-warm milk, the pretty pic-
ture of cows in the field shattered, and Beth appeared, so did Betty and
Babs and Bubu and Dude and Dixon and Dotty, and Deb. And I won-
dered how they were doing.

If you would draw closer to Nature, age with Nature. Find a portion
of the raw world that is nearby. Adopt it. Your concern for the fate of
the Nature can be played out and developed through the degree of
care you devote to this one tiny arena of the whole. The daily con-
versations you have with Nature enfold you both. No matter how
small an area it may be, it creates particular harmonics that ripple
across your common time and space. The degree of your sincerity of
concerns draws taut the weave, creating a four-dimensional tapestry:
Nature, time, space, and you.

In this four-dimensional world, not only the forms of Nature appear, but the story of Nature begins to emerge, the intricate story of how things came to be the way they are. You begin to notice how as little as an hour changes Nature's complexion. You see how the slant light of morning rolls across a leaf, and how midday, afternoon, and twilight carry on conversations taken up in different keys, B minor, E-flat major, C major. You see that the wind does one thing with water one moment and something else the next, and what the angle of the sun and the moon add to the trio. You see the stretch marks of constant birthing, the healing of shattered limbs, the debris from a day's downpour become nests for something, dinner for something else. You see the same light and rain and wind and heat do similar and different things to *you*. In this way your work becomes full and care-full seeing of things and processes. Having them soak into your soul like this, your art is the telling of news about what happens when what is out there transforms what is in here.

The work of Monet provides a stunning example of an artist's interest in the metamorphosis of a portion of Nature over the course of time, a day, the seasons, the weather. We notice that not only does Monet study the evolving complexion of Nature over a period of time, but also the quality of his efforts evolves over the course of his life; hand in hand, so does the quality of his *thinking*. Visualize, if you will, his series of paintings of the Japanese bridge over his lily pond. His early paintings do indeed study the look of a Japanese bridge over a lily pond. The graceful arc of the bridge rises on one side of the canvas and symmetrically falls toward the other. The pond reflects the bridge in a pattern broken by the ripples in the water, scattering light here and there. Reeds and trees and clouds and shadows all glisten in the bright light of a summer's day. All the things in the world that are in front of him are now in front of us: the bridge, the pond, the reeds, the trees, the sky, ripples, and shadows. His joy in making the acquaintance of each one of them, in observing how each one shimmers in a special way because of its own genius and the company it keeps, becomes our enchantment too.

As Monet continues to return to this scene, to the *exact* place from which he has viewed the scene a hundred times before, not only do the day and the seasons advance from painting to painting,

but *he* advances as an ever more virtuoso paint and color and brush man, and also as a man. The evidence for his advancing skills as an artist is well known and ample. His palette of color expands, becomes more audacious: pistachio, vermilion, periwinkle, lime, lemon, peach, apricot, rose, lilac, azure. This seeming cacophony resolves itself in symphonies of harmonics not seen or experienced before. His brushstrokes seem to take wing. They fly about, they swim and flutter and pirouette, making light of matter. They become full of light that has been soaked in things but now is free of them. The patina of his painting becomes so laden with paint that the suchness of the paint disappears and transforms into a thick condensate within which light is trapped and made to do things that up until this very moment no one knew light could do. This is Monet the painter who has grown to be an artist.

He also grows as a man. How do we know this? It is there in his late paintings. What do we see now? We see no thing and we see every thing. His compositions, once so full of particular things, become full of no particular thing at all. No bridge, no pond, or if there is a pond, where is it? Perhaps it is the sky we are being shown, or might it be the mirrored plane of the pond that serves only for the sky to be seen? Did I say sky? But surely that is too firm a word to describe what we have here. There is no sky, there is only thick light, light with heft, light that is slow to come and go, light that seems to have been here a long while. Old light that has absorbed not only the colors of its neighborhood but also its aromas and speech. Nothing here grows old, nothing weathers, nothing to break and nothing to have. Yet we miss nothing and we want of nothing. We are silent. We see nothing and we are asked to believe it is all we need. Like Job, like William James, we agree.

The Encounter "A Natural Sanctuary" (page 261) invites just this kind of long-term relation with a chosen portion of Nature. Find a portion of the world that is close at hand and adopt it. Become acquainted with it. Draw closer to it by staying with it over a long course of time. In all seasons, all times of day, all weathers, all circumstances of your own life. The more often you return to this chosen portion of Nature, the more finely you will be able to perceive its more delicate features, as well the slow-to-emerge pattern

and rhythms. This deeper seeing forms the structures of deeper thinking. This honing of your mind will allow you access to recesses and nuances of Nature's divine presence, unavailable to those who have not paid the price. Your art? Your lens through which to see the world and to see your Self. The judgments about your art by others? This is not a question that serious artists ask while engaged in the work at hand. It is not your business. Wait and see; hope for everything, expect nothing.

———

✎ *BURNING SAPLINGS AND JUNIPER*

I spent six hours yesterday
burning saplings and juniper
I had thinned out from our stand of woods last year.
I cut the trees and the brush
in order to see deeper into the woods and grow a
wider range of woodland plants than the thick, close growth
 allowed.
I killed hundreds of saplings to do this
and the moral weight of doing so
will be the subject of some future essay
but I have another story to tell just now.

I began by digging a pit in the snow
ten feet across, a foot down.
Then I dragged the brush from a number of stacks
and piled a good-sized mound about eight feet high.
A little before ten I lit the fire.
It took until the third lighting to raise a sustaining burn.

It was in the twenties, no real wind, a bright clear day
and I looked forward to spending the entire day
outside feeding and tending the fire.

There were apple prunings, maple, chokecherry and
ash saplings, some pine and juniper.

Once ignited and settled down, the furnace-like heat
took in whatever I gave it, green wood, rotten wood,
ice-encased wood, some seasoned wood.

Occasionally my wife came out to say that the fire was
too high and I should stop adding wood.
Later in the morning she helped me drag the cuttings
toward the fire from the piles I had left the season before.
Each time she delivered another armful she had something
 to say about the fire.
After each armful she would sit down and watch me for five
 or ten minutes
and talk to me about something
even though I was mostly on the other side of the fire
and couldn't hear her.
I, however (I am now sixty-three and we have been married for
forty-one years), felt good about a girl (she) watching me
 (a boy)
doing something physical, something manly
like lifting, throwing, burning.

It was simple work:
pick up some saplings or prunings
free them from entwining others and from the snow and ice
drag them over to the fire
and throw them on in the right place.

Toward one o'clock
I could feel my fingers throb
from the many little bruises of the spines of the apple,
the twists, squeezes, and strain of clamping down on the
 bigger stuff.
My shins and thighs were banged around and scratched.
My ankles were sore from stepping on the ice,
the piles of brush, getting caught in forks,
punching down at an angle through the snow.
My nose was cut by a snapping branch.
My eyes were red and teary from the smoke.

My nose was running down into my mustache
and onto my top lip where I could taste it.
My knees and hips ached from the extra burden
they were asked to carry.
I burnt a hole in my sweatshirt.
The hair on my chin got scorched and turned from white to
 yellow.
My shoulders and forearms began to lose
their strength and resiliency.
I began to slow down between dragging the wood to the
 fire
and going out to get more.
The armfuls got smaller, the throwing got shorter.

A little after two
I had cleared all the brush I could free from the snow
and sat on a bench with a container of ice water
my wife had brought out earlier.
The burn was steady and low,
all the small things were gone,
only thicker pieces were burning.
There was hardly any smoke.

So I went in for lunch.
My hand shook so much
I had to leave my elbow on the table
when I put a spoonful of soup in my mouth.
The sandwich
required two hands,
neither one of which could clamp down on the squishy
 thing
firmly enough so that one thing or another wouldn't slip out.
After lunch I washed the few dishes and was in no hurry to
 finish,
letting my hands wallow in the warm soapy water.

I looked at the fire at around three.
No wind, steady burn of coals, just a bit of smoke.

So I took a hot shower
and got into bed to read and take a little nap.
Arms at my sides, palms up, legs straight out,
I lay on my back.
My body tingled, joints throbbed, bruises pulsed.
Every thing ached.
Sleep pulled me quickly under.

When people see me lifting rocks, digging earth, dragging
 wood,
they think I am working hard.
When I stop to talk with them
my clothing is soaked
I am covered with dirt
and my breathing is labored.
It does look like I am working hard.
But I am not working hard.
I am not working.
I am having a conversation
between my bones and blood, muscles and guts,
and the world.

I often do this,
wear myself out acquainting my bones and muscles and skin
 with
trees, stones, earth, water, and fire.

I want my bones, my blood, my guts
to meet the world directly.
It's not enough for my eyes and fingers to meet the world,
to go out on blind dates with the world,
to see, touch, smell this world
and then to tell the rest of me, the inner things of me,
what's going on out there.
I want to introduce all of me, with no translations,
to the world.

I want to be stopped by the world.
I want to come to the end of me

the end of what my bones will bear.
The end of what my muscles will lift
what my lungs can sustain
my hands hold
my heart endure.

I want the world to be my rule.
I want the world as it is to be my rule.
Not my wife, or my mother, or my friends, or what's in books
to tell me when to stop
when enough is enough.

I want my will, simple and fragile,
to be measured against
the stubborn stones, sullen logs,
goddamn gravity.

I'm tired of my mind timidly bossing me around.
I want something I do to be honest
to leave nothing out
to go to the point where I can go no further.

It's not only my desire to meet the world directly
that drives this peculiar behavior.
It's: how else will I ever meet me?

My quivering collapse into bed
I take as a measure of me
that I can obtain from no other trustworthy source.
How could anyone else tell me of these kinds of things?

If I could make it to the bed
with energy to spare
it would be just that same portion of me that would never meet
 the world,
never have *that* conversation with the world.
And as in all conversations,
never serve either as a mirror or a lens.

I want to know the world.
In a biblical kind of way.

———

❧ *LATER THAT EVENING*

Later that evening we were going out for dinner.
What earlier in the day was a great tangle of apple, maple, ash,
 juniper, and cherry roaring aflame
Was now a pale gray mound
Much like the weathered hills around here
Only smoking.

The surrounding forest had turned magenta and blue and
 black.
A single sheet of deep blue did for the sky.
Rising, curling, dipping in half time
The pale mound emitted a wisp of smoke
Nonchalantly.
The light blue smoke hung in the clearing
then filtered through the vertical black band of trees
rejoining them in the deepening gloom.
I liked that.

I mean last fall I had cut down these sapling and branches and
 brush,
Dragged them away from the forest that spawned them
And heaped them into a pyre.
Just a few hours ago I set them afire.
All that promising cherry, maple, ash, juniper, and oak became
 flame.
Then ash and smoke.
Now they became a haze that found their way back into their
 forest.
I thought *that* was nice.

I returned to the smoking mound that evening
To quench what was still afire
Before we went out for dinner.

Since I had tended the fire earlier in the day
And seen the burn through to its quiescence
I had washed up, had lunch, taken a nap, and changed my
 clothes.
Now I was returning to the fire's side where I had spent the
 morning and afternoon.
To tell the truth, I felt somewhat awkward returning in my
 clean clothes, washed and combed.
I felt the way I feel when I meet a past girlfriend on the street
 when I am with my wife.
I feel torn between the two people with whom I have had
 shared intimacies.
True, one love is current and the other past.
But what was once loved still retains the original ingredients
 that created the
give-and-take of shared love.
Memories of lovers gone by are never so dormant
that "in remission" better describes them.

So how gracefully to introduce one to the other in accidental
 crossing?
How to explain?
How not to injure? Not be a fool?

It was like this when I returned to the fire that evening.
Having spent the day with first one, and dressed for the
 occasion,
Having a swell time of it, both of us on fire, both tugging at
 each other, exhausting ourselves
both now quiet and changed.

She had stayed where I had left her, in the clearing of the forest
 under the wild sky visited again and again by the wind.
It was me who left her for another woman,

For another life.
Now, dressed for a life lived indoors,
I returned to the other
The one with the tangled hair, searing touch.

She had lost her high color
Now gray, pale blue, mostly powder,
She rested where I left her.
She seemed serene, unperturbed, as far as I could tell, by my
 absence.
If anything, I thought she had transposed her raw beauty for
 something more refined.
And why not?
She hadn't had me to contend with for a few hours,
prodding her, enflaming her with things heaped her way.
Staring at her, enraptured by her fierce light and music.
She had settled down now to smolder.

I didn't return to her only to see how she was faring.
I came to disturb her again.
This time fatally.
I returned to kill her.
Not as the first time with the ax, nor the second with flame.
But to put a final end to her with water.

We were going out for dinner
And my wife said,
Peter, before we leave you must put out the fire.
We aren't leaving until that fire is completely out. Dead.

I brought a pail of water and a rake from the house
to the pale mound.
I thought it would be an easy job.
She's all but gone already.

Wanting to gather her ashes into a smaller mound—
easier for me to douse whatever was left of her with just the one
 bucket—
I reached across, thrust into her side with the tines of my rake,

bringing her ashes to me.
A curl of smoke, A crimson glow. She lives!

Peter, How are you doing with that fire?

Not well.

I'm a sixty-year-old guy.
Things like this shouldn't be happening to me.
How can I explain to her that I must kill her?
How can I explain to my wife that I can't kill her?

———

Forensics

———

OBSERVING HOW NATURE FORMS the world provides a deeper understanding about the creative forces behind the appearance that the world takes at any one point in time. The same is true about the processes that go into the look of your own completed work of art. The history of the making of our art provides more revealing insights into the structural development of our thinking as we go about the making of our art than does an account of the current state of our art, its completed facade. Drawings provide particularly revealing evidence of this.

Preliminary drawings are usually more interesting to artists than the finished work because in them one can observe the many elements that went into the project, the evidence of which is erased by the final virtuoso handling of the media. The problems the artist raised, the strategies used to resolve them, what was invented on the spot, what was derived from the artist's legacy, how adversity was faced and overcome, how ideas became refined—all these remain apparent in a drawing and offer the careful observer instruction in their own work, as well as insights into the magnitude of any artist's real gifts.

Think of the meticulous surfaces of an early Degas painting compared with that of any of his preliminary studies of ballet dancers and washerwomen. Degas's paintings make his superb draftsmanship seem effortless, as if getting down on paper a pack of prancing thoroughbreds required nothing more than a quick glance and then some deft

marks. Ha ha! Done! But look at his drawing of dancers or women at their bath or washerwomen at work pressing clothes; see how many times he attempts to get that arm to actually come out of her shoulder socket and not from her ribcage, how many times it took to get a foot to turn on the page the way a ballerina's does on the stage. See what seeing takes. See how seeing evolves with more seeing tested against increasingly scrupulous visual accounts.

Try this. Save all your work for the entire period of time you give to a particular project. Date each one, jot down notes of pertinent details of the thinking you might have had at any moment. Then assemble all your work chronologically and submit the entire array to the same scrutiny that Rudolf Arnheim devoted to the genesis of Picasso's *Guernica*. The evolving forces and insights of your work will be illuminated by the patterns that only appear as you scan them from a distance of elongated time.

The successive and necessary phases of life through which all individuals and colonies of Nature evolve provide a model for describing the phases of a single artistic enterprise or a series of individual works. Understanding the necessary complexity and phaselike quality of an artistic enterprise helps us to discover our natural style of artistic engagement. By identifying the distinctive patterns of our working procedures, we may also be able to diagnose where in the history of the project faults appear that result in weak and unsatisfactory outcomes. Looking at the work when it is complete will expose the manifest features of a wobbly piece but will not necessarily indicate where, when, how, and why the problem arose. For this kind of analysis to be complete we must step back from the finished artwork, indeed step far away from the easel or throwing wheel or loom, as far back as outside the studio itself. To stand this far removed from the completed piece of art may seem a rather oblique way of analyzing one's artwork, but it is not at all strange for actors or dancers or athletes who, before they ever perform on the stage or compete on the field—the equivalent to painting a canvas or throwing a pot—prepare their bodies with appropriate nutrition, stretching, breathing, centering, strengthening, and rest.

We will first address the element of art that that attracts the student's greatest attention, the materials that go into the work's construction, then turn to the other basic elements of the artistic

enterprise, space and time. All three will be treated in greater depth and in more general terms in part three, "The Structure of an Encounter," and part five, "Media and Technique." Here we will address these issues in the form of questions and invitations that are intended to help you refine your powers of analyzing the entire artistic enterprise. The questions and reflections are in turn based upon the search for the abiding genius of the place, then cultivating it in ways that are consistent with the natural unfolding of its potentialities, drawing you closer to Nature.

MATERIALS

We begin with a series of questions concerning the materials with which you give form to your ideas and feelings about the world.

What are the minimal essential media you require to embody the intentions you wish to speak about? The absolute minimal?

What is the minimal quality of the material beneath which your effort is likely to be dissipated and distorted?

What is the maximal quality of the materials above which your results are probably no longer going to be enhanced?

How much material do you need to have on hand to provide you with a sense of sufficiency, flexibility, and inspiration, without the softening of focus that surplus might induce?

Do you desire a silver bullet, an Excalibur, some quite special material that will provide you with an ally to see you through difficult times? (I treat myself to a special grade of compressed charcoal and Rives paper when I feel my mojo waning.)

What about a handmade tool or something you modified to more exactly fit your hand or movement? Some long-distance runners always run a race in new shoes but carefully slice away extra slivers of the shoe with a razor blade so as to eliminate milligrams of weight, which, in the course of a race of one hundred thousand steps, reduces by several hundred pounds the total weight they must lift and put down.

Of the many hues and tints and shades of any color available, experiment and find just the right ones whose personality fits your own, whose viscosity and transparency and temperature, and miscibility and

tinting capacity, are just right for the thing you are speaking about and the point you are trying to make.

Where do you like to go to acquire your media? Some bibliophiles have favorite booksellers whose stores and services are in themselves comforts and an essential portion of their love of books. The smell of such stores, the lighting, the muffled sounds of considered conversation, the heft of the volumes, the exchange of pleasantries and recommendations, all this provides a history and a delight before you even open the book back in the solitude of your own reading corner. Cultivating a trustworthy informant in the form of a salesperson, proprietor, janitor, or supervisor of the landfill helps you to gain confidence in the capabilities of your acquisitions. A salesperson who knows your projects and who knows the nature of the inventory can supply you with invaluable information on new materials, better equipment, health issues, and cost-saving specials, and will do some research for you the next time you pay a call.

How did you come by your predilections? What art teacher, parent, relative, or friend introduced you to your current preferences? How about something new, something from unexpected places—a scrap yard, the cosmetic counter in a department store, another section of the hardware store (plumbing, electrical wiring), a commercial printer, the supermarket (try out a new palette of colors gained from the array of colors in the produce section of your greengrocer or supermarket).

SPACE

The process of creating art is one of embodiment, incarnation, transforming interior states of mind to externalized things and events in the palpable world. As such, there needs to be an actual place in the world for that to occur. Making adequate, inviting room for this alchemy is as essential as equipping yourself with the media to manipulate. Not only must you consider the space in which your work can proceed unhindered by walls and ceilings and impinging furniture, but the space must be inviting, feel opportune for your *body* to be in. Your body, the physical form your Being comes in, has certain affinities, appetites, and requirements, just as any other living thing does. To the

extent of your resources and will, provide yourself with a space to be in and work in that invites high and deep and broad and generous thinking and doing. Otherwise, before you even lift your brush to the canvas, high and deep and broad and generous work will have to leap into the unknown unsupported by ready companions. Significant art of course can emerge from the most miserable of circumstances, much fine literature having its unhappy place of origin in prisons designed for humiliation. But if choice is available, why not make that choice informed and brave?

Monet built himself a studio the size of an airplane hangar to accommodate the scale he had in mind for the water lily series—his intended gift to the French Republic. Picasso, Motherwell, De Kooning, Rauschenberg, Warhol, Stella, had equally expansive ideas, will, and (later on) resources. Mondrian painted in a Manhattan office space, Joseph Cornell painted in his basement in Queens and was quite pleased about it, van Gogh used his bedroom. You probably do not have the resources of Picasso; you may have nothing more than van Gogh (there is a sobering thought). Whatever your means, some effort at extravagance can be worthwhile for the reciprocal stimulation in your work that it will bring. You could, for example, turn one entire wall of your dining room or bedroom into an easel: just tack the stuff in progress up, and leave it up.

Rent a space even if only for a month or two. Feel what it is like to have a designated space out side of your home waiting only for you. Feel what it is like to get up and leave your usual domicile. Get dressed, go out, get there, open the door, put on the light, smell the air, change clothes, pick up a tool, look out a new window. See what all this invites your mind to consider, what strokes your hand is now free to make, what new colors become more agreeable, what ambitions seem more promising.

Go outside. You don't have to travel far or bring a raft of art materials with you. Just some charcoal and some paper or fabric and the great sky overhead. The distance between the surface of the earth and the nearest star is so much greater than that between your rug and ceiling, that surely the increased headroom will have its effects on your work.

TIME

Like space, time is an essential feature of an embodied world. I often think that much of children's art produced within our public schools looks as uninteresting as it may be charming, not because children are themselves uninteresting or incapable of saying interesting things about life, but because their efforts to express what they know and feel are squished into a thirty-minute parcel—including cleanup! It is not "children's art" we are observing, it is students' thirty-minute art, overseen by a well-meaning teacher, who is in turn overseen by a principal, who in turn is overseen by the state standards. The same problem exists in art produced by well-intentioned people who, rub and scrub as they may, do it so infrequently and within such tiny packets of time that there is insufficient opportunity for the ordinary cares of the world to give way and open onto the great plains where art awaits the unhurried practitioner.

Thoreau says, "Time is but the stream I go a-fishing in. I drink it; but while I drink I see the sandy bottom and detect how shallow it is. Its thin current slides away, but eternity remains. I would drink deeper; fish in the sky, whose bottom is pebbly with stars."[11] How much time have you allowed yourself to set aside the concerns and necessary accompanying behaviors of the day so that the issues you are addressing in your studio can emerge and take on heft sufficient to form their own behaviors? What talismans and perhaps ritualized acts do you need to serve as the vehicles allowing you to transpose your cares of the day into artistic enterprises that draw you closer to Nature? How much time do you allocate for artistic stretching exercises, for what Thoreau might describe as sauntering about: cleaning brushes, arranging tubes of paint, sweeping, straightening up stacks of paper and boxes of pastels, pencils, brushes, inks, tapes, pen nibs? This may indicate hesitancy to some. But for others, perhaps you, this idling about is a time of ingathering of energies derived from reacquainting your physical self with the sensations of your materials, their voices and aromas. It is a time for the geometry of the space to shape and focus your attention for the new task at hand.

A portion of each Encounter described in part four allows a framework of time within which the particular requirements and

potential rewards of the Encounter may be maximized. Here we sim-
ply say that time is manna, that most precious thing that is provided us
daily, and we are, as all of Nature is, this moment's portion. Again
Thoreau:

> If the engine whistles, let it whistle till it is hoarse for its pains. If
> the bell rings, why should we run? We will consider what kind
> of music they are like. Let us settle ourselves, and work and
> wedge our feet downward through the mud and slush of opin-
> ion, and prejudice, and tradition, and delusion, and appearance,
> that alluvion which covers the globe through church and state,
> through poetry and philosophy and religion, till we come to a
> hard bottom and rocks in place, which we can call *reality*, and say,
> This is. . . . Time is but the stream I go a-fishing in.[12]

FREQUENCY

Frequency of engagement creates a bridge between one moment and
the next along which thought continues to flow and outer behaviors
take on a well-worn grace. Frequency provides momentum to propel
the next session, as in the stroking rate of rowing a boat or the forward
leaning of a walking stride. A great deal of work gets resolved between
one day and the next, if it is only a day or thereabouts. With too much
time between engagements, we lose our constant preoccupation with
the enterprise as other necessary concerns must be attended to. Infre-
quency often results in the necessity to recapitulate the gains achieved
from the last effort, at which point it may be time to close shop again.
A working procedure in fits and stops makes each new time in front of
the empty canvas the uncertain and disorienting thing it is, weakening
effort even before it has gained a foothold on the project.

When you are working on the forefront of your thinking, you are
in a subtle and fragile landscape, inhabited only by yourself and crea-
tures of your imagination just born and still soft in the joints, barely
held in place by the force of your sheer will. Often it is only the con-
stancy of your efforts that supports the credibility of the entire enter-
prise. Critically viewed against the features of the rest of the world,
this young thing of yours is hard put to defend its legitimacy. Habit,

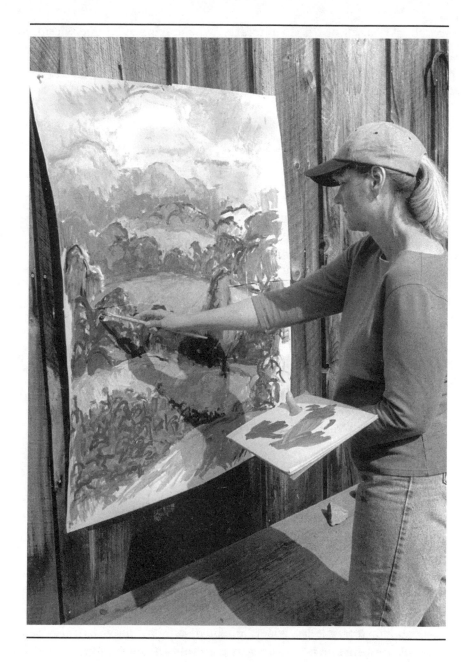

occupancy itself, has the force of legitimizing behavior and the ideas that give rise to it. Therefore, look to the frequency with which you attend to your art. The hesitancy that may be apparent in your art may be less a sign of a timid soul behind the brush than the more easily corrected problem of the infrequency with which the brush is wielded.

We accept that conventions of family and career require set times to do things, yet all but the most dedicated of us treat our creative work as a "filler" to be attended to only when other obligations have been put in place. Beware, says Virginia Woolf, when your art is left to the very dregs of your time and space. Can you insist on establishing a scheduled time for your art practice? An evening a week, a morning, a day? A month during the summer, a sabbatical of some duration at some frequency? Without the ability to carve time, the likelihood of your carving anything else is in serious question.

SETTING UP YOUR STUDIO

All people who take themselves and their work seriously pay careful attention to the design of their place of work. A racing sailboat, operating room, laboratory, or concert hall, the kitchen of a first-class restaurant, are arenas within which everything present is carefully selected and choreographed to support and enhance the exacting requirements of the unfolding event. People who perform any task at a high level of excellence extend the care they devote to all the parameters of that performance, including the design of the arena of their performance. The furnishing and choreographing of the theater of engagement is an integral portion of the creative process, without which there is weak support for the contingent elements that usually gather the most attention: the throwing of the heddle, the pouring of the bronze, the placing, letter by letter, of the word upon the page. I know artists whose studios appear as litter piles of cans, rags, tubes, bottles, canvas, stacks of paper, books, postcards, brushes stuffed into the open mouths of whatever will hold them, dangling lights, knives, stuffed animals, bones, clothes, all of which they find perfectly inspiring. This type of artist requires the world to come apart into its constituent pieces so that she or he can recombine it in the way seen fit, unhindered by conventions of domesticity or business. Others need to

work within a rigid geometric grid so that their fluid thinking has something to resist and bring it in check.

Giving serious thought to aligning the furnishing of your work space with your working procedures establishes a necessary congruency, one that initiates and shapes the ensuing phases of the creative process. In a piece of music, every note and every pause counts, as does every letter in literature, every mark on a page, every gesture and pause in dance; and so does the choice and place of every item in your atelier. Art is made up of choice supported by will. We nurture our capacity for choosing and willfulness by their exercise in all that we do; sculpting the shape and extent of our atelier is no exception.

NATURE AND THE STUDIO

As much as an artist's studio is different from the great out-of-doors, there are interesting aspects that the two have in common; both Nature and the studio present us with infinite choice. Nature because it contains everything explicitly and the studio because it contains everything implicitly. Since this degree of freedom is absent from the ordinary arenas of our lives, our social and commercial settings, it is worth our while examining the rich and heady atmosphere both Nature and studios provide, lest we mince our efforts in our studios as propriety requires in the rest of our lives.

It would be best if you were able to read this while out in Nature. It need not be grand, raw and wild, just abundantly there. If this is not possible, you might at least provide yourself with a view of a good hunk of sky. Even if it is only a small sliver that you are able to see, the sky is always untamed and its infinite shores always stretch beyond our reach. The purpose of having direct access to raw Nature while you read this is to allow you to test for yourself the soundness of the views offered here for your consideration.

The terrifying thing about Nature is that at every moment it presents each one of us who—so to speak- comes open-eyed to the banquet of the world, with the entire spectrum of everything that it has on its menu and, unlike our well-meaning dining companions and waiters, Nature offers no recommendations. We are free to choose or not choose anything; to see, taste, touch, do whatever motivates us.

Nature accepts the slam of the ax, the insertion of the carefully planted seed, the footfall, the loving glance, and the suffocation of blacktop equally. It has done the same without the presence of humans' moral overlay in incinerating volcanic eruptions, drowning hurricanes, scouring ice ages grinding this way and that, and the desertifications of what were once teeming seas. Whatever the day's weather, the rich and the poor, homeless and mansioned, sages and scalawags, all neighbors and neighborhoods receive the same allotment of rain and sun.

Human notions of propriety and fairness constrain the appetite, and it should only be so that conscience makes cowards of us all. Within the sturdy walls of the social compound, the menu of choice is a minuscule fraction of what the world in fact consists of. Civilization depends upon people appreciating the necessity for this healthy diet and choosing accordingly. However, when we convert legitimate moral restraints into constraints upon the imagination, we unnecessarily preclude from consideration the possible extent of our imagination's capacities. The habit of respecting social propriety too easily converts to artistic timidity, which leads to a great loss for good people.

If you are able to, look about you just now and observe the teeming, graceful face of Nature. Allow your senses to come to the doorway of your very Being, your senses of sight, touch, taste, hearing, smell, temperature, time, rhythm, gravity, balance. As you move from the center of your house of preoccupation and come to the threshold, see if Nature, who waits just outside, is not abundant and comely. See if one thing or another, this cloud or that one, this tree or that one, presses itself upon your attention. See if Nature does not seem to expand its finely made, stunning mystery as you expand your interest in it. See if one thing deprecates another. See if the wine list offers any price but one. Notice any racial profiling? See how Nature somehow gets away with mixed housing. See if there is any pushing or shoving. See how in Nature there is coherence without piety or morality, utter expression of potential vitality, leaving nothing out, yet maintaining a dynamic ecology of all things.

As in Nature raw, it is this fullness of menu that we want for the precious time we spend in our studios. It is this unpredetermined opportunity of choice that we want to present ourselves with. Commensurate but in the exact opposite, it is the absence of a thick and

well-fit world that we want for the growing conditions of our studios. We want to come into our studio time/space wealthy with unmitigated opportunity, just as we are afforded a stunning wealth of things-in-the-world every time we venture outside the tent of meeting and face into the wind of Nature's unbrushed but oh so sweet breath.

SETTING SIGHTS

A profound flaw in the very foundation of a work of art, which often dooms the enterprise before it even has an opportunity to prove itself, is that at the outset the artist might simply have not proposed an issue or set out a problem in the first place. Thus, there was nothing in the work to purposefully focus either the energy of the artist or the attention of the audience. A great deal of unconvincing art owes its woeful state to the fact that the artists offered no convincing argument or no argument, issue, or problem at all. Instead, they began their efforts by making another rendition of the thing they already resolved—or borrowed—sometime before, hoping in this way to make a nice-looking commodity, or, more rarely, something not nice looking. Setting out for such small game so easily bagged leaves both artist and audience unsatisfied. Why bother with such weak artistic enterprise when by just stepping outside the door, into the given raw world, everyone is greeted with a heartbreaking and astounding and tragic and glorious and intricate and immense ocean of stuff and stories?

The keel that provides a determined course of an artistic undertaking is constructed from the hard substance of an idea that seems worthy. Worthy for our purposes may be said to mean that in the light of everything that one *might* do, and can do, and even ought to do, *this* enterprise is defensible. And so this may be an opportune time to review your own work to date and examine the bases of the worthiness of your creative enterprises. Not how they turned out, but what they intended to accomplish. It is important to make the distinction between what means an artist employs to investigate the issue they posed for themselves and the issue itself. Let us once again draw upon the work of Monet to illustrate the point. We could cite many artists who seem interested in nothing more than pears on a plate, bottles on a shelf, lines on a page, stacks of cans and soap boxes on the floor, glean-

ers picking at stubble, a single rock in a pond of jet-black water, or the clouds overhead. But Monet will do for our purposes, for what could be less pretty and more ungainly than a couple of lumpy haystacks resting on an undistinguished field? Nothing is happening. Nothing seems to be at stake. But come closer. Or rather, step farther away and observe the four or five *other* paintings of the same haystacks, and the metaphysic of Monet's project comes into focus. This is not about haystacks at all, just as his other paintings were not about cathedrals or lilies or poplars or the river Thames. It is about the primary coupling of the sun with the earth that somehow creates all the life that we all must have. Monet's project involved the investigation of how the infinite facets of the receptive earth is enlivened by a singular source of light, producing the infinite hues, tones, tints, and arabesques of energy we call Nature, we call our life. Monet was investigating the look of how this phenomenon played itself out on the most rudimentary, common facets of the earth. Not as the light played on majestic or heroic or even picturesque vistas, not on particularly comely faces, cutesy children or pets, or noteworthy deeds. Stacks of hay were sufficient for Monet, ripples on a sluggish pond, stacked stones, green leaves against a blue sky. Cézanne's apples, peaches, and pears? Not about fruit. Apples and peaches and pears were handy ciphers for working out the equation of how to construct a firm edifice on a plane that spoke of a maddeningly ephemeral world. Manet's asparagus? How to swipe a loaded brush across a ready surface so assuredly that the mark left is as full of life as a spear of asparagus, newly cut from the garden, on a plate. Goldsworthy's staked sticks, leaf necklaces, and ice walls were prompted by something like: "Let's see what happens when I kiss the earth with nothing more than what she offers me to kiss—right here and right now."

The Process

———

INITIATING THE PROJECT

You thoughtfully acquired your materials; afforded yourself the time, space, and frequency for your efforts; purposefully set up your atelier (be it the kitchen table after all things and people have been swept clean, or an airplane hangar all to yourself); and set out after a worthy quarry. Now you are ready to launch into the deep. How shall you begin? Just as there are countless opening gambits in chess that establish at the outset a strategy that takes into consideration your own strengths and weakness and those of your opponent, the same can be said for the initial phases of the art enterprise.

You come to the place of your art from the swiftly flowing river of work and domesticity in which from choice and necessity you have swum and bobbed along with everyone else. You emerge from this wide and deep stream, towel off, slip into something more comfortable, and step into your atelier ready to do a new kind of business.

We have said that how you go about forming your ideas into expressive things and events deeply influences the outcome of those processes. You may be among the fortunate few for whom the ways in which you go about your daily rounds are the same ways in which you go about creating your art. If so, skip this section. If, however, there are dimensions of your artistic being that are not cultivated and expressed in the ways in which you address work and family, please read on.

Your daily bread won, chores done, family at peace or at least at bay, you enter the time and space of your atelier. Setting aside the common and necessary habits of the day, consider a new choreography for new undertakings. The quiet of the studio, the blank canvas, the empty page, the waiting block of stone, the still-wrapped hank of wool, present you with distinct opportunities and obstacles; therefore, distinct opening strategies are called for. You may find that initiating an artistic enterprise requires you to overcome the awkwardness of first-date syndrome. You might want to fiddle around with the paints and tubes and brushes for a while before actually picking something up and boldly making your first mark. Or perhaps your first mark is going to be on a scrap of paper where you sketch out your proposal. Or you might be emboldened by returning to the last piece you just worked on and push it around a bit further, drawing up your courage by reviewing past triumphs.

In the life that I have, enmeshed as it is with family and friends and students and neighbors, I am purposeful, clear, polite (mostly), sequenced, timely, wanting to serve. I love this life and I embrace these behaviors with no reservation. When I go up to my studio, things change. There I indulge my indefensible magical thinking. I rub my hands across the yearning sheet of paper as if we were secret lovers waiting for this precious moment to be reunited. I allow my gaze to hover over the jumble of pastels on the bench and wait for one color to stand up and say, Here am I, start with me. I breath the color in, I look into the eye of the color, taking its measure, I smell it the better to know it. Then I introduce this brave and forthcoming bender of light to the waiting page, seeking the music that this trio—paper, chalk, and me—might make. No preliminary sketches, no forethought, no conception of where we might end up, an open field with no horizon. Indefensible behavior, but there it is. For me, sometimes after a brief reacquainting myself with a bit of charcoal and the virginal surface of a nice-looking sheet of something or other, it's plunge right in and make for the other side.

Other phases of my life and other kinds of artistic enterprises have called for other approaches. The point being made here is for you to be as experimental in investigating a variety of approaches to initiating the creative process as you are in determining the eventual look of the created object. Plunge right in? Preliminary sketches? Meditation?

Reading inspirational poetry? Mixing paints? Dancing to inner and/or outer muses? A walk along Nature's way? What is your pleasure? Or what about finding that quiet place "within" and positioning yourself in the midst of this Nature, listening in on the conversation that you spontaneously emit? When the deliberate you finds something of particular interest here, well, say it. Discovering what that might be and saying it full and clear, well, that's art.

THE FIRST MOVE

Wait.

Observe.

If you are very still, not impatient, quietly receptive, at some point Nature will make the first move to initiate the conversation. To the exact degree and moment that you are ready to receive, Nature will ever so slightly disturb the equilibrium between the two of you, will reach toward you. The initial move by Nature may be quite subtle and may be received by any portion of your receptive Self: your top lip, the corner of your eye, a certain fluttering of your heart, a quiver across your shoulders. Don't let these signs slip away because you were seeking some more auspicious sign that you might have picked up from reading the Bible too literally. Don't interpret subtlety as inauspiciousness.

The literature is full of accounts by witnesses who claim contact with Nature beyond the threshold of ordinary consciousness, and whose stories are invariably met with incredulity and often dismissed as quirks of perception. The now venerable founders of Findhorn, who tell of their conversations with devas, fauns, even Pan himself; writers such as Gitta Mallasz, who transcribe their searing exchanges with their confidants of another realm;[13] skeptical Carlos Castaneda patiently taught by Don Juan; Moses hesitant before the burning bush; Muhammad reluctant to hear and to write—all began their testimony with astonishment and wonder as a consequence of the kind of "disturbance in the field" that I have described.

Trust your senses at least so far as to not dismiss the registration of a *something* that has come your way. You might begin to do so as simply this. Bring your awareness to the part of you that first "heard" Nature's approach, and allow that part to select the instrumentality

required to respond to what it has just received. Was it your lip that quivered? Then perhaps your response might be in the form of a vocalization, a breathed tone, a melodic line, a word, or words set in prose or poetic form. Was it your shoulders and back, the nape of your neck, that first responded spontaneously to the call? An intentional reciprocating movement of your torso might acknowledge that the message was picked up. Maybe you heard something new or heard a common sound in an uncommon way. Just a warbler off tune? Maybe not. Maybe the change in tune was meant for you to hear, to catch your attention, to wake you to another dimension of the world. Perhaps Nature made itself known initially through a visual event. Don't turn an unusual rock or cloud or tree into just another unusual rock or cloud or tree. Hold it if you can as evidence from another plane of existence, that another plane of existence lies just above and beneath and beyond the one within which you mostly conduct your affairs. Something that perhaps slipped out of its place in the dimension of reality where you go each night when you enter the reality of your dream life. If it is a visual sign that Nature used to tap you on the shoulder, then it may be a visual dialogue with Nature that you wish to entertain. You have no paper or commercial marking instruments at hand? There is the earth, there are your fingers, there is your saliva, there are sticks and stones about.

The initial mark, gesture, or sound may be of a brief moment's duration or it may continue on for quite a time. The important thing is not to force the effort any longer than befits a genuine response, an acknowledgment of what you have just received from Nature. Don't be in a rush to tell Nature what you already know or feel. The more you "speak" at the outset, the more Nature will remain silent. Listen, and respond only enough to sustain the conversation. Devote your energy to maintaining your state of alertness, vulnerability, and response-ability. Be without ornate ambition. Do not seek to consolidate your early achievements. Do not rush to make a picture out of this private, delicate conversation.

Your initial mark in the world has materialized an overture of Nature, and now there is a new thing in the universe: your mark. This mark establishes a third entity, a third plane of reality, and it can serve you as an arena within which you may continue your conversation with Nature. Think of your paper as a magic slate upon which mate-

rial things (the world and you) can transmit, via immaterial forces (ideas, feelings, and force fields), rematerialized marks on the page.

If you allow your conversation to proceed with genuine listening and responding in kind, the evolving engagement and the accompanying marks will begin to construct their own history and look. The temptation at this point will be to shift your focus of attention to these accumulated marks and to drift dangerously near the maelstrom called "How can I make a picture out of this?" Try to catch yourself drifting off course like this, and when you do, steer back in the original direction. You can help yourself to do this in a number of simple ways:

○ Close your eyes when you are actively marking; open them only to see what has been most recently laid down.
○ Make your eyes into passive rather than active instruments of your mindfulness, allowing them to impassively observe but not direct your hands and their doings.
○ Lay down your marks with both hands moving the same instrument at the same time.

There are so many physical sensations going on during these actions that your eyes cannot keep up with it all and eventually settle for merely observing these antics. Have another surface to work on nearby. When what you are doing drifts off onto another approach, shift your activity onto that other surface so that other aesthetic impulses need not be denied, or allowed to interfere with the work at hand, but are given their rightful place somewhere else. As in any adventure or vital relationship, the eventual outcome is always unknown—and unknowable. In all events, a critical ingredient in what will come next is what just happened. So will be the case with your own work-in-progress. What you have just made will invite Nature to reveal more and different aspects that it couldn't reveal to you unless you had attained the quality of relationship you just achieved. Likewise, you wouldn't be ready to perceive what Nature was revealing to you unless you had grown in sensitivity through your last experience.

At some point in the conversation, you will have extended the boundaries of your Self to their limits of the moment. You will notice it, Nature will notice it—and your imagery will show evidence of it. You will notice it when your mind loses its focus. No matter how

you try to concentrate on the issue at hand, your mind will wander in utterly different domains, presenting you with an array of images having no important relation to the field of vision you just were in. Nature will "notice" that you have reached the limits of your present capacities in this fashion; what was a moment before a vital presence, a partner with whom you were having an intimate exchange, will collapse back into just handsome shapes and fetching colors, just another pretty face. You will know when you have come to the end of your interview when your work seems self-sufficient, replete with a vitality that no longer requires anything further from you. You may also learn that the interview has concluded when the work of your hands has no signs of life and the experience has run its course without producing viable offspring.

THE PURSUIT

Having established the initial presence of your intentions in the world by some purposeful marks, creating the initial web of guy wires linking your inner Self to the outer world, another phase of the creative process emerges, one that is characterized by *expanding the possibilities* of the work. You may find that your working procedures during this phase of your creative process differ from the initiating ones, for the same reasons that first dates differ from subsequent ones and those from the ones after you are going steady. This is a phase of the project where you must be observant of the issue under way, its voice, and its young but demanding personality, as well as the possibilities it invites for subsequent exploration and maturation, and coming upon the unexpected.

Perhaps you have begun to notice a rhythm to your working procedures, a nascent look, a point of view. This phase of the creative process requires that you recognize these consolidating tendencies yet resist their domination of your affections. To devote your energy to *refining* these early efforts is to miss this pivotal opportunity of *extending* those same initial investigations for what they may portend. Keep open the portals of the possible. A mark of the most accomplished composers and jazz improvisers is their daring to leave the melodic line or theme they were just developing and seemingly leap ahead to-

ward some yet-to-be-defined purpose, only to somehow find their way back, eventually, to the original premise, but now wiser and more satisfactory than might have been expected. Mahler, for instance seems to wander off into private reveries in *Song of the Earth* but brings the piece eventually to resolution, encompassing a richer, more difficult terrain than the opening phrases seemed to suggest. De Kooning, who was famous for resisting the refining act of art, constantly struck out on fresh reconfigurations while working on the same piece, imparting a perpetual sense of excitement and anxiety to the work. Frank Stella throughout his career and ever more astonishingly in his recent painterly sculptural series, *Moby-Dick*, and *Hacilar Level I-IX*, demonstrates this same ever-abundant eagerness to turn the corner, exploring the country of the possible.

This ability to expand upon the possibilities inherent in the project, instead of stepping back from the adventure into the calmer waters of refinement, may be more in evidence between one work and the next than within any one work. When I use the term *artwork* or *art project* or *enterprise*, I mean not only the single piece in hand but also the entire collection of pieces that severally explore the issue under investigation. Any one painting may be *a* view of Mont St. Victoire or *a* view of a cathedral in Rouen, or *a* self-portrait, but the project intends an exhaustive study of the subject over time and circumstance, each piece another probe via another angle of inquiry. Each such effort reveals further and finer dimensions of the subject; at the same time, such effort sharpens the instrument employed in the probe. For evidence of this, assemble a collection of contemporaneous works of yours and observe to what degree this may be so. Surrounded by this assemblage, you should be able to observe the structural dynamics of the entire artistic process you employ, what I term the archaeology of your marks, that typically generates the look of any one work of yours. If there is scant evidence of improvisational vigor within a piece or within a collection, you have something to think about. Again.

How to resist the tendency for comfort when you have endured such discomforts opening the door of becoming? This indeed is the phase that separates out the ones who go forward from those who stay close to home. What proportion of each of these movements is found in your creative endeavors will be determined by how much of each

you desire at this phase of your life. Remember that the practice of your art provides you with practicing for the life that you would prefer to be living. Accordingly, this phase of your artwork can provide you with the skills necessary for your life.

WHEN THE FRUIT IS RIPE

When he was four years old, we enrolled our son in a Suzuki-method violin class. He was given a tiny violin a bit longer than my hand, and for the first several weeks all the teacher taught him and the other children about music was how to stand properly, hold the bow with a soft palm, have the violin tucked rightly under their little chins, breathe evenly, and listen to the teacher play beautiful-sounding notes and simple melodies. Only after some time, when the children breathed evenly without fussing, the violins stayed tucked under their chins without falling, their palms remained soft holding the bow, and beautiful sounds had washed over and through them many times, did the teacher say, "Now, children, *you* make beautiful sound." And they all did.

When Eugen Herrigel went to Japan to study the art of archery, he enrolled in a school of the martial art. His story, recounted in his marvelous book *Zen in the Art of Archery*, is one of setting aside the conventions of desiring, doing, and being, familiar to him as an educated Westerner, and of initiation into a way of doing things, or rather a way of being in the world, that lies at the heart of Zen Buddhism. Herrigel describes an education in desiring and achieving stunningly different from Western conventions, an education that informs the conduct of life through the practice of some outer form, such as calligraphy, flower arrangement, ceramics, or martial arts.

Herrigel begins his quest only somewhat in advance of the many students I am familiar with, who desire to learn how to draw or paint in the course of a weekend, and who have been to other workshops where the teacher is perfectly willing to supply that kind of instruction. Loaded with portable easels, brushes, paints, solvents, rags, jars, rolls of paper, tape, pushpins, glue, and all the rest, knowing they have wrested a precious weekend from their jobs and families, the would-be artists can't wait to launch into their first painting and *this time* to get the instruction that will enable them to achieve the

look they are after. They are, initially, somewhat taken aback by the amount of time I dedicate to having the people in the group become acquainted with one another, establishing some simple conventions of speaking and listening that create a safe and judgment-free context, locate their own place to work, participate in centering and breathing exercises, heighten their sense acuities, and learn to listen to the voice of their intended media, and establish a working relationship with them.

So too with Herrigel. Eager as he was to achieve a bull's-eye, how frustrating for him when his master at first only provided him with a bow but no arrow, teaching him first how to stand and breathe and become acquainted with the life of the bow. Then a bow and arrow but no target, learning how they fit together, and fit with him. Then a bow, an arrow, and a target, but a target with no bull's-eye, only a few feet from the tip of the arrow, this in order to get a sense of the draw and release with no aim. Only when the bow and the arrow and the target and Eugen himself were in alignment did the master archer allow his student to release the arrow, not to hit the bull's-eye so much as to realize what was already immanent: the alignment in the mind, body, and spirit of Herrigel—the aim of archery.

Standing quietly with no mind
Breathing easily with no anxiety
Turning toward the target with devotion
Picking up the bow with care and respect
Gripping the bow with no expectations
Knocking the arrow to the bow as a marriage of necessary partners
Drawing the bow with no effort
Holding of the draw with no hurry
The uniting of self, breath, bow, arrow, interval, target
Relinquishing success
When all is aligned and ripe to the touch
releasing the arrow

Archery
The forgetting of Archery

When the fruit is ripe it falls of its own accord.[14]

Herrigel went east in the 1950s to learn this, as many Westerners did in the sixties. But the value of preparation and maturation has also been a significant part of non-Eastern traditions as well: Judaism, Christianity, Islam, Bahai. The spiritual practices indigenous to the Americas, Africa, and Australia are equally developed in this holistic appreciation of what is necessary for the complete life and the complete artist.

But of course wobbly people can make unwobbly things. That's what they mean by teaching the tricks of art. Copy! Mimic! You know what the good stuff looks like. You know where the how-to section of the bookstore is. Why go through all this crap about drawing closer to Nature? Pretend! Pretend you are an artist. Pretend this stuff is yours. Pretend you know what it is all about and for, for all the good that does you. Want to leap and soar with Keats and Shelley, Degas and Köllwitz, Brahms and Basie, without *being* like Keats and Shelly and Degas and Köllwitz and Brahms and Basie? Oh dear.

> *Stand quietly with no mind*
> *Breathe easily with no anxiety*
> *Turn towards the target with devotion*
> *Pick up your materials with care*
> *Grip the marker with no expectations*
> *Touch the marker to the page as a marriage of necessary partners*
> *Draw the line that comes from the heart*
> *Hurry not*
> *Fear not*
> *Unite your Self, breath, media, interval, and page*
> *Relinquish success*
> *When all is aligned and ripe to the touch, release*

> *Art*
> *The forgetting of Art*

> *Things to have: pencils, paper, bows, paints, inks, clay, arrows,*
> *targets, easels,*
> *Space, time*
> *Things to do: Breathe, center, balance, draw, release,*
> *Things to be: patient*

> *When the fruit is ripe it falls of its own accord*

CLOSING IN

The work now stands in the world. For the present, allow that it could be likened to the creation of a golem, a semi-autonomous creature sprung from the loins of your imagination and carefully made labors. Not quite sensate, still without independent vitality, nonetheless it leans into the world of the living, in the realm of things that matter. But it still requires more of you to complete the task and set it free.

Introducing bold new structures during this phase of your process would refigure the thing as it has now become and would be at the expense of the thing as it now appears. This is a phase of the creative process that requires keen observational skills and analytic deliberation. The solutions to the problems presented will demand delicate refinements and bold surgical procedures without loss of the thread holding together the bases of the original enterprise. This also is the phase of your project that ensures the sustaining strengths of the ultimate work. If you were too glib in your resolutions of the problems set, you and your audience will soon become uninterested in your project's charms. If you were incomplete in your efforts, the work will collapse in on itself, and its awkwardness will be seen not as the attraction of a cavalier attitude, but one of mere incompetence. This is the time to deepen what you say, in tune with the deep experience of the world that prompted you to dare say something in the first place.

Some questions you might ask of the work at this phase of your project: Is there something remaining to be said about this, some truth, that has been overlooked? Do I dare disrupt the aesthetic finish of the piece as it now is to make room for this neglected factor? (Matisse claimed that he had to overpaint the entire painting each time he changed any color anywhere.) Is there something here now that really no longer belongs to the evolved point of view but is a mere, if charming, hanger-on from earlier times? Are all the props used to make my point as necessary now as they were earlier on when they had to assume a larger burden of responsibility? Have I overbuilt it, making it unnecessarily rigid and severe? Is this all there is, is this all I know, is this all I can say?

SNATCHING THE PRIZE

You're almost home. You have set out into uncharted waters and come upon new territory. As a consequence, both you and your world have become more extensive and wonder-full than you were able to observe, savor, and understand before setting out. This is the phase of your work that requires yet another array of skills and calls up other dimensions of your character. Now is the time for reflection, for becoming acquainted with the creature you brought into the world, this work of art. It is also a time of setting the thing free, free of your fretting and fussing over it. Most important, this is the phase of your creative process for you to be free of it, free to get on with new adventures that just might turn out to become new loves. The exiting strategies you employ in your creative process are just as critical to the success of the enterprise as they are in exiting any other profound relationship, including the Great One, from life itself.

Stand back. Put your tools away. Clean up the mess. Leave the studio for a while. Come back after you have spent a little time with the rest of the world. If what you just created is going to be sustainable, it will have to acquire legitimacy without the support of the closed and special atmosphere in which it was created. I am not speaking here about its aesthetic merits measured against prevailing fashions. That kind of reflection is alien to everything this text values and wishes to promote. I am speaking instead about *you* witnessing the sufficiency of *your* voice in the world. Is this what you want to say? Is this what you know to be true? Is this a fair account of the gifts that you bring to bear on the issue? If this were the last piece you had the chance to do, could you say, "OK, that's as much as I know and can do"?

However far your work may bring you, every work is also a platform from which to observe the immensity and intricacy of the world. From this newly won vantage point, you most likely will observe that the gains you just made, however meritorious, encompassed but a fraction of what still remains out there, still to be forged by hammering yet again on the anvil of your soul. You might achieve a closer proximity to Nature the next foray out by asking yourself: What do I now see of the many features of Nature that were closed off to me before? What did I have to relinquish in order to gain that new height?

What will secure this new gain I have made in my efforts to draw closer to Nature?

IT'S OVER, ALMOST

At some point the work has run its course and you feel quit of it. This is not the end of the artistic process, but yet another phase that requires conscientious application, as did the earlier phases. For the first time since its conception, and your now having seen it through its early stages, the work now stands on its own in the world, and you too stand alone, or at least apart from it. Artists experience this phase of their work in many different ways, often shaped by the kind of pregnancy and rearing practices they just experienced or endured. We will suppose the phases that preceded the work's completion to be of normal success and the same for the joys and tribulations of its creation. Your saturated state of involvement in creating the work has allowed you to perceive qualities that only close proximity permits. There are qualities in the work, however, that can only be discerned from a greater distance of space and time and by a psyche unattached to the difficulties of its creation and concerned only with whether the outcome matches the intent.

The myriad decisions that went into the moment-to-moment creation of the work were of the moment and took but a moment. With a greater field of time within which to observe and reflect, patterns and tendencies too subtle or grand or complex to observe, or not grand enough, become apparent. But do not be in a hurry to go back into the work and correct it accordingly; wait a bit more. Judgments made quickly may in fact bring the work around to where you would have it. But if you allow your seeing to mature still further, other qualities will begin to appear and disappear, become of concern and fade in concern. Let the work continue to unfold and to speak to you. Allow yourself the time to learn how to read the meaning the new work *actually* offers, in contrast to the way you had intended the piece to speak. Sometimes the work in front of you is about something that has not consciously arisen, but has slipped out instead of what you had intended. Of course it would look all wrong relative to your intentions, but it was not guided by your intentions, at least not overtly. To

rush to modify the piece in front of you according to plans that don't match its structure would be to miss the opportunity to perceive the covert/subconscious plans that may have found their expression in the current piece, plans that might only be able to make their presence known in this fashion.

Here as elsewhere in your creative process, use time as sumptuously as you would use any other media that your resources and will can bear. Nature does it all the time.

Further Reflections

———

TALKING WITH NATURE

The world is in constant flux, always expanding, contracting, budding out, falling apart in particular ways. Every particle and conglomeration is pulsating at a different frequency and harmony. All this jiggling about comprises the cosmic melody within which we too sing, however subtly. Just as our harmonies can be said to be "our way of speaking," so may we say that everything in the world is speaking, broadcasting its particular frequency and harmony, emitting its characteristic energy patterns. I'm not speaking here of talking plants. I intend only to point to the general strategy and form all organic life displays.

The particular form at any one moment that everything exhibits is the physical manifestation of the way that entity organizes itself, selects its necessary ingredients from the cosmic broth, and systematically constructs from those now dissociated ingredients a new entity designed along exact parameters and sequences. Most entities live out their existence, slipping from the universe, forming exquisitely designed, complex, choreographed, highly tuned selves from blueprints that are compressed into infinitesimal, somehow living codes without realizing an iota of what they are doing or why or how. Humans are of course no exception. The least intellectually endowed of our kind, the profoundly microcephalic, who are minimally responsive to any external sources of stimuli and, as far as brain scans can determine,

have little or no internal consciousness, nonetheless are capable of turning the porridge they are fed each day into exquisitely made eyes and fingers, and metabolizing with a staggering degree of sophistication, orchestration, and differentiation all the cells, systems, and organs of their body. Just like others more generously endowed.

So, we have every living entity in Nature speaking simultaneously in many "tongues," emitting their particular signals (speech) at the frequencies of heat, light, aroma, sound. Everything is speaking. Everything is listening. That is, everything in the universe is responding to "communications" received. Plants respond to different climates and weathers and soils and touches. So do animals. So do galaxies, so does oxygen, so do quarks, with or without charm. So do we.

Taking this fundamental observation further, we may ask: Everything may be speaking and listening, but is anything in this cosmic babble intelligible across species and genre? Or is it all just a hubbub, each entity doomed to emit and receive messages only from the circle of its own kind? (The story of humankind, all tragedy and comedy, reveals the apparent impossibility of interpreting accurately the messages we do manage to receive even from our own kind.) The

consequences of the answer to the question "Is any of this babble intelligible?" are profoundly critical, one way or another. If the answer is no, everything is "speaking" but in a language intelligible only to its own kind, then we humans can only enjoy relatively limited commerce, understanding, empathy for all that is nonhuman in the universe, the vast majority. The vast majority? We are all but the sigh of a mote. On occasion, we can and do emote well enough with Nature; lovers are moved to tears by full moons and misty mornings; we love our pets and mourn their passing. We love and tend our gardens, decorate our houses with showy flowers and plants, take long, soothing walks along the beach, woodlands, and rolling meadows when we can find them. These are all real, serious demonstrations of love of the natural world that have a deep effect on our lives, determining how some of us devote a significant proportion of our time and resources and restore our souls.

I am speaking here, however, of what I take to be another level of communication with the natural world, a level of dialogue occasionally achieved by certain madmen, mystics, young children, many tribal peoples, and some artists. I have heard tales of Saint Francis, read and seen films on the worldview of tribal people, and know there are individuals who have communed with Nature and sought in Nature guidance, inspiration, wisdom, solace.

Paul Shepard, in *Nature and Madness*, writes that the child

will learn that his childhood experiences, though a comfort and a joy, were a special language. . . . Thenceforth natural things are not only themselves but a speaking. He will not put his delight in the sky and the earth behind him as a childish and irrelevant thing. The quests and tests that mark his passage in adolescent initiation are not intended to reveal to him that his love of the natural world was an illusion or that, having seemed only what it was, it in some way failed him. He will not graduate from that world but into its significance. So, with the end of childhood, he begins a lifelong study, a reciprocity with the natural world in which its depths are as endless as his own creative thought. He will not study it in order to transform its liveliness into mere objects that represent his ego, but as a poem, numinous and analogical, of human society.[15]

What I can attest to in this regard is only what I have personally witnessed. One instance among many involved my daughter, Danielle, when she was about seven years old. The cat that my wife and I had had for almost twenty years, Freddy, had died. After a heartfelt and respectful period of mourning, we acquired a new cat to replace the hole in our family that Freddy's passing created. We went to the local ASPCA, and after agonizing over the choice of one adorable and beseeching kitten after another our daughter finally settled on a frumpy-haired kitten that she named Cream Puff. Cream Puff was not a very clever cat. This intellectual level in a cat, or at least in Cream Puff, expressed itself in an innocence, sweetness of disposition, unguarded loving-kindness, a slight ungainliness, and an open but unfocused curiosity. Cream Puff immediately became devoted to Danielle, breaking off whatever she was chasing or eating to sidle up to our daughter, and unashamedly purring till she shook. Danielle, in the early grades at elementary school, was going through the rigors that many children endure as a consequence of attending school, or just attending to the forces of shifting alliances and affections among the children of the neighborhood. Best friends, archenemies, secret clubs, parties, presents, bruised knees and feelings—whatever storms Danielle may have encountered during her day in the raucous world, when she returned to the safety of our home, she was always met by her faithful companion, Cream Puff, and after a brief exchange with us, the two of them would go off to Danielle's room for their chat and some milk and cookies. Cream Puff and Danielle were each other's best friend. Who knows what actually was discussed between them; they always closed the door. But we would hear constant chatter, laughter, or long periods of silence. On occasion, when all was quiet in their room, we would peep in and see that Danielle and Creamy had climbed into bed and were now napping. Later, refreshed, they emerged from their room and would say no more about it. No cross or demeaning word could ever be said about Creamy in front of Danielle without being challenged, and the remark made to seem what it was—a callous and unworthy slur about a decent being.

One summer, while our children were away at camp, and we were away from home for the weekend, we were told, upon our return, by a neighbor who buried her, that Creamy had been killed by a neighborhood dog. We were terribly upset for Creamy, but our thoughts

went immediately to our daughter; how ever was she going to handle this black news, and, how ever were we to tell her? We decided to delay the telling a couple of weeks until we brought her and our son home from camp, waiting in dread for that fateful day. When that arrived, not to compound her swirling emotions during the necessary promises, tears, and embraces of camp farewells, we postponed telling her until some time and distance from camp. Finally we could forestall our ugly task no longer and, pulling off the road ostensibly to take a little break in the journey, we stopped at a pretty little park to tell our daughter and son the dark news. We walked into the park. With my wife on one side of her, and I on the other, we soon came to a setting that seemed as good as any and, sitting down, began to steer the conversation toward home and Creamy. Immediately Danielle sensed that there was danger in this and with tight-lipped and wide-eyed alarm demanded to know how Creamy was. Her skinny white arms grew taut, her eyes searched ours for forecasts and honesty, and we finally said the unacceptable word, dead. Creamy was dead.

The forces of love that had bound Danielle and Creamy inseparably together instantly converted to a red howl that exploded from deep within her, a scorching sound that silenced everything else. Whatever was alive in Danielle became sheer sound. A great violation had occurred for the first time in her life, and who she had been, she would be no longer. We were all sucked into the vortex of her grief and cried too: cried for Danielle, for Cream Puff, for the hurt of all children, for death's ugly hounds, for the fate of parents and children they can't perfectly protect. She sobbed convulsively in the woods, rising from time to time to ask why, why. After a long while she said she wanted to go home, and getting back into the car, swollen, damp, exhausted, she slept, crumpled in the backseat, the three hours home.

Cream Puff was buried in our garden not far from Freddie, their graves marked by a large stone surrounded by a circle of smaller ones. On occasion, I would see Danielle, just home from school, by Creamy's grave, on one knee, with bowed head.

Why tell you this? This sort of thing happens millions of times a year to millions of kids, and some adults too. It's the melodramatic stuff of grade B movies and TV series. The commercial appeal of these stories, however, reveals the more important underlying affinity we all retain with those who still speak, as we used to speak, with Nature.

It is told because one need not be a member of a group who has lived uninterruptedly close to Nature since the dawn of time to listen with intelligence and feeling to the world as it speaks. Nor do we need to feign childishness or madness in order to decipher the many languages of the natural world. We need indeed go no further than our own Selves, if not our current self, then the Self we used to be, the child we used to be. The direct speaking with Nature that we all possessed in our earlier years is not erased by the overlay of our subsequent life experiences. New thoughts arising from new experiences *layer over* older, earlier, primal material, but do not entirely replace them. Indeed, it has been my experience in working with thousands of students of all ages for three decades, not one "deafened sophisticate" was not able, once again, to listen intelligently and speak expressively with Nature.

Children, artists and mystics, and madmen, have been heaped together in the minds of casual observers as seeing the world in similar fashion. Important distinctions must be made among them, but the traits of perceiving the world directly and freshly and fully, unrestrained by received opinions, are qualities they do most importantly share, allowing attention to be paid to every element in the given world with equal receptivity and seriousness.

I believe there is an underlying metaphysic that guides this democratic openness to the world, as in Blake's seeing the world in a grain of sand. Or in the musical compositions of John Cage, where determined and random sounds weave a democratic/ethereal musicscape. Or the choreography of Twyla Tharp, the improvisations of Lester Young, the gestures of Jackson Pollock. There is an essential common basis that underlies these artists; their ability to perceive the world as if for the first time. As a consequence their work looks organic, inevitable, natural.

What happened a few years back as I returned from my walk on a beach that allowed me to see a different world than I had seen when I started out along the same beach just an hour earlier? Making sense of this event allowed me to build a new cosmology with which to not only steer my art, but more hopefully, if less assuredly, my life. Without reconstructing my worldview, I feared I would let slip a gift of great potential reward, leaving me little recourse but to revert to a system of art- and life-making that had insufficient sustaining interest or vitality. I desired something more. I suspect, so do you.

TRICKS

I have written that there are no tricks in the making of art; there is only honest effort in saying what you mean, nothing less and nothing more. But there *is* a trick to doing art well, a trick in the sense of a shortcut, promising the likelihood of bypassing years of awkwardness and shallowness.

It is this: Everything you do as an artist, *mean* it.

Are you disappointed with that secret to making good art? Does it sound obvious and easy? Yet it is neither as obvious nor as easy as might be supposed. Our normal social conventions prescribe that we never say or do exactly and fully what we feel and believe in a social setting. Permitting expression of our full and exact feelings and beliefs would destroy the very protections our hard-won social contract provides us. We are comforted in the knowledge that when we venture out into the world of others, with all our scars and shortcomings, and certain that others must surely know of them too, that no one, no one in their right mind, will make mention of them. Our reserve in making mention of these embarrassments is the likelihood that the others are also aware of how painfully flimsy is the veil covering their own shortcomings, and thus the likelihood of the return of candor. The social contract is our written and unwritten code of decency, propriety, manners. The keen knowledge that we are an inextricable member of an interdependent social system, with dire consequences to all who we rend that web, especially if they do so knowingly, keeps our behavior in alignment with these common expectations.

Taken to extremes, adherence to conventions leads to a frozen civilization, creaking under the growing weight of evolution, finally falling prey to rambunctious iconoclasts. In all fairness to its benefits, the social contract also provides a ready model of excellence and meaningful forms for all its members and for those artisans who are quite satisfied to lend their gifts to the manufacture of conventional expressions. Much superb art of sublime sensibility flourishes under these conditions. The problem arises when the opinion about the good and the true and the necessary that one may individually arrive at departs from the opinions of one's compatriots. Then what? Then how do you say and do exactly and only what you believe when what

you believe is not exactly what is conventionally believed, said, and done? How to be true to one's own self while also being kind and respectful of the other's dignity and of the necessary maintenance of the social order?

This is the dilemma that confronts all respectful members of a social contract all the time. The dilemma is resolved in any number of ways: submission, forbearance, negotiation, diplomacy, capitulation, generosity, compromise, tact, silence, and when all else fails, downright lying. A person unable or unwilling to acquire these social graces makes for a poor partner to the social contract, indeed a boor or even worse. We swim in the safe waters of the social contract, and once you get the hang of it, it becomes second nature. And it's all mostly for the good.

It's not so good for art. It's not good at all for that art which is born from authentic responses to firsthand encounters with life. The trick, then, to the art we are speaking about is setting aside the conventions of the social contract that have become our second nature, and returning to primary responses to life, responses in which you *mean* what you say, nothing less and nothing more.

"Setting aside" is the key maneuver of this trick. Bracketing the times when you conduct your affairs in the mode of an artist, the one who means what he or she says, from the one who will not or cannot. Most of us are unwilling, even unable, to pay the price of designating no boundary between the demands of artistic integrity and those of social decency. We may read about the hedonistic, sometime charming, often boorish social manners of artists who are incapable of drawing this proprietary line. If their talent is large and they bring us news and delight, we mostly forgive this breach of the social contract, indulge their embarrassing excesses, but not without exacting a penalty. We do so by imposing our own line of demarcation, setting them over there with the other charmers who both fascinate and terrify: the enfants terribles, bohemians, bikers, cross-dressers, wayward but oh-so-adorable stage and screen stars. Perhaps, too, our prophets, seers, and mystics. Them over there, decent folks (sort of like us) over here.

It may be argued that the real artists of integrity owe the ferocity of their art precisely to their unwillingness or inability to draw a line between their behavior as an artist and their behavior as a civilian. I have learned from my personal acquaintanceship with many artists over fifty years that *from their perspective*, their creative and artistic gifts

are restricted and unintentionally distorted by their inability to draw this most important line. They are not happy to be unable to form and maintain intimate relationships. They are not happy to be taken for fools and madmen. They are not happy to be seen as charming entertainers unable to manage their own affairs. They are not happy to be talked down to or up to. They are not happy to inadvertently offend. They are not happy to speak in a fashion that few can understand. They speak the way they do because they find no ready language to say the things that they must say about the life they must live. All the rest is affectation they could well live without.

The artists that I know, who do practice their art with integrity, who do say only and exactly what they mean, preserve their integrity as artists by drawing a strict line between what they demand of themselves as artists and what they demand of themselves as civilians. The impenetrability of this boundary allows them to be as uncompromising in their art as they are empathic and compassionate in their civilian life. *That's* the trick.

Have I drawn the distinction between the integrities of art and of society too crisply and as mutually exclusive? If I have, it was to draw them distinctly. In fact the insights and qualities gained by the full exercise of one inform, broaden, and deepen the other. I have relentlessly put forward the argument that there is an interpenetrating flow between the conduct of one's life and the expression and refinement of that life through the exercise of one's art. The important distinction being made here is that although one's art and one's life interpenetrate, they are not without their necessary semipermeable boundary membrane, and each contains unique qualities. Their differences create the opportunity for an interpenetrating flow.

Your art is your willingness to say what you mean, nothing more and nothing less, and say it clear. The quality of your art is to be found in the degree of care with which you form your expressions. Exemplars of utmost artistic integrity abound. Here is a spoonful dipped into an ocean. See Marion Jones run. See Chungliang Al Huang practice t'ai chi on a cloud. Look over Rembrandt's shoulder as he looks and looks at his Self, spend an afternoon putting your life in order as Morandi puts his bottles just so on the shelf, shrink your precious little ego as you gaze into the depths of Monet's last water lily painting, go ahead, stare at Alice Neel or Lucien Freud's portraits of pals, listen

to Beethoven's Razumovsky Quartets again and again, listening for light wresting its way out of darkness, or Brahms's clarinet quintets, Bach's Goldberg Variations, listen to Glenn Gould play them, then listen to Murray Perahia offer another interpretation, watch, listen to Yo-Yo Ma, Erroll Gardner, Janis Joplin, invite Elizabeth Schwarzkopf to sing you to sleep with Strauss's Four Last Songs, do Otis Redding "I've been Loving You Too Long," then quick call your sweetie, watch yourself becoming a believer again reading Rumi and Hafiz, say goodbye to yourself for a while as you read Cynthia Ozick, Neruda, Pinsky, Rushdie, Borges, Nabokov, Waugh, Mishima, or, or, or. Or read Shakespeare again, listen to Olivier speak the lines. In a room of your own, you read the lines, trippingly on the tongue.

Were they all able to draw a line between their integrity as an artist and their place within the prevailing social contract? No. Did their inability to do so enhance their art? I know of no one who said so. Did their inability to do so enhance their life? I know of no one who said so.

In everything you do as an artist, *mean* it.

Some trick.

When I notice I'm losing my edge, I sometimes listen to Otis Redding *doing it*.

You could also watch a cat stalk a cricket, or a bass smack a plug.

MASQUERADE

Interpersonal interactions resemble a masquerade: what we are given to see is not all there is to see, what we say is not all there is to say. Because we are complex creatures composed of many and different elements, some conflicting with others, some to be shared only in certain company, both for compression and precision we present a particular aspect of our multifarious self, given the circumstances and company we keep. *Così fan tutte.* We all tacitly understand that who greets us and how we return the greeting is a choreographed performance calculated to enhance our separate and mutual ambitions. Everybody knows there is more to the one who appears before us than is allowed to be exhibited: more light and more shadow. But for the purposes at hand, what is shown to us and what we show to the other sets the

scope and depth of the interaction. Given the complex and layered character of human beings and the complex and layered qualities of our affairs, being adept at masquerade and simultaneously having the ability to peer through the concealing/revealing mask are requisites of getting along and doing well.

I will not argue the merits of this contract; its many rewards are well known. My concern is what happens when we apply our habitual ways with one another to our affairs with Nature. If it has become our habit to appear less than we know ourselves to be, we will impose a veil between ourselves and Nature, distorting and obscuring both our Selves and Nature. Since it is my premise that direct encounters with Nature as it is will provide us with vital news about our Selves and the World

that we must read direct; if there is pretense in the way we present our Selves to Nature, then we will be caught in the web of our own miscalculations, and will only have what we already have, be who we already are; less than we our potential, less even, than we would prefer.

For us to evolve toward a closer and more finely made relation, our inner nature as well as outer Nature, our habitual life of masquerade must be set to the side. We must find a way to come to terms with the way that we are, if we are to find a place to witness Nature the way that it is. The artistic arena can become such a place and—potentially, a process of self disclosure and world discovery.

How can we drop the habit of donning a mask before we leave the sanctuary of our own privacy and meet Nature raw and simple? I have a number of suggestions. The first is: *want* to, intend to. Desiring to become something you are not introduces a formative structure in your mindfulness that biases behavior over time and warps it in a corresponding direction. Desiring something not yet in hand disposes our mental acuity and senses accordingly, shifting our abilities of perception and valuing around the nexus of those desires. Wishing does not make things so, but seriously desiring does predispose us to intersect with particular portions of the world in particular ways, and the results of these new features of our life enhance the opportunities for success.

Each of the Encounters in this book provides an opportunity to step out from behind the mask of our usual mindset and behavioral habits and to witness Nature as directly as we can bear. In this way an Encounter can be understood as a formal practice, not only for the immediate purposes of enhancing our ability to create fuller, more genuine artistic expressions, but as a *constant* practice, even a daily practice of composing our life along more natural ways, guided by Nature's ways. The first phase of each of the Encounters, before we set out on a journey to meet a particular aspect of Nature, is to prepare our Self for the journey by coming to an interior still point, allowing pretense to drift away. As the layered cloud of many ambitions, swarming memories, and ticks of petty discomforts begins to lift, Nature, which only a little while ago appeared as a silent background to all this internal chatter, approaches and begins to speak. Quiet, unadorned, you begin to listen.

You can enhance your conversation with Nature further by some other strategies of unmasking. When you shed the clothes that you

wear in the proper conduct of your day, and now habit yourself for your artistic endeavors, choose your clothes not only for the utilitarian necessities of comfort and safety, but for the ritualistic purpose they serve of reminding and directing your thoughts and behaviors. Any clothing intended for ritualistic purposes becomes ritualistic in effect. Selecting them, dressing yourself in them, seeing them on you in the act of engaging in your project, viewing your work dressed as you are, disrobing at the conclusion of your work, storing them until the next occasion; all these intentional behaviors, enhance the effort just as they enhance the purposes of any artistic or religious performance whose purposes and behaviors are distinct from those of ordinary discourse. Garbing ourselves in any purposeful way places an external reminder in the world of our internal intentions, thus signaling both to others and to ourselves that we have particular business at hand.

Nature stands in the world exactly the way it appears. What you see *is* what there is. But if you carry over from human affairs your habitual way of perceiving communications as guile, then Nature too becomes guile, and the guile that *you* project cloaks Nature with a fabric of your own design. You begin to believe that honesty itself is a naive concept, that you will never be shown the truth, that the whole world is intentionally crouching out of sight, ready to spring with lethal consequences. How are you ever to extract yourself from this masquerade that seems to extend from horizon to horizon?

Draw closer to Nature.

Go into Nature raw and simple and just sit quietly doing nothing other than allowing Nature to become accustomed to your presence. Soon enough, often just beyond what you had taken to be the threshold of your patience and perception, Nature steps forward and begins to reveal its features to you. Rush it and you will never see it. Grab for it and it will give you nothing of its real self, only what you set out to grab. But wait a while longer, and the place begins to breathe audibly, to creep and flutter, beat, to speak in a thousand ways. You listen. That is today's conversation.

The Encounters described in part four are offered as excursions out of our ordinary ways of meeting Nature, the ordinary ways in which we engage with our fellow humans—guile, pretense, and concealing—and as invitations having the likelihood of drawing you closer to Nature, unimpeded by guile, pretense, and concealment.

Stop fooling around
Mean what you say
Do what you mean
From here on in, every mark matters
Just the way Nature does it
Just the way every serious artist does it

Look at a Vermeer, see any extra strokes? Listen to Mozart, hear any extra notes? Find any missing? Take a big bite of a peach and don't wipe your mouth right away. Watch someone sleep. Fall in the water with your clothes on, with no clothes on. Try picking up live crabs, see how much they are fooling around. Call someone you love and don't get off the phone until you have said all there is to say. Call now.

Now get back to drawing that tree, or what have you.

IN ART, TO WIN IS NOTHING

One of the most ferocious forces that weaken and distort artistic expression is the fear of making a mistake. No one enjoys making a mistake, and some mistakes lead to real jeopardy. But in the arts, more often the fear is one of seeming inept, unprepared, an amateur, a fool. This harm to our psyche is no less real and damaging than a bodily injury. As a consequence, uncertain of our actual level of competence, we stay far away from exercising the full range of our capability and potential. I propose a reframing of the notion of mistakes and what I believe is a more enabling appreciation of effort gone astray.

In the creative frontiers of the arts, the growing tip of ideas and performance, the map of the domain is always yet to be drawn; there is only the possible. Far back from this frontier, toward the center of things, effort that aims for compliance with the accepted canon and fails to achieve is taken to task. In these circumstances, one has indeed made a mistake. The error of one's ways is to be gently but clearly pointed out and corrections made; the canon is upheld, and the circle is drawn tight once again, with the prodigal one now safely within.

On the frontier, such comforts as the true, and the good, and forever, are harder to come by. Something else must steer effort. Here,

people are having firsthand encounters with the world as it is and bringing back the news as best they can, whatever it turns out to be. Here, people are at work peering over the ramparts of memory and knowledge, trying to discern the outlines of emerging possibilities.

In the frontiers of art there really are no mistakes; there is only being brave enough to see what's out there, what we allow to penetrate what's in here, and then telling the rest of us what happened, as clear and full as we can. Sometimes we are beaten back by the strangeness of what we are given to witness. Science, too, is full of examples of the brightest, most careful, and most daring and imaginative of researchers—Niels Bohr, Max Planck, Albert Einstein, Charles Darwin—who at first rejected the credibility of their own findings, so far did they depart from the accepted and probable. Sometimes the means to express what we are in the vicinity of are beyond our reach. Sometimes the news we bring risks the all-too-ready condemnation of our peers. Sometimes, less gloriously, our work consists of just fumbling around in the dark for something that has no name and face but ought to, even might be, out there. This probing and groping about, ever alert to detect a pattern that might emerge from the soup, often characterizes important phases of the artistic-creative process. The fortitude to stay in this phase for prolonged periods of time, to come up with endless ways to probe and to grope, to coalesce and to disassemble, to test its worth in one fashion and then in another, to push it toward the brink, to lose battle after battle until you "win" the war, these are the hallmarks of an artist of whatever discipline. Those who fear to make mistakes, to lose a contest, don't venture into deep water where the big stuff is. It will come as no surprise that the notion of winning in art is much the same thing as it is in Nature, and unlike winning in human endeavors such as sports and business and war.

In art to win is nothing.

In art, to say what is known and what is not known, clear and full, is all there is.

This is why art that is most successful is also heartbreaking, for what artists set themselves to accomplish is so difficult to achieve. It strikes us that the very heart of the meanings we seek, the things we want to come closest to, the impermanence of the things we love, the brevity of our chance to see and to get it right, are here laid out before us in the art form by one who sought these same things and came this

close to grasping them. It is there in the last self-portraits of Rembrandt and in Giacometti's portraits of his brother—in every work that leaves you with nothing left to say, nothing to do.

We know certain things are impossible to achieve, in part because someone has come so breathtakingly close to actually getting a good glimpse of what's there, and coming back with a clear account. Through their . . . their *something*, they carry us also so close to seeing by their saying that *we* experience ourselves as almost there, *we* almost get to see the meaning of how this whole thing fits together. And we understand when we permit ourselves full contact with the art at hand that this may be the closest we will get. So we are left with that which is given to us. Presented with a slight but telling portion of a grand pattern, we, like Job, have nothing to say other than

> *I am speechless: what can I answer?*
> *I put my hand on my mouth.*
> *I have said too much already;*
> *Now I will speak no more.*[16]

William James, most likely examining this same source in his *Varieties of Religious Experience,* says there is a state of mind that the spiritually motivated seeker sometimes is privileged to experience, "in which the will to assert ourselves and hold our own has been displaced by a willingness to close our mouth and be as nothing in the floods and waterspouts of God."[17] When the effort of artists achieves such an elevated level of comprehension and elegance of expression, what ordinary perception has taken as opposites, where winners indeed can be separated from those who have not won, there now appear only complementarities, each aspect manifesting a necessary but partial truth, the whole truth emerging only when both or all partials are assembled.

In both art and Nature, winning is nothing because Nature presents us with an advancing tide of things, not one of which is "better" than the next, no best bet for ultimate success, no perfection apart from any other perfection. Front runners, early starters, strong finishers, all posit a start, a direction, and a finish. In the affairs of men, this is the common course, the one that discriminates winners from losers. In Nature, dead ends, sports of nature rising up, then falling back into

the great stew of possibilities, branching, deltas, piles, layers, folds, floods, upwellings, accretions, epidemics, pandemics, all things have their moments, no gain or height is permanent.

Nature employs another razor to determine viability: "if it lives." Or even something less severe and much more common: "as long as it persists." Here in the kitchen of Nature and also of art, cooking is the thing—trying, tasting, fiddling around, trying once again. Trying, tasting, fiddling around, because art is constant inquiry. As such it has no final end in sight that, once achieved, ends the inquiry. To employ a telling phrase of James Carse's: art is an infinite game inviting continuing engagement. He tells us that a finite game is played for the purpose of winning, whereas an infinite game is for the purpose of continuing the play.[18]

In this game we call art, the purpose of effort is to extend the features of the map of consciousness. In this infinite game every probe attended to brings back news for consideration. All the news is vital because it *may* fill in features of the world as it is. All news must be attended to in order to discern noise from pattern, novelty from redundancy. A probe not made for fear of bringing back bad news misconstrues the purpose of news. News is the only means we have to draw up the ever-expanding map of what is. Bad news is as much a feature of the world as any other news. A probe weakly made brings us distorted news, corrupting information, insinuating structures into the map of the world that are not in the world but only on the map, making for a dangerous journey for those who consult it. A probe that brings back news that ought to alert and alarm but is ignored, poisons assuredly. In the infinite games of art and Nature, nothing is incidental, and there are no meaningless mistakes. Erasing efforts gone astray rather than leaving and reading them deprives us of vital information, information that is being provided us, often incomplete and sometimes slanted. All artistic undertaking that is motivated by inquiry rather than by manufacture is awash with probes and gropings. All the returns are scrutinized for news, the news then assembled into a story that references antecedents and projects consequences. In a great story, a pattern emerges that articulates all the particular features into an overarching insight into how all stories satisfy and how the whole thing works.

———

∾ *I HAD JUST COMPLETED*

I had just completed writing
 an essay that concluded
"See for your Self. See, for us all"
 and, feeling pleased
folded the tablet, closed the pen
 put them in a nice gray plastic binder
and began to put it down, next to me
 on the grass.

A tall wildflower
 a pale-violet-type daisy
was in the way
 of my binder on its way from my lap to the earth.
Hesitating between knocking over the daisy
 and spilling the contents of my binder
I knocked over the daisy
 and spilled the contents of my binder
Jesus

The gray binder lay on its side on the grass
 The bent daisy and some of its companions
cast their blue silhouettes across the binder's gray rectangle

Perfection

———

SYNCHRONICITY?

I have been speaking of entering into a conversational relationship with Nature, not a metaphoric conversation but an actual one, in which both parties, the artist and Nature, become aware of each other's presence and emit signals that the other has been taken into consideration. The conversation I speak of is one that takes place wholly within the confines of the natural world, the things that adhere to the general laws of

natural bodies as accounted for by physics, chemistry, and biology. I find this domain sufficiently large and interesting to carry on a conversation that is at least edifying and often transformative.

The efforts necessary to become a worthy conversational partner with Great Nature strengthen and refine the quality of that conversation. The consequences of this self-improving practice appear in the increasing strength and refinement of one's artwork—artwork understood as the metaphoric sign of one's corresponding life work. It has been my experience that when I make a sincere effort to speak with Nature, and actually address my words or movements or artistic endeavors to a particular aspect of Nature, *that* tree, or cloud, *this* stone, Nature more often than not seems, at least to me, to signal that my efforts have had an effect, *and that I am being shown something in the form of some sign that has correspondence with my efforts.*

One might say that the above statement is no more astonishing than to state that when I feed the dog she wags her tail, or when I throw a rock into the pond, perfectly made concentric ripples are produced, or even that every step I take, like Kali Herself, causes death to thousands and signals to still untold millions more that their time has not yet come. The following may illustrate the kind of interpenetrating awareness that I do have in mind.

Some time ago I was a member of a trio of teachers facilitating a weeklong workshop in Oaxaca, Mexico, entitled "Sacred Art in Sacred Places." Our group of about fifteen adults had spent a portion of the day on Monte Alban, an ancient temple mount built over many generations by a number of successive civilizations, the Zapotecs, the Mixtecs, and most recently and lastly the Aztecs. Since the conquest of the indigenous population by the Spanish over five hundred years ago, the highly ornamented grand temples and plazas that once ornamented this platform halfway between heaven and earth have fallen into near ruin; only their astonishing geometry and grandness of ambition silently pointed to the glory that was.

Having explored the magnificent site overlooking the contemporary city of Oaxaca, and having created artworks arising from our experiences there, a group of about eight others and myself withdrew from the scorching sun to the shade of one of the few trees on the site for a drink of water and some reflections on the day. Before we

descended, we engaged in a rambling conversation about art and our own "sacred" conversations with the natural world. Some of us had tales to tell of our communing with Nature when the last to speak told the following story. She said that she had always been fond of Nature but had had no special encounters with Nature other than the common joy of being in the midst of this handsome world. The world had suddenly changed a few years earlier when her only child, a teenager, died in an automobile accident. Over time, she would have to find ways to renew her faith and reestablish the very purposes and meaning of her life.

"On the day of the funeral," she told us, "something told me to go to my studio to prepare myself for the hard day ahead. While rummaging around I found an old broken butterfly and somehow felt I needed to use it to make a piece of commemorative art for my son. I made the piece by patching up the broken butterfly and later, in the funeral home, placed it on my son's body. I had the distinct impression when I did so that the appearance of a butterfly would be the sign of my son's presence in my life from here on in.

"In Catholic practice," she continued, "when one goes into a church, it is customary to light a candle in memory of a departed loved one or to accompany your prayers. It is a practice I often perform. While in Oaxaca, just the other day, I went to a small church to pray but found that all the tapers were already lit. A voice made its presence known and directed me to the rear of the church and to look up and toward the left. I went to the darkened rear of the church and on the left side was a mantle with an embroidered image of a butterfly; on it lay an unlit taper."

When she had gotten to this point in her story our small group of intent listeners all saw something at the same moment. We said, "Sally, look up." Above her head fluttered a black-winged butterfly. None of us had noticed a single butterfly all day long on top of this arid mount. None of us had seen this one appear, but there it was now. The butterfly flew three or four times around Sally a few feet above her head. She looked up, smiling and nonplussed, and said, "Yes, he is here again." Once more around her head, then the butterfly momentarily touched down on her upraised hand (she called it "kissed"), and, not bothering to visit anyone else, flew straight up, disappearing from whence it came.

Synchronicity? Coincidence? Self-fulfilling prophecy? Wishful thinking? Or communication across species, even communication across realms? Let us for the while put aside all the evidence and anecdotal stories that partisans for each of these responses have in abundance. Let us, by default, allow for the most banal, shallow, and least interconnected, interpenetrated of claims on human intelligence and the intelligence of all "others." Let us claim only that when we are in the state of mind that holds serious interest in the fate of the rest of the world, in this heightened state of sensitivity, phenomena of Nature too subtle for ordinary levels of awareness become perceptible to us and enter our lived world. And they do not enter the world of persons not thus concerned and whose attention is focused elsewhere.

The artists I have in mind, their minds full of these ideas, their work taken up by attempts to say fully and clearly all they know and feel about the fate of the earth, their personal history replete with encounters with Nature, surrounded with companions having similar experiences and creative endeavors—these artist live out their lives differently from others. One person believes Nature stupid and mute, and all their friends agree; and for that person Nature *is* dumb and mute. The other thinks Nature aware and speaking, and for that person, Nature speaks, and wisely so.

Did Sally's call bring the butterfly? Sally thinks so and lives her life accordingly. She speaks with Nature and Nature speaks to her. Her art deepens that conversation.

Sally is not alone. Saint Francis spoke with doves and donkeys; I know a woman whose best friend is a tree, my seven-year-old daughter did it all the time with her pet cat, every kid does it with worms and toads and goldfish. Not to mention those who speak with plants, or some, so they say, with the sun and the moon and the stars. The folks at Findhorn have been thinking this way for some time and as a consequence, so they say, have grown some very nice fruit and vegetables.

If this is your wish, to be a good conversational partner with Nature in your life and in your art, start out by becoming a good listener. A good listener is one who is open and sensitive to every nuance in the changing complexion of the object of attention. A good listener attends to the other without predetermining what will be said and how it will be said. A good listener is ready to be surprised by unforeseeable

news coming from any direction. A good listener is an active listener, constantly emitting signs that the efforts of the other are registering on all levels. A good listener listens at the same pace and distance that the other is speaking. A good listener desires nothing more from the speaker than to have the speaker say what they are ready to say.

As you devote your mind and body and spirit to the deepening of your acquaintance with Nature, the more finely made structures of Nature become discernible. The more you look, the more you see. The more you listen, the more you hear. The more you try, the more dexterous you become. The more you think, the more there is to think about. The more you undertake, the more ambitious your artistic appetite becomes. The more history you have with Nature, the more poignant Nature becomes for you. The more you employ the vocabularies of color, form, texture, and line, the more vocabularies you have with which to convey what you know and feel.

I began by raising the question of the reality of speaking with Nature. Are our efforts to do so met with Nature's response, or is what we take as Nature's response a matter of coincidence, synchronicity, or wishful thinking? Suppose it is all of the above. The very question one asks, the instrumentation one devises and employs, the mind-set that reviews the data, impinges upon the broad possibilities of Nature and shapes in some degree not only what is observed, but what may be, for as much as we can know, what is actually out there.

As I am writing these words early on a spring morning in my greenhouse, a male cowbird, who is desperately in love with his sweetheart, is perched on a vine just adjacent to my window. Deeply troubled by the apparent presence of an intruder just his size and with the same exact ambitions, he constantly puffs his neck feathers out, opens his wings, chirps ominously, and flies at his rival just inside the window, delivering what should be a convincing blow. Again and again he keeps his virtual enemy at bay with his heroic efforts, and time and again his enemy appears equally undaunted by his attacks. Our hero has to settle for a perpetual standoff, until later in the summer, when, certain appetites satisfied, his attention will wander toward different pressing matters. Just a coincidence between my writing this portion of my book with the appearance of a jealous cowbird? Perhaps. But then, what about Sally?

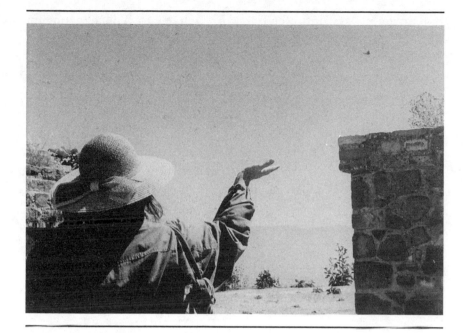

HOPE FOR EVERYTHING, EXPECT NOTHING

In *The Courage to Be*, Paul Tillich makes the case for the necessity of a determined will to believe, to believe that there is a moral purposefulness underlying the seeming amoral and random events of life. And that the originating purposefulness is a nonpalpable God who can be present in a life that elects on faith to believe in such a source. The courage to be humane in a world that seems to be self-serving, and to take courage in those convictions, requires a leap of faith, embracing the belief that goodness is in the world and that *the* source of goodness is God, and providing its adherents with tremendous resources of directionality and resilience.

There is a constant element in the artistic process that I find importantly similar to the world that Tillich finds in the world without God. That element is the initial phase when you can go anywhere, do anything with the work, and nothing is overwhelmingly clear about which direction to go. This aesthetic ambiguity of the unbegun and

potentially always unfinished artwork, I liken to Tillich's constant moral ambiguity of the world that remains uninhabited by God until there is a faith-based acceptance of God's presence.

The aesthetic freedom to choose is as broad and infinitely inviting as the moral freedom to choose anything to believe in. But artists do not have the benefit of Pascal's bet. If, according to Pascal, you bet there is no God and live licentiously in this world for perhaps sixty years or more, and it turns out there is a God, then you have had your sixty years of fun but you get to roast in hell for a lot longer. If you decide that there is a God and live a righteous life for sixty years, and

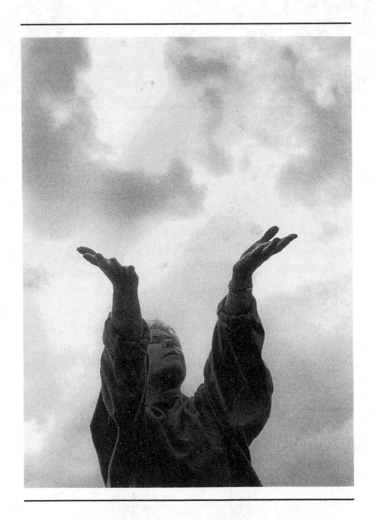

it turns out there is a God, then when you die in this world, well, you win the heavenly jackpot from now to kingdom come. Since there either is God or there is not God, the chances are fifty-fifty. Those are the up-front odds. But if you bet against God and you are wrong, the consequences are sixty against infinity. Why not cover your bet? suggests Pascal. Bet on God.

When it comes to the dilemma of making aesthetic decisions, all such odds and all such consequences disappear and offer no guidance. One is left with the original dilemma, plain and simple: what to do when faced with an infinite menu that constantly renews its choices, given the last selection just made. Here is where the element of hope comes into play in the artistic process. Hope is akin to faith, but without a ready theology. The hope of an artist is to remain in a state of hopefulness while effort is sustained, to act purposefully without aid of assured signs that our acts have the prospect of eventual success, much like the infinite game that James Carse describes. For the artist interested in drawing closer to Nature, hope is betting on Nature to provide enough space, time, and substance to allow for infinite choice. For this type of artist, hope arises and is made possible by Nature's ultimate "goodness," Nature's infinite provision of choice.

THE STRUCTURE OF AN ENCOUNTER

The Purpose of an Encounter

In MY ROLE AS A TEACHER, the enterprise of Drawing Closer to Nature is initiated by an Encounter with Nature in which one's old world and old self give way before a fuller and clearer witnessing of one's Self and Nature. Part three describes the structures and phases of such an Encounter.

The purpose of an Encounter is to enable the transformation of our Self that has learned to distance itself from Nature to our Self that is in the process of drawing closer and deeper into Nature, the Self we wish to become. We who are serious practitioners of the Encounter desire a particular and significant change in our lives: to draw deeper and closer to our infinite family of all Nature, and to unite that enlarged identity with a deeper and closer appreciation of our own nature, cultivated by and expressed through our art. This ambition may appear less inflated if we substitute the word *ritual* for *encounter.* A ritual is a sequence of carefully designed events that conveys a willing party from their existing state of being to a more desirable one. So is an Encounter. In my book *No More Secondhand Art,* I wrote: "If we step back from the particular story line of such rituals of transformation as confirmation, marriage, or election to high office, and examine their underlying structure, we will notice certain patterns throughout. By 'structure of ritual' I mean the distinctive events that a novice undergoes in order to attain the status, privileges, and obligations associated with that ritual."[1]

Like the formal structures of myth and ritual, the structures of an Encounter correspond to the general trajectory of any transformational experience. The dynamic form of an Encounter may be characterized as a series of events, each one gathering power, focusing attention, and building momentum that eventuates in an arch of a tensegrity[2] conveying participants from a lesser state of being to a higher one. A program of Encounters displays the same organic dynamics. As in Nature's great engine, evolution, there is a succession of determined and undetermined events, of intentional compression and fortuitous expansion, of simple and local beginnings toward complex and universal expressions, of gain and loss and gain.

In what follows, the scope and sequence of elements in any purposeful transformative experience are described; in our case that will be art experiences intended to draw us closer to Nature. Each element is essential; each serves as the foundation for the solidity of the next; the entire edifice exhibits tensegrity beyond the bearing capacity of any one element. I have used the term *Encounter* to convey the open-ended adventure quality of such transformative experiences.

Participants

———

A READY STUDENT

A desire for change, if not the full readiness for it, is the prerequisite for change. So it is with all change that is not compelled and enforced by outside agents. Likewise an Encounter must begin with the participant's willingness to in fact draw closer to Nature. By willingness I mean something more than a passive interest in the desirability of creating a new relationship with Nature. What is wanted is the readiness to undergo the rigors of reassessing key old beliefs and ways of being in the world, and the determination to experiment with new ones, releasing indefensible ones, enlarging cosmologies, deepening inner identities, and emerging finally with elevated views of Nature and Self, with their corresponding behaviors.

None of us endure the rigors of such profound transformations without the abiding conviction that the life we are presently living holds less promise of reward than a life we can imagine for ourselves and toward which we are now willing to embark. The first phase of an Encounter begins with you, dear reader, with your determination to succeed to a higher form of living, characterized by a deeper, more intimate relationship with Nature, a more informed and appreciated sense of your inner nature, and a life that is more exuberant in its expression of this expanded Self-in-the-world. Your determination to draw closer to Nature already begins to draw you in that direction.

A TRUSTWORTHY TEACHER

A parent, a teacher, dear friend, a trustworthy guide, a caring sibling—all make our journey through this uncertain life less fearsome, more confident in the possibility of the success of our efforts. Each of our lives bears ample evidence of the critical importance of mentors, those who have been where we have been, where we are now, know the territory toward which we are heading, and willingly devote a portion of their resources, on occasion their very lives, on behalf of the success of our own journey. A mentor is an essential element in the structure of

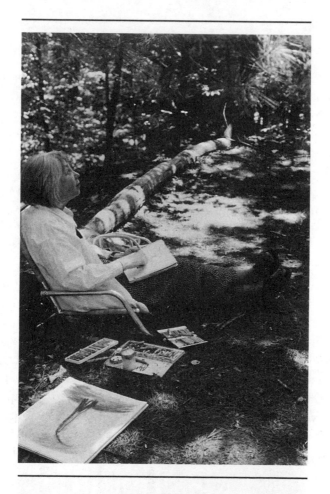

an Encounter. For our purposes and for consistency of usage, I will employ the term *teacher* to stand for the many educative relationships one might enjoy from mentors, guides, mates, and other companions. Whether they are formally trained and titled, or in a role of similar responsibilities but called by another name, we will entitle all such helpmates "teachers." Whoever it is that will in fact be *your* teacher, it will be someone *you* deem as trustworthy, someone whose prime concern during the encounter is, *without a doubt of yours*, your well-being, one who has the wherewithal to provide what is necessary when necessary.

In shifting from what you know toward what you would like to become, you necessarily traverse a passage of unfamiliar territory; thus you are vulnerable. You don't know the way, you don't know what may be coming next, you won't know what will be asked of you, what it will be like when you get there, or even whether you have arrived. All these uncertainties absorb a significant degree of your available energies, draining you of inner resources that might better be put to use engaging in the actual rather than the hypothetical (and often exaggerated) matters at hand. Hence the importance of a teacher who will lend the full array of their resources to the assurance that your journey from knowing through unknowing toward elevated knowing will successfully arrive at its desired destination.

Who has such credentials? Really anyone *you* deem trustworthy. If that trust is sufficiently vouchsafed for you by paper credentials, well and good. If you require personal attestations, seek them. If you require personal experiences for that teacher to demonstrate sufficient trustworthiness, seek those. The confidence you are able to place in the strength of this I-Thou form of relationship will significantly contribute to the success of your journey. In part six, "Notes to a Teacher," I describe more thoroughly the particular characteristics that I believe an able facilitator of Drawing Closer to Nature ought to possess. Reading that section in conjunction with this will provide you with additional criteria for selecting a trustworthy guide.

WORTHY COMPANIONS

Much of the literature dealing with the visual arts speaks of the individual artist and his or her singular enterprise. Most visual art is created

by individuals working in private spaces. The artist's studio *is* a place to retreat from the world of others, the world of compromise and nego-tiation, and to pursue one's special muse. Although we can draw closer to Nature by ourselves, there are aspects of Drawing Closer to Nature that are substantially enabled in the company of others who are simi-larly motivated. Martin Buber's observation that all life is lived in dia-logue is particularly relevant for my recommendation to secure the company of others for some aspects of your efforts to draw closer to Nature. There are two reasons for doing so; one is ideational, the other has to do with the artistic process. I will represent the ideational case first.

Mind is what is created when the brain has experiences with the world. What we think, and even how we think, are consequences of what there is to think about, and the pattern of reality making (think-ing) that we have been exposed to. Soon enough, how we think and what we think are taken to be reality itself. We say, "That's life," when all it is, is *my* life. The teensy sliver of the world, observed through the narrow perceptual portals of our senses, striding across a fragment of the universe, equipped with an idiosyncratic way of fabricating things—*this* reality we take to be *the* reality. Thus enclosed, and further insulated and reinforced by like-minded others, we construct each new day on the matrix of yesterday. It is comforting, efficient, sane. A problem arises, however, when we set before ourselves a project to change the way we think about the world and how we intend to be-have within a new "it." How to hoist ourselves by our own bootstraps, out of our own boots. In fact, those of us whose life's project is to re-main curious about what is out there continuously employ internal acts of will, imagination, dreams, and intuitions as prime sources of creating disturbances in the field. We are further enabled by the com-pany of others who possess similar inclinations for change and who come equipped with distinctive gifts and talents.

A group of people interested in the same discipline of knowledge is called in the academic world a community of discourse, and for good reason. The effort to draw closer to Nature requires such sus-tained effort, often in a direction different from the ordinary flow of thinking and talking and doing, that the company of like-minded others provides us with insights and affirmations that are otherwise difficult to come by. It is hard to sustain the credibility of a novel idea

when there is no commerce for that idea. It is hard to ascertain the correctness, even the very contours, of an idea without some echolocation from an outside source. It is hard to be alone with an idea that is precious, one's tendency being to share it. It is hard to be alone especially with ideas and inclinations that are themselves social: that is, interested in and desiring exchange with the world. To draw closer to Nature is to break out of our isolation from Nature, out of silence and toward the joining of one's own Self to a larger sense of Self-as-belonging. The desire to become a member in good standing with the world, without being in the company of those members of the world with whom you just happen to share the most affinities and particularities, undermines the premise and weakens the force necessary to pursue the project to completion.

Individuals who arrive at a gathering, a course, a workshop, or a lecture bring with them their own set of convictions and history of experiences with the subject. What happens when there is a gathering of such like-minded people is the same thing that happens when any critical mass of like elements are brought together in an enclosed space for a significant period of time: the individual members align themselves into a harmonic that reinforces the predominating tendencies that in ordinary circumstances may be too diluted, too unfocused, to create the desired transformation of the original ingredients. Drawing closer to Nature is not yet the predominant tendency of our society. The employment of the artistic processes is not the predominating process of our society. Being a part of an intentional community, based on shared and valued principles, enables the formation, here and now, of the world as you would prefer it. Hesitant people begin to speak up when they know that the issue about which they speak is of genuine interest to the listener. Uncertain people move forward into unknown territory when they know they are surrounded by others on a similar path. Innovative people have the opportunity to say what they know without feeling isolated, even crazy, in their discoveries when in the midst of other researchers also involved in the creation of original ideas. Those confined in the sharing of their joys because not everyone shares their joys have their moment to proclaim and celebrate. These are the rewards of dialogue, of being a member of a community of discourse.

Several qualities of the artistic processes are particularly enhanced

when conducted within a community of discourse, various examples of which are illustrated in part four, "Encounters with Nature." Here I wish to focus on only one such quality, the one in which individual effort in the creation of the artwork has run its course and the work is now brought to the attention of one's companions. This is a particularly vulnerable moment in the creative process, as it is in the birthing of any new thing. Something new has been added to the universe, and it has not yet found its place in the map the mind makes of the great web of life.

Incomprehension, incredulity, uncertainty, disappointment, chagrin, curiosity, fatigue, triumph, greet every genuinely new thing, not only for its audience, but also for the artist. It is impossible to redraw the map of one's world, modifying it proportionally, without referencing some other known points that have been arrived at independently. I remember once having a breakthrough in my work and creating a most compelling but strange image. Scrutinizing it for meaning and worth, I couldn't find its handle. Some major shift had occurred, but I couldn't tell in what direction. I called a painter friend and said, "I just made a wonderful thing, but I can't tell if it's the best thing I've ever done or the worst." He said, "I'll be right over." The whole enterprise of Drawing Closer to Nature means going into new ideational and artistic territory. At our artistic best, we are always new to the place where we have just arrived. It is important to have other sojourners in the vicinity to help in the confirmation that indeed we have arrived (or not), and from this more secure data, redraw the map of our world, ideally a little closer to Nature than the previous one.

There is another function of community in the creative process, especially as conducted in the manner I describe. Each of us, given the particular life that we have had, is predisposed to observe the world through a particular lens, thus seeing a particular aspect of the world unobservable to others. Each one of us therefore knows something about the world that no one else knows. When we come back from our solitary expedition seeking to find, for instance, "My Self As Landscape" (see the Encounter on page 229), and see the many aspects of Nature that are revealed through the several lives represented in the group, or study the many characteristics of the cardinal points— north, east, south, and west—that could only be evoked by the particular life-lens of each member of the group, or the infinite personalities

of the prime elements—fire, water, earth, and sky—seen through the experiential filter of each other person's life, we necessarily expand our comprehension of Self and of World, thanks to the contributions of our companions. Beyond good and bad, beyond right and wrong, naive and sophisticated, each view of the world is a view inaccessible to anyone one else but that particular observer. Since our quest is to draw closer to the world—to Nature—the distinctive news of the world that someone else possesses is vital for us to draw up a more complete map of Nature so that we might steer a truer course.

We not only draw up a more inclusive and detailed map of the world through the enabling perspective of someone else, but we are also made to notice that maps of the world are themselves constructed in a dialogic manner. That is, what appears on your map appears because you happen to be interested in that particular aspect of the world, and also because of what you are prepared to see. The full, the actual map of the world could be nothing less than the world itself. The maps we have, and will ever have, must be a subset of the whole, and the map we particularly are in possession of is an artifact of the place where and the moment when our lives intersect a particular portion/moment of the world. This is a humbling conception both of the world and of the Self— or should be—and is the hallmark of the artist's appreciation of how Nature works and the nature of their own work. No matter their power and compass and facility, for an artist the world remains a constant unfolding mystery, an infinite source of the possible. Hence the constant renewal of interest in inquiry rather than illustration, the constant animation of the conversation.

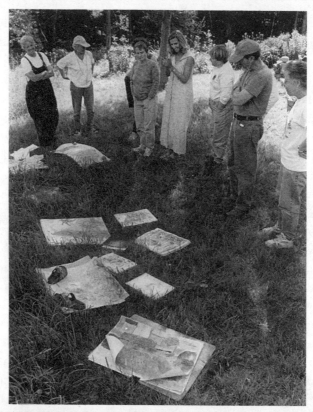

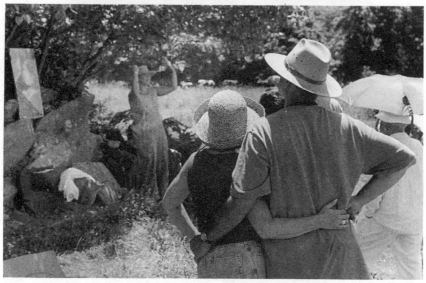

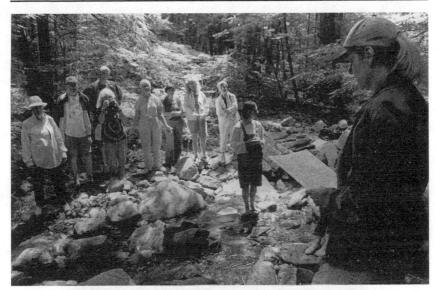

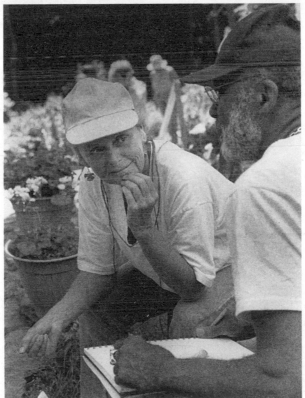

Structure

———

BEFORE LAUNCHING INTO THE TEACHING of anything, espe-
cially those things that intend a shift in our sense of self in the world,
it is important to remember Gregory Bateson's observation that learn-
ing is hard and supposed to be hard, because it may be so consequen-
tial. In this way all real news is met with some degree of anxiety. Too
much anxiety and we take flight; too little disturbance in the field and
we remain asleep. A later section in this part, entitled "Disorientation"
describes a disturbance in the field sufficient to awaken curiosity, but
not enough to arouse anxieties leading one to quit the premises. Here
we discuss preliminary conditions of time, place, and materials that
undergird the student's resolve to work through the successive phases
of the Encounter and program of Encounters to their successful
achievement.

THE SETTING

What the student seeks in coming to the place of instruction ought to
be suggested in realized form in the place of instruction itself. Al-
though there are many circumstances that limit the full deployment of
this principle, serious effort ought to be devoted to creating an am-
biance consistent with the core intentions of the entire enterprise.
And so, upon entering the arena of engagement, participants ought to

feel that their arrival has been anticipated and is welcome. The space, the allowance and pace of time, the furnishings, equipment, supplies, signage, everything that is within the reasonable purvey of the teacher has been thoughtfully prepared and is now in place and readiness, waiting only the arrival of the students who will now animate the enterprise. The care and the anticipation of the teacher are announced by the quality of concern that the teacher has devoted to the preparation for their eventual meeting.

THE COVENANT

"Only connect" might be a ringing motto for this entire book, what we are after, and how it may be achieved between humans and Nature. It is precisely this axis of connection we are interested in establishing at the outset; not simply a strong connection between the teacher and the student, but a very particular form of connection, one that unequivocally locates the points at which each party is bound to each other and to the work at hand. I recommend the following covenant, which, although all of one whole, is described in terms of three elements:

- The student's general well-being of mind, body, and spirit will take precedence over the particular lesson at hand.
- The teacher's effort will be to reach the students as they are and help them become who they desire to become.
- The students' efforts will be to fathom the full dimensions of who they are as they have become, and to become the persons they desire to be.

I have found that when these elemental understandings and appreciations are made explicit at the outset, an observable emotional calm settles over each person and the community as a whole. The normal trepidations elicited by finding oneself in a novel setting, facing unknown trials, together with performance anxieties about being judged by peers and teacher, become markedly reduced when all parties appreciate the nature of the covenant that will bind all to all. The immediate consequence in terms of the student's fullness of commitment to the enterprise is directly proportional. When this much has

STRUCTURE · 175

not been vouchsafed, effort is proportionally weakened. Much weak, equivocal, awkward, shallow art may only be expressions of self-uncertainty and not the limitations of talents and gifts the person actually possesses.

OF SPACE AND TIME

I am forever taken by the strength of the thesis of Virginia Woolf's book *A Room of One's Own*. It may be described like this: Unless one has the determination to secure a place and a time in the world solely for and about one's Self, the likelihood of drawing closer to and giving creative expression to one's inner nature or the great outer Nature is highly unlikely. We simply cannot assume that the world is a ready partner to our desire to enter into relationship with Nature if we do not have the stuff to demark and defend a time and a place to stand on our own. To be by and for our Self is the prerequisite for any subsequent thinking and declaring about and for our Self. Or for and about Nature, or the relation between them. Having said that, there are some obvious qualities of space that ought to be taken into consideration in their election as critical components of an Encounter. Every living creature envelops itself within successive spheres of proprietary space, each layer of which provides different degrees and kinds of well-being. So basic and universal is this sensitivity to incursions within these envelopes of space, that such sensitivity and reactability is one of the very signs of life itself. The anthropologist Edward T. Hall in *The Hidden Dimension* provides a close examination of what he called "proximics"—the use of personal space—in all life, particularly human life. Each one of us, at different points in our life and for different occasions, constructs different sizes and shapes of zones of well-being. That is, we each possess, idiosyncratically and culturally induced, a space within which we feel optimally welcome and safe. Outside that zone, either farther away or closer to another party, we feel progressively less sure of ourselves and more uncomfortable. Hall makes the point that humans are predisposed to interpret physical events as psychological realities, which in turn we manifest into physiological reactions. Joining Hall's findings about physical space as a sphere of personal well-being with Woolf's observation that to have

something distinctive to say about one's life, one must first have the gumption to declare a distinctive place to literally stand in, we may say that an Encounter requires a special place, time, and materials: special not because they need be extravagant in cost or scale, but only because they were *chosen*. An Encounter can take place anywhere, at any time, using any materials. What imbues these essential elements with the power of being agents of transformation is that their choice has been informed and willful.

How much space is necessary for your studio, a place of your own? As much as *you* deem necessary. Your self-searching response to this vital question is the only one that will suffice for you to *be* self-searching. Too extravagant a claim for space will only provide you with a reason for not working at all, or diverting your resources to the obtaining of something that is superfluous—the enemy of all art and elevated living—that is, living that is deeper, broader, more considered, more inclusive, more generous. Too timid a request, and you have already compromised yourself before you even uttered a word, launched an idea.

Space is as much a state of mind as it is a physical geography. Your very act of designating a desirous space within which to go about your business is a significant disruption of the life you are already leading. Even if you are living alone, things will decidedly shift. If you are living with others, your new claims on space will ripple throughout your family with immediate, profound, and long-term consequences. Your claims on space and how you go about negotiating for it will inflect your work no less than the very fabric of your social relations. After all, you are rearranging the world, and everyone will move over accordingly, those closest to you the most.

With the understanding that space is both a physical and a psychological event, the following questions might help you to arrive at a room of your own.

Do you need all the space all the time?

Are there some portions of Drawing Closer to Nature that do not have to be completely owned and controlled by you to get on with the task? A beach, an evening walk, looking up at the sky?

What equipment do you have to leave out and undisturbed that would provide you with a sense of continuity for your work and a measure of respect for the sanctity of your working process?

What materials and tools can be gathered and stored away at the end of the day or the working time?

What size and proportion of space do you require, to accommodate not only the person you are at present but the person you wish to become? Low ceilings may not provide room for lofty thinking. Narrow rooms may inhibit expansive ambitions.

Do you require complete privacy to engage in drawing closer to Nature all the time, some of the time? Will semiprivacy do? What about visual privacy and auditory privacy?

Finally, can you proceed to acquire this room of your own the way Nature mostly proceeds: gradually? Of course, Nature sometimes explodes, quakes, snaps, and bursts, but even then it does so after a long period of gestation that was resisted. As in the seasons of the year and of our own lives, Nature evolves over time to the next stage of its mysterious "progress." In claiming your space, you might start out modestly, signaling to others and yourself that you understand that you are requiring something profound not only of yourself but of the adjacent world: to move over just a bit so as to make room for a nascent Self. Give yourself and others some time to see just what room in the world is required for this birth to come to full term.

This brings us to the other dimension of our reality, and the nature of our being: time. Time and space create the cross hairs of the character of every entity in the universe. Time is sufficient when the entire process runs its course without fear of running out of time and thereby aborting the full term of its genesis, and with an additional buffer of time for inadvertencies. Aphrodite may have arrived at this world's shores fully formed, riding the winds of her father's breath, but for most of us our birthing takes the more prosaic form of nine months in which strange and marvelous things happen. Likewise, the creative process is composed of a complex of many procedures, some of which take up considerable portions of linked time and devoted space, some of which do not. Fabricating an ambitious and intricate object requires significant passages of time within devoted space. Pausing before taking a bite of bread and noticing its color, texture, and aroma, appreciating the distant hands and minds that made it, or looking at the night sky for a moment before you slip into bed, seeing its cool light on the roof next door, the hair on your wrist—these and other such efforts require no designated space and an unimposing

portion of time. But they too are significant elements in your being the artist you wish to become. Walking briskly along the banks of a pond, or dawdling along that very same trail, each reveals different aspects of Nature, each releases different aspects of your nature, each requires a different portion of time.

Any activity done mindfully, exercised with devotion, to the brim of your capacities, is already an artistic enterprise. Conversely, any activity done in a careless, halfhearted manner, no matter how exorbitant the space in which it is conducted and no matter the duration of time, fails to satisfy the basic requirements of an artistic project. I think of Aleksandr Solzhenitsyn's circumstances when he wrote *The Gulag Archipelago*. Not being provided with a nice little cubby in which to write the account of his endless deprivations, humiliations, and sadistic torture by his tormentors, and to document the slow and brutal deaths of his comrades, Solzhenitsyn nonetheless found the time and the place and the materials to write his five-hundred-page memoir. His materials were scraps of cigarette papers and carefully guarded pencil stubs. His writing cubby was the latrine. The time he gave to his writing project was the time of a bowel movement. When he finished writing the day's account, he read it and reread it so that he could remember it for a later time, when he just might be able to write the entire story, should he ever be released from that hell. Then he ate the cigarette paper so as to leave no incriminating evidence.

Matters of Perspective

———

ORIENTATION

We now turn our attention to the organization of the components of an Encounter that make it function. Every system "works" only insofar as its component elements are precisely aligned, whether it is an ecological bio-region of a protein, a pinky, a painting, a community, or a planet. So it is with the organization of an Encounter. The first phase of an Encounter to take place is what I term "orientation," which establishes a firm base from which to journey into the unfamiliar. If a student is going to risk giving up the known, now undesired but still *known,* for the promise of the new, desired but still imaginary, a scaffold of trust between teacher and student must be constructed, upon which the subsequent educational arch will be built. The initial phase of an Encounter recognizes this need and provides it by designing experiences that align students with teacher, objectives with methods.

There are three main points of orientation that should be in place before the more exploratory phases of the Encounter are undertaken. One is an orientation that aligns students with the resources *they* bring to the journey: who they are and why have they come. Another axis of orientation introduces students to the overarching framework of the course or program. The final axis aligns them with the particular and universal forces of Nature.

The alliance between teacher and student is primary and is the first orientation to be established. (That is the subject of part six, "Notes to a Teacher.") The teacher's first enthusiasm for the well-being of their students, above even their enthusiasm for their subject matter, allows the students to know that they have been seen for who they are, accepted as they are, and welcomed as determining agents of what and how things shall proceed. This first call establishes one portion of the scaffold of trust. Students are invited to reflect upon and then respond to an open-ended question such as "What brings you here?" or "What have you come for?" or "To what family do you belong?" or even "How may I be of service?"; they are thus offered an opportunity to speak from their "Thou" to the teacher's "I" and so contribute to the content and form of their journey of Drawing Closer to Nature. So begun, the Encounter has the carrying capacity to maintain this high level of investigation and discourse. As all participants respond to the same question, other strands of this superstructure are assembled, creating an emerging web of common knowledge and empathic regard.

The next structure to put in place orients the student to the conceptual framework of the program and, later on, to the particular features of the Encounter to be addressed. It is important to orient the student to the cosmology within which the conceptual map of the program/Encounter is taking place. Although we share many affinities for the subject matter at hand, my experience has been that no one is located in the same place as I am, and that unless I disclose the particular features that are paramount to me, my requests that students loose the grip with which they hold their present reality and sally forth into a potentially higher, broader, and deeper one must be met with legitimate hesitation, if not trepidation. And so I take pains to describe the worldview in which I am embedded and from which my invitations to join in are reasonable, hopefully inviting. We discuss our several points of view on this, not with the intention of arriving at consensus but to hear and appreciate the extent and limits of our community of discourse. The preamble to each of the Encounters exemplifies this proposition.

The overarching worldview now described, the next point of orientation establishes a clear linkage between the student's learning style and the teaching strategies employed. The structures of Encounters

are significantly different from those of lessons, and a holistic educa-
tion of mind, body, and spirit is dramatically different from that of
most schooling. It is important, therefore, for the students to know, be-
fore they are invited to engage in undertakings with which they may
have no prior experience, what they may be and why they are offered.
For example, I begin each day with centering and balancing, breath-
ing, and aligning exercises in keeping with my views on the necessity
of aligning mind with body with spirit before launching into any par-
ticular learning. I also employ guided imagery, working without sight,
working in tandem, dancing, and singing, none of which is common
fare in conventional teaching practices. The very novelty of these
things being off-putting for some, I take care to offer a straightforward
description of the endeavor with an explanation of its reasonableness.
This offers the students a degree of foreknowledge, which is their due,
and allows them the important right of electing to engage in the pro-
cess or to devise some other way they deem more fitting to pursue the
same objectives.

Establishing operational links between the students' own talents and
powers, and the powers and tendencies of Nature, allows them to swim
in the same direction as the great river and imparts a natural grace, flow,
and momentum to their efforts. Time of year and weather exert
tremendous forces on the behavior of every entity, particularly living
ones, people too. The season counts and the weather counts. They count
in our bones, they insinuate themselves in our psyche; the vessel of our
bodies already knows what the teacher is not speaking of. Morning is
not midday, and rain is not sunshine, nor is spring fall. We know this.
We know this because *we* are morning and we are also evening, our lives
are carved out of the same block as the seasons, for don't we have the
springtimes of our lives and the autumns? How can we ever draw closer
to Nature unless we sink into Nature and allow its seasonal touch,
its breath of weather, speak to us and we speak with it? And so each
program of Encounters roots its particular objectives and dynamics in
the atmospheric and seasonal moment. If it is raining, we work with
the physical and metaphoric qualities of water doing business with the
physical and metaphoric qualities of earth. If it is a gentle rain on a sum-
mer afternoon misting the still leaves and grasses, we seek affinities with
our own silent dew points wetting down our own leafy urges.

Orientation established, student aligned with teacher, the map

shown, purpose and method presented and assented to, we are now ready to enter into a conversation with Nature. Little tiny squishy you and the Great Big One, sitting quietly talking things over. Or the two of you might find yourselves wrestling over some point about why or why not, and like the one who wrestled with the angel, you will favor that leg for life.

DISORIENTATION

The ultimate purpose of an Encounter is to create a context by which we may undergo the rigors and rewards of a shift of mind and accompanying behavior. In the frame of reference of this book, that reference is our deepening relationship with Nature, inner and outer, expressed through the enhanced quality of our life and our art. It is often the persistence of our selves that is the constraining factor to the achievement of our desires for more and better. And for good reason, the way we are is held in place by the way we and everything else in the world is, and was. Indra's Net works, that infinite web of Hindu myth wherein a gem at every intersection of threads reflects back all the other gems in the net.

Our purpose in establishing a firm and trustworthy orientation was to be able to launch into the deep, springing from firm footing. Confidence, strength, and efficiency are established in this way. We cannot thrive without the fundamental capacity for orientation and constant reorientation of our Selves relative to our world. But if we employ our resources only to align our selves with the world as it glides all around us, there will be scant resources remaining with which to embark on distinctive enterprises, no leaping of the imagination, no new paradigms formed; no intentional evolution can arise, and our creative urges will have no grounds for their realization. The uncertain consequences that may flow from a change in our established order we often take as sufficient reason to retreat from the new even when the old is undesirable. In order to create a context in which to shift our behaviors in the direction of our desires, we must initiate a forward leaning by creating a state of disequilibrium, enlarging and softening the boundaries of the field for a higher state of equilibrium to succeed. We must begin by having experiences that sufficiently dis-

orient our Selves with the world as we presently know it so that the new elements may be introduced and new configurations created.

The term "having an experience" is employed here in the same manner as John Dewey describes the phenomenon in his landmark book, *Art As Experience*. Dewey observed that the complex series of acts that are involved in having an experience, any experience, is similar to those involved in the creative process, any creative process. Further, the morphology of "having an experience" follows essentially the same complex series of epiphenomena as does learning, learning anything. Having an experience, learning something thoroughly and enduringly, participating in a transformative ritual, engaging in an Encounter, all have similar structures and dynamics. I do not believe we will be mistaken if we also say that in evolution, Nature itself exhibits these same structures and processes.

Dewey observed that all experiences are initiated by some event that creates disequilibrium in the stasis of the system. Unless there is a disturbance to the functioning of the system, all systems stay in a repetitive mode. The disturbance requires the entity to accommodate this new event in order to reestablish a new equilibrium. The trick is to disturb the existing order in such a manner and degree as to have the system achieve a higher order after the event than before; that is what distinguishes a propitious aftermath of a disturbance from its other possibility: chaos and madness. What does a higher order mean here? A more inclusive, finely integrated, and more invigorated system. That is what we mostly desire for the quality of our lives and the quality of our art.

∾ WHAT'S THE MOST TERRIBLE THING?

> What's the most terrible thing
> that happened to you
> as a kid?
> Here's the most terrible thing that happened to me.
> I was about seven or eight and it was a school night.
>
> My dad was painting the foyer of our apartment a gray blue.
> My aunt was an interior decorator whose signature

colors were gray blue with gold trim.
He had the ladder in the middle of the small room.
You had to pass through this room to get to the bathroom,
the kitchen, the living room, and the door to the apartment.
He was working on the ceiling,
so he had a roller and brushes,
a large pan, and the can of paint
on the small shelf at the top of the ladder.
My dad said, Peter, be careful,
don't knock into the ladder, I have paint up here.
Then he climbed down for something.

I'm going to now cut directly to just after I
knocked over the ladder and splashed the paint
in the bucket over the walls,
carpet, little telephone seat and stand,
my sister, and me.

Although I was only seven or eight
and you wouldn't think that a child of that age could have
 thoughts
like these, but now, some fifty years later,
I truly believe I did.

I remember having the thought that I was now on
the other side of my life.
That I had walked through a doorway
(run, really).
And now I was in another room, and there was no more door—
only a solid glass wall.
On one side was my father, mother, sister, brother,
all my aunts and uncles, cousins, friends, my block,
PS 177, the Dodgers, my clothes, toys, special sticks,
everything.
And on the other side—the side where I was—
was just me.
In gray blue paint.

I was so upset I ran around the apartment.
My mother and father were upset too

and ran around after me.
Finally I ran through the foyer again,
almost slipping on that goddamn paint,
and ran out the door, down the steps,
down the hall, out the front door,
and outside and kept running until I was
way down the street.

I heard my parents screaming my name,
so I ran around the corner.
I ran to the yard in back of the house
where we played punchball.

Because there were no streetlights,
it was mostly fences and garages and some trees,
it was very dark.

I could see the orange lights in people's apartments
and I could see a person or two, but mostly all
you could see were ceilings and lights and curtains.

I felt I could never be a part of that life again:
children with parents,
food on the table that your mother cooked,
coffee tables with candies in cut glass bowls,
going places with your parents on the weekend,
taking a bath,
taking accordion lessons,
nothing.

All that was over.

I remember sitting against a wooden fence on the rough ground.
I don't think I was crying
but I think my heart was pounding like crazy.

My parents stopped screaming for me,
so it was pretty quiet back there.
I wasn't cold,
and I remember it being a nice night.

With plenty of time now on my hands,
I noticed the sky. It had stars.

I'll tell you the truth, I don't remember seeing stars
at night in Brooklyn before this.
The moon, yes, but no stars.

I looked at the stars for a while and then
the thought came to me

They are outside, too.

They don't belong inside the house,
with living rooms and sofas and coffee tables and drapes,
and highboys and radiators and kitchens and closets
and carpets and photographs or paintings on the wall.

They are outside.

No yelling, no screaming,
 no homework, no spelling bees, no looking for your shoes in
 the morning, no changing your good clothes after school, no
 milk and cookies after homework, no going off with your
 dad early Sunday morning to go fishing.
No big family dinners.

Outside, with nothing.

Like me.

———

PROFFERING THE INVITATION

How to disturb the system? Not too much, for there lies chaos and
madness, fight and flight. Not too little, for in that direction, well, why
bother to change at all, a cursory swat will do. Disturbing the field to
just the right degree and kind is therefore critical for the ensuing
change to have the characteristics of desired growth, depth, and re-
finement. All effective agents of change know this, teachers, artists,
healers, scientists, parents, lovers, even—or especially—politicians and,
why not admit it, hucksters. However the pattern is managed and

mismanaged, the basic dynamic of propitious change is initiated by a critical disturbance of the existing system. The pivotal event of this necessary disorientation in the service of growth is what I term "proffering the invitation."

Similar to a Zen koan, but with important differences, the invitation presented to the students seeks to lift the veil between themselves and Nature by offering them a fresh way to view their Selves and Nature. Rather than turning to the facade of Nature—a striking tree, a pretty flower—these are invitations to explore an inner aspect of Nature with which the student may share important affinities. By seeking and finding how Nature succeeds in being-in-the-world in the similar ways in which we seek to be, we place our Selves in a student-to-teacher relation with Nature, closer to the one who knows and never lies. All the Encounters contain this pivotal moment when the invitation is proffered. Take the following by way of illustration.

It is a morning in July, dew still on the earth, mist rising from the low spots. The brook we are going to weaves deftly over rocks, tumbled trees, sandbars, and through swampy still pools. We have been working for some time on the issue of the journeylike qualities of Nature, life, and art. After arriving at the brook, we spend a while orienting ourselves to the genius of the place, centering our Selves in this sloping, rock-strewn, mossy crease, seamed by the brook. We align ourselves with the powers of the north, east, south, and west, the above and the below. We touch the earth as we would touch a beneficent mother. We stand quietly, doing nothing, allowing the world to come to us.

Now come closer, I have something to tell you, ask you, really. Looking at the brook gliding along the crease in the earth, I want to make this observation and invite you to engage in the following Encounter. Life presents endless obstacles and opportunities that impede, divert, and enhance the life force that flows through each of us. Bring to mind the object, be it person or circumstance, that stands between you and your desires at this moment of your life. Feel its presence in your body, your heart, your spirit. Feel your impeded life force desiring release and a return to a full flow. Thus aware of this moment in your life, again turn your attention to the brook that flows before you. It too has an urgency to return to its source. It too has traveled far to this point, has emerged as a product of both heaven and earth. It

knows infinite ways of overcoming things placed in its way. It knows how to remain still and gather its forces until a critical mass and opportunity present themselves. It also knows how to seep down and under things, to pour its all over the smooth and the rough, to rush, to pool, to babble and remain silent. Walk along the flanks of this great teacher who knows how to do what you require. When you have found the chapter of the brook concerning the lesson you need to study—a fall, a pooling beside the shoulder of a fallen tree, a slipping over gravel—sit and observe how Nature does what you desire doing. When ready, use your art supplies to further your studies, helping you to see, feel, know, and become. In a while you will bring back the news of your efforts in whatever media and creation your undertaking required: in images painted, drawn, sculpted, spoken, danced, sung. And we will talk.

The proffered invitation:

- casts the enterprise as being one of inquiry, exploration, conversation
- invites inward reflection: "What is important for me to resolve at this juncture of my journey along this road I call my life, and what encourages the seeking of ways in which Nature goes about resolving a similar condition?"
- is sufficiently broad so as to allow unhindered choice in specifying particular agendas, means of exploration, and forms of expression
- permits the time and space for solitary seeking, experimentation, and expression as well as the time and place for the communal sharing of the fruits of these labors

ONE ON ONE

Whereas during the orientation and the disorientation phases the teacher plays a critical role in the proceedings of the Encounter, once the student has been guided into an imminent relationship with Nature, the next phase of the Encounter is entirely between that student and Nature. In my fashion of conducting an Encounter, this requires that while you go about establishing your unique relationship with

Nature, doing what you need to make it full and revealing, I as the teacher absent myself from that budding relationship and make myself available only when sought after. No coaching, no encouragement, no instruction, no affirmations are offered. My faith in the students' ability to find their particular ways into meaningful relationships with Nature encourages them to have faith in themselves and make that faith explicit in the things they say and do.

People finding what they need to do and know, and working devotedly at their efforts, characterize this phase of an Encounter. This phase has all the qualities of the solitary enterprise that Anthony Storr refers to his book *Solitude: A Return to the Self*. Here, the one who draws closer to Nature parts company with all other companions, sheds them, as it were, in order to advance, unadorned, toward another union. At this place of meeting, only those who have lived their singular history are admitted. Only with their singular lens do they ask their question and ponder the response given only to them. Imagination, dreams, intuitions, fantasies, exist in the world only within the confines of an individual's mind. The singular location of inner reality requires no other company than Nature itself for the Self striving to form a perfect union with Nature. Storr writes that "man is so constituted that he possesses an inner world of the imagination which is different from, though connected to, the world of external reality. It is the discrepancy between the two worlds which motivates creative imagination. People who realize their creative potential are constantly bridging the gap between inner and outer."[3] Hence the critical phase of an Encounter, wherein the students are released from the active tutelage of the teacher to find their own way to draw closer to Nature. No teacher but great Nature itself must stand before them. This is the transformative phase, when the students actually draw closer to Nature *on their own*. All prior work has been to prepare for this moment. It is now that the student repositions him- or herself vis-à-vis the Great Other. The fears and joys, trepidation and letting go, the leaps of faith and dogged determination, all emanate from the student; all of the student's forthcoming is met by Nature alone. No teacher must come between this primary couple. The mood enveloping this arena of becoming is mostly one of quietude, occasional sighs, spots of laughter, some sobbing too. People study, ask, speak, make things, and learn.

The quarry set, the sojourners sally forth to find their way closer

to Nature. Their tools of the trade (art materials) applied to the task, they come back to campside with what they have seen and learned. Then we speak about what happened. Because we sought a different prize than a handsome rendition of Nature's handsome face, something that not only repositioned colors on a page but repositioned our Self in the World, in this final phase of an Encounter we must speak in a new way.

Let us listen in on an exchange between an artist and her companion that derives from the Encounter "My Self As Landscape." The artist has just spoken of what she sees as she surveys the landscape she calls her own.

Artist: And so those dark areas behind the meadow are behind and tucked in back because that's how that episode feels to me just now. I want more sunlight and warmth on that meadow, but at least I have a meadow in my life now. There were times when that was not the case.

Companion: We really don't know each other all that well, mainly through our artwork and these get-togethers, but from the amount of painting and overpainting in that meadow area, looking like you increased the richness of the color and vibrancy of the strokes as you went on, I get the impression that there must be some parallel between how you painted that and how you accomplished that in your life.

Artist: Hmm, there is more truth and a lot more stuff behind that than I care to share with you just now. But you are right, overpainting, overworking, is how I get though a lot of things.

Companion: What about this area? This place keeps catching my eye, and you haven't spoken about that yet.

Artist: This here? Didn't I speak about that? I thought I had gone over every square inch of this thing.

Companion: I don't remember that you did. Can I point out what I mean?

Artist: Go ahead.

Companion: Look here. Actually, you did mention it but only in passing. It's in these cloud forms. As I see them, they aren't simply background things, they seem to be more present, more developed, more pressing in on the rest of the scene. As I see them,

they seem to mirror some of the shapes in the meadow, the forms . . . as if there were something, some force underneath the meadow. . . .

Artist *(pouting, looking)*.

Companion: And it looks to me as if you spent a great deal of time on these clouds, changing their color and shape a number of times, maybe corresponding to the stuff that was going on with the meadow.

Artist: *(looking intently at the work)* I did.

Companion: So?

Artist: So?

Companion: So? So when *I* put so much effort into an area, beat the hell out of it, I know something's up. Something's there that is calling my attention to it, something I'm more interested in than I thought I was.

Artist: You know, that's interesting. . . . Because that was an early part of this landscape, and I just let myself brush it in and thought I was done with it, some background clouds and that's it. But you're right, every time I developed the meadow further, it seemed those clouds had to be worked over too . . . as if they were having a conversation.

Companion: And look at this, you didn't paint them out completely each time like you did in some other areas; it looks to me as if you kept going back into them with the colors you were just working on in the meadow. Like the meadow came first and the clouds kept trying to catch up.

Artist: *(long pause, pursing of lips)* You know, that's right, that's how I did it. *(With eyes on the landscape)* When I began to paint these clouds, I seemed to no longer be thinking about me, and that this was about myself as landscape. When I got to the clouds part, I began to think about a friend of mine who I'm actually out of touch with for many years. We were friends in elementary school, and she was the kind of kid who did things that I didn't dare to do. Anna was her name, Anna something. I wanted to be like her, have her mom for my mom. When I started on these clouds, I wasn't thinking of her or anything else but background to something else. But you're right, there seemed to be a certain tug between the work I was doing on the meadow and the work it called

for in the clouds. As above, so it is below, or vice versa. So it could be that I was the meadow, working real hard at being me, getting it right, and the cloud stuff was Anna, or me as the Anna I wanted to be. Underneath me as a kid was the Anna kid, that kid who I saw in Anna. Interesting this below/above stuff, huh?

Notice that the role of the companion in this conversation was to point out something that caught his eye that the artist slighted in her earlier account, and to do so *without judgment or interpretation*. His role was to see and say what was not seen and not said by the work's own author. Or to note the *possibility* that some clearly overworked area had some importance, without speculating on what that importance might be. By taking the time and effort to see something carefully that the artist put care into, the companion allows the artist to revisit that area and investigate its meaningfulness more thoroughly, without being biased by the particular take on the matter, a take that can only be unfounded and, whether correct or not, peremptory and thus disempowering.

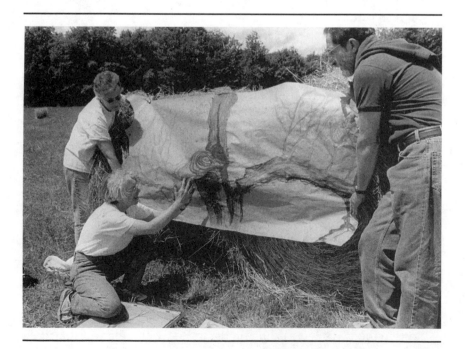

Earlier I quoted from Paul Shepard's book *Nature and Madness*, in which he writes that "natural things are not only themselves, but a speaking."[4] This speaking becomes a source of knowledge for those who have learned to understand that speaking. In the above conversation, the artist saw that the meadow was indeed having a conversation with the clouds, a conversation that was important for her to understand and, at some point in the future, with which to come to terms. Helped by her companion's astute observations to notice that a speaking was occurring within her Self as Landscape, she gradually transformed the presence of both the clouds and the meadow from aesthetic devices to please the senses into sources of meaning. That's just what we want to do: observe that underneath the beautiful face of Nature lies a wise, articulate presence, one that knows something we also ought to know—and can.

ENCOUNTERS
WITH
NATURE

Encounters
with the Prime Elements

———

I<small>N</small> THESE ENCOUNTERS WITH NATURE we seek to do business with the primal and grand divisions that the human mind has made in the great soup of World, one of which will be explored more fully in the next section: the universal elements of Fire, Water, Earth, and Air. Our purposes here will be to establish a fresh relationship with each of these primal elements, a relationship based on the appreciation that all the world is alive and speaking, and if we listen carefully, indeed engage in a serious conversation with the world, we will have drawn noticeably closer to Nature. What we then might learn and become will resemble the attributes of Nature: endurance, grandeur, grace, fullness, candor, subtlety, roots, and unanticipatable possibilities.

Leonard Koren's book *Wabi-Sabi* provides keen insights into an aesthetic rooted in lessons from Nature cultivated by Japanese tea ceremony masters and informed by tenets of Zen Buddhism. There are deep affinities that underlie the naturalistic values of *Drawing Closer to Nature* and those of Wabi-Sabi that are particularly in evidence working with the four universal elements. The creation and appreciation of this naturalistic persuasion of art derive from the spiritual values of Wabi-Sabi, which themselves originate in the study of the natural ways of the universe. Koren tells us:

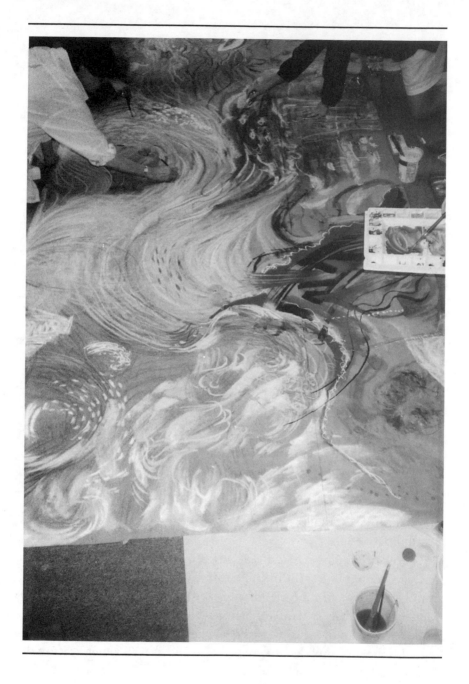

Three of the most obvious lessons gleaned from millennia of contact with nature (and leavened with Taoist thought) were incorporated into the wisdom of Wabi-Sabi.

All things are impermanent. The inclination toward nothingness is relentless and universal. . . . The planets and stars, and even intangible things like reputation, family heritage, historical memory, scientific theorems . . . great art and literature . . . all eventually fade into oblivion and nonexistence.

All things are imperfect. Nothing exists without imperfections.

All things are incomplete. All things, including the universe itself, are in a constant, never-ending state of becoming or dissolving.[1]

In our efforts to draw closer to Nature, we will be enabled by working with what I call the Prime Elements, simple prime factors that inclusively account for the infinite variety of forms and degrees of energy our world comes in. The four elements of Fire, Water, Earth, and Air, posited by ancient Greek tradition, comprise one of the great divisions of Nature with which we humans attempt to find meaningful order in the roiling world. We also make seasonal divisions; in the temperate zones of our planet they are Summer, Fall, Winter, and Spring.

Times of day, morning, midday, afternoon, evening, and night make up another great and familiar division. These parts of our day have a parallel with the divisions of our years: infancy, childhood, adulthood, and . . . senior citizen. In the "Drawing Closer to Nature" courses that I conduct, I employ all of these divisions of the Prime Elements, selecting those that seem best to fit the needs and resources of the particular participants and our circumstances. Finding affinities between these Prime Elements in Nature and their counterparts within our Selves is a most empowering gain of drawing closer to Nature and thus is a main organizing principle of the content and sequence of these courses.

FIRE, EARTH, AIR, WATER

Fire, Water, Earth and Air, in the constant state of being interpenetrated one by the other, create the great dance of life that is the way of

Nature and of course our own way. It is more accurate to describe this great dance as being one of life and death, much as the Hindus would have us understand in their embodiment of this formidable truth in the form of Shiva, Lord of the Dance.

These venerable four have since been superseded by a plethora of more finely made distinctions and categories, recently being collapsed again to an equally smaller number of elementary particles given such fanciful handles as bosons and quarks with and without charm. Yet Fire and Water and Earth and Air are phenomena that are available to our unaided senses, saturate our language, and make up so much of our cultural heritage that we may be excused if we employ these archaic but still serviceable categories in our efforts to draw closer to Nature. In courses that I teach that extend for five or more days, I direct our attention to Encounters with these great and ancient categories of the world. Each one of these Prime Elements can of course be the subject of more extensive time and study—weeks, months, years—so necessary are they to our lives and so ubiquitous are they in the furniture of our world. But a workshop or course is conducted in a relatively brief segment of time, and it is important for the critical interdependency of all these elements to also be witnessed as they are in Nature and our inner nature. At the outset of our work, I spend a while framing the ensuing Encounter, providing the participants with an opportunity to step outside of their prevailing relationship with the elements and to approach them with fresh and more dilated senses. Whatever the form employed, the purpose that the introduction serves is to sufficiently disturb the way in which participants currently hold these elements in their minds so that, holding them more loosely, they may allow themselves a fresh encounter, form a new relationship, conduct their life in a new way, and create their art with greater fullness and grace of expression. I shape the conduct of each Encounter to take advantage of the genius of each student; every good teacher knows this is the art of teaching. And thus it would be expected that other students and other teachers in different settings would require other ways. One of the elements, Water, will be developed in greater detail in the description of an entire Encounter. The other elements—Fire, Earth, and Air—are briefly described to provide the reader with a sense of the way these elements of Nature are brought to bear upon the parallel features of our life.

FIRE

Although one may begin the series of Encounters with any of the four elements, I have found that opening the series with Fire seems the most reasonable. Fire is where we are told by science and religion and myth that the whole shebang began. Many stories of creation open with "In the beginning," the important element being that there was a finite moment of creation, and that moment in Western traditions opens with a great light that divides the timeless Before from the time-space of Since. We too are remnants of that First Fire that ever since lights the heavens as well as the tiny fires that warm our brief lives. Our planet remembers this original heat deep within its core, as we do in our fashion. The manifest world is fire at different degrees, as are we, offsprings all of the original Fire. The setting of our life's journey takes place upon a stage in which we spend half our allotted time in yellow light from a ball of Fire, the other half in pale blue light from a mirror-ball. We are diurnal creatures formed with all the rest of the biota upon a diurnal planet. The two lights provide us with different-appearing worlds, which in turn form our two different minds: the one that reasons and the one that dreams. One that is familiar with color, specificity, spatial perspectives, firm truths and their conse-quences, the other that knows no color, thus is uninterested in distinc-tions of color but familiar with subtle variations of tones and shades. One Encounter with the element of Fire asks the participant to con-sider the form that *their* interior fire assumes: its form of heat, how it warms and what exactly it warms, and what kind of fuel is employed to keep the inner light alive.

EARTH

Our play rests upon the firm foundation of earth, of the Earth. Not only must we constantly be in contact with the Earth, but we are off-spring of Earth—of Adam. Of all the forms that the elements come in, the elemental stuff that we are most like is the element of Earth. It is the stuff of our own bodies that, combined with Fire and Water and Air, forms and constantly re-forms our body, the vessel that contains

our soul for the while we are on this Earth. As the Earth rises, folds, creases and breaks, it is as if Earth's body is like our body, *is* our body— rising, folding, creasing, breaking under the relentless call of gravity. Each of the great forms that Earth takes—mountains and hills and plains and valleys and meadows and steppes and swamps and marshes and deserts and forests and jungles and savannas and beaches and is- lands—each of these geographies we transmute to geobiographies of our own personal journey across time and circumstance. We consist of upwellings and cavities, of wet and dry places, of creases and folds. We too rise up, we ascend, we fall, only to rise and fall over and over, until we are leveled and become one again with the single mantle that is the resting ground and the birthing ground of all. The meanings we as- cribe to the trajectory of our lives are the same as the ones we observe in the fate of the Earth. The finite summit of the mountain's peak, the river's final arrival to the sea, the clearing in the depths of the woods, serve as exemplars and as metaphors for the often steep and uncertain and perilous journey that is our life. The Encounter "My Self As Landscape" (page 229) is one way to explore the relationship between the Self and Nature.

AIR

Most intangible, most subtle, most effusive: Air. We seem solid enough, but cut us off from the Air that washes through the gills we have for more than a moment and we expire. We are really quite porous sorts of things requiring constant immersion in a thin sea of air to feed and bank our fire. Air is our breath of life. It is what the Master of the Universe, we are told, breathed into the pile of dust, birthing life into that senseless form. Invisible, except as the rosy fin- gers of the dawn, the haze drooping over summer's afternoons, the air is intimate with all the hubbub that goes on between heaven and earth.

We are told, this time from the East, that if we truly seek the clar- ity that comes from a mind stilled of its turbulence, we would do well to follow our breath, pay undivided attention to the Air rushing in and the Air rushing out, and do this many times, being fully present to the

flow. In and out. In and out. Mind wandering? Return to breath. Mind becoming turgid again? Keep breathing. There is something more than and different from mere well-oxygenated blood that occurs when one breathes deliberately. There is more than a deep attraction between iron and oxygen; there is an affinity between our finite body and the infinite air that, when they are in intercourse, not only supports life but elevates mind, makes mind as transparent as Air: boundaryless, democratic, life-sustaining.

An Encounter with the prime element of Air succinctly described may proceed in the following manner. The quality of Air we will focus on is breath. Find a place in Nature where you can stand motionless for a while, facing into whatever breeze there may be. Breathe as you ordinarily breathe, come to this place with nothing but your Self. As you face into the breeze, no matter how slight, become aware of it washing over you, rustling the hair on your head but also the finer hairs of your face—upper lip, eyelashes, ears—and any other exposed skin, wrists, forearms, neck, cooling one side of you, rippling the fabric of your clothing. Passively permit the anonymous broad breath of the planet to roll over you; with each breath, sip from it. Standing quietly, doing nothing, enjoy its refreshment. After a while, turn your attention to the entity you call your Self. Become conscious of your Self standing in the world, standing on the planet, standing on the surface of the Earth's skin. Become aware that the substance of your body is pressed against, in a life-enabling embrace, the body of the Earth through the all-powerful, nondiscriminating, and universal aegis of gravity. Stand quietly, do nothing, only reflect on these matters. As your mind drifts past these thoughts, steer it toward the idea that your body is also a sail, a semiporous sail that is lofted by the breeze, keeled by gravity. Canvas your body, your Self, which you desire to be more full of life force, more vital, less dull or perhaps less hurting. Cast your attention from head to toe and bring your attention to that area. Take stock of its heat, its inner light, its density, porosity, color. Bring all your attention to this area that you now wish to do something about.

You will return to this area of concern in a moment, after you prepare yourself to return bringing aid. Once again become conscious of your normal pattern of breathing. When you can observe the

rhythms, rate, and depth for a period of time without altering them, on your next exhale slow down the rate of exhalation and expel all your breath until it feels like there is absolutely no Air left in your entire body. Hold this state for as long as you can without feeling dizzy, then allow the Air to rush into your body, directing its force toward the area of your designated concern. Visualize it pouring through the permeable substance of not only your skin but the entire material of your inner structures and workings. Fill your Self up with the Air of Life again, holding it inside you until it has done all it can; then expel it once again. This form of breathing is very efficient, bringing richly oxygenated blood deep into your circulatory system, and may make you feel light-headed. Therefore repeat this series of deep and focused breathing only to the degree that such symptoms do not appear. Or, if they do, return to your normal breathing pattern for a while, then repeat the cycle.

The artistic processes can enhance the rewards of this Encounter with Air as the breath of life, in the form of visualizing, then embodying these visualizations in artwork. A series based on an exploration of the primal element of Air might be entitled "My Archetypal Self As a Form of Weather," with the understanding that weather is produced by a confluence of a number of different states of energy meeting over a particular geography. What inner and outer weather conditions bring the best of you forward? What conditions occlude your vitality? Under what "weather" conditions would you prefer to live?

WATER

There is Water in our life. The Water of our blood, the blood of our mothers, the milk of our mothers, the honey, the tears. There is the Water of our rain that slakes our endless thirst and the thirst of our soil for the same reasons; life must swim in brine. Two-thirds of the earth's surface is covered by Water. Two thirds of the mass of our body consists of Water. Perhaps a mere coincidence. Perhaps this proportion of wet to dry is one more demonstration on the micro- and macro-scale of the world's common recipe for life. Human menstrual flows correspond to tidal flows; the saltiness within our cells is

much the same as that of the Atlantic and Pacific oceans, the journey of human life over the course of its mortal adventures is like the saga of a rivulet emerging from a spring in the highlands, added to by myriad other watery flows, becoming brook, stream, occasionally pond and lake, advancing inexorably across life's bumpy terrain, along wider and wider channels until it arrives home from whence it came many years and incarnations before, the sea, *la mer*. So strong is life's dependence upon Water that without liquid Water there is no life. The universe comes in a wide range of temperatures; from the trillion degrees just recently achieved in our own labs and perhaps in the first nanoseconds of the birth of time and space and everything else, to absolute zero, or just about. In that wide continuum, a tiny arc of degrees, 100 on the Celsius scale, a fraction of the possible temperatures, is the arc of H_2O in liquid form. Indeed, although we say we are dust and to dust we shall return, it is more accurate to say that we are Water, more exactly a thick brine laced with rivulets and rivers washing through and over and around islands and reefs encased in a not-quite-watertight sack. Somehow this somewhat inelegant metaphor turns up in real life as a Walt Whitman, Audrey Hepburn, Mozart, Balzac, Michael Jordan, a hummingbird, a tiger burning in the night. And all the rest of us.

There are many forms that Water takes and thus many ways for the ways of Water to be instructive. By way of example, we will go to a place where we can participate in a grand meeting of Water, Earth, and Air. What we are after is to have a visceral, cellular engagement with Water so that its lessons will be incorporated into our life and our art at the same deep level. We are after immersion so that what our mind knows our body feels and our spirit embraces. It is a truth that Baptists, Hindus, and Jews, among others, know quite well.

Where Water does business with Earth creates the fruitful edge of each. This zone of interface between the wet and the dry, the mobile and the stabile, generates an arena of meeting, really an intercourse. This milieu of greatest interpenetration spawns the most varied and concentrated portion of the biota. Combined with heat and light energy and the dilute but sufficient soup of Air, we have the soup of life.

Let's have a big bowl of this soup—let's go to the beach. Don't pack much; we'll find most of what we need along the shoreline. But do

take some art materials that you enjoy working with, and don't mind getting sand and saltwater and seaweed on and in and completely screwing up. If the time of the year is such or the longitude you are in affords, wear clothing that allows you to get in and out of the water as needed. Once again, don't rush into artmaking. Set the stuff you brought with you aside, far from the water's edge. We'll introduce the two later. For now take off your shoes and let the skin of your feet introduce itself to the sand. Feel what the Water has been doing to the Earth for billions of years, pounding it to pieces, milling mountains, leveling the high places. Just under the Earth's powdered skin, feel the wetness left by the retreated sea. Bend down, allow your hands to sink into the sand, see if the news that the skin of your feet brings is the same as that of your hands. Let the sand sieve through your fingers. Pour sand on your arms and legs, see what catches, see what lets go. Just grains now, but once mountains cracking, bending, shearing, once foothills and planes, a river island's silt, a finished city of mud or brick. Now on you. Now you.

Shall we go to the Water? The One Sea? Walk to the Water as if you were returning after a long absence. For it has been a long while. And things have changed. It's not like it used to be. Don't think that what you have in your mind is what She is. She is more. And you are not the person with whom She had an earlier acquaintance. You are more. More than even you will know. She being herself over there, at work making endless love (in her fashion) to her Earth. You, a child of her later years, now returning. Walk along her flanks, can you smell her salty breath? Hear her work on her lover? Has she turned her attention to you yet? Why not take the first step? Dip your toe, toes, foot, feet, calf, knees, thighs, groin, belly, chest, arms, neck, face, lips, nose, ears, eyes, hair. She'll allow you to float on her and in her if you will allow yourself.

Had your fill? Time to get out. But if I may suggest, don't rush back to where its nice and dry and warm just yet. Sit or even lie down at the water's edge and let the heft of the Water, pulsed by the Air and tugged by the moon and heated by the sun and scraped by the Earth, loll you around, anoint you again and again. Feel the oscillations of helplessness and struggle, one moment a child of the Sea, lifted and dunked by a force beyond your own, and the next willfully seeking to

be master of your own tiny ship. Emerge from the Sea mindfully. Your simple act of leaving the Sea for a life on Earth and in Air marks one of the great transitions in the who-would-ever-believe-it journey of life assuming all possible forms and places. Mark it mindfully; otherwise She will leave no mark at all, and no school that day for you. Then sit by the Water's edge and allow the Air to take away the Water from the Earth of your body. A bit cool? Teeth chattering, goose bumps, turning a bit blue, skin crusting with salt, nose running back to the sea? That's all right.

Before you retreat toward higher and warmer ground, this might be the right moment for you to begin to assemble the many sensations and fleeting thoughts you had during your time on the beach. To help you do so and bring you to a point of creating an art form that explores these reflections further, I suggest that you now take a slow walk along the Water's edge and reflect on the following question. "In what ways am I struggling with issues of 'to have and have not,' to hold and release, permanence and impermanence, which have counterparts in the way Nature, this time in its Water form, holds and releases things of the Earth?" As you continue along the Water's edge, observe the unfolding world about you through the filter of these and kindred thoughts. In your own good time and in Nature's uncanny way of opening itself up to just the right chapter for the one who sincerely seeks, you will come upon the place, the materials, and the circumstance that somehow fit the concern you bring. Then go to it, explore, and do what you have come here for, nothing more and nothing less.

One member of a workshop had this to say about her encounter at the beach.

And I Just Brailled It with My Chalk

The experience I had on the beach this afternoon was coming all week from lots of directions. Peter's love and support. His reassuring that it's safe to take the next step. That he will be there when you take that step. Boom. He's there. . . . Peter's affirmations every time I took a step, even when I couldn't see it or feel it because I was still focused on the paper, on the art instead of the experience. (This doesn't look like art. It looks like a mess!) Baby steps all week. Didn't think they'd amount to anything.

Didn't think *I'd* amount to anything. Then the beach. Resisting everything—being seen in a bathing suit, going in the cold water, thinking about trying to make art in this chaos. Afraid to BE HERE. To BE ME. I started to pay attention to my fear instead. I decided to be sweet to Myself . . . to not dive in & thrash around like I always do even if I'm afraid & cold, but to be gentle, ease in. Not go in if I didn't want to. But the ocean was so inviting, it wasn't long before I was having a wonderful time jumping and diving, the waves taking me. . . .

When Peter said, "Do an Interface" [between your Self and some poignant aspect of the setting], I went to the dunes because I thought they'd be interesting and easy. But the vibration wasn't strong enough there. I knew I had to go down to the edge of the water where the action was, no matter how difficult & overwhelming. Right away I got it that there was nothing to look at—nothing to hold on to. *Scary.* It wasn't a "beautiful" day, you couldn't see the horizon, no interesting rocks, no outstanding features, monotonous shoreline.

But the *energy* was *fabulous.* Knees in the hot sand, the waves coming right up, seaweed floating in heaps, the sun penetrating. I made some tentative marks, not knowing what to do, easing in, exploring. Then a big wave came and almost got my paper and me and everything. It washed the seaweed I was drawing away, and then it went away itself. Nothing to hold on to. All of a sudden I got it on a *cellular* level that *everything* is moving and changing. Nothing to hold on to. *NO NEED TO HOLD ON.*

Just become it! I closed my eyes and became the seaweed and the sand and the ocean and the wind and the sun—and I just brailled it with my chalk. The chalk & the paper were just part of all this energy, not separate. In that moment, *I stopped THE WAR.* I stopped fighting and posturing and resisting the chaos and the life and the energy. I went with it. I REMEMBERED THAT I *AM* IT. And for the first time in my *whole life,* my being and my art were connected.[2]

The possible lessons that one might derive from immersing your body (and mind and spirit) in the body of Water are as many as the lessons you are ready to learn. Returning to the wisdom of the ways of Wabi-Sabi, you may have found a greater acceptance of the hard but implacable truth of the evanescence of life, of a new economy of

means, a keener appreciation of what it means to tread lightly, speak gently, have a clearer focus on the intrinsic rewards of labor and a giving up of hierarchies, a deeper appreciation for the intimate, quiet, and the inward found in all of Nature and within your Self.

Aligning Your Self
with the Cardinal Points

—————

So POWERFUL HAVE WE BECOME through the leveraging factor of technology that overcoming the forces of Nature, except on the rarest of occasions, is a commonly assumed prerogative of ours. No mountain is so high or rock so dense that we can't blow it to bits or tunnel our way through or under it. No weather is so cold or hot or wet or dry that we cannot concoct a cocoon to endure it. We will pave over anything, divert anything to anywhere, go any place we want to, do what we please. The Devil be damned. Nature be damned too. How clever of us. How much fun.

It is clever, and for many it is fun, but there is a price to be paid. The price is many-dimensional; the one we are addressing through this Encounter is the price of disorientation. When nothing natural matters, the landscape, the world, becomes suddenly flat and feature-less, for nothing natural (save death) matters. No signs, no propensities of Nature need be seriously attended to because any signal from Na-ture can be thwarted by a technological maneuver. Nothing to it. As a consequence of our overblown opinion of ourselves, we have lost the ability to read the signs that Nature is always presenting, and a lot of news goes unattended. Heedless of Nature's patterned forces, we are compelled to rely upon our own instructional manuals. They seem adequate under many circumstances; however, humans make up an in-finitely small fraction of the stuff of the rest of the universe, and what we know of the world constitutes such a tiny fraction of that, it is

imperative to learn to read Nature for instructions on how to live sympathetically with the rest of creation. Since the earliest recordings of the mind, of the myriad variations in topology, season, climate, weather, distribution of flora and flora across the surface of our planet, humans have noted a pattern and periodicity to all phenomena. The world is not only vast and complex, but it is ordered and therefore to an extent *predictable*, at least enough for us to plan accordingly with crossed fingers, thus gaining the house's slim but real advantage.

Early on, we also made the observation that not only is the world ordered but that things don't just happen, they happen because of a causal chain of interdependent events. Everything is necessarily linked. Everything. Of course, if you posit that the universe is dead and therefore dumb, composed of hunks of mass traveling at certain velocities, then orienting yourself to this ballistic junkyard is only important to the extent of not getting smacked by something hurtling by.

We have posited something else. The world is ordered, humans are ordered, everything is linked. The power that anything possesses is precisely a function of its ordered structure and its linkages to other constellations of order. For some, "ordered and linked" is too modest; they claim that the exquisite fit of the world is predetermined. I'll settle for ordered and linked—exquisitely.

Imagine this. Unlike your actual early childhood, you have arrived in a New World, one in which everything you see and hear is already familiar to you. You have been taught the name of everything and the proper relationships of all things to all things. You know how things came about. And you know the correct use of all things. You understand the language all things use to convey what they are and know and desire. You can perceive the pattern according to how all things fit together in space and how they move together in time. You see how you fit into this cosmic schema and you see how all is family from one side of the horizon to the other. It is clear to you how the cycles of morning to evening and evening to morning, from springtime to next springtime, from birth to death to birth, all follow similar and necessary trajectories. You see how mountains and stars, toads and birds and trees, forests and clouds and whole continents, obey the same pattern-making forces everyone calls Nature. In this world, everything speaks its own dialect, yet is comprehensible to all else. In this world, everything has a designated role to play and particular delegated powers,

powers commensurate with responsibilities. You do too. You know why you were born, what you must do, and what you might do. You also know what occurs after this mortal life concludes its course.

There is an invisible but palpable grid that holds everything in order in this world. Everywhere you face, you face into the breath that emanates from a source of particular powers. The North, the East, the South, and the West are all structures and sources of powers that, like great ocean currents, shape the fate of the world. In this world, everything born is born under the influence of one of these cardinal points. Consequently, these points are linked with the distinctive powers and responsibilities of everything and everyone, including, of course, you. You know how to align your Self with the powers of your cardinal point, creating a harmonic that makes all your effort natural and grace-full. Although you and all else live within a vast and sacred geometry of time and space, life is still an adventure of preparing yourself to see more, therefore understanding more, therefore loving more, therefore living more fully and dying more easily.

Now stop imagining and return to the world in which you did happen to be born. Make an assessment of the world in which you find yourself. Do you know everything's name? Speak everything's language? Do you know your origin, your purpose? Know how to cultivate your powers by aligning your inner qualities with those of the outer world? Are you familiar with the powers of the North, the East, summer, rain, evening, the willow, the toad, the radish, up, down, in, out, right, left, blue, red? Do you know how to read anything other than words? Can you understand anything other than people? What have you learned last from leaves of grass? If you have not as of yet made the acquaintance of the other cardinal points, the Encounter that follows may help to make the introductions.

This Encounter with Nature asserts that the order of the universe counts, that the linkages count, that when we align the order of our Selves with the order of the universe, that too will count for something, a lot of something. In this Encounter, we focus our attention on drawing closer to the *directional* aspect of Nature: the North, East, South, and West of Nature. By way of example, we will deal with only one of the great points of our planetary and personal compasses, the North.

As in all the Encounters, before we put a mark on the page, we

prepare our Selves for the Encounter. When I lead this Encounter, I describe the following process to the group after we engage in some simple centering and balancing processes drawn from sources such as yoga, t'ai chi, chi gung, and the Alexander technique. So composed, grounded, heightened in attentiveness, interested in our own becoming and that of our companions, we are ready to launch into the deep. You do what *you* need to do to create a similar state of mind, body, and spirit.

The perception that the cardinal points have distinct qualities that can be called forth to shape the outcome of human effort has been common to societies throughout history. In our current Eurocentric civilization, which conducts its affairs without any significant operative metaphysic and maintains only the most tenuous alignment of individual and societal conduct with the powers of Nature, this parallelism between the powers of the cardinal points and those of humans appears to be a naive holdover of earlier beliefs. But for those humans who do see the sun rise from the darkened bed of the earth in the East as they arise from their own bed, and who call that rising morning, dawning, ascending, arising, and for those who see the sun set in the opposite horizon, having had the sun as their companion throughout their labors of the day, who see the cooling sun return to its recline, then decline back into the dark folds of the earth just as they slip back into their own deserved sleep on the same earth—for these humans the East matters, the West matters, so do the North and the South. The ubiquity of this sensibility in other civilizations should give us pause, as should its absence in our own.

Early Egyptian cosmology describes the world animated by the rising and declining of the sun, delineating the distinctive and complementary powers of the earth and the sky, the night and the day, man and woman, up and down, east and west, good and bad, subject and monarch, life and death. Creation stories of the Dogon of West Africa also assign particular qualities to particular directions, which in turn provide instruction for the proper design of their granaries. The Mayas, Aztecs, Incas, Zapotecs, and Mixtecs lived within both a temporal and spatial calendar of divinely inspired geometry. Christians and Jews and Muslims and Hindus and Buddhists do the same in the alignment of their temples and other holy grounds. Native Americans respect these same powers of the world in the orientation of their

dwellings and the order of their spiritual and healing ceremonies. Living in the midst of such a sacred geometry provides the sojourner orientation, without which purpose, direction, balance, value, priority, persistence, and proportion are hard to come by, making it difficult to steer this fragile craft we call our life.

Let us be bold, let us also claim—if just while we make a thorough investigation of the alignment of our Self with the cardinal points— that the North and the East and the West and the South have something to tell us, something to enhance the quality of our lives.

We will begin a direct engagement with the North in the simplest of manners, by facing North. From here on, our effort will be to convert the abstract and secondhand stories that come to us from endless and anonymous sources concerning the North into a personal, existential experience with the North. To convert "the North" to "*my* North." The North is not only a feature of the planet, a characteristic of Nature, it is also a feature of our personal lives, and for all we know, it is a subset of the collective unconscious of which we are all a part. Turning our body and our mind and our spirit to the North, we evoke the Northern dimensions of our own Being. By asking yourself the following or similar questions, you might do just that. First, what do you know about the North? What aspects of your Self do you associate with North? What powers do you possess that are like the powers that you attribute to the North? What does the North feel like to you? How does it affect your breath, your posture? What tones of voice, what pitch, what rhythm, what melody, what movements does the North evoke in you? How do you stand in your "Northern posture"? What words do you associate with this Northern aspect of your Self? What images come to mind? What flora, fauna, weather, climate, season? What strengths do you possess that you liken to Northern-type strengths? What are your Northern aversions, curiosities, passions? What relationships do you have with people of a Northern persuasion? To observe the Northern dimensions of your Self more distinctly, you might try contrasting them with their complementary direction, the South.

As you read and mull over these questions, take the time necessary for them to bite deeply into the experiences that they elicit. The deeper and closer you go now, the deeper and closer you will go when you come to make your mark on the page.

Once again, select the media that at the outset seems appropriate to the task of investigating this vast Northern juncture of your Self and the World. Call your attention this time to the scale and proportion of the surface/space you elect to work on. Also give careful thought to how to position your Self to the task at hand; will you sit at a table, on the floor, or will you stand? Will you work on an easel, directly on the wall, or on the floor? A theme of this scale requires a format that fits its special requirements.

To initiate your work, it is critical that you select a particularly important correspondence between *your* North and *the* North and enter the field of artistic engagement in that particular state of mind, body, and spirit. A diffuse focus may dissipate your energies and weaken your imaginative powers. A willful choice should provide you with a sturdy keel for this voyage, as is always the case in art, into only partially charted waters. I have found an hour or so in this phase of the artistic process to be sufficient, but you may find this subject more engaging, more complex in its associations, and therefore needing more time. Do what you need to do to raise what must be addressed, say what you need to say. This matrix of alignment is so rich that it could take your lifetime to explore. Morandi took as long finding the ordering principles of the universe in arranging bottles on a table; Cézanne took as long arranging peaches and pears.

When your work has investigated and revealed as much as you have prepared yourself to experience, the next phase of the process is as always a reflective one. I would like to suggest a different way to proceed than offered before. When working with a group of others, you might find that the following approach adds richness to your own experience that solitary reflection cannot.

Assemble all the work in an open space, preferably on a wall; if not, lay it out close together as in a mosaic on the floor. Once the work is so displayed en masse, peruse it without attention to its authorship. See the collection as a collective map of the place where the human North meets the North of Earth. Each person's work provides a distinct region of this metaphysical map. All the work taken as a whole enlarges the territory and sharpens the focus that any one witness is capable of perceiving and representing. The entirety, composed of each person's work, not only enlarges the frame of reference, it cre-

ates new layers or dimensions to the map than are possible to perceive through the examination of the work of any one artist.

You now have insights gained from your individual efforts to perceive and convey personal linkages between your Northern Self and the North itself. Through reflecting on the work of all the other artists and observing the entirety as if it were the work of a meta-entity, you also have the opportunity to obtain a glimpse of the collective conscious/subconscious as turning its attention to Mind contemplating Nature. You may bring this collective view further into focus by asking yourself the following questions and sharing your responses among your companions.

- What qualities of the North do you observe in the work of others that is not in evidence in your own work, but that now uncovers something of value for you?
- Is there a quality of the North in someone else's work that, although foreign to you, is nonetheless attractive, that you want more of in your North? If so, have a conversation with that person and learn how they came to be acquainted with that aspect.
- What recurring qualities are there in a significant number of the works?
- What seem to be the farthest reaches of the "map"? What seem to be the highest, the deepest?

A more elaborate process has provided groups that I have conducted high moments of meaning, beauty, even epiphany. Each member of the group writes a sentence or so that holds the essence of what their Encounter with the North meant for them. Gather these and randomly redistribute them so that each person has the statement of someone else. Now study that statement to gain an appreciation for its intent and for the appropriate voice with which to read it. Invite anyone to begin the reading who believes that their assigned piece ought to initiate the collective reading. Listen empathetically to what is being read and contribute your reading when you feel it fitting to do so. Allow for pregnant pauses; their silence makes the surrounding statements all the more poignant and resonant. Each direction of the world, each dimension of your Self, has it own particular features; each

such meeting and aligning will have its own trajectory and dynamic unfolding. Each additional alignment between your Self and the other cardinal points will go toward the construction of an even more inclusive alignment, more deeply and assuredly providing you a place of firm standing in the world. How could your art not benefit from this new sense of composure?

Balance

FINDING YOUR STILL POINT

———

I N T H E F O R M A L T R A I N I N G of visual artists, much is made of the characteristic of balance as a critical feature in artistic compositions, but there is little in the literature of teaching art that begins with first establishing a personal sense of balance before attempting to do so on the page. How we can cultivate a sense of balance both within and without, taking our lessons in this from Nature, is the subject of this chapter. Strange how this idea, so foreign to the visual arts, should be so common to the preparation of dancers, actors, and athletes. But there it is, good theory and practice right next door, going unattended.

Balance is what every one seeks in life. The third way. The watercourse way, the Sophists' ideal, and the budget's.

> Balance is to locate the still point at the center of complexity.
> Balance is to be in a constant state of sensitive fine adjustments.
> Balance requires exquisite sensitivity to inner and outer forces.
> Balance requires yielding and resisting, yielding and resisting.
> Balance cannot wait.
> Balance appears spontaneous and improvisational but is utterly responsible and devoted.
> Balance is thwarted by pretense, also by insistence.
> Balance knows both this and that, and prefers neither.
> Balance is opportunistic.
> Balance finds home anywhere, finds the center everywhere.

"Balan*cing*" is more like it than "balanced."
Balance is a state of mind and body and spirit that manifests itself in the actions of our mind, our bodies, and our spirit.
Balance is homeostasis, is dynamic harmony, is ecological well-being.
Balance is what Nature requires, sooner or later, at all scales, of all things, micro to macro.

Balance has its flip side: imbalance.

Imbalance opens the door.
Imbalance knows excess.
Imbalance is always immanent, always in the wings.
Balance is opportunistic in its own way; imbalance wins by default.
Imbalance is almost all, except for the fraction ceded to balance now and again.
Imbalance is indolent, achieves by carelessness.
Imbalance is the child of time.
Imbalance is what Nature requires, sooner or later at all scales, micro to macro.
So is balance.

Imbalance: the sea. Balance: the perfect wave.
Imbalance: everything over time.
Balance: everything outside of time

Loving one without embracing the other defeats the creative and even the artistic potentialities that each possesses; separately and, even more so, in conjunction we flee from the confusions of imbalance, strive after perfect and permanent balance. Either one sought after or held on to too hard and long compromises the creative process as it would compromise if not destroy any process, especially one that evolves—that is, goes from simple to complex, fixed to spontaneous, reflexive to self-reflective behaviors.

Without a sense of personal balance, we are always guarded, at some level anxious about our well-being, our capacity for achievement. So unsure and tentative in our own orientation to the world

and to life, how sincere, how sure, how brave could our mark be on the page or our choice of color, our gesture? We could of course mimic the look of the art that more genuine artists achieved—it happens all the time—but what good is that?

How to find that dynamic relationship of balanced phases within a field of associated imbalance, which in turn leads to an evolutionary synthesis of greater complexity and interdependence? Look to Nature. Look to Nature, for Nature is just that, a dynamic relationship of balanced phases within a field of associated imbalance, leading toward evolutionary synthesis. Look at yourself.

For we are Nature too and exhibit these same dynamic character-istics in spite of the rigid or chaotic mess we sometimes claim is our lot. The subject of our Encounter with the nature of balance/imbal-ance shall be our Selves—our plain and not so simple Selves. We will begin with our plain and anything-but-simple body.

BALANCE WITHIN AND WITHOUT

Give yourself at least an hour for this Encounter; two or even three hours would be better. Providing for an uninterrupted hour or more establishes the initial step of creating an inner sense of balance because any interruption is already a state of imbalance, a condition we are all too familiar with. The firm decision to allow a continuity of time al-ready establishes the premises and the emergent sensations of balance.

Having provided yourself the time and the space, just stand there doing nothing, savoring the quietude of nondoing in the midst of sus-pended time and constant space. In this simple way you already have achieved another degree of balance. Earlier, in part two, I discussed a series of steps in preparation for making your first mark. You might consult that section again if necessary to align your body, mind, and spirit for the next portions of this Encounter. Aligning the "experi-enced center" of your body with the center of the earth, along the axis of gravity's universal tug, connects you with the earth in a precise and balanced way. Breathing in a mindful and proportioned manner balances the flow of your inner and outer breath, and all that that con-notes. Your posture, your breathing, and now the movement of your limbs in a symmetrical way around your frame inform your skeletal

structure, your musculature, your circulatory, lymphatic, digestive, and breathing systems that all are in congruence and in dynamic balance.

Close your eyes. Without your visual system operating to provide you with a sense of vertical and horizontal orientation and balance, allow your somatic system to predominate and guide you. Take a while for this seemingly simple phenomenon to register, to actually take over the work for which your visual apparatus is usually responsible. Feel your orientation to the center of the earth by the equality of pressure experienced by both your feet. Still with your eyes closed, shift all your weight onto one foot. Stand quietly on one foot, doing nothing. Let that one foot provide you with all the information you require, orienting yourself with the center of the earth. Try it with your other foot. Notice whether one foot feeds you more and better information than the other. Shift your weight to just the ball of your foot. Stand on that narrow platform for a while, doing nothing but balancing yourself on a still point right along the axis of the center of the earth and the top of your head. Doing nothing indeed. Redistribute your weight to the entire flat of your foot. Feel the greater security and balance an entire foot provides you. Now stand back on *two* feet. Open your stance just slightly and experience the added sense of balance and surety that that minor adjustment makes. Open your eyes. Experience the added surety and balance that *that* makes.

Close your eyes again. You are not quite the person you were prior to the experiences you had just a few moments ago. When you close your eyes this time, notice whether you experience yourself somewhat differently, perhaps with somewhat greater confidence in your balancing ability, a stronger sense of communication between yourself and the earth (the *center* of the earth). Perhaps a more confident sense of being grounded, being present.

Let's go further. With your eyes closed, and now provisioned with your newly attenuated sense of balance, walk. Slowly, mindfully, walk about without guidance from your sight. As you shift your weight from the heel of your foot to the ball and from one foot to the other, retain your sense of balance throughout the transitions. Slow down; the quicker the pace here, the less confidence you will have in its outcomes. Could the very pace at which you navigate life be a contributing factor to the degree of imbalance and hesitancy that constrains your Self and artistic expression?

As common as it is for most of us, walking is a perfect example of the balance/imbalance duality. Moments of balance arise from a shifting sea of associated imbalances. And with a slight tilt in the direction of your desire, evolution! Slowly walking about the space you are in, with your eyes still closed, keep your primary awareness on always maintaining your balance. First give all of your weight over to the heel of one foot, then gradually shift to the ball of that foot, releasing the other leg's weight-bearing responsibilities and swinging that same leg forward just far and long enough to accept the weight of your body just being released by the ball of your other foot. Sounds complicated, and it is. But that is why walking in a mindful, balanced way is the perfect practice of the idea and the felt experience of the balance/imbalance *continuum*. Life *is* complicated and always surprising. So is Nature. By practicing this mindful way of balanced walking over uncertain terrain (Nature), we may get the feel of what a physically balanced gait is like. This in turn may provide some vital information on what a balanced period of life might actually feel like. Once we get the feel of what balance is like in our bones and muscles and viscera, we bring powerful resources to experiencing what a balanced emotional state of being may feel like, as well as its offshoots: a balanced state of mind, body, and spirit as you engage in artwork.

What about some art? Of course that is exactly what we have been just working on, but I know what you mean, what about some *Art*?

OK. Get a full-length piece of paper and put it up on a wall so it is as tall as you are—and touches the floor—again, just like you. Get some media: charcoals or pastels or oil crayons or any medium that is easy to manipulate and doesn't run out as you work, like paints or inks that require periodic refilling.

You are going to create a full-length Self-portrait. With your eyes closed. You have oriented yourself with the center of the earth by feeling the ever-so-slight difference of gravity's tug on you as you shift the distribution of your mass to either side of your centerline. That established your vertical and horizontal balance points. The vertical starts from the top bump of your skull, bisects your body along the column of your spine, exits your body right between your two lower exits, and goes down to the center of the earth. What's on one side of this center line is almost exactly what's on the other side.

Your horizontal axis can be any point along the column of you

that you wish to align with the horizon line of the earth: the point be-
tween your eyes, your heart, your shoulders, your solar plexus, your
navel. For this Encounter I suggest you employ the line created by
stretching your arms directly out from your shoulders to either side.
This great horizontal axis of you stretches from the fingertips of one
hand along your entire arm through your shoulders, the apex of your
neck, through to your shoulder, arm, wrist, palm, and fingertips on the
other side. This beautiful, variegated line traversing important merid-
ians is now made parallel with the horizon line of the earth itself, a
horizon that is the meeting point of heaven and earth. With these
simple acts, you have balanced yourself along your vertical axis with
the center of the earth and your horizontal axis with the circumfer-
ence of the earth. How could you go wrong?

Back now to the Self-portrait. You may want to engage this pro-
cess without wearing clothes, or the least clothing you are comfortable
with, for two reasons. The first reason goes to the heart of the thesis
of this book; the second reason is strategic. Our own bodies are the
closest we will ever draw to Nature, for we of course are Nature too.
The unadorned self is Nature unadorned. This is a self-portrait, not a
fashion show, nor is it a lesson in using chiaroscuro to create the illu-
sion of draped cloth. There is no place to hide and nothing to hide.
Just you. Somewhat weathered, dragged down a bit by gravity's persis-
tent attention. Just like the rest of creation. The strategic reason is, as
you will discover as you actually engage in creating your self-portrait,
that if clothed, by constantly touching yourself with hands covered
with charcoals or pastels, as you touch yourself in order to orient your
self on the page, and to refresh your somatic memory about what
shape you are in, you are going to miss a lot of vital information, and
at the same time cover your clothes with a lot of smudges.

Still uncomfortable with the idea of drawing close to Nature un-
adorned? Your concerns may be the conventions about nudity and
self-exposure that are the inherited conventions of our society. If so,
consider the following approach to bounding the process, much as
figure-drawing classes impose certain strictures and understandings on
all participants. This entire process will be for your eyes only. This is
between you and the great mystery of the universe itself. You are an
offspring of the universe, a universe that comes no less naked than you

are and, unlike you, remains that way. Modesty before other humans soaked in taboos—certainly. But modesty before the moon, in sight only of meadows and stars? The hesitancy you feel may be so deeply embedded in your psyche, given the life that you have had, that drawing an image of your unadorned Self may feel awkward. Just this resistance may prove to be a worthy issue with which to contend right here. After all, who's looking?

What if you experience sensual, even sexual pleasure? Our enculturation codes self-arousal as unseemly. It need not be. There is a tradition in Hasidic teachings that addresses the appearance of uninvited sexual fantasies while one is at prayer or study. Rather than rejecting them as abominations, thus creating interior states of self-loathing, one is to accept these intrusive thoughts as a form of bodily arousal for uniting with God.

So. Stand in front of the full-length paper you have put up, with clothes or without. Stand at a comfortable arm's distance from the paper. You might tape a slight bump of something on the floor aligned with the center of the paper and at an arm's length from the paper. This will allow you to always align your body's midpoint with that of your drawn image. Remember, this is going to be done without benefit of your eyes, only with your sense of balance and touch.

Stand face-to-face with your image-to-be, experiencing your Self balanced, oriented, and aligned, with your marking tools in hand, no sight but insight. When there is nothing left to do than to begin, begin to create an image of your Self. All of your Self. Your Self, not merely yourself. Without peeking. Proceed as best you can at this point, working out the procedures as you grope along, discovering pathways through the Maya of sensations without benefit of eyesight, relying instead on your internal guidance system of dynamic balance.

When you have done all you can do, still with eyes closed, put down your media, face away from the drawing, sit or stand still for a while, somatically synthesizing what has just occurred. Something has just happened to you, and you must now comb it through for what may be of value, allow your mind's eye and somatic memory to work over the experience. When this portion of your reflections has run its course, it may be time to acquaint your eyes and visual sensibilities with what has happened.

Seeing your Self imaged in the way you have just done will present you with a look of, and a look at, your Self that you may have never seen before. You were the author, the subject, the one who found the way. Now you are the one who beholds the handiwork of Nature and the history of your Self. It's a first-time meeting. Provide yourself with ample time to survey all that lies before you, to remember the occasions of the first appearances of the various features of your Self—an archaeological view of your geography, to comfort and congratulate yourself on the hand that you were given to play, to imagine future permutations of your Self as you desire to evolve. Look closely at the marks your hands have left as they tried to account for your presence in the world.

Before you open your eyes to see the work, think of the most appropriate distance from which to take your first look: from a few inches away, from across the room, from the arm's length that you drew it from? Each distance of first viewing will shape your initial and subsequent reactions to the work, so choose mindfully. Your insights may be extended through the different lenses of the following questions. In what ways does this Self-portrait differ from other self-portraits you may have done? What elements of your Self appear for the first time, or as pronounced as they now appear? How come?

FURTHER EXPLORATIONS

There are any numbers of permutations on this basic issue of balance that you might want to explore; the following are a few.

- Find a form in Nature that has a symmetry similar to yours along both its vertical and horizontal axis. Study it, its juvenile and adult forms, its parent bodies, where and how it thrives; find aberrant forms it may take. Which ones of these have a greater affinity for you than the others? Why is this so? Make visual studies of these things and qualities to further investigate these affinities. Perhaps make a final celebratory portrait of it/them, as tall as your Self-portrait.
- Draw your Self-portrait using both hands simultaneously, alternately, once with your dominant hand, once with your "other."

- ○ Change media to something softer or harder, wetter or dryer, in only black and white, in a different color chord.
- ○ Work with color in one hand, black and white in the other.
- ○ Work in a darkened room, using only as much candlelight as you require.

Because of that portion of this Encounter that invited you to draw unadorned, you might want to have no one else be party to viewing and discussing your work. But if you wish to have your efforts affirmed by someone else, or wish to see the enterprise in another light, sharing your work with someone who has experienced the same or a similar process might be an advantage. This would afford you and your partner a parity of exposure and vulnerability and a common base for reflections. There is something about saying what you know, nothing more and nothing less; that, once announced to the world, works to legitimize what you know and who you are. Sharing your work resulting from this Encounter with your own nature with a trusted someone may yield similar rewards.

My Self As Landscape

I T HAS OFTEN BEEN NOTED that when an artist creates a portrait of someone, it often reveals as much about the artist as about the sitter. Much art criticism takes note of the relationships between the artist as a person and the stylistic devices employed in the representation of their subject. The postmodernist reading of art goes further in claiming that not only does the work reveal deep structures in the nature of its subject matter and its author, but because the work is really not complete until it is "interrogated" by its viewer or reader, the interpretation so derived reveals significant information about its interrogator as well. Postmodernism also claims that what is not made apparent by the author—the "subtext" of the work—is also revealing. Sticky, this postmodernist business, isn't it? To return to *our* thesis: Not only is every portrait a self-portrait, but so is every still life, landscape, and abstraction. The manner in which an artist employs media, the choice of subject matter, color preferences, compositional devices, every graphic dimension of every mark—*everything* one sets one's hand to leaves an unmistakable, distinctive, and revealing imprint. For example, the stylistic "signature" of a still life by Cézanne immediately distinguishes him from Morandi, Janet Fish, Braque, O'Keeffe. Extracting the pear and grapes from any still-life composition still leaves the composition, the color scheme, the line quality—in other words, the telltale architecture of the mind and soul of its creator.

This is one premise of the Encounter "My Self As Landscape."

Another has to do with the conviction that Nature is neither dumb nor stupid, nor is it dispossessed of spirit. Many traditions know this to be so and construct a worldview and patterns of personal and social behaviors accordingly. The prevailing cultural attitude in our society understands otherwise, delineating human attributes and our ensuing rights severely from the rest of creation. The prevailing culture, but by no means the entire one. For Western traditions have had a long and robust tradition of observing and honoring the continuum of humans with the rest of Nature, from Druidic times through our own transcendentalists, Emerson, Melville, Thoreau, Whitman, to our current philosophers from the Deep Ecology movement, Jean-Jacques Cousteau, Rachel Carson, Paul Shephard, Thomas Berry, Matthew Fox, Barry Lopez, Joanna Macy, John McPhee, Carolyn Merchant, Michael Pollen, David Abram, to name only a few. An insightful observer of the inextricable embeddedness of humans within Nature can be found in the brave words of Pierre Teilhard de Chardin, the twentieth-century existentialist-Jesuit-anthropologist theologian:

> The egocentric ideal of a future reserved for those who have managed to attain egotistically the extremity of "everyone for himself" is false and against nature. No element could move and grow except by all the others with it. Also false and against nature is the racial idea of one branch draining off for itself alone all the sap of the tree and rising over the death of other branches. To reach the sun nothing less is required than the combined growth of the entire foliage. The outcome of the work, the gates of the future, the entry into the super-human—these are not thrown open to a few of the privileged or to one chosen people to the exclusion of all others. They will open only to an advance of *all together*, in a direction in which *all together* can join and find completion in a spiritual renovation of the earth, a renovation whose physical degree of reality we must now consider and whose outline we must maker clearer.[3]

In this passage, "all together" refers specifically to all humans, but elsewhere and throughout his writing "all together" means the whole creation; creation must be understood as all one enterprise, or it cannot be understood at all.

Having posited these two underlying premises—that every cre-
ative act reveals the imprint of its author and that humans are one
more distinctive crop of Nature that is neither stupid nor dumb nor
spiritless—we are at point of introducing our next Encounter. "My
Self As Landscape" will be different from the more familiar activity of
landscape painting. For instance, taking a walk through the woods on
a fine day and, moved by the symphony of sights and sounds of this
drop-dead beautiful world, returning to the studio and creating some
visual souvenir of the experience. Nice work, that, and much quite
marvelous artwork has derived from this perspective, but not our
quarry. Our view is that Nature is intelligent, articulate, imbued with
spirit, that it is not only we who are observing Nature but that Nature,
in its own way, is observing us, knows that we are here, and, again, in
its own way of speaking, is speaking to us. We may not have noticed
it, but perhaps Nature has all the while been our secret sharer, our
companion through time, even though crushed, maligned, on occa-
sion rapturously adored. Cultivating this deep if all but veiled rela-
tionship by making it explicit will change everything: our Selves and,
in time (if there is time), the world.

The following may be read as a personal meditation to establish
the premises of this encounter with Nature, or offered by a facilitator
to a group in the form of a guided imagery.

It is early dawn. Everything is still. Every object, no matter how dif-
ferent, is drawn only in shades of blue or violet. You have been walk-
ing along a path for some time, which now bends around a tree,
obscuring where you came from and opening on a new view of Na-
ture. Following the path as it arcs to the right, you move into the turn
and ascend the shoulder of a hill whose beginning and end dip out of
sight, pausing to take in the vista that spreads before you. The edges of
everything are made blurry by the morning's scant light and heavy air.
As you stand there, slowly allowing your gaze to feed on the features
of the world around you, the gradual increase of sunlight seems to
awaken the earth, the land before you begins to reveal itself, form and
color make their way through the veiling mists. The day's first breeze
is first heard in the treetops and then descending with the morning's
advance to the forest floor, lightly touches your own hair, cools the

skin of your face. With the rising sun, the noise of the world newly wakened begins to fill the air, composing this day's musical interlude, just as John Cage said it does.

The many forms that Nature takes begin to distinguish themselves in this day's light. Each tree, hill, stone, bird is seen for the first time, yet you have the unmistakable impression that the landscape as an entirety feels familiar, evoking a sense of well-being, of being present at a homecoming—your own. No great hosannas welcome your return; rather it is like slipping back home while the rest of the family still sleeps. The land seems to turn ever so slightly in your direction and quietly but assuredly greets you.

Everything that now lies before you seems to fit the person you take your Self to be, as when you put on an old, familiar outfit, its shape accommodates your shape. The features of the landscape are reciprocals of your psychic landscape; that is, the features of your personality, your heights and valleys, your craggy and your open spaces, your curves and straight lines, can all be found in the scene that now surrounds you. In truth it is not so much that your appearance resembles the forms that Nature takes; it is more tellingly that the internal forces that animate you, make you the person that you are, are similar to the subterranean forces that have created the features of this landscape. No wonder there is this sense of homecoming.

To set this Encounter with Nature more simply: You are invited to discover the landscape without that is the reciprocal of the landscape within. Or: If your Being were cast in terms of a landscape rather than in the form of a human being, what features would it/you have?

As in other Encounters where you are encouraged to discover affinities between your nature and Nature, several approaches to artistic expression are possible. You may indeed begin as we just did, with a guided imagery that will bring you to a place evoked by your internal imaginative powers. You may meditate for a period of time, repeating a phrase, in this case one as simple as "My Self as Landscape," or you might simply plunge into the adventure with paint and brush, clay or pastel, and see what can be found. All roads seriously pursued lead to rich rewards; in this instance the "finding your way as you go" approach will be described in greater detail. In many cases, the scale and kind of material I set to work in often plays a significant role in shap-

ing what I will find, no less the look of what I find. In this Encounter, media and scale are of particular importance, so we will start there. Although one may work on any scale, the very scope of this enterprise indicates a large surface. You might even consider working on a surface that is as long or high as you are tall. This way you already are working with reciprocals.

Elsewhere I suggested that the choice of media you employ for a particular task not only determines the look of the completed work but has a substantial effect on the very content and meaning of that project. Each medium inflects one's own voice by its own voice. Each medium is always both an enabling and a distorting lens through which we observe the world and a mirror with which we may observe our Selves. Therefore, select your medium purposefully, perhaps because it is old and familiar and is the kind of companion you would like to have along on this trip, or perhaps something fresh and new because of its daring, that you want more of just here and now.

Where you work is important as well, especially if you have chosen a large surface. It does matter where you are in the world, for being aware of how gravity tugs at you is to be cognizant of being a body in the world; this too is drawing closer to Nature. Directing your energies to the expression of your Self while leaning over a table that is three feet above floor level is quite a different experience from standing fully erect, addressing your paper of the same height. Leaning over is not just leaning over, it is leaning over. Leaning over feels different from standing upright, standing on your own two feet, and psychologically is different. Therefore, position your Self relative to the task at hand, which in this case is positioning your Self relative to Nature, to the horizontal of the earth's surface, to the perpendicularity of gravity, to the center of the earth!

Earlier, by way of example, I sketched in general form a particular landscape. The landscape that is *your* reciprocal may be quite different. The greater specificity of the sought-after metaphor, the deeper will be your inquiry and the richer your rewards. In order to help you identify parallelism between your Self and Nature expressed in the form of a landscape, you may find the following questions helpful. Remember, you need not visualize these metaphors before you commence your artistic enterprise; only raise these qualities about your Self as you engage in the creative process.

What kind of natural setting do you find your Self most at home in? Windswept open meadows, soft rolling hills, craggy sandstone highlands, moist woodlands, coastal salt marshes, high country plateaus?

What time of year suits you best? As in all the other considerations, be slow and subtle with this. There are many more seasons than four; there is early and late spring, quirky early summer, fat hot August, and smooth and gentle September; February is not at all like March nor like the waning daylight of December.

What sort of weather conditions makes you feel most alive? I have a friend who is positively beside himself in still air; unless there is a breeze he feels suffocated and trapped. I happen to prefer still days, especially mornings and evenings. Drizzles are comforting for some, snow at night for others.

What time of day is your time of day? Time of day and quality of light I think go hand in hand. The long August evenings stretching until bedtime seem awfully good; some prefer midday with no place to be lazy or hide in the shadows. Afternoon is naptime for me in any season.

Nature has an infinity of complexions equivalent to our moods and complexes. The more carefully you consider Nature's vast array for the investigation of your Self as landscape, the more particular and revealing the fit between your Self and Nature will be in return.

We are now ready to make the first mark. The strategy will be improvisational; that is, begin with no particular image in mind, allowing one mark to suggest the next. Having selected the kind and size of surface that seem to fit the general point of view you now have as a consequence of all the characteristics of place, season, weather, time; having found a "good" site to work in and selected a medium that will appropriately combine its voice with your own, you are already deeply situated in your metaphoric landscape. The unblemished surface of your paper awaits your first touch.

The first mark cuts the pregnant void and places the entire surface in dynamic tension. Feel this disturbance in the world of your piece, become sensitive to how the echoes of your original mark rebound, creating overtones and vacancies. Your first mark was a call into the world, "Here Am I." Your next mark will be the world's response, "Show us the 'you' embedded within your human form." Keep this searching conversation going for as long it remains authentic, convincing. Then stop.

REFLECTION

The magnitude of this work, no matter the scale you worked in, most probably required a significant amount of time, two to three hours, perhaps longer. More than likely it presents news to you that you have not reckoned with before. Therefore it is appropriate that you give an appreciative amount of time to disengage with the process of creation and get into a frame of mind of reflection. The cutting edge of your inquiry was the question, "If I were to transpose my outer form into the form of a landscape, what natural forms would my Self assume?" As you scrutinize the work just completed, keep raising that question repeatedly. You did not start out to make a beautiful thing; you set your sights on the meaningful thing. Stay the course, mine that vein. Here again, a reflective journal can be of help to pursue a line of thinking, clarify its features, and hold them for future reflection and employment.

You may find reflecting on this work's meanings with another person particularly worthwhile, for several reasons. When alone, answerable only to yourself, you can be more candid but also less confrontational, less revealing. In this way, potential strengths and weaknesses may be overlooked. What anyone else sees in your Self as Landscape must be different than what you see, what you *can see*. Both the congruence and the dissonance of seeing provide important information for you to consider, news you could not obviously obtain on your own. Because this news may be extremely sensitive—either because it is true but prematurely announced, or untrue and thus misleading—choose as your partner someone who is truly dedicated to your well-being. Reflecting on the meanings imbedded in your work with another person establishes a field of truth-finding energy that may overcome your habitual areas of hesitancy and insupportable humility, permitting you to see and say what is already true but unacknowledged, thus unemployed in your life and in your art.

Loving Subtle Things

———

THE OBJECTIVE OF THIS ENCOUNTER with Nature is to recognize the positive worth of the more humble dimension of our Selves by noticing that Nature too is made up of quiet things. No matter how full of confidence and assertive we may be, there remains a quiet and unobtrusive quality to our sense of Self. In a culture that values the conspicuous and the loud, these qualities that provide richness, depth, and solidity to our personhood often go unnoticed and unexercised. Yet the qualities of humility and of quietude are of ancient esteem and offer a source of balance and resiliency so vital, especially in a period such as our own, full of shameless extroversion. Experiencing our Selves as possessing unique qualities, unlike those of the majority around us, sometimes makes us reluctant to employ these same aspects of our Selves in the world, even though they may be of real worth. Our reluctance is greater because they seem to have no counterpart in the rest of the given world. And so we subdue and conceal them, and by so doing become less than our actual gifts allow. A pity. By building an alliance between our Selves and the rest of Nature, particularly in the shared, quiet, and more subtle qualities, these same qualities will be nurtured in both our life and, of course, our art.

Turn your attention now to these more subtle qualities within yourself. They may be ones you might find of little social or commercial value, ones about which you feel tentative, ones that seem holdovers from childhood, qualities that you might have acquired as a

result of injury or insult. In some way these quiet elements impart an essential depth, richness, and strength to the total constellation of attributes that go into the alloy you call your Self. It would be good to recognize them, embrace their positive attributes, and position them in your life work and artwork for fuller expression.

Although any time of day may be chosen for this Encounter, I have found the quiet times of mornings and evenings particularly amenable. You may feel that time of day is not as important for you as some internal energy cycle. The point is to be sensitive to the experienced alignment between your Self and the rest of Nature, and to conduct yourself accordingly.

The setting in Nature most conducive to this Encounter is one in which you can be by your Self and Nature, neat. You will be poking around, looking slow and careful, pausing often, not the usual behaviors of a gainfully employed adult in our society. So you will want to find a place where folks unfamiliar with what you are about are not apt to drop by. Still can't think of a suitable place nearby? Remember that all Nature is wild and exhibits all the characteristics of any live thing: a pot of chives obeys the great and severe laws of Nature that are just as compelling for the oak, the butterfly, and the shark.

So, holding the thought in your mind, "My quiet, subtle qualities," walk into Nature and, perhaps with a slow, reflective gait, seek elements of Nature that are quiet and humble in ways that you experience within your Self. You may find that even walking is too fast for this task. Stand still, sit down, lie down. You may find that standing five, six feet above the earth is too far a distance from the surface of the earth. Kneel down, sit on the earth, crawl, allowing your hands to touch, caress the earth. Perhaps seeing itself is too assertive; close your eyes and only listen to the world's subtle music. Feel your own skin rub across the world's skin. Don't be in a rush to immortalize these found affinities right away in some finely made picture or essay. Wait; allow this new companionship to sink in. Savor Nature's humble elements slowly, lovingly, as you would sample a fine wine or gaze at the face of a loved one, or the way in which you would have a loved one come to know something delicate and precious about you.

Some examples:

On an imperial tree, a tiny red mushroom bravely perches on a

slab of bark that in turn casts a faint damp shadow where a pale green lichen hugs its small world with ferocious strength.

Under a half-buried rock, a city of ants scatters as unexpected daylight intrudes on its humorless labors. But one ant, who refuses to abandon the soft life encased in the transparent egg secured in its jaws, defies you—or any intruder, no matter their monstrosity of size— defies you to countermand its ancient orders to protect with the price of its life.

The steaming surf has torn the bottom from the ocean's bed, heaping dark mounds of life interrupted. One pink crab with one re- maining claw surveys the field of slaughter with one good eye, calmly.

A bird, a junco, waits on the fence. Night is coming. The snow turns blue. Then indigo. The wind picks up cones of twirling snow; frost tears stream from my eyes and freeze as they coat my beard. I turn to go in. On the fence, the junco faces into the wind.

Ice freezing late in the afternoon across a shallow puddle on the roof of my porch outside my window, at eye level. The little pond served as a watering hole for birds all day. Miniature waves created miniature bays, archipelagoes, and islands. Now with sun gone, ice crystals fan out from unexpected points along the shore, converting the ephemeral beauty of free water into the fixed beauty of ice crys tals. If I turn my head away for even a minute, an entire bay becomes an exquisite etching to be found in a quiet corner of a museum.

A spider in the corner of my studio, not five feet from my easel— impossible that it would not have observed my wonderful painting in progress—expresses enthusiasm only for a hapless gnat.

Geranium buds waiting their turn to flower.

When you have made your mutual acquaintance, then with ap- propriate media further explore and celebrate your mutual, subtle el- ements. You might begin this effort by pausing for a long moment, seeking a quiet place within your Self. So centered, so quieted, you are ready to select a color or an object whose own inner presence of a more reserved, veiled, or subtle nature will lead you into the creative experience. You might allow your nondominant hand to initiate the process; after all, it well knows silence and rectitude. Don't rush into this, but allow it to find its own tempo, which might be different from the one in which you ordinarily go about your artistic endeavors.

Before you share the process and its products with others, this might be an apt moment to tease out the more subtle qualities of the experience by remaining by yourself and composing your thoughts by writing them in a private journal. When this more personal reverie has been mined for its worth, this Encounter may be further emboldened by discussion with a trusted companion.

Some questions you might ask yourself to take in the full measure of these subtle qualities:

- What new vitality or complexion has this subtle quality begun to add to your art work?
- Who or what incident taught you that this trait was not to be made public?
- What price have you paid to keep this trait from finding its expression in your life and in your art?
- What benefits have accrued from your hiding this light?
- How interested are you in maintaining a veil over this light, now that you have glimpsed its effects on your Self and your art?
- Have you now mined all the subtle qualities of your Self? Or perhaps there are more to be explored?
- Notice the color system you have been employing, the grammar of your work, your line quality. How has each contributed (or not) to conveying these quietly spoken but real dimensions of your being?
- Having uncovered these subtle qualities in your Self, see if you can discern qualities in your companion that you also might have overlooked.

A Glade, a Tree, a Rock

A GLADE, A TREE, A ROCK: three profound archetypes that have engaged the imagination of people over the eons. Archetypes have the power they manifest in our lives because the objects they refer to in the world represent qualities that reside deep within our personal psyches, even, as Jung observed, within our collective histories, our collective unconscious.

A glade: a sudden opening in the woods, a solid place, a relief from the cool, moist depths of the forest through which we have been traveling. Surrounded by a palisade of tall and somber forest, the glade invites us to enter as an island welcomes the weary, wave-tossed ocean traveler. Unable to see deeply where we are going, so twisty the trail, so uncertain our footing underneath, we enter a tranquil open space, easy to take in at a glance, simply and certainly *there*. But a glade is not all that simple and transparent, for the glade is still the thing of the forest; it is not the garden, a human thing. It is Nature's place. It is a place where nothing is overt, but full of possibilities, green possibilities. We trespass when we enter a glade, for the glade is not of human origin, it is the world's—a magical place where every thing is imminent, waiting. How is it that we have come upon such a place? By mere happenstance or something more determined?

A tree: the behemoth of the green world. The oldest living thing. The tallest living thing. The heaviest living thing. The strongest living thing. Like its mineral counterpart, the mountain, the tree is the

watcher over the antics of men: silent, stoic, patient, and indifferent to our scurrying about, dashing after this dream and that hope, plotting and planning as if what we do is somehow consequential to the fate of the universe. Like wizened grandparents, the trees in our lives seem ever capable of enduring our adolescent ways, suffering our presence, perhaps waiting for the next evolution of our species, waiting for a little something better, kinder, more intelligent.

The forms that trees inhabit are as many as the personalities that humans come in. The analogy between the personalities of trees as displayed by their forms and habits of growth, and the personalities of humans as displayed by their cast of mind and consequential behaviors, has been observed throughout literature and theologies. In the Kabbalah, the divine order of the universe is symbolized by the Tree of Life, with its emanations correlated with spiritual attributes and parts of the human body, central features in explaining the isomorphisms that underlie Nature. Less esoteric, the longevity of trees and their conspicuous presence in our lives throughout the course of the year cause us to imbed images of trees within memories of our personal histories. We remember certain significant personal experiences overseen by a particular tree whose vivid appearance helps us to locate that memory in a bounded address of time, place, and season.

Living indoors as we do, our view of the world is most often framed by a window, which, if we live no higher than the sixth floor, frequently contains the sight of a tree. This tree, this living wild thing, becomes a special companion to our domestic day. We on one side of the windowpane surrounded by human furnishings, going about our business doing human-purposed things, the tree on the other side of the transparent sheet, open to the direct and obscure (to us) forces of the universe. Ah, the idealized pleasures of the open life, there in the grand presence of *that* tree, just the other side of that thin sheet of glass. And our life, wrapped up as it must be in the endless gauze of thought, feeling, plan, and schedule. An isomorphism of another kind. Besides the commercial and structural supports for so much of our lives, shade for our bodies, beauty for our soul, food for our bellies, trees serve our inner lives as points of memories, confessors, companions, participants in our inner dialogues, by means of which we try to assemble the events of our days into something resembling a purposeful life.

A rock: a piece of the very mantle of the earth. If a tree of a thousand or two years of age is the Methuselah of the plant world, a stone of a million years is an infant in the mineral realm. Millions of years old, perhaps billions, a rock holds the history of our planet within its silent self. So encapsulated, so densely confined, this seemingly inscrutable *thing* seems so available and common that we hurl it away from our paths, crush it up for our roads, pulverize it for our mortar. Only its hardness protests. But like the mineral of our own structure—our bones—a rock retains the entire history of its creation. Its long memory is unparalleled, and we miss the opportunity to know where we came from if we fail to pause long and carefully enough to inquire into the rock's own particular way of telling us what it knows. As old as the universe itself, rocks are the most direct descendants of the primal forces of the universe. Pick up a rock and you have in your young hand a most ancient thing that knows in its structural memory the story of the planet from which you too were created.

The gain that we seek in this Encounter with Nature is to bring our Selves into a position so as to have a "sacred conversation" with these three co-denizens of the earth: a glade, a tree, and a rock. By way of a guided imagery, you will be encouraged to take a journey, in your mind's eye, to a glade within a forest through which you will have just traveled, in the midst of which resides a great rock that emerges from the earth as an iceberg rests in the ocean. Where one edge of the rock touches the earth, a tree grows. While in this virtual space, now in the dome of your mind, you will have a special kind of conversation and learn what you are prepared to learn. We will travel to this place in the woods via an imaginary journey. The guided imagery exercise below offers one such model, one that I am comfortable with; other facilitators, participants, and circumstances will of necessity adapt this one to other inclinations and destinations.

GUIDED IMAGERY

The purpose of a guided imagery is to set aside the particular time, place, and circumstance of our immediate life and to create a virtual journey, furnished by the powers of our imagination. We go from here to there because of the same reasons we embark on any journey to a

desired destination: the "there" contains special features not to be found in the "here," features that we desire to make contact with and from which we might grow. The guided imagery is conducted by an adept and trustworthy facilitator, in a place where the consenting participants can safely and uninterruptedly experience the several stages of an imaginary journey that usually requires between ten and thirty minutes. The traits of the competent facilitator are the same that make up the trustworthiness of any teacher or partner to an important relationship: absolute fidelity to the care and well-being of the other.

To begin our guided imagery, imagine that we are on a grassy field; the temperature is mild, and there will be no or few distracting bugs or other interruptions for the next half hour. We have worked together before, and so you have a sufficient degree of trust in me and consent to be guided on an imaginary journey. We could also be doing this indoors or anywhere that the above simple requisites are in place. I will narrate a guided imagery that intends to bring us from where we are now to a virtual glade within a forest where our Encounter with Nature will take place.

Find a comfortable position in which you may remain without effort for up to half an hour. Sit or recline as you will. Look around you, taking in all the particular sights and sounds and smells of your surroundings; this is the place where you are now and to which you will be returning in a short while. Breathe comfortably and, when you are ready, close your eyes. Still breathing comfortably and now listening to the background sounds of the world around you, start to focus your attention on the words I am speaking to you, permitting them to sink into you as if they mattered. Feeling the weight of your body pressed gently against the earth, accept my assurance that your welfare is my prime concern and that together we will be going on a journey via the capacities and desires of your own imagination, to a place that will be a prosperous one for you.

With your eyes closed, comfortable, and feeling supported by the earth itself, in companionship with one who is devoted to your well-being, with each breath feel yourself becoming slightly more buoyant, and begin to float slowly upward. Visualize yourself as you are just now, but from this new position a few feet overhead. There you are comfortably reclining; you hear my voice and listen to it; you float

higher still until a gentle breeze lofts you away from the force of grav-
ity and you begin to feel yourself drifting along in a definite direction.
Beneath you, the landscape has become obscured by some light
clouds. The warmth of the sun is welcoming, the breeze is light but
certain, the current you are in feels assuring, and the direction you are
going in is appealing.

You begin to have the impression that there is a destination draw-
ing you toward it, which desires your presence. Feeling yourself being
drawn in this direction, you notice that there is a break in the clouds
ahead and that you are perceptibly drifting toward that opening. As
you approach, the clouds open, the light grows fuller, and you become
aware that below you the earth has appeared again. The rich colors of
the earth draw you down further, as if now gravity once again has be-
come a force that gathers back to it all that springs from the earth. You
slowly descend as if held gently between heaven and earth, now with
the earth being the host, welcoming you down. Taking several breaths,
and exhaling slightly more fully than inhaling, you become less buoy-
ant, until your feet touch the waiting earth. Looking around, you have
the impression of a place both new and familiar. The exact features are
new, but the general mood or tone or atmosphere evokes a sense of
shared history.

You find yourself in a meadow with wild grasses and field flowers
almost waist high. The same breeze upon which you floated here still
remains but more lightly, flowing now through the grasses and dis-
tance trees, making new music, ripples, and patterns of light across the
land. For a reason that is not clear, yet unmistakable, you begin to walk
through the grasses in the direction of a forest that begins a short dis-
tance away. As lovely as the meadow is with grasses, flowers, birdsong,
aromas, and vistas beyond, you feel yourself being drawn toward the
grand palisades of the trees making up the forest's avant-garde.

Approaching the edge of the forest, but still in the meadow, a cool
and moist breeze flowing from the interior of the forest's life greets
you. It is a welcome fragrance, and you quicken your steps in its di-
rection. You now come to the edge of the great forest itself. Fine
grasses, slim flowers, and warm, unblemished sun overhead give way to
the solemn, tall cathedral piers, columns, and arches of the forest. Light
becomes dappled; sounds become resonant and echo. Smells become

thick and complex. Shapes fade and dance in and out of focus. Your footsteps now fall on the carpeted forest floor. You walk a few paces, stand quietly, allowing the forest to adjust to your presence, take your measure, invite you further in. And after a while you do feel welcome and then notice what might be an old trail leading off deeper into the forest's heart. Feeling drawn to walk this trail, you do so with both anticipation and the anxiety of embarking on any journey whose destination cannot be fully known.

Your walk is accompanied by song from invisible birds and other denizens of the forest. Sentinel trees benignly gaze upon your progress. Aromas perspired by the forest's entire outrageous family waft over you and soak into your clothes, hair, skin, breath. The branches and leaves of the lower depths are constantly caressing your skin. You know you have not traveled this way before, yet you feel unafraid, you feel somewhat at home, but in rooms you have not yet had the chance to open. Walking farther on, you come to a bend in the trail and notice in the near distance a warmer, brighter light in the forest. Making your way closer still, you pass by several particularly grand trees whose canopies form a speckled dome high overhead. You bring your eyes from above, down the bodies of the trees, and notice that in front of you stands a glade, an island of emerald green, a welcome calm after the dense, vertical world of the forest's mossy umbers and damp grays.

The cool of the forest is still with you, in your hair and your clothes. The skin of your face is first to feel the somewhat warmer and dryer air residing in the bowl of this opening in the forest. The light is fuller, brighter, though not so much as in the meadow where the earth bakes from morning to sunset; here only the sun from the column of sky above the glade falls directly on the slender green grasses that carpet the space, from tree to tree. Although you do not recall being here before, there is something about the place that feels familiar. What is it? The proportions of the glade, the slant of the light, it's particular color and warmth? You still remain at the threshold of the glen, your body in the shadow of the forest, but your mind and heart are already advancing toward the center of the green oasis. As you leave the forest's palisades and step into the glade, the thin, light grasses gently blow against your legs, different from the brittle and whipping branches, twigs, and saplings that accompanied you through the

forested portion of your journey. This is neither the forest's wilderness nor the cultivated landscape; this is both and neither.

Your attention now turns to the most conspicuous feature of the glade besides the glade itself: a great rock partially emerged from the earth and, growing from the crease of the rock and the earth, a tree. Different as they are, you have the distinct impression that together they make up two portions of a whole, and that the whole is more and different than a mere combining of the two. Another thought begins to take form; there is a third element, the glade itself. The glade, the rock, the tree—three distinct elements of a larger, hidden entity. The surrounding forest's walls enclose the three as a proscenium arch holds the play. The atmosphere is thick with expectation.

Nothing moves and nothing speaks. Not because the glade, the rock, and the tree have nothing to tell you, but they wait upon a sign from you indicating that you are ready. You do this. You slowly walk through the grasses toward the rock. Reaching the rock, you pause, then slowly extend your hand and lightly touch it with your fingertips. A slight but definite shudder propagates across its frame. You touch the rock again, this time with your palm, then with both palms. The rock warms underneath your touch. You are now drawn to come closer. You take off your shoes, then slowly and gently and respectfully you crawl up onto the great back of the rock and lie down. There. The mineral of your body, your bones, underneath the soft fleshy elements presses against and makes contact with the mineral part of the earth's body, now emerged from the soft humus flesh of the earth. The beating of your body's pulses, breath, blood, sends ripples through the rock that the rock echoes back through you. You close your eyes. The sun's light, dappled by the tree's leaves and branches, falls across your closed eyelids, and you glide into yet another layer of dreamtime.

Because you have come as far as you have, because you have allowed yourself to touch and be touched so closely, because you have come to this place at this time of your life, thoughts come to you shaped by the inhering forces surrounding you, images come to you, things you need to know come to you. Stay in this glade, press yourself to the rock, let the sun's light play across your face, let the murmuring tree whisper to you. Stay awhile and permit your mind to interpret the speaking of this special portion of the world. Thoughts and images will arise as spontaneously as your breath flows in and out,

as your heart beats, all by themselves. Absorb these impressions; allow them to penetrate your frame, your mind, your spirit. Let this simmer awhile.

RETURN

The return to the place and moment of origin of the guided imagery is as significant to this journey as was setting out on the venture and arriving safely at the site of the Encounter. It has been my observation that the out-of-body experiences that a very few participants have, and the more common shifting of orientation that many people have, warrant a thoughtful, informed, highly crafted presentation of se-quenced guided images to ensure that all participants "return" to their former sense of self and place in the world.

It is now time to return. After some time you become aware that the sun has continued its journey across the rim of the glade and the light has become more slanted, the temperature cooler. These signs of the waning day make it clear that it is time to leave the glade and re-turn to the world that you left. But the you who returns is no longer exactly the you who set out just a short while ago. For the you who returns carries new information, new clarity, greater resolve to make manifest in your life work and artwork a fuller account of the actual depth and richness of your Self.

Stand now in the glade, quietly doing nothing. Allow your eyes to take in the arena of the glade about you. Cast your gaze one full final time on the glade, the rock, and the tree, filling your mind's eye with their presence. Now close your eyes. Breathe in slowly and fully, with each inhale taking in slightly more breath than you exhale, imagining yourself slowly filling with breath that is lighter than air. After several breaths you begin to feel yourself once again slowly rising up, gravity releasing its hold on you. You feel yourself rising off the grassy glade, past the trunks and branches of the trees, past the canopy of their leafy dome, and higher still into the light above. The air is brighter here, more uniform. A breeze that seems to have been waiting for you greets you once again, and you feel yourself being taken up and, as in a great, broad, silent river, drifting along with its steady current. You look passively all around you, sky above, clouds beneath, sun warming

all—if somewhat less so than before—and you relax into the river carrying you homeward. Your breathing is easy and in harmony with the pulses of the breeze without. You drift along this way for a while, feeling sated yet full of quiet vitality, even eagerness.

Soon you notice a slight downward pull. Gravity once again has made its presence known. Without concern or hurry, you allow the mass of your body to be welcomed home by the call of the earth. As you drift downward, the layer of clouds begins to thin, becomes a milky veil, then finally evaporates altogether, revealing the face of the earth once again. As you look down from your berth above, the features of the land become cleared, and the more they do so, the more familiar they are to you. There is the field in which you began your journey, and look, that is you resting comfortably. Descend closer to the earth, come closer to the recumbent you. Look closely now at your features, the color and texture of your hair and skin. See how your breath goes in and out, rustling your clothes ever so slightly. Come closer still, actually touch the skin of your face right now, run your fingers through your hair, listen to yourself breathe. Feel the ground upon which you are resting. Notice the heft of your body as it is met with the body of the earth. Rest quietly, doing nothing, for a moment or two. Now take several slow, full, careful breaths, allowing your lungs to swell to their capacity and exhaust themselves. Feel the breath of life filling you to capacity, then deliberately and willingly let it go. Feel life suffusing throughout your entire body and Self. And let this fullness of your life join with the rest of earth's life by opening your eyes, looking about you, saying yes and yes to your special place in Nature. Thoughts and images that came to you while you were on your virtual journey must find their expression in the world of flesh and blood if they are to insinuate their wisdom in your flesh and blood, your art and your life. And so we come to the next phase of your journey, embodiment. Again, it is what artists do all the time, it, embodiment, is always the necessary complement to inspiration.

Some advice. You cannot make an easy illustration of an image that first appears in your mind's eye from dreaming, from imagination, from any source. The interior world of the mind's eye and the external "thingy" world are domains with different affective properties. An overwhelming scene in a dream, if illustrated as such, will more than likely appear in the world as melodramatic and corny. It's only while

you are still in the dream that the dream's images have the power to persuade that they do. How then to proceed? Begin by thinking about the overall mood of your experiences in the glade, and select an array of media that seem equal to the task of investigating the portent of those experiences. That's it. That is what you are now about; not an illustration of what you "saw" in your mind's eye some time ago, but a *current investigation of the portent of the Encounter with the rock, the tree, and the glade.*

You may initiate this investigation in any way that seems fitting; I have a suggestion. Array your media about you so as to compose your Self like the glade surrounded by trees. You are in the center of the glade: the rock, the tree, and you. Now close your eyes; feel again, feel *anew,* the encounter with Nature, the ripples of which are still vibrating at some level within you. Let your hands find the media they have somehow been drawn to. Begin your inquiry, begin to make your mark that furthers and deepens the impression registered in you from your initial encounter. After some time, you may wish to open your eyes and allow your more deliberative mind to join in the process. You may find that the richness and complexity of the original and subsequent experiences with these archetypes invite any number of investigations. Do it. Do it ten times, a hundred times, each time with new enthusiasm for what still remains "out there," or in there. That's what they do in the majors.

I have found that reflecting on all this in an artist's journal provides another voicing, another kind of thinking process to further mine the vein of this Encounter with Nature. The process is so personal, so internal, that speaking about it with another person, at least for a while, seems to flatten the experience somewhat and bring something extraordinary into the ordinary too soon. Just as the rock, the tree, and the glade had in a fashion a private conversation with you, allow this to remain just among the four of you.

VARIATIONS

In this Encounter with the three archetypes, your point of contact was the rock. You can have a different Encounter, providing you with a different portion of the news, by shifting your focus to the other

elements: the tree or the grasses of the glade, or the special light in the glade, or the surrounding wall of trees. Each contact point will provide you with a prime informant, each can provide you with another partner to this sacred conversation, and of course, each series of Encounters can become the basis of a series of creative enterprises.

The different art materials through which you express yourself, or investigate the impressions left by the Encounter, each open a different facet of the multifaceted worlds exposed by this and every Encounter. Therefore, if you find that this Encounter with Nature struck a particularly rich vein, you might explore it more fully by changing your media, say from paint or pastels or collage to clay or fibers, wood or stone, or any combination thereof. Every material provides you with a different lens that both reveals and conceals the thing that it speaks of. Why not mine this for all its worth?

A Blind Walk

———

Come with me as we take a walk into Nature and experience some carefully modulated experiences that are designed to initially disorient you in the service of reorienting you toward an evolved sense of Self, Nature, Self-in-Nature, and the artistic expression thereof. We are going to spend two or three hours together taking a walk through a portion of Nature that is free enough of human noise and fabrications so as not to distract us from our mission. We are seeking as full a degree of unmitigated contact between the raw world and ourselves as possible. Given that we have become mostly urban creatures, it may not be easy to find such a place. But the place we require need be neither remote nor ideal. In fact, the more accessible to where we ordinarily live, the more likely the experiences we have there will have currency in the lives we ordinarily lead. Perhaps a park, a seashore, a garden, or something more remote and raw. Selecting the right time of day and week and season, I have found, often transforms an ordinary and popular place into something where I can be quite by myself and quite close to grand, solemn Nature. Near to the town in which I live is a beach bordering a bay. During the summer, in fine weather, at midday and on weekends, there are several dozen folks enjoying the day. The other eight months a year, during weekdays, at the beginning and end of the day, or with the slightest severity of weather, I am there alone. And of the some hundreds of acres of beach

and surrounding marshes and woodlands, even on a hot Labor Day, except for five or six acres around the parking lot, and the beach closest to the parking, I can still be quite alone.

Let us journey together to a quiet patch of woods not far from that beach. It's a Wednesday afternoon in early October. There is no one else about, just the two of us. We have brought some simple art materials with us: paper, pencils, pastels, perhaps inks and brushes too. We'll pack a knife, some cord, maybe glue, and off we go. If we are so moved, I am sure we will be able to find other materials in the area, the same stuff that Nature uses in its version of self-expression. The world being what it is, there will be plenty of unexpected occurrences during our time together that are intended to be disorienting. Too much of that would not be productive in the creation of a more evolved orientation. Therefore, we will stabilize some less critical aspects of our journey so as to better prepare ourselves for a fortuitous outcome of those events that *will* disturb our equilibrium: simple and familiar media, comfortable clothes, a place not too far from home, and the company of a trusted companion. As you and I go on this journey of the imagination together, I hope you will find me to be that trustworthy companion.

Well, here we are. We left the car in the parking lot—the only car there. Our walk along the beach has been accompanied by some gulls and a tight squadron of sandpipers dashing and swooping before us. We turned in from the shore at some large rocks now half covered by the incoming tide, walked no more than a hundred feet into the woods, and now find ourselves in an open glade with sandy ground underfoot. White oak and scrub pine rise up around us, but not too far up, for their tops have been sheared by the constant shore breezes. We'll put our things down here and just get used to being together, alone in this little crease of the world, before we set off on our journey into a deeper unknown.

I'll stand here; why don't you stand over there by those bayberry bushes and that mossy stone outcropping? No gulls complaining here, no sandpipers to amuse us, no chop of the surf, even the breeze passes far overhead, leaving us quite undisturbed in our little alcove. Just one hundred feet from the byway and we are in Nature that looks all but the same since the retreat of the last ice age over ten thousand years ago. Same sand, trees, bushes, sky. I feel very new and very old and

very timeless here. What about you? Let's just stand here doing nothing for a bit longer, you there, me here.

OK, I'll come over there with you. Feel up for a little adventure? Good. Here's what I thought we might do to make this particular Encounter a rewarding one. So that this "Blind Walk" is not the blind leading the blind, we will begin with one of us closing our eyes while the other remains sighted. To make it a little more interesting, the blind partner will be able to speak, asking questions and expressing wishes, and the sighted partner will not speak but only touch, gesture, and lead. As your sighted partner—that will be me first—I understand your primary need for safety as well as your desire to have a rewarding exploration of Nature through your senses of touch, sound, smell, and even taste.

I also want you to know at the outset that I appreciate the fact that you are voluntarily giving up your sense of sight for a while, for your sight is your first and primary sense of orientation, knowing, and safety. Further that you will be placing your well-being in my care for a while. I will bring you to no harm. I also want you not to merely get through this, but to have a rewarding, enjoyable time; I want you to draw closer to Nature in a way that you could not pursue so readily by yourself. I only know you a bit, but even that small portion of you I have glimpsed provides me with important clues as to what kind of adventure you might best profit from. The gravity of my responsibilities is apparent, and I accept them fully. This journey will be about and for you, not me.

You determine how best for us to hold on to each other: hand in hand, or wrapping our arms together more fully. Would you like me to hold one hand and put my arm on your shoulder as well, or around your waist? Do you want to put an arm on or around me too? Whatever kind of proximity will allow you to feel both secure and free enough is fine with me. We will take a walk around this area in this fashion for about ten minutes; then we will exchange roles: you will become sighted and silent, and I will be blind and talking. Ready? You determine the pace, I'll determine the places and things you will be introduced to. Hold on to me just so. We're off.

We stand still, your arm twisted around my own, your hand secure in mine. Your head is held high as if you can see, your breathing is calm but high and somewhat shallow. The first bit of ground is rather

flat, with not much to take note of, and so we'll walk across the glade, toward the bayberries on the other side. You stay right alongside of me, lifting your feet higher than necessary and placing them down carefully. There is a sweet little smile on your face; it might be nerves, or maybe you're just relaxing your grip on the steering wheel of life, going along for the ride. Getting to a bit more broken ground as we get to the edge of the clearing, I feel a stiffening of your arm and a slowing of your pace, so I proceed more slowly. I stop just before one of the bayberry bushes and stand still a moment for you to compose yourself; then, bending down, holding your arm close, I extend my hand with yours for you to touch the grainy berries of the bush. You seem surprised but delighted at their hardness and rough texture. I squeeze one of the berries between your fingers, then bring your fingers up toward your nose. You get the meaning and breathe in deeply. You turn to me with a full smile on your face and say, "Delicious. What was that?" I squeeze your hand rapidly twice, intending to remind you that I am not speaking. "Right," you say. I raise you up, and we walk slowly to the right where there is an oak that I want to introduce you to.

The oak is a grand old fellow with a wide, open crown, but all of that is out of touching range; I'll have to settle for something closer at hand. Before we get to the tree, I slow down our pace and again bring you down by bringing myself down to the ground and holding you close. "Hey, what's going on?" I squeeze your hand twice, and you say, "OK, I'm game." We crawl forward where the ground rises up by the thrust of the tree's tenacious hold on the earth and reach for the light. A muscular root emerges, then another one overlapping the first. I bring your hand to where the root emerges from the soil, follow it up a bit with you, then release your hand for you to follow the root further if you choose. You are smiling again. "I'll take it from here." Disengaging from me, and now on all fours, you carefully follow along the roots to where they merge with the base of the tree proper. You glide your hands along its trunk. "This is some big fella." Further up you come to a scar from a limb that was lost a long while ago. "Ummph, what happened here?" You feel around the smooth, annealed edges of the wound, around the center where the source of the wound remains. "Just like us, eh, fella?" As you pat its trunk, the oak makes a deep and hollow mutter in return. Reaching higher still, you

stretch overhead as far as you can and come to a branch that shoots out from the trunk and extends beyond your reach. Stretching along its trunk has brought your face against the oak's own side, sheathed in bark as it is. Noticing its abrasive skin, you initially bring your face away, pause, then return your cheek to its side. This time you stay cheek to bark for a while, one side of your face to the air and the slight warmth of the sun, the other side pressed lightly against the cool skin of the oak. You bring both arms around the waist of the tree, running your hands up and down its hoary sides. You say, "I think I'm getting the picture." Smiling again, you lean more fully into the tree.

We go on like this for several more minutes, me introducing you to rocks, leaves, grasses, vines, birdsong, wind blowing through tree-tops, the smell of moss, moist clay, a wayward clamshell. Coming to the end of our allotted time, I stop our haptic journey and gesture that it's time for us to change roles. For a moment we are both sighted, and you look all around as if seeing for the first time. Walking over to the tree that you take for *the* oak (you are correct)—"I remember you, old fella"—you stroke its side, walk around the trunk, feel again its roots snaking into the earth, then come back to me and say, "Ready?" And so it goes.

After each partner has had the opportunity to lead and be led, I suggest that you not immediately speak about the experiences you had with Nature and with each other. By conversing too soon, you often miss the more subtle fragments of your experiences. This is a ripe moment to break off our entwined relationship and separately reflect on our gains. Work in solitude now, surrounded by the Nature that you have come to know in a different way. Provide yourself with sufficient time to do justice to these efforts, and process the entirety of your blind walks and creative work before you leave the area. Create a work that is evocative of some element of your blind walk that struck you most deeply, employing the materials you brought, and perhaps materials that you find around you. Thinking about what of the many experiences was most salient, combined with the effort you will put into its visual exploration, will further deepen and synthesize your particular rewards of having drawn closer to Nature in the manner you just experienced. I have found that a rather large format is helpful here. Small-scale undertakings tend to convert this whole-body experience into a wrist- and finger-sized expression. Once things get going on

that scale, it is hard not to make something picturesque rather than a fuller expression of immediate impressions. You can always refine and craft the work once you have gotten the main proportions and features resolved. You are in the woods now, your body is still tingling with the sensations of the new; why not take advantage of the moment to make a full contact sheet?

You might find, after selecting the materials you wish to work with, that you want to proceed, at least at first, with your eyes once again closed, guided by impulses of the physical sensations that are still with you. These physical impulses are never merely muscular twitches, echoes of earlier stimulation. All sensation has reciprocal intellectual and emotional content, and spiritual content as well. When you work with your eyes closed, you often gain access that is more direct to these sources, avoiding the often severe judgments of our eyes, eyes wanting to make things prettier than truth requires.

REFLECTIONS

When you return to your partner to share your reflections, you might try engaging in a conversation that is made with the same deliberate care of saying and listening as you took during your blind walk. That is, say what might be prosperous for your partner to hear, and listen in the same fashion, as if the other's well-being depended upon the sincerity and fullness of your listening.

Some questions you may ask yourself about your personal gains:

- Are there some new dimensions of Nature that you perceived for the first time or perhaps in new ways or degrees?
- Are there some old fears or hesitations that now seem less compelling and inhibiting?
- Without your sense of sight to unify and make coherent your experiences, were there distinct perceptions of Nature that were brought to you by your other senses: touch, hearing, taste, smell?
- Are there now some appreciations of your Self as a legitimate presence in Nature, not quite the interloper you may have considered yourself before?

○ Are there some new qualities, some more expressive shapes, lines, color systems in your artwork as a consequence of this brush with Nature and your efforts to express them?

This trip is not over; watch your dreams for any new material, vocabulary, grammar, plot, outcome, characters. This Blind Walk may have brought you not only closer to Nature in a new way, but close to your partner in a way you may not have experienced before. Being so beholden to another for your safekeeping, and responsible for your partner's safekeeping, in the always new great out-of-doors, may have provided you with a way to notice how different social circumstances

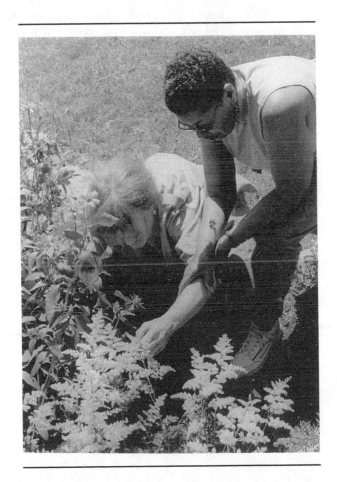

predispose you to experience Nature in new ways, from novel perspectives. If this was indeed the case, what aspects of Nature were you able to notice while you were mutely leading someone else? What of Nature revealed itself when you were blind, but being led by someone else? What aspects of your Self became evident in these two situations?

FURTHER POSSIBILITIES

There are other ways of conducting a blind walk that further deepen the experience and enlarge its rewards. For instance: *Both* you and your partner might journey about with eyes closed holding on to each other; both of you may speak, or one and then the other may speak, or neither may speak. In the creation of your expressive imagery, you might explore the possibilities of working with your partner on a joint piece, perhaps postponing talking until the entire process has run its course.

The blind walk is a powerful way to reexperience Nature, and when done under the careful tutelage of a trustworthy partner, gives rise to many new ways of seeing the world and your Self. Such news invites many ways for it to be mined and refined, and it is hoped that this is exactly what you will add to the suggestions above.

A Natural Sanctuary

SANCTUARY: A PLACE in the world safe from unwanted intrusions, out of harm's way, a room of one's own. A special place that serves not only for privacy and quiet, but for that elusive state of mind, body, and spirit that chosen solitude can provide. The very form and substance of the kind of sanctuary we have in mind, a simple and natural setting, should provide added dimension and power to the rewards. That is, the place will be even more modest and unworked than a tea ceremony hut. It should be a place as close to Nature as you find it. Any elaborate fussing to "improve" the site only betrays your dissatisfaction with Nature *as it is*. Indeed, a great deal of Nature is unruly, unkempt bumpy, falling apart, incidental, and, why not say so, dirty. Civilization may be understood as the pains we humans take to rectify the ways of Nature in order to better accommodate the ways of humans. We like things more ordered, more temperature-controlled, easier, safer, softer. Why not? We are squishy things, here for only a bit, and during our moment in the light, we need to make ourselves comfortable and to have a good time, a decent go of it. However, when we construct a cushioned enclosure that all but separates the furnishings and the experiences of our microworld from the things and goings on of the big, fat, dirty world, we run the risk of cutting ourselves off from the grand eternal World in which all the lessons about making it in this grand eternal World reside. When we draw away from Nature, we become correspondingly less natural. As a

consequence, we act unnatural, anomic, awkward, mannered, disori-
ented, weak, frantic. Not good.

What we are seeking here is to provide our Selves with a door
through which we may enter into an intimate relationship with Na-
ture, find a nook in the natural world just large enough for our Self to
fit into, and carry on a private conversation with Nature. That is the
aim of this particular Encounter. Other Encounters intend broader
consequences; here it will suffice if we succeed in drawing our Self
closer to Nature. Just our Self. People I know, those who have the nerve
to call themselves artists and those who do not, take pains to furnish
their domestic surroundings with care. We like to create settings that
complement our values, tastes, persuasions. We do so as a reflection
of the persons we take ourselves to be, and to make accommodation
for the opinions and tastes of those we live with. In the creation of a
personal natural sanctuary, our concern will be both more modest and
ambitious. More modest in that it is a space that is intended to accom-
modate only one—you. No one else, at least no other person. It is also
modest in economy: zero monetary cost. Why? To level the playing
field. No matter how successful or fortunate you may be financially, it
ought to have no bearing here. It's like looking up at the sky—anyone
can do it, and it is always free. It's more modest in another way, too: no
one else will ever know what went on in your sanctuary, so there is
nothing to concern yourself about except your Self.

This is a more ambitious enterprise than decorating your home
and garden. It is more ambitious because it *is* about your Self. It is about
those aspects of your Self that more fully reveal themselves when only
you, as a unique, ephemeral, delicate aspect of the world, come face-to-
face with Mr. and Mrs. Everything. You and they, each in quite a dif-
ferent way, are groping toward contact in a confined and inconspicuous
space, a modest sanctuary where the two of you can finally have that
nice little conversation you always were meaning to have.

It is a rather simple matter, amazing only in rarity. Yet Anthony
Storr, in his book *Solitude* (and before him, Blaise Pascal), tells us that
unless one has the sense of one's own worth sufficient to provide for
a room of one's own, and to spend the necessary time there, undis-
tracted by the pleasures of the noisy world of friends and family, the
likelihood of making contact with the World as it is, no less observing
the particularities of one's own genius, is slim—no, nil.

Find a place just large enough to accommodate your Self. Prefer-
ably, it will be outdoors in the natural world, a place that you can visit
as frequently as every day. But this degree of frequency is not para-
mount; it could be once a week, a month, even a year, although the less
frequent the visits, the weaker the gain is likely to be. If your circum-
stances do not permit an outdoor sanctuary, you could make do with a
dedicated indoor space furnished with some carefully selected living
thing that you decided on after careful deliberation, perhaps something
that required a significant sacrifice in its obtaining. Why? To up the
ante, to freight the effort with a precious cargo.

If you do have the good fortune to be able to elect a place that is in
Nature, your initial expressive act may be the quite simple one of mark-
ing it (perhaps in an inconspicuous way) as a special space where your
Self can converse directly with Nature. The history of sacred groves,
shrines, temples, and cathedrals may have begun with nothing much
more than this: one person come upon a particularly vibrant pulse of
Nature and something shifts within. They bring home the news and
the disturbance spreads. No elaborate effort or display is necessary here;
some polished stones marking the bounds of your sanctuary will do. A
ritualized sweeping and light ordering of some leaves might suffice to
sacralize the space, allow it to shift in your mind from just any place to
This Place. Martin Buber calls this kind of attentiveness to the "other"
a form of saying "Thou" to the seemingly appearing ordinary "it" that
the world often comes wrapped in. Your purposeful attention, your
dedication to the effort, your will to witness the extraordinary that al-
ways resides within the world and within you veiled by the ordinary,
prepares you to engage in the ensuing conversation.

Disengaged with all the rest of humankind, it's just you and a bit
of raw Nature, World, Universe. You a fresh young, squishy thing; Na-
ture, infinitely exquisite, endlessly complex, all ways mysterious—
cheek to cheek. Who will speak first? In this inconspicuous, private,
tiny place, an entire culture can develop, a society consisting of only
two members, you and Nature. Not the entire You that you have come
to be and know. For only a fraction of even "you" will be invited for
membership in this exclusive club. The you who is already a member
of other organizations is not invited. The you who is a family member,
a member of a profession, a town, a nation, a race, a class . . . all these
affiliations are of no consequence here; only the you who remains after

all the ordinary affiliations and definitions fall away. The enduring you who resides beneath and above and beyond these local dimensions of you, meets big, fat, juicy, all-over-the-place Nature. An interesting thing may happen at this point. Juicy Nature somehow dresses down for the occasion and becomes the perfectly fit partner for tiny squishy you. And the two of you, in your little place, get to "talk" about stuff as if you were the only two in the whole universe. You will be surprised what comes up.

Allow your Self to be surprised by what arises in your mind, your body, and your spirit during these sacred conversations. You could, of course, come to your rendezvous with an agenda, and that has its own merits. We probably cannot escape bringing with us the mind-set that preoccupies us wherever we go. When we do so, however, it is we who have the first word in the conversation, and thus it is our hand that always firmly grips the steering wheel, determining the itinerary if not the details of the journey. If, by contrast, we come to this place of meeting with a more open frame of mind, focusing our attentiveness on our powers of perception rather than those of conception, surprising issues and points of view may arise. Points of view and issues that may leap beyond the ones we usually entertain. The degree and kind of surprise is what Nature is bringing to the conversation.

So find a close nook in the side of Nature that fits you and your circumstances. Bring a few essential things with you to mark the occasion and to help you to explore, refine, and retain the substance of your sacred conversations: a notebook, some art materials, a book to read, a talisman, something to ritually eat or drink. You might enrich the rewards of providing yourself with a sanctuary by designating a specific and regular time to make your visits. Self-imposed regularity requires discipline, and it also cultivates the capacity for discipline, a prerequisite of any serious practice of art. Visiting your sanctuary periodically over an extended expanse of time—a year or more—provides you with an order, an orientation to your day. It also provides meaningfulness to your identity as one who has made a real and substantial commitment to draw closer to Nature.

The seasons change, the weather becomes inclement, it gets dark and cold at night. Not all times are congenial for a visit to your sanctuary. That's all right. Do visit in all kinds of weather, in all the seasons, at all times of day. The conversation that might come up in early morning may be quite different than one in starlight. What Nature has

to show and tell you in springtime is not the same thing to be discussed in autumn or when lightly dusted with snow. A rainy day, a hot August afternoon, a brisk and gusty wind in October, all are different pages in a great lesson book, a grand libretto. There will be occasions when you simply cannot make your appointment. That's OK too; go to your sanctuary in an imaginary rather than physical way. Are you at the airport? Sick in bed? Just can't make it there in time? Designate some moments for you to be in your sanctuary within the dome of your mind. Plenty of room in there.

Keep a day book or journal of your sacred conversations. Include something in the journal that was added to your sanctuary since the last time you visited: a leaf, a feather, even a snowflake. These interlopers are bringing some sort of news from the outside. What is it? Nature speaks in things and phenomena; our minds turn them into metaphors. What does the feather "mean" to *you*?

How will this be conveyed into the rest of your life and your artwork? It may take a number of forms that evolve over the period of time that you visit the place. Your visits will begin to gather force when you become aware in a simple but sincere way what it is like to actually be in a sacred grove, and not in an abstract, hearsay, literary pointing to something that someone else, somewhere else, some time ago, referred to. You might initially come to this sanctuary with issues and feelings that derive from your life outside the place. However, if you persist in your visits, you will begin to discern the genius of *this* place. Then this place, like any work of art, will become a distinctive lens and mirror by way of which you can see aspect of the world and yourself that no other lens/mirror provided.

Since art-speak is always elevated speech, the language you employ in your sanctuary, referring as it will to new inner and outer perceptions, may also begin to take on a local dialect. Unfettered by the necessity of being comprehensible to anyone else but your Self, the images you produce in your sanctuary may evolve into an idiosyncratic form, quite distinct from your work outside the sanctuary. You may also find that this new way of speaking and the perceptions gained while in this space begin to inflect the rest of your artistic expressions.

It is all for the good.

Sure? Sure.

Forgiveness

FORGIVENESS APPEARS AGAIN AND AGAIN in the literature of holistic healing as a prerequisite for confronting the illness that we intuitively flee from. Our own anger, guilt, frustration, and sorrow we associate with the transgression becomes embedded in our self-concept, which in turn exacerbates the toxicity of that illness, whether it be of the mind, body, or spirit. "Forgiveness," we are told by Stephen Levine in *Healing into Life and Death*, "allows us to let go the curtains of resentment, the filters of life that have kept us so lost in the mind. Forgiveness softens the clinging and allows our holdings to sink a bit more deeply into the healing heart. Cultivating forgiveness softens our life."[4] Forgiveness presents us with an approach to the toxic event rather than expending vital time and energy attempting to avoid it. Redirecting our energy from anger or the elaborate strategies usually employed for avoidance has the effect of dissipating the toxic frame of mind and allowing the natural healing capacities of the mind-body-spirit continuum to proceed. It does so by replacing the toxic event's associated feelings with a new association: forgiveness.

Because forgiveness originates within the Self, in contrast to the mostly external causes of the toxic event, we gain a measure of control commensurate with the measure of our sense of forgiveness. This reorientation of the self from helpless victim to responsible party replaces a sense of powerlessness and diminished self-worth with an invigorated authority and personal worth. In this manner, holistic

healing teaches us how to forgive the one who injured us even when we ourselves are culpable for our misfortune. So reoriented with our dis-eases and more at peace with ourselves, we can proceed to be an active participant in healing our wracked mind, body, and spirit. Would that it were all that easy, but certainly a forgiving heart is a lighter thing to bear than one beset with anger, guilt, and frustration.

There are two directions of forgiveness. One emanates from ourselves toward the person who has injured us. The other also begins from within but seeks the other's forgiveness for an injury that we ourselves have caused. The holistic health literature speaks of healing from bruised relationships by forgiving the people who have injured us. This book, *Drawing Closer to Nature*, urges us also to seek forgiveness from Nature.

The question that comes to mind is this. What of our long-term troubled relations with Nature, our endless transgressions, the infinite occasions large and mostly small when we bruised the World through acts of carelessness, overstuffed appetite, abuse of power, acts of groundless fear? How are we to find peace of mind, and of body, and of our spirit, when we have been such an abusive partner to our one and only? We ate too much at her table, we bought too many of her dwindling stock, we drove too far across and into her, we pulled up, cut down, burnt up, snuffed out, caught, cut, leveled so much of our dearly beloved's comeliness. Unreconciled with our primary relationship, the one that we consume and drink and breathe from moment to moment, the mother of us all to whom we are permanently affixed as in utero, how can we expect to complete the healing task provided by an act of forgiveness unless we devote sufficient energy to presenting our Selves in front of Nature seeking a state of forgiveness?

How then to turn to Nature and present ourselves as supplicants seeking forgiveness, for reinstatement in a state of grace? Of course, we cannot seek a sign from Nature that we are indeed forgiven as we seek a sign from another being. The sincerity of time and effort devoted to this state of forgiveness, without requiring some special sign from Nature that all is forgiven, is all that ought to be expected here. Asking Nature for a sign, especially addressed to our own selves, places us once again in a preeminent and demanding position before Nature, requiring something of the injured party that is as unseemly as it is un-

realistic. The task of seeking forgiveness must rely entirely upon our own desire and purity of intention, requiring no affirming sign that we are indeed serious in our intentions.

The many ways of achieving a state of forgiveness with Nature begin to arise as soon as we quietly and seriously turn in that direction of concern, almost as if our inner nature has been ready for this for a long, long while. You might start at the place where any sincere effort must begin, with pausing from the business with the world that you are accustomed to doing. This pause in and of itself is a dedicatory act. And the longer and purer the pause, the more dedicated will be your subsequent effort. Step out of the place in the river of life you usually swim in, in order to reposition yourself in a more advantageous place. Call in sick (you *are* sick at heart after all—is a sprained ankle any more hobbling?). Tell them you can't make it, something has come up. Bow out. Present your Self and Nature with a gift, three hours, a half a day, devoted to working on your relationship.

You could stay at home, but if possible, it would be better if you actually stood in the presence of Nature. How about doing a little something with your Self for the occasion? It doesn't have to be elaborate, nothing more than you would do before meeting someone you have known for a long time but haven't seen much of recently. Your face doesn't really need washing, but wash it anyway. Same with your hands, give them a little extra scrub, not to physically cleanse them but to purify them; that takes a bit more rubbing. How about putting on something special, you know, as if the impression you make matters. It will, in exact proportion to your effort.

Perhaps you have a favorite spot in Nature nearby that has served you before as a place of peace, solace, and reverie. You could take some artmaking materials with you or allow the place of meeting to provide for you. You might take something to eat or drink; it's not that you would be out there long enough for you to want a snack, but the food might serve as part of a ritual that might come to mind while you draw closer to Nature as a supplicant seeking forgiveness. You could jam all these things into a sack and off you go, but why not make this entire journey a mindful, aesthetic, soulful enterprise? Why not wrap the art supplies just so, even if only with a ribbon or a piece of string? How about doing the same with the food? And why not do all this at

half the pace that you usually do the things you do? When acting in this manner, you are already deep into the creative-artistic healing process.

Let's continue with this degree of attention and carefulness. You have just arrived. Well now you *are* there. You might have chosen an overlook, a woodland path, a spot in your garden, someone else's garden, a place by a window where you can glimpse the sky, or even a pot of chives on your kitchen table. Don't start to work right away. Just be. Be still. Be full of a quiet conviction that what you do and what you think matters somehow in the world, matters to and affects Nature. Present what you have brought: your materials, your nourishment, your Self. Compose them as if you are presenting gifts before a beloved whose pleasure is your interest and concern. There you are, you and Nature. Be bold, you make the first effort to approach. It is up to you to say what you need to say and do what you need to do to embody your intention to be in a state of forgiveness with Nature.

THE ENCOUNTER

When we approach the solemn task of seeking a state of forgiveness with Nature, the many ways of achieving that desired state begin to arise as soon as we quietly and seriously turn in that direction of concern, almost as if our inner Nature has been ready for this for a long, long while.

You might begin this journey of seeking a state of forgiveness with Nature by starting at the place where any sincere effort must begin, with pausing from doing business with the world as you are accustomed to. This pause in and of itself is a dedicatory act. And the longer and purer the pause, the more dedicated will be your subsequent effort. Step out of the place in the river of life you usually swim in, in order to reposition yourself in a more advantageous place. Call in sick (you are sick at heart after all; is a sprained ankle any more hobbling?). Tell them you can't make it, something has come up. Bow out. Present your Self and Nature with a gift, three hours, a half a day, devoted to working on your relationship.

Having begun this project from the moment you desired to embark on this seeking after forgiveness, and every step along the way,

you are already in a new position vis-à-vis Nature, and the creation of an expressive metaphoric something is actually well under way. Let's continue with this degree of attention and carefulness. You have just arrived. Well, now you are there. You might have chosen an overlook, a woodland path, a spot in your garden, someone else's garden, or just a place by a window where you can glimpse the sky—or even a pot of chives on your kitchen table. Don't start to work right away. Just be. Be still. Be full of a quiet conviction that what you do and what you think matters somehow in the world, matters to, affects Nature. Present what you have brought: your Self, your materials, your nourishment. Compose them as if you are presenting gifts before some beloved whose pleasure is your interest. Compose them as if you are presenting them to a beloved whose pleasure is your concern. There you are, you and Nature. Be bold; you make the first effort to approach. It is up to you to say what you need to say and do what you need to do to embody your intention to be in a state of forgiveness with Nature.

> Consider the work of Andy Goldsworthy.
> Consider clay vessels baked raku style with the branches of the tree whose life you have taken.
> Consider a photographic essay.
> Consider prayer flags strung along a path, or along a skyline, along the banks of a stream, strewn here and there across a meadow, cast into the sea—at night, at dawn, at dusk, at the first sign of the new moon, along a line of beans you planted, in the four corners of your bedroom.
> Consider planting a tree in honor or memory of a dear one.
> Consider fasting for a period of time, donating the money saved to a nature conservancy including in your letter a work of your art.
> Balance—consider keeping your life in balance.

FORGIVENESS: A PERSONAL NOTE

Felling trees for firewood is a seasonal task I perform that necessitates slaying those trees and burning their bodies for my own comfort. This taking of life for the maintenance of my life is one of the occasions in

which I come closest to Nature, her blood for my blood. It is as primal an act as any, and as such I engage in the act of taking life and giving life with both exhilaration and remorse. Life will be flowing in a new direction now that I divert it from the trees to my family, and my will determines what shall live and what shall die. It is as ancient and profound as that. I carry out these tasks in a mindful and respectful manner. Still, before and after such takings, I find a seeking of forgiveness for what I have taken and some sort of giving back to Nature to be a requirement to reestablish a world order (at least my world order). What I happen to have to offer the world in return for what it has provided me is this thing called art: the making of mindful and crafted expressions of how I have received life. That was the gift I received, that is the gift I have to return.

The perspective I assume in my own creations for many years has been guided by this quote from T. C. McLuhan's *Touch the Earth.*

> When a woman cuts the roots of a young cedar tree she prays, "Look at me, friend! I come to ask for your dress, for you have come to take pity on us; for there is nothing for which you can not be used, because it is your way that there is nothing for which we cannot use you, for you are really willing to give us your dress. I come to beg you for this, long life-maker, for I am going to make a basket for lily roots out of you. I pray, friend, not to feel angry with me on account of what I am going to do to you. And I beg you, friend, to tell your friends about what I ask of you. Take care, friend!"[5]

I pray, friend, not to feel angry for what I am going to do to you. I bring my ax and saw with me to the tree I have chosen to fell, and lay them down away from that tree. Then I sit a distance from the tree, where I can see it in its entirety. I bring its vision into me, like a photographer's camera taking into its own body the light of that tree. Something terrible and something wonderful is about to happen. Leaving my ax and saw, I approach the tree, walking up to it, touching it, feeling its taut and sinewy trunk, its skin, how it springs from the earth, how its limbs reach for the light, the neighborhood it lives in, the neighbors.

I pray, friend, not to feel angry for what I am going to do to you.

On my knees, with my hands, I sweep a circle around the base of the tree, making a slight ridge of the forest's dun. The tree has lived its life in one spot, each portion knowing best a particular phase of the day; morning, midday, and evening. I create a small assemblage in these same directions: north, east, south, and west. I make some images, sometimes some writing in the earth with branches shed from the same tree. I walk around the base of the tree in the direction that the life-giving sun has traversed the same path. Still facing the tree, I walk away, toward the place where I have left my ax and saw.

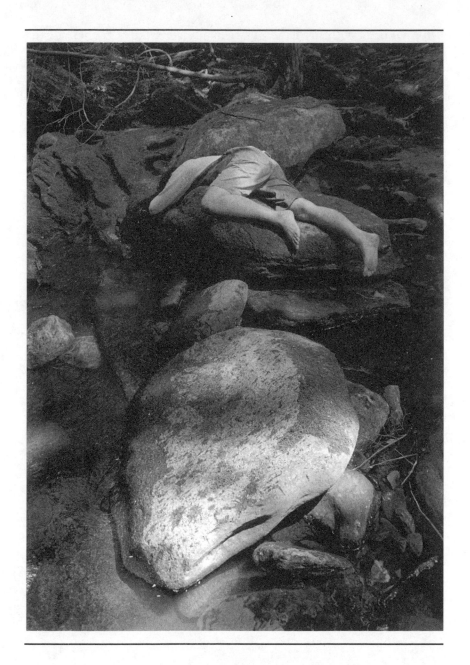

MEDIA
AND
TECHNIQUE

Media

———

THE MEDIA OF ART and techniques for manipulating them take up the major portions of many books offering advice in the creation of artworks. My interest is to be of service in the same way, but with the more expansive and necessarily inclusive ambition that lies at the center of this book. Because our ambition is more than mechanical, our discussion about materials and their manipulation will be likewise. In truth, this entire chapter might be compressed into two sentences: *Any substance will serve as an art material. Handling any medium with devoted care for its outer and inner reality enables you to draw closer to Nature.* Since our initial concern is neither about the durability of things nor their monetary value in the marketplace of beautiful objects, we will devote our attention to other qualities of materials and techniques, ones that are underrepresented in the literature. My remarks here will be in keeping with the two attitudes that form the background of so much of my thinking: *all Nature is alive and speaking* and *only connect.*

I have said that any activity done mindfully, exercised with devotion, to the brim of your capacities, is already an artistic enterprise. Along this same way of thinking, I propose that it is the *intention* of the person taking up the material that establishes it as an art material. Even when the intent, such as Drawing Closer to Nature would seem to suggest natural materials, in truth it does not; sand, sticks, and fire work just as well as a lovely box of Winsor & Newton paints, Kolinsky sable brushes, and Arches creamiest 400-pound, full-sheet, cold-pressed

watercolor paper. It is the fit that counts, the alignment between the artist, the media, and the task. When all three are appreciated as different aspects of one complex and universal phenomenon—Nature— the process of bringing them into alignment is the reciprocal of drawing closer to Nature. We draw closer to Nature as we align our Self, media, and task. Alignment begins by bringing all three substances into the same category, the category of "Thou." Addressing any substance as "Thou" transforms the slumbering pencil, crayon, ingot, or thread *first in the mind of the artist,* then into an elevated presence in the world. The first stop in obtaining your art materials for drawing closer to Nature is in your own mind.

A substance that is thoroughly an "it" is something without interiority, having nothing that is able to respond to a call seeking a dormant "Thou." If you pick up a substance with which to convey your inner life into the outer world, and there is no inner life to the substance you pick up, you will be pushing around dead things; even worse, things that are so completely alien to you and Nature that they possess neither death nor life. It is hard to speak in a language that does not partake of the world that it is required to refer to. Do things have an inner life, an essence that is distinctive, a voice in potential? We do, animals do, plants do—but brushes, clay, paint, hammers, a hank of saffron yarn? Where do you draw the line? Where you do draw the line will be a significant determinant for how you draw that line and to what purpose you draw it.

I know of no artist who doesn't have an informed and serious relationship with every one of their tools and materials. Being a painter, I can remember making the acquaintance with every color I use. I remember the time when I found out about the limitations of Cadmium Red by Rembrandt, and its stiff-necked reactions to a quite decent Ultramarine Blue by Grumbacher. I was hopeful of achieving some good-looking offspring in the violet line, but that is another story. I will tell you the story of the first time I met Scarlet Lake. I was just a kid, and looking for some excitement in the red range. It was a Saturday afternoon, I had just finished with morning art classes at Pratt, and for next week the teacher asked us to get a couple of nice reds. Nice reds. I immediately thought Cadmium Red Dark, or Medium or Light, perhaps Alizarin. I'm in the front of the store with

the great big racks of colors by Grumbacher and Bellini, student grade. I don't have much money for this sort of thing (for *any* thing), so I have to be careful. Eventually I settle on a decent Grumbacher Cad Red Medium and an Alizarin by Bellini. I bring the tubes up to the counter, lay them down as if I know the score. The guy behind the counter looks at the tubes, looks at me, and says, "What are you going to use *them* for?" Uh oh, was this going to be a conversation about art or another opportunity for an adult to make sure that when I became an adult it was going to be with a limp? I tell him I'm looking for some reds that will make a nice violet. He says, "C'mere," and takes me to the back of the store. "You can't go violet with *them* reds. C'mere. You want to go violet, stay away from student grade, you gotta go professional. Ever use Winsor Newton?" No. (I hadn't *heard* of Winsor Newton) "C'mere." And he takes out a little pad of paper, selects a tube, squishes it a bit, opens it, smells! it, smiles down at me, turns back to the tube, puts the mouth of the tube to the pad, squeezes a dab of paint on the paper, and wordlessly shows it to me. A ruby, a drop of blood. "Watch this." He puts the cap back on, tucks the tube back in its little sleeve, places it back on the rack, walks to the front of the store where there is sunlight, expecting me to follow—and I do—and with his pinky smears the dab across the paper. Liquid ruby! Looking down at me as if I had a forgivable birth defect, he says, "Scarlet Lake. I'll give it to you for the price of the Bellini."

Let us suppose for a moment that all traditional artists arising from all traditional peoples were and are not now crazy. Let us suppose that when traditional people assert that a particular tree beckons them to be used in the making of a mask, or when they ask permission of the reeds to be cut down and used in the weaving of a basket, or when they hone the edge of their cutting tool, invoking the spirit of fire to lend its strength to that of their blade, let us suppose that they are not crazy, or pathetically naive, or innocent of the way the world is actually constructed. Suppose they were onto something about the nature of Nature. Something that many artists—Brancusi, Noguchi, Klee, to name but a few—were also onto. That something goes like this; there is a continuum across all of creation, that everything, *everything*, has both an inner and an outer nature in varying degrees of concentration and kind. Everything has a nature, an inherent particularity and

susceptibility, a distinctive manner of responding to its context. Everything's inner and outer nature is meaningful to the total character of all Nature, all reality.

If we substitute the term "characteristic energy" for "nature," we can say that everything possesses distinctive inner and outer energy: humans, animals, plants, brushes, clay, paint, hammers, a hank of saffron yarn. Of course we can ignore this truth and go about our business as usual, shoving and pushing, cutting and nailing, squeezing and pulling stuff as if nothing had an inner dimension except of course us. We also could make really good-looking things this way. It is the way we often make most things. We compel lots of things, and people, to do our bidding in the same way: clay, paint, hammers, children, students, workers. Mind you, you *can* make very nice-looking things that way. And if you are in the business that you call art to make nice-looking things, read no further. What I have to say will only slow you down, making something that is quite simple for you unnecessarily complex.

But if you are into this thing called art for something more, a lot more, then there may be something here for you to read. If the more you seek in the exercise of the artistic process is to indeed draw closer to your inner nature and Nature, elevating not only the quality of the page but also the quality of your Self, then there is another way, the "I-Thou" way of establishing a working relationship between your Self and whatever you employ to make your mark.

Let us be a bit more prosaic after that rather lofty point of view on the nature of materials. You just bought some pencils, a couple of erasers, and some decent sheets of paper. They are, after all, Art Supplies! They did not come with a shaman's blessing; they came from Sam Flax, Binney & Smith, Dick Blick, Wal-Mart! They were made by machines, sold from a rack, and carried in a plastic sack, now tumbled out on a table in your studio, or on your kitchen table. There they are, waiting your command. Here is where you draw the line between what is sacred and what is profane, between what has an inner life and what does not. It is *you* who draw the line, you who make the first cut. Either they are on your side of the line or they are on the other side. You might perceive them and thus treat them as being imbued with an essence that exists prior to and outside of you. Or you might hold that

they take on their character as a consequence of you; your will breathes life into their still forms. Or they are merely things, not even dead, just things to push this way and that, cut, smear, stack, bend, break.

Am I getting too metaphysical again? I hope not. I mean only to say that you have the choice of belief system with which to conduct your affairs. Either the stuff that you work with is dead, or it is *somehow* alive, having both an inner and an outer nature. Not alive like you, but alive like clay, paint, knives. Maybe even this is too much of a stretch for you. But you do want to warm those pencils and paper up a bit. How about this? Can you extend yourself far enough to make a small ceremony of acquaintanceship with these newcomers?

Maybe just lay them out on the table before you grab them for your own pleasure. Lay them out slowly, lay them out in a row, an evenly spaced row. Pick each one up, feeling its heft, weight, texture, size, and flexibility. As simple as this appears, and without any metaphysics: becoming acquainted with your materials before you employ them creates a history of relationship between the two of you, not unlike (in kind, though not in magnitude) parents becoming acquainted with their newborn by slowly and meticulously examining every finger, knuckle, and nail of their little gift from heaven. Developing a personal sensual history with your media is well illustrated by the sensibilities Andy Goldsworthy employs in the establishment of a close working relationship with the natural materials he gathers for the construction of his work. In his book *A Collaboration with Nature*, he presents an ethos on art and Nature that has deep affinities with the principles of Drawing Closer to Nature. "For me," he writes, "looking, touching, material, place and form are all inseparable from the resulting work. . . . Place is found by walking, direction by weather and season. . . . if it is snowing, I work with snow, at leaf-fall it will be with leaves. . . . I stop at a place or pick up a material because I feel there is something to be discovered. Here is where I can learn."[1] Goldsworthy has put his finger on the pulse of a living world, and the work he produces is indeed a collaboration of the inner and outer life of natural things and the powers of Nature to attract and collude with one another. "Movement, change, light, growth and decay are the lifeblood of nature, the energies that I try to tap through my work. I

need the shock of touch, the resistance of place, materials, weather, the earth as my source."[2]

The next time you are preparing yourself to draw closer to Nature, you might start out as so many seekers before you have who also wanted to draw closer to "the source." Start out empty-handed and let the world assemble your hand to play. The willingness to walk into the world with no prescribed outcome, with no prearranged supplies and equipment save the gifts of your mind, body, and spirit, presents you with opportunities for a degree of intimacy with Nature that is unlikely if you are burdened by specific expectations, equipment, and procedures. Thus transparent and vulnerable in your aspect, the more subtle aspects of Nature reveal themselves. And when you respectfully work with the very body of Nature, and employ her methods of creation for your own, you will indeed form a collaboration with *the* partner. Dancing with this one, drawing closer to that one, is to dance and draw as if for the first time.

There are still other ways for you to select and employ the media of your work that deepen and lighten the task. Start out with what the energy of the universe itself has done with the mass of the universe, in the vicinity of the universe that you happen to inhabit. The intelligent imprint of the universe at work is evidenced in all the things of Nature. Earth. Clay. Charcoal. Stones. Grass. Sticks. Water. Fire. Air. Starting out to explore your impressions of being in the world with the things of the world brings you into a collaborative relationship with Nature at the very outset of your journey. Again, not unlike the project that Andy Goldsworthy sets himself.

If you find even this seemingly simple array of media overwhelming in richness of choice, consider an even further refinement. Select only one or two primordial materials to work with for a designated period of time, say a month or two. Clay and sticks, charcoal and paper, grasses, stones, and vines. That's it, no more messing around with "What shall I use today?" Clay and sticks, that's it. No matter what experiences you might wish to explore, only employ the vocabulary and grammar permitted you by the nature of clay and sticks and, of course, you—your mind, body, spirit. With these few variables you can investigate and form just about anything. By working with primordial elements and only one or two at a time,

you begin to understand the dictum that any road followed long enough leads to heaven. If not to heaven, then certainly into the farthest reaches of the nature of Nature. Would it be that surprising that that turns out to *be* heaven?

Crystallization,
Sedimentation, Erosion

In the chapter "On Horseneck Beach," in part one, I wrote of observing the many strategies Nature employs in creating the world and how useful that was for me in expanding upon the strategies I had previously applied in the creation of my work, strategies I had learned while at school. I would like to follow this idea further now. The art instruction that I am familiar with frequently begins with the teacher presenting the students with an admirable object to be emulated in some degree and fashion, followed by a sequence of steps that shows the student how to construct a similar object. The properties of different materials necessitate particular procedures in order to build durable objects that exhibit desired properties of the original object. Since most art teaching concerns itself with how to make a certain class of things, these procedures of *construction* become procedures of *instruction*. Art courses are almost entirely organized according to media and sequenced according to degree of complexity of manufacture. In this way a great deal of advanced art instruction is organized in the same manner as methods and materials: simple to complex. One works one's way from introductory courses through advanced, until the highest level of instruction is achieved, wherein students are encouraged to formulate their own issues and projects, but still within the bounds of propriety, respectful of standards of good form expected of students of that particular school, in that particular year, in that particular department, of that particular instructor. The best

teachers use this opportunity to engage in vigorous dialogue with the students, deepening and broadening their insights into the relationships between who they are and what they are doing, as well as encouraging them to push the limits—within limits—of the possibilities of their art form. It is an effective method of teaching art that brings about the making of many admirable things.

A problem arises, however, when the way one has been instructed to put art together is incompatible with the way one puts one's life together. This results in a not uncommon situation, in which not only are the structural procedures for making art objects at variance with those that are natural to the student, so are the instructional procedures. Where there is a tight fit: nice student and nice work. Where the fit is poor: not so nice.

Most of my teachers, decent, bright, articulate as they may have been, were mostly what might be described as graduated pearl stringers. That is, not unreasonably, they started out small and simple and gradually progressed to large and complex. I came to learn, much too late in my academic career, that I am by nature, helped by inadvertent nurture, a conglomerator, and on occasion, a weaver. That is, whatever the size, shape, complexity of the thing or task, I take it as it is and initially create rather bumpy things, then gradually work those bumps down to something more lean and reserved. I happened to grow up in a family, on a block in Brooklyn, in a world that didn't seem smooth or predetermined at all. It seemed, well, bumpy, like a conglomeration of stuff that got pushed together to make up a day, or a meal, or my room, or my homework.

This may not be the best way to go about organizing one's life; indeed it was an ineffectual and a painful way, but it was my native one, the one I knew best, and it seemed to fit everything and everyone I happened to be squashed together with. And so I got to be not all that bad as a conglomerator. This did not help me out as a student, and frankly did not help me all that well as the child of my parents. Not that they were graduated pearl stringers themselves. They were what might be described as page-turners; once the book was picked up, they turned the pages from the first to last. Not me.

What has all this got to do with art and drawing closer to Nature? It is this: you may have an affinity for a creative process different from the one employed by your art instruction. You may organize your life

in any of the ten thousand ways Nature organizes the ten thousand things on a beach after a moon tide, or you may put your life together the way a stand of saplings sort themselves out when a field has been abandoned by the dairy farmer now that his children have decided that farming is not for them. While you might have wanted to build a mosaic of catch-as-catch-can employing principles of gravity, density, buoyancy, surface tensions, and fluidics, your teacher was stringing pearls, or laying up walls of Boston pavers. The problems that you may be having with your art may turn out to have nothing to do with your problems with art; it may be very different, and much easier to resolve. It may be due to an incompatibility of the way you put your life together with the way the teacher put their course together.

The thinginess of Nature misleads us into thinking that Nature is a noun. But as Buckminster Fuller observed about the nature of his particular life, he seemed to be less a noun and more a verb. Nature too is a verb, and the action it engages in is creating. Because the pace of some of this activity is slower than the pace with which we conduct the creation of our own lives, what in actuality is a verb, we perceive as a noun. We see a tree, but Nature is in the act of treeing. The same is true of mountains, meadows, roses, flamingoes, smelts, stars, and summers. The dance of genesis may at times be slow, its steps subtle, but dance it is.

However, before we launch into an account of the many ways that Nature endlessly creates the world to find systems congenial to the way we create our Selves and our art, we might pause a moment and refine our appreciation of the common noting of Nature being synonymous with change. Merely to observe that all is change is not to observe Nature either carefully or long enough. Change refers only to an unsettling of things, moving them about now here, now there. Change implies no pattern, no direction, no coherence, no interdependency of what gets moved or why. Saying that Nature and our lives are all about change, and that one must learn finally to come to terms with the impermanence of life, is to say too little and too much. Too little because the changes Nature exhibits are not just a colloidal mess. Nature's changes have particular character; from the Big Something-or-Other until now, a lot has developed. A lot of new things are around today that were not there in the first million or so seconds, no less on day one of some of the other versions of the

creation story. Later things exhibit greater specification, complexification, and interiorization than earlier things. It is not our hubris alone that noted the greater vocabulary of responses to being in the world that humans demonstrate, compared with earlier experiments of Nature, say the flatworm.

Too much is inferred from the term *change* as a descriptor of Nature because Nature is constrained by, well, natural laws that allow and disallow certain behaviors. Change implies "Do whatever you want." Nature does not run about helter-skelter; Nature dances. As complex as the math gets, the patterns are remarkable to the degree that some infer a divine intent. Is the dance too slow for you? Too fast? Too subtle? Too intricate? Hard to keep the beat? Your toes get stepped on now and then? Getting dizzy? The music not your cup of tea? Like to sit down for a bit? Nothing to wear? Welcome to Roseland.

But of course there is no one single dance; Nature is multifarious and simultaneous, and so we have in fact an infinite number of possible aspects to partner with as we seek the one that forms its portion of the world in a manner similar to the one we employ in fashioning our own portion. It should be remembered that we are not interested here in the variety of *shapes* Nature assumes at any moment in time, but only in the *processes* that created them, a more powerful kind of information. If we are familiar with the form of things but not with their method of manufacture, we can only gather and rearrange things that are provided us. Much art, and much life, is formed in this way; novel iterations are generated, but only at superficial levels. Bigger bells, louder whistles. If we come to understand the procedures that created the form, how Nature choreographs time and space and things, we are possessed of a system that can not only generate the archetype of the particular form we are attracted to, but also create infinite permutations of that formula by introducing an endless stream of new variables.

We must hasten to add that what we are observing is the macrolevel of Nature's ways of creating, not the microscopic or the telescopic. We are artists, after all, and not necessarily observing Nature here with the equipment or acumen of biologists, chemists, physicists, or astronomers, as more deeply informative as that may be. Eyeglasses aside, we will content ourselves with what our unaided senses bring to us, and we will find that more than ample for our purposes. See if there aren't some fabricating processes here that feel natural for you.

A small sampling of the ways Nature employs to create the world:

The way the forest floor is created by the intermittent rain of things falling; branches twisted off in a sudden gust, the crumbling of limbs gone dead, nuts and fruits and seeds dropping, bursting, their time having come, the peelings of bark, feathers, leaves, and needles, their season in the light now also complete. All this shed life roughly weaving a blanket shot through with one surprise after another.

The way fire probes a pile of things, taking advantage of every vulnerability, every opportunity of air and tinder to burst forth here, suck in there, consume, and leave nothing undone. Fire's leaping about, insane appetite, hissing and roaring as it devours everything within reach. No flaw or weakness is pardoned, nothing not snatched up, nothing sacrosanct. Not finished until every bone is licked clean and a pale innocent powder left where once there was Technicolor life.

But wait. I wrote the above remembering a brushfire I was in the midst of as a young child, and later a kitchen fire that threatened my daughter asleep upstairs. Now, many years after these terrifying acquaintances with fire, it is evening and I was about to address some other portion of this text, when the fire in our wood-burning stove across the room caught my attention. Silently, languidly, the flames danced under the proscenium of the glass door. Blue, then violet tongues tipped with scarlet, then crimson, then orange, back to arabesques of blue. Think of Judith Jamison, Martha Graham, Isadora Duncan. Imagine them draped in filaments colored as above, carrying their own light. Imagine them dancing unbothered by gravity to the great chorale, "Dank sei Dir, Gott," within Mendelssohn's *Elijah*. For that is exactly the piece of music I was playing that the fire danced to a few minutes ago. Please believe me, now that this has been written and the chorus ended, the fire glowed crimson, and the flames are no more. What shall we make of this? Coincidence? Most likely, but then again most of my life consists of remarkable and unremarkable coincidences. What shall I make of *this*? Now back to our list.

Snowing. The many ways snow has of returning water through crystals to earth. Yesterday, as I was writing this section, the snow came down rather nonchalantly in the form of a light powder. No wind, small stuff, so the flakes zigged, then zagged, in no particular hurry to conclude their journey. I got lazy, too, watching them and just stood by the window looking at the same thing over and over. Nothing new

from minute to minute but so complete that I felt complete and couldn't be bothered with doing anything, like making dinner or getting back to writing. No, the powdered snow and now me were just going to hang out for a little while longer. Much longer. I imagine Seurat enjoyed this sort of thing too. But I am not really a Pointillist at heart. I am more drawn to driven snow, the kind of swirling that Monet, toward the end of his life, saw light performing as it danced to a Dionysian music, daring the Appolonian Japanese Bridge to join in, then, having done what it could, danced again across the lily pads and across the pond itself as the cool freshets of evening mixed with the thick light of afternoon. The older and sicker and blinder and fatter he got, the more sublime the music he heard Nature play, the lighter and more athletic his brush as it whirled across the enormous stage of his canvas.

Swelling, as in tomatoes, gourds, melons, and all things pregnant.

Wrapping, as in wisteria, scarlet runner beans, silkworm cocoons, spiders their prey, clematis, morning glories.

Beaming, as in joists and rafters and stringers and femurs and tibias.

Sedimenting, as in a two-day snowfall, a glass of chocolate milk not finished, the seasonal buildup of the forest floor over many thousands of years, the same in marshes and meadows, the annual wash of rivers over its flanks, my son's room.

Shingling, as in the scales of fish, and moth wings, one end fixed, the other free, the free edge overlapping the fixed one beneath. Leaves, too, are shingled, fixed at one end, free at the other, allowing for constancy and variety, rigidity and flexibility: leaves of plants and of books.

Smearing, as in what an over-the-banks river does with fields and houses, and lava flows do with more annihilating and lasting effects. Artists such as Jackson Pollack, Karel Appel, Jean Dubuffet, Antoni Tàpies, George Segal, Georg Baselitz, found troweling, daubing, flicking, spreading, brushing, particularly satisfactory ways to convey their points of view. Painting with somewhat viscous liquids is related to smearing and brushing, but a bit higher up on the refining tower.

Carving, as in what a stream does to a drooping meadow, what a river does to anything, or waves do to a coast, beavers to trees, a farmer pulling a plow does to the field. What a kid does with a bar of soap and a jackknife, and the legion of men and women who over the face

of the earth have carved out of its many substances the record of mind in the world.

Laying up, as in the tumble stone of a glacial moraine, as in short-handed New England farmers setting the boundaries of their fields with the stones of the newly opened fields, keeping cattle on one side, crops on the other. As in Robert Smithson's *Spiral Jetty* or Julian Schnabel's plate paintings.

Gluing together, as in freezing, as in Andy Goldsworthy's winter work, dunking leaves and twigs in the water, holding them until they freeze together. Or the collages of Picasso, Miriam Schapiro, Robert Rauschenberg, or Louise Nevelson.

Unfolding, in New England, as in snowdrops in February, hepatica in March, a fern in April, lilacs in May, a rose in June, a dahlia in July, chrysanthemums in August, the asters of September, late witch hazel of October, the book art of Sas Colby and Paulis Berensohn any time of year.

Arching, as in rib cages, the vaulted domes of skulls and shells and caves and cathedrals and aqueducts and bows and igloos and nut and eyes.

Sheet wrapping, as in skin and bark and Christo, Mr. and Mrs.

Then of course there is crystallizing, veining, webbing, platting, plaiting, pleating, plotting, coating, stacking, sticking, caking, casting, chewing, cooking, bending, blowing, burning, burnishing, breaking, baking, kneading, dripping, draping, hammering, forging, crocheting, stitching, knitting, knotting. Stringing as in graduated pearls.

Another form that Nature takes is my son. As an adolescent he employed the crumple, ball, and stuff style of packing. Unpacking was somewhat simpler: dump and kick. His method of seeking was burrow and toss. However, when it came time to write a paper, all I could observe of his method was: sit down, ooze out, pat dry . . . finished, A+. A gifted boy, and crumpled.

We haven't assayed the many ways animals build and hunt or the ways of weather and geology. But they, too, are there for our instruction and would multiply by several magnitudes our already overample pedagogy. As vast as the array of world-forming procedures that Nature employs, even on the scale of ordinary perception we humans have the dizzying power to combine and order and proportion and

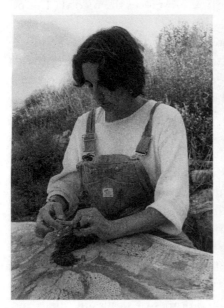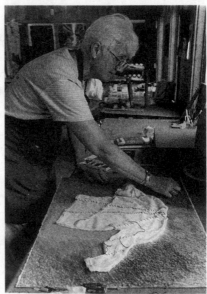

modify each one of the ten thousand ways. As expert as an Early Girl tomato is at swelling early, it always comes up tomato. Same thing for monarch butterfly cocoons and maple seeds and cows' lactation; whatever the color or breed of cow, no matter where and when they get milked, no matter what variety of grass is eaten, it still comes out plain whole milk. However, unlike most other crops of Nature, our particular one has the extraordinary attributes of imagination, calculation, desire, will, play, and some other subtleties of mind that, when they work well (and, it is only fair to say, also when they don't work well), produce unprecedented astonishments.

All these ways Nature employs of creating the world are not just techniques, they are ways of being in the world, they are procedures of making sense, of prioritizing not only tasks to attend to, but values. Just as they entail the handling of different things, tasks to do and the order of those tasks, they also have their own smell, heft, texture, rhythm, sounds, requirements of time, strength, endurance, invited and necessary company. Each one of these ways of creating, whether it be a portion of Nature, a life, a curriculum, a pedagogy, a work of art, is itself a complex system often requiring full understanding, particular

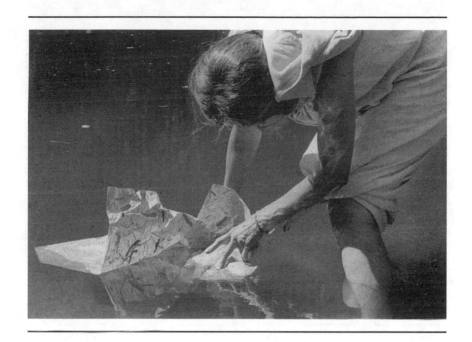

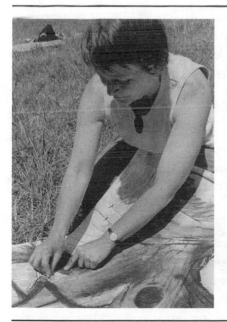
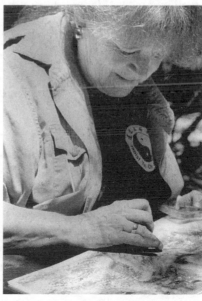

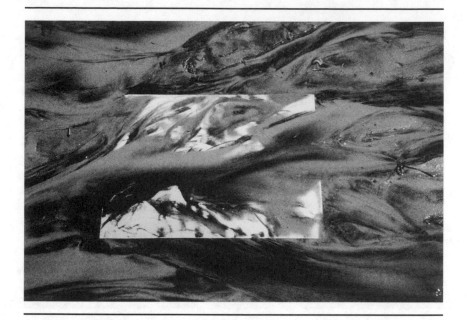

materials, and exact procedures. Weaving, for instance, is indeed a personality trait, a body movement, a certain range of satisfactions of smell and touch. It is also knowledge of the tensile strengths of yarns; the properties of different materials and their capacity to accept and retain certain dyes; how to comb, cart, spin yarn from sheep's wool differently than from alpaca; how to set up a loom so that the design you have in your mind or on the paper gets translated into the many movements necessary to make that into woven goods; how to tie off and knot.

The prime observation that serves as the basis of the preferred pedagogy of Drawing Closer to Nature is that when there is this alignment across the mind and the body and the spirit, there is an automatic shift of performance to greater grace, fullness, and depth of expression. Each of Nature's ways is an entire culture complete with its own history, its own paragons of excellence, its host of stories, its method of instruction, its admirers and critics. To find a way of putting your life together that is in harmony with your basic character and to employ that modus vivendi in the way you school yourself and create your artwork is to establish a profound economy and har-

mony of means. When who you are and what you do and how you do it share deep affinities, a perceptible degree of comfort, of feeling at home in the world, of personal legitimacy, of full disclosure and unashamed presence, suffuses your Self. It looks artistic, it feels natural, and it is.

What about Technique?

———

Much art instruction limits the meaning of technique to the steps necessary to fabricate a structurally sound object, one that exhibits not only physical but aesthetic integrity in its purposeful harmonies of its elements (line, color, form, texture) and its principles of design (pattern, rhythm, dominance). The meaning we propose for technique of course includes the above but expands the term to take into account the pivotal principle that art is a symptomatic expression of life. Physical dexterity, informed and tasteful as it may be, is an insufficient understanding of what technique encompasses for the artist seriously interested in Drawing Closer to Nature. This book is replete with matters addressing these meanings of technique.

There does come a time when our progress toward a fuller expression of our intentions is limited by what we know and can do. Forty years of teaching art with a variety of learners in many settings convinces me that John Dewey and the Progressive Education pedagogy had it right: learning anything occurs more rapidly and thoroughly, and with greater portability, when what is being learned is experienced as necessary to know and do in the present life of the learner. Where this book parts company with most other treatises on making art is in the principle determining the *order* of presenting instruction in manipulative techniques. There is the key to the effective teacher—*the timing of instruction to coincide with the pace, style, and direction of the student's learning.* More is said about the characteristics of the

effective teacher in part six, "Notes to a Teacher." Here we may say about instruction in technique that it has, strange to say, a great deal to do with the capacity to love. Mozart, that great master of unsurpassing technique and refinement of taste, tells us, "Neither a lofty degree of intelligence nor imagination nor both together go into the making of genius. Love, love, love, is the soul of genius."

Much art *is* difficult to manufacture. Learning how to weld, create a glaze, run a seamless wash, cast bronze, make dovetail joints, use three-point perspective, use a router, glue, bake, anneal, rivet, dye, spin, weave, on and on, require complex operations, to be executed in strict order, few of the procedures being self-evident. All technique requires diligent study and deliberate, often prolonged practice if the final work is to reveal the artist's intentions rather than their efforts. There is no substitution for this; there *are* more efficient ways and better materials, but there are no tricks. The thing that makes art a serious thing to do and to consider is that it is not made by trickery. It takes a certain kind of person to dedicate so much of life to getting it right, who measures their efforts against a Platonic ideal of the "good." Not content with only satisfying the viewer as potential customer, this kind of person seeks the contentment of the archetypal critic, who will never, can never, appear.

This effort on behalf of excellence is illustrated in this tale of the reception afforded Beethoven's five middle quartets, the Razumovsky Quartets—difficult, dark, sublime. After the premier performance, an admirer of long standing approached the maestro and said how much he had always loved his music in the past, but that these pieces went too far; he could not follow their logic and purpose. Beethoven was said to have turned to the patron and responded: Well, yes, for you this music did go too far. But, my dear friend, it was not written for you nor for this generation; this music was written for a future audience.

Whether or not this is an accurate account of the conversation, it is a true story. Artists of a certain level of ambition and attainment work to bring heaven and earth together. Impossible to achieve? Yes. And precisely for that same impossible-to-achieve reason, this life in art is always both anxious and delicious. More exactly, delicious *because* anxious. Anxious about what? About achieving "IT." Not that we won't achieve IT; we are old hands at that. No, anxious that we might

just indeed achieve IT. Each time you stand before the blank page, just like each time you cast your lure into the great ocean, you just might hook into the Granddaddy of them all, you just might be there when the Master of the Universe yanks on your line, and hook, line, and sinker, pulls *you* in!

Hafiz says as much in this poem.

> *Fire has a love for itself—*
> *It wants to keep burning.*
>
> *It is like a woman*
> *Who is at last making love*
> *To the person she most desires.*
>
> *Find a Master who is like the Sun.*
>
> *Go to His house*
> *In the middle of the night.*
>
> *Smash a window.*
> *Act like a great burglar—*
> *Jump in.*
>
> *Now,*
> *Gather all your courage-*
> *Throw yourself into His bed!*
>
> *He will probably kill you.*
>
> *Fantastic—*
> *That's the whole idea!*[3]

I believe that we can fish in these same waters with all the delicious anxiety of going after The Big One without waiting to first achieve a high level of technical mastery. *By going after Nature*, the Big One, you draw closer to Nature. There is another way to fish. Another way to draw closer, or pray, or paint. Not by mastery of visual vocabulary and

grammar *before* artistic expression is attempted, but by mastery of vocabulary and grammar *as a consequence of* persistent experiments in artistic expression. This way may be variously expressed:

When there is something of importance to say to someone of importance, then the urgency to say it full and clear is sufficient to say it well.

Or: The engine of craft is the urgency to say something of importance to someone of importance.

Or: The urgency to say something clear and full about something important to someone of importance always results in spontaneously crafted speech, where nothing is left out and nothing is extraneous.

And: We call speech that is clear and full, with nothing left out and nothing extraneous added, crafted speech. More simply we call it art.

And: It is also called sacred speech, for the reason that it is speech of ultimate concerns.

Drawing Closer to Nature always engages one in a sacred conversation, the effort that the emerging Self undertakes to speak with evolving Nature. The effort to draw closer to Nature is always an act of ultimate concern, absorbs our resources, and invites our ultimate commitment. The magnitude of what is at stake crafts our effort proportionally.

NOTES TO A TEACHER

A Holistic Paradigm

I AM AN ARTIST, an art teacher, and an art therapist; consequently the voice in which I compose my ideas often appeals to readers who seek to use these ideas for themselves as artists, art teachers, and art therapists. This section is written mainly for teachers already familiar with the art of teaching who are interested in employing these strategies of Drawing Closer to Nature, not only for the enhancement of their own creativity but for that of their students. It is hoped that others involved in the arts and with Nature, who are primarily neither artists nor teachers, may also find the following viewpoints on teaching of value in their work with their own clientele. Although the term "teacher" is employed throughout this part, readers are invited to consider these ideas from the vantage point that corresponds best with their own purposes.

Our fundamental lesson has entailed how to draw closer to Nature, to "only connect," and to evoke an I-Thou relationship between our Self and any other. Hence the necessity of a pedagogy in which the teacher draws closer to the student, modeling the ways in which a student might draw closer to Nature. In a civilization that has cast Nature out from its midst, how can a friend of Nature bring children of that civilization closer to the Mother whom they recently abandoned? If we are to shift our own lives and those of our students to a more desirable place—closer to Nature—then we require an educational process that addresses all three constituent elements of that life: mind,

body, and spirit. Drawing Closer to Nature therefore requires such an inclusive pedagogy, a holistic pedagogy that is commensurate with the nature of Nature, an infinite web of interdependent elements. *It* is the way it is because everything that there is matters to everything that there is. Just like us. Just like art. Just like art's instruction.

The key observation that the quality of one's art flows from the qualities of one's life forms the single most important premise of our holistic pedagogy. Able teachers will have practiced their own efforts to draw closer to Nature. They will not presume to have completed the task, for then they surely will not have understood that, like evolution itself, personal evolution has no recognizable endgame; evolution *is* the game. Able teachers have committed themselves to this life-long journey of firsthand encounters with Nature. They read this in the hope of finding something of value to make their presence more empowering for their companions' progress as well as their own.

A second bedrock proposition that underlies our pedagogy is a truth succinctly pronounced by Martin Buber: all life is lived in dialogue. From this flows the prime responsibility of the teacher to enable the student to achieve a deeper and broader dialogue with the world. Buber, like the other authors whose perspectives have influenced my own, appreciates that the entire creation is imbued with a sacred geometry, an encompassing complex but real order that humans are capable of perceiving and guiding their lives by. All understand the heavy and marvelous burden on all parties and at all levels of Forster's dictum, "Only connect." An eclectic collection of authors, each with a distinctive perspective and voice, but each holding central and common tenets of the complete human being, would agree: Gregory Bateson, Thomas Berry, Ananda Coomaraswamy, John Dewey, Abraham Joshua Heschel, Jean Houston, Ivan Illich, C. G. Jung, Viktor Lowenfeld, Carl Rogers, Jean-Jacques Rousseau, Rudolf Steiner, Anthony Storr, D. T. Suzuki, Pierre Teilhard de Chardin, Sylvia Ashton-Warner.

Let us begin our notes to a teacher by describing what an education of the mind and body and spirit entails, and how this holistic view of the human being in turn becomes the model of a pedagogy that fits the nature of our student, and the nature of Nature, and corresponds exactly with the nature of art.

Why do the creation of art and the teaching of art become the ar-

duous tasks they so often are? It is not because *art* is difficult—not because grace and fullness of expression and depth of feeling and dexterity are not inherent to the human being—but because we are rather damaged goods: damaged by being brought up in a society that has separated out humans from the rest of creation, and, modeled on this cosmology, separated one from the other by gender, age, race, religion, and class. This endemic dissonance, this vast turbulence, brings about inter- and intra-turbulence. Thus, our personal and collective behaviors are often awkward, weak, hesitant, distorted, unbalanced, anxious, and too often dangerous and unhealthy for the fate of our Selves and for the fate of the Earth. However, when there is *congruence* among the mind, body, and spirit, there is an *automatic and natural* grace, depth, and power of expression.

There is an important corollary to the alignment of mind, body, and spirit, first observed in the literature of art education by Viktor Lowenfeld, the most original and influential art teacher of the twentieth century: The urgency to communicate something important to someone who is important to us supplies all the force we need to express it fully, clearly, and well.[1]

Two principles, then, drive the holistic paradigm of art education: (1) A person who is developed and aligned in mind, body and spirit, *naturally* and *automatically* is graceful, powerful, and full in the expression of all aspects of their life, and (2) the urgency to say something important to someone of importance to us makes us articulate.

It is my contention, based upon the practice of this approach for twenty years, that a teacher who models congruence of mind and body and spirit, and who employs a curriculum and a pedagogy that attend to the mind and body and spirit of each student, can help each student transform a graceless, weak, anxious, and fractious expression to one of grace, depth, power, and even wisdom. Anyone seriously educated, in mind, body, and spirit, and encouraged to address the important issues of *their* life, in their moment and place in history, will express themselves with fullness, wisdom, and clarity. That is, they will be, in their person and in their expression, *artistic*.

What we now refer to as "art" is merely elevated living. The rarity of elevated living, the rarity of the congruence of mind and body and spirit, make art the precious and the arduous thing it is made out to be. It need not be that way. If our ultimate ambition is to elevate

behavior to the degree that the whole and integrated person appears, one who has drawn closer to their inner nature and to Great Nature, then it is the integration of mind, body, and spirit we are after, and it is a *holistic* pedagogy we must employ.

THE ARTFUL MIND

By mind, I mean more than reason. Reason, as powerful a capacity of mind as it is, is only one characteristic of mind and is not in any way the only, or even the primary, agent of awareness and intelligence. For we not only reason, but we dream, imagine, intuit, fantasize, exaggerate, remember, believe, and have the capacity for faith, wonder, and awe. All of these are distinct capacities that, together with reason, form the full array of mind. I believe that a great fault of our systems of education, public and private, is that they take reason as equivalent to *mind*, when reason is only one capacity of the mind's intelligence. This single segment of the mind, to the exclusion, thus the atrophy, of all the other forms of intelligence, damages those other qualities of mind, and in the end weakens and distorts reason itself.

Here is a significant observation that Gregory Bateson made in *Mind in Nature*: when there is *agreement* between what is derived from reasoning and what we intuit, hope, dream, imagine, and remember, we are prone to act accordingly. But when there is *dissonance* among the several intelligences, we are *reluctant* to act. Any one intelligence—even more so, any group of intelligences—not in accord with the persuasion of others tends to veto the whole enterprise and constrain consequential behavior. Learning is supposed to be this hard because learning new behaviors is so consequential.

The mind has many ways to know the world, each way bringing distinctive and necessary news. Only when all the news is in and there is substantial agreement among the reporting agencies of the mind, does the corpus of the Self get permission to act, to behave differently. It is for this characteristic of mind that schooling, as we now practice it, is insufficient to shift behavior, no less elevate it.

The artful mind is a holistic mind. Wonder, awe, intuition, dreams, fantasy, the subconscious, are all states of mind familiar to artists and frequently cited in the literature concerning how artists think. These

states of mind of the artist, in fact of all creative people, ought to find their way into the literature and practice of all education, but they rarely if ever do so. Literature without wonder and fantasy? Science without imagination and intuition? Math without daring? History without an accounting of subconscious forces? You can teach math without daring, but you won't go far. You can teach art without wonder, awe, fantasy, intuition, and in this way, you may even go far, but you won't go deep. The work produced will *look* like art, but it won't do the *work* that art informed by awe, wonder, fantasy, and the subconscious does. *Holistic* education calls upon and cultivates reason, but it also calls upon and thus cultivates wonder, memory, awe, intuition, dreaming, fantasy. Not peripherally and incidentally, but centrally, consistently, and importantly.

How to nurture this domain of mindfulness? You do not have to teach a person how to dream or imagine, or intuit, or to have a subconscious; these states of mind come with being born human. But as teachers, we can allow these qualities of mind to atrophy by our neglect of them. We may nurture this broad and native array of mind by calling upon dreaming and wonder and intuition and fantasy and all the rest as seriously, as often, as rewardingly, as instrumentally, as we now call upon reason. And just as reason flourishes or languishes based upon the degree and kind of attention it receives, so will wonder and dreaming and the rest of the array of mindfulness.

THE ARTFUL BODY

The second element of being human that holistic education deliberately addresses is the body. "A sound mind in a sound body" was even the credo of the architects of reason, rationality, and the academy itself, the Sophists. Here, however, we are not addressing the need to mindfully cultivate the body for healthful and graceful rewards, although this might be motivation enough. Instead, we wish to call attention to the fact that the entire body has intelligence. Every organ, every system, every cell, has intelligence. That is, every cell, every organelle, every amino acid, knows what's happening inside it and outside it, and knows what to do when things are OK, and when they are not OK, and of course knows what is OK and what is not OK. Every

vital entity possesses uncanny pattern recognition, constant awareness, peerless manufacturing agility, unrivaled ability to surmise from the scantest of evidence, and the capacities to improvise, heal itself, and make new parts.

The body is constantly, critically, truthfully telling how it is functioning. But we were never taught how to interpret its form of speech. And so the critical information that this billion-year-old system of refined awareness is constantly providing is all but opaque to us. We must learn the language our medulla and our cerebellum and our spinal cord, our musculature, skin, and the entire network of our central and peripheral nervous system, is speaking. The news is vital. The discipline of medicine is coming to study and understand the synergistic nature of the human being; mental health professionals certainly know this, deep ecologists know this, theologians know this, physicists and cosmologists know this. It is time that teachers of art know this too, and build a practice accordingly.

Further, if the intelligences saturated throughout the body come to a conclusion at variance with those arrived at through the mind, then this dissonance between the body and the mind will inhibit behavior. Holistic education carefully, explicitly, constantly, cultivates the multiple intelligences embedded throughout the entire body. How? The visual arts can learn a great deal about what the informed, aware, practiced, and attuned body requires from the community of dancers, musicians, and theater people. Too, many cultures have developed sophisticated systems of educating the aware, alert, intelligent body— such as the several forms of yoga, ayurvedic medicine, t'ai chi, or the leading edge of our own Western medical traditions. Whatever the tradition, all bodywork that I am familiar with begins with quieting the noisy rational mind and the twitchy, impulsive body so that the more subtle utterances of the whole Self and whole Nature may be heard and attended.

The intelligent, harmonious body is no stranger to the arts. It may well be said that the creative process *is* a process of embodiment. The accounts of artists—visual, theatrical, musical—are replete with evidence of how much inspiration and guidance originates in their kinesthetic selves. Artists are constantly referring to feelings, literal feelings that often appear to them to be automatic, physically demanding of expression in their artistic forms. These physical inclina-

tions need not be the unreliable, vague, and untutored phenomena they are now treated as. There is a nonrational intelligence that is characteristic of our Selves that is located all throughout our many cells, organs, and systems. Teaching that fails to cultivate this body-intelligence reduces and distorts the full and proper education in and through the arts.

THE ARTFUL SPIRIT

We come now to the dimension of holistic education that at first glance might seem quite contentious or at least obscure: spirit. But it need not be either contentious or obscure if we simply define spirit, for our purposes, as any quality we hold to be of *ultimate value.*

The spiritual dimension provides an essential quality to our being and the overriding complexion to our general behavior. Whatever resides enduringly at the core of our belief and value system, or again, whatever is of ultimate and irreducible concern, can be said to create our spiritual dimension.

We should not be surprised to observe that just as dissonance within the mindfulness of the brain leads to inaction or weak action, and dissonance between the intelligences of the body and those of the brain lead to similar constrained behavior, dissonance among our *spiritual convictions* and those of our body and of our mind also confound and constrain behavior. The news is actually worse than this, for dissonance among mind, body, and spirit does not simply dampen or inhibit behavior and learning; more perniciously, dissonance *warps* behavior, more often than not with violent consequences for the practitioner.

However, when there is harmony among mind, body, and spirit, people enjoy what Abraham Maslow termed a "peak experience," or what James would call a "religious" or ecstatic experience, or "flow," as Mikhaly Cziksentmihalyi would say, or just being "in the groove," as Mickey Hart or Louis Armstrong would say. Whatever the name and from whatever the cause, *when there is congruence across mind, body, and spirit, people all report remarkably similar states of being:*

Effort becomes light; ideas flow easily and rapidly; endurance is extended, so is patience; focus becomes more concentrated; time becomes

extended; boundaries soften; definition becomes clearer, crisper; the ego retracts; all the senses become more acute; images appear entire; the world seems pleasant if not joyous; everything seems interesting; everything seems to matter; everything seems to be a portion of everything else; a feeling of affection attends to all; emotions are full but without strong eddies and turbulence; there is a sense of being both replete and full of appetite; it seems easy to be the subject and object of love; there is a sense that one has been privileged to glimpse the features of some divine plan, the feeling that somehow, everything is all right.

In other words, artistic behavior is the natural human behavior whenever there is a congruence of mind, body, and spirit.

What evidence is there for this seemingly radical proposition, aside from what I offer from my own twenty years of its practice? The evidence is ample. It is the basis of instruction of the Bhuto school of dance-theater of Japan; of Gyuto chanting in Tibet and Nepal; of mandala painters of Nepal and Tibet, and among the Navajo of the Americas; of the traditional martial arts of China and Japan; of didgeridoo players and dancers among aboriginal Australians; of traditional Shaker architecture and artifacts, song and dance; of totem pole carvers and mask makers of the Tlinglit of the Pacific Northwest; of sun dancers of the Plains Indians; of the poetry schools of Sufism; of the international Waldorf Schools based on the work of Rudolf Steiner; of Olympic athletes; of atmospheric-level astronauts; of Yehudi Menuhin and Ravi Shankar; of tea ceremony masters; of yoga, t'ai chi, chi gung, tai kwan do; of the Kirov Ballet, Alwin Nicolais Dance Company, and Mark Morris and Company; of the Bread and Puppet Theater; of chanters of the holy books of Judaism and Islam; of the Creation Theology of Matthew Fox in the design of the New Mass; of the deep ecology movements such as Culture's Edge at Black Mountain; of arts training programs at holistic centers such as Esalen, Naropa University, Omega Institute, and the Open Center of New York.

How to evince and nurture matters of the spirit in art education? Here again, the response is straightforward: raise the great perennial existential, philosophical, anthropological, theological, scientific, and *artistic* issues that every person and every society in every generation has wrestled with, with your *own* students as a basis for reflection and expression in *their* work. The very same category of questions that lie

at the core of everyone's arena of ultimate concerns. The questions that impel us to draw closer to our inner nature and to Great Nature:

Who am I? Why am I here? Where am I going? Who are you? Who are we? What is of ultimate value to me and about me? Where are we going? How shall we get there? How will we know when we have arrived? Is this the end of evolution? Is what I am all that I may become? Is this all there is?

These questions, faced squarely, wrestled with by using our full array of mind, within an aligned body and elevated spirit, should prosper the adventure—the immense journey—toward the endlessly possible human, toward the healing of the breach between humans and all the rest of creation, which (not incidentally) has always been the central subject and task of art.

Having just briefly described a general model of holistic arts education, we may proceed to some particular features of applying the model to the teaching of Drawing Closer to Nature.

Empathic Listening

———

EMPATHIC LISTENING IS A FUNDAMENTAL CAPACITY of Drawing Closer to Nature. Like fresh seeing, to which it is related, it is the prerequisite of drawing closer to *anything*. It is the *how* of "Only connect." Empathic listening, as the term is employed here, means paying close attention to what the mind and the body and the spirit of the other is uttering. At some level, everything in the world emits indications of how it is doing in all aspects of its responsiveness to its conditions. We humans, as alloys of mind, body, and spirit, emit indications of the state of our mind and body and spirit all the time, intentionally or not. The effective teacher, like the effective parent, therapist, lover, or friend, is one who can "hear" what is being uttered by the other in all three dimensions of their being. Sometimes all the modalities speak from a consensual position. More often, they do not. The excellent teacher not only can simultaneously read the several languages spoken by the student but, if there is dissonance between what is spoken and how the body emits those statements, can discern which modality is uttering a deeper truth. The truly gifted teacher can then shape their own way of speaking to match that of their student's deeper truth and in this way help the student to arrive at deeper truths because they know that someone has been listening and that they have been "heard."

An exceptional practitioner of empathic listening was the chairman of the art department that I had the good fortune to be a member

of at the outset of my career as an art teacher. His name was Charles Beck, a tall man near to retirement, always in shirt, jacket, tie, and shined, well-worn shoes. With a long, slow gait, this uncool-looking gentleman would wander the halls looking for recruits to his art classes. He sought out truants behind the building where they huddled for a smoke, or in the boiler room or men's room where they were cutting class; often there was a good crop on the bench outside the dean's office waiting to be expelled. He invited kids to his classes who were thrown out of gym after being thrown out of shop on their way to being thrown out of school. Not all this hand-picked crowd signed up on first being asked.

Once I went along with him on one of his recruiting drives, and we found some fellows in the basement playing cards. Mr. Beck walked up to them and said something like, "Fellas, anyone interested in helping me out of a jam? I've been asked to make some posters for the basketball game this weekend and I'm shorthanded, Anyone got some time?"

A kid answered, "We don't wan nothen to do with that fucken basketball stuff and we don't wan nothen to do with this whole fucken school."

"Jeez," said Charlie, "sometimes I feel the same way." And they all laughed. "But whaddaya say, got some time?"

A couple of these denizens of the lower depths would end up going with Charlie. You would think with kids like that, Charlie's art room would be pandemonium, like mine. But no, it wasn't, it was quiet, ordered, with the misfits and ne'er-do-wells all hunched over their desks, rubbing and scrubbing away at work that can best be described as exotic. Charlie would go from student to student, talk to them in hushed tones, the recruit would nod seriously and get back to work. That was it. I couldn't keep a college-track, elective art class from stealing art supplies right from my own desk drawer, and this guy could take a bunch of punks who were bounced out of arts and crafts class and transform them into an elite group of art students. How did he do it?

I asked Charlie. He said, "It beats me. Why don't you come in and watch what's happening and maybe you could tell me."

I did. All I could see was this: no presentations to the whole class, no motivations or demonstrations, no threats or cajoling, just Charlie

going up to each person, looking them dead in the eye, telling them what had to be done, asking them what they thought the possibilities were of them doing something about that, giving them all the time they needed to think their responses through, listening more carefully to their responses than even they were themselves, slowly considering their responses, respectfully responding in turn, asking if there was anything he could do to help them do what they had in mind to do, fully supplying it if he could, then providing them the necessary time and space and material to do what they had to do. When the work ran its course, or they had a question or request, he received them as fully and politely as before. He listened respectfully and fully; they began to speak and act respectfully and fully. He weighed every word they said to him, they weighed every word they said to him, and eventually to each other. They did the same thing with every mark they made because he did the same thing with every mark they made. That's how Charlie did it, taught art.

Empathic listening is the quintessential characteristic of the teacher of Drawing Closer to Nature because the world speaks in many ways. Being literate in only verbal linguistic systems hardly prepares us to adequately communicate with our fellow human beings; it utterly fails to allow us to listen to the many ways the rest of Nature is speaking, and of course, to allow us to reply.

Who Gets to Draw

———

As LONG AS THE STUDENT is under the impression that they are a distinct and separable entity in the universe, they will remain a distinct and separate entity in the universe and will just draw so close to Nature and no closer. As long as the teacher is under the impression that it is they who are the unique possessor of vital information they will remain vis-à-vis their student and Nature the unique possessor of vital information. So encased within the confines of their own egos, neither one will actually be able to draw close to the other or to Nature. And so we must raise the question, albeit quite late in this text: Who is it that draws closer to Nature? Quickly we must answer: You never were distant.

The distance we feel is the distance we make between our concept of Self and our concept of Nature. The more different Nature is from Self, the further we have to go to draw closer to Nature, and the harder it is to get there. Get *there*? Nature is as far and unreachable as it is in direct proportion to how firmly we draw the boundaries between it and us. Desirous as we may be to draw closer to Nature, if who we take ourselves as being is inherently distinct from our concept of Nature's being, we would not be able to recognize Nature even if we were standing on it. Which of course is what we are, or where we are. How could we know that we were heading in the right direction, or how close we had gotten, if we had an image of what the place looked like that we wanted to get to that did not match the look of the place

we wanted to get to? Which is where we mostly seem to be. Nature is not far from us; it is we who are far from Nature.

But suppose we *are* Nature. Suppose we are one more interesting crop of a universe whose nature is fecundity and whose manifestations are infinite. Suppose there is no divorce. And that drawing closer to Nature is not so much an outer journey to some distant exotica but a journey in the exact opposite direction, inward to an awakening of what is already contained within. What we so fervently desire to join *is* joined, just veiled. This is the great truth that all spiritual teaching methods know. It is the truth that informs the practice of Drawing Closer to Nature.

In *Zen in the Art of Archery,* Eugen Herrigel offers a description of the ways of instruction of a master archer in terms that illuminate this issue of "who gets to draw." The context and texture of Herrigel's exposition is important here and so I quote a portion of the text at length.

Several years into his archery practice, Herrigel, an accomplished rifle marksman, is stymied by his inability to even release the arrow properly, no less hit anything with the arrow, and is at his wit's end, hopeless of ever achieving his goal.

> One day I asked the Master: "How can the shot be loosed if 'I' do not do it?" " 'It' shoots," he replied. "I have heard you say that several times before, so let me put it another way: How can I wait self-obliviously for the shot if 'I' am no longer there?" " 'It' waits at the highest tension." "And who or what is this 'it'?" "Once you have understood that, you will have no further need of me. And if I tried to give you a clue at the cost of your own experiences, I would be the worst of teachers and would deserve to be sacked! So let's stop talking about it and go on practicing."
>
> Weeks went by without my advancing a step. At the same time I discovered that this did not disturb me in the least. Had I grown tired of the whole business? Whether I learned the art or not, whether I experienced what the Master meant by "It" or not, whether I found the way to Zen or not—all this suddenly seemed to have become so remote, so indifferent, that it no longer troubled me. Several times I made up my mind to confide in the Master, but when I stood before him I lost courage; I was convinced that I would never hear anything but the monotonous

answer: "Don't ask, practice!" So I stopped asking, and would have liked to stop practicing, too, had not the Master held me inexorably in his grip. I lived from one day to the next, did my professional work as best I might, and in the end ceased to bemoan the fact that all my efforts of the last few years had become meaningless.

Then, one day, after a shot, the Master made a deep bow and broke off the lesson. "Just then 'It' shot!" he cried, as I stared at him bewildered. And when I at last understood what he meant I couldn't suppress a sudden whoop of delight.

"What I have said," the Master told me severely, "was not praise, only a statement that ought not to touch you. Nor was my bow meant for you, for you are entirely innocent of this shot. You remained this time absolutely self-oblivious and without purpose in the highest tension, so that the shot fell from you like a ripe fruit. Now, go on practicing as if nothing had happened."[2]

Lest you are led to believe that you too must endure several years of frustrating practice before you may begin to enjoy the rewards of your own efforts to draw closer to Nature, please understand that the Great Doctrine that Zen adheres to sets no time limits, and that satori can be realized in an instant if awakening is thorough.

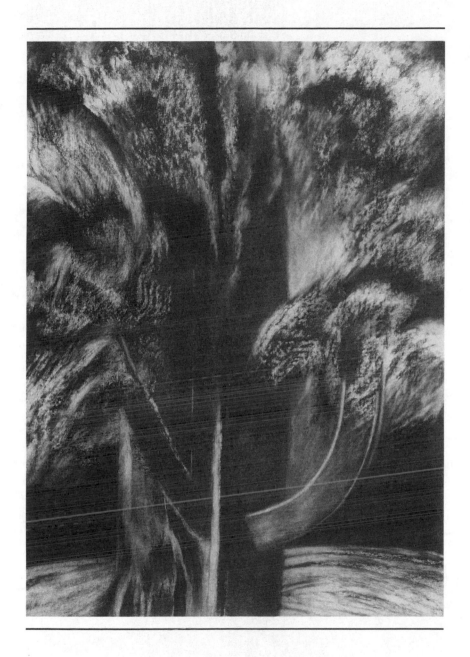

You Can't Go Home Again,
but Homeward You Must Go

───────

EVERYONE WHO HAS HAD a rewarding experience in a workshop or course feels grateful to the teacher, to the other participants, and to the host institution. This is as it should be. What is troubling is the frequent perception that the only way for them to continue to experience these same gains is to replicate the circumstances of the original setting, hence the phenomenon of workshop gurus and their followers. There *are* unique niches in Nature housing ultraspecialized life forms. But these are circumscribed lives in the extreme, confined as they are to their island of vitality. It is the portability and adaptability of vitality that is the greater sign of life's success. More to the point, everything and everyone is a teacher for the one who is the constant student.

We have said that the basic role of the teacher of Drawing Closer to Nature is to reintroduce the student to Nature so as to provide the circumstances for a deeper, fuller, more mutually rewarding relationship: between the student and Nature, and between the student's inner nature and outer Nature. The successful conclusion of the teacher's work will consequently involve the self-sufficient, continuing, evolving, deepening, relationship between their student and Nature. No retreat center, no facilitator, no special companions, no world-class organic vegan cuisine, no exotic island, mountain, or temple is essential for the initiation or sustainability of transformative experiences. They are of great benefit, but they are not uniquely essential. The stars

will suffice, sunrise and sunset, springtime, snow, rain, breathing in, then breathing out. These and all the rest of creation must be instruction and comfort enough. The temple, the master, the cuisine, are the platforms, the pathways; they are not the destination.

There are two prime ingredients for a transformative meeting of the student and Nature: the student, and Nature. The good teacher is ever mindful of the supremacy of that dyad. True, the teacher serves to catalyze a new relationship, and this is no mean task, requiring impeccable performance of knowledge, skill, and utter commitment of self to the service of the other. Nonetheless, the teacher must not *remain* the necessary and active link between the student and that student's primary relationship with Nature.

How to accomplish this when just a short while earlier the very task of the teacher was to position themselves precisely between their student and their student's old ways of perceiving Nature? The same issue arises with parents nurturing their children so that their offspring may at the appropriate phase of development fly free. It is the grand saga of human evolution: from dependency to autonomy to a higher interdependency. How can the teacher of Drawing Closer to Nature ensure the orderly flow of this universal series? Particularly the final stage of their direct responsibility? I suggest that there be several qualities that ought to be taken under consideration.

Most important, don't *you* be confused as to who you are. Then your students will not be confused about who you are. You are not the gift. The gift is what you know, what has been shown to you. You bear the news; you are not the news. The truths you know are the world's truths, they describe what Nature already is. You did not create these truths, you were shown them. You were shown them not only to enact them in your own life. You were shown them so that you may show them. Did you work very long and hard to achieve the level of seeing you have now attained, enabling you to see what some others have not yet seen? *That* is not the big news, that is instrumental news. And unless you make it instructive for others as to how they might also find a better seat in the House, this of course is of no interest at all. When that is clear to you, it will be clear to your students. For those students who mistake the brightness of the news—how the world actually works—for the one who announces the news (a common, because cultivated, misperception), the true teacher corrects this grave error.

You must do this: deflect your students' wandering eye away from you and turn their attention constantly back toward the one that matters: Nature. Do this and the autonomy of your students is ensured, and their return to the life that they must return to, bearing with them the rewards that they just acquired, will be vouchsafed. They will have drawn closer to Nature. You will have shown them what has been shown you. Now it is proper that each of you continue on your journey: moving forward and upward.

Not Necessarily a Bad Day

───

Not NECESSARILY A BAD DAY but a full one. An hour meeting with a departmental colleague went as well as could be expected. Still, toward the end I noticed that my mind was drifting away from my heart (again) and I was feeling slightly dizzy and empty. Right after that I spent more than half an hour going over my e-mail, campus mail, U.S. mail, and voice mail. I taught a class—that's always rewarding. In the hall I had a pleasant enough conversation with Harvey about the underuse of a classroom. I signed some registration cards for two students who were waiting for me back in my office. I wanted to leave by two, but after this and that, finally got out at three-thirty. I could have stopped to speak to a student at the elevator but took the stairs instead. It was still nice out, but this being early December, I only had an hour before sunset. I had a number of things to prepare for tomorrow, but I was so thirsty for a walk on the beach that I decided to go anyway. It's only a half hour's drive.

When I got there, I parked in a different place than usual, closer to the water so I could start walking right away. I had my school clothes on, but I didn't want to go home first, then change, then, then, then. Just go to the beach for a walk. By myself.

The sun was a yard from setting; of course nobody else was out. Cold but no wind, so I was dressed all right. I started out, the sun and water to my right, the sloping beach and slight dunes to my left, in front of me a long stretch of beach that hooked to a rocky point. It

was already getting dark in the east over Cape Cod. In that direction the world was made up of three bands: a thick and textured gray-blue one (that was the ocean), an intense thin gray one (that was the Cape), a very wide one that started out deep gray, then went pale blue (that was the sky). Covered with the grime of many small events of my day, I buttoned my top button and started out.

I wasn't going to relate the following but then I read a poem by Hafiz in which he said:

> *The sun rolls through*
> *The sky meadows every day,*
> *And a billion cells run*
> *To the top of a leaf to scream and applaud*
> *And smash things in their joy.*
>
> *Of course things like that can happen.*
>
> *Rivers stay up all night and chant:*
> *Luminous fish jump out of the water*
> *Spitting emeralds at all talk of Heaven*
> *Being anywhere else but—Right Here!*[3]

So I'll go on with my own true story. As I stepped alone onto the beach, the low-slung sun spread a rosy glow over the rutted sand, salt marsh grasses, and drifts of shells. But the sand and grasses and shells were not a landscape. This was different. (How many times have we heard *that* before?)

But it *was* different. I rushed through the day in order to take a walk on the beach. I hadn't been out for a couple of days, the weather finally turned nice, and I simply wanted to get outside, get some fresh air, be by myself, take a little walk. So I was as surprised as perhaps you are as you read this, that after I had taken only a step or two, things changed. "It" became "she." The sand the grasses the shells the knots of seaweed the small waves lapping at the wet edge of the sand, became to me the unsurprising features of, well (remember how crazy Hafiz was!) my lover. Please understand, it wasn't "as if" the beach was, *she was,* my lover. Search as I might for a more accurate term to describe the relationship—friend, dear companion, secret sharer—as nonsensical as I know it to be, I experienced in the clearest, nonextra-

ordinary way the beach as my *lover*. Although we had met many times
before and none of her features were unfamiliar to me, prior to this
moment the beach and all its artifacts remained just that, a beach with
nice things to look at, pick up, chuck away. I think we were both taken
aback for a moment by this turn of events, but almost immediately we
both seemed to accommodate to our new relationship. At the time it
seemed no big deal. Nobody was watching, we could be who we
were.

As it turned out, she had been going about her affairs all day just
as I had mine. When I arrived, not even changing out of my school
clothes, there she was. Waiting, not impatiently, just waiting. I said,
"My God, you are so beautiful." (This being literature of a sort, I
know that I ought to use a more original, more poetic word than
"beautiful," but that is what I said, and this is a true story.) When I said
this, in response she showed more of herself to me. I saw that the rosy
sand was dimpled with violet lines. I saw sea clams pale blue, mussel
shells, a stout iron hoop, eel grass entwined, a busted whelk showing its
spiral orange interior, tracks of gulls, sandpipers, mice, arcs of dune
grasses, small, mostly gray drifts of pebbles, wider swells of pink bar-
nacles in long chains humping each other. . . . This doesn't sound
beautiful? To me it was. I thought the pink marsh grass spouting up in
large bundles, pulsing now and then in the shore breezes, was beauti-
ful. I thought the long violet shadows cast by rocks and things across
the now-lilac sand were beautiful.

I thought that where everything was, in heaps, mounds, drifts, lay-
ers, plaids, sprinkles, and dots, and how they got there, by being swept,
blown, dragged, smeared, folded, twisted, buried, pounded, was per-
fect. Nothing appeared out of place or in poor taste. I had no urge to
rearrange anything, make something clever, more telling, artsy. I had
no desire to express myself, to work the crowd. I did walk to the end
of the point, but I could have just stood where I happened to be be-
cause everything was already there. I didn't have to do anything.

Or be anyone. I didn't bring anything with me. I didn't feel
obliged to introduce myself, say what I did for a living, make excuses
for why I was late or why I would be leaving early.

I felt I had come home to my other family, the one nobody else
knew about. It was not a bad secret, just our secret. I just said I had
come home to my other family. It was not like that. I had no role in

this other family; I was not a father or a husband. No one depended on me, expected me, called me. I had no place at the table that was mine alone. Still, I felt I could have lain down, looked my fill, fallen asleep right in the middle of everything, and nothing would be bothered. Everything would go on doing what it had been doing, and when I awoke, whenever that might be, everything would still be going smoothly, only now there would be stars and everything would be cloaked in night shades, doing what they do at night.

The sun sank lower still. From where I was standing, the sun goes right into the water. I watched until it did. Everyone stayed at the beach except me: the big rocks in the water, the seagulls, the purple clouds and some stars, the entire stretch of beach all the way to the point, the drifts of shells and seaweed, the marsh grasses and the small waves chopping pebbles.

EPILOGUE

DRAWING TOGETHER

The aim put forward in this book has been to draw closer to Nature via the artistic processes. Simply said, not so simple to do. If our business were to offer instruction in making pretty pictures of pretty Nature, then indeed the doing would be as simple as the saying. Well, almost. But our aim is different, more ambitious.

We want to draw closer to Nature, to shift our very position in the world out of the axis that has us distant, special, alien, exiled, dumb to the ways and languages of Nature, and into a new alignment, one in which we are once again within an infinite Eden, a member on speaking terms with the rest of creation, home for good.

Employing the artistic processes with the complexions proposed, we are about drawing closer to Nature: mind, body and spirit. More difficult to say, more difficult to do. But far from impossible, and quite exciting and rewarding an adventure, and in our opinion, necessary.

A holistic approach to any effort to change our current status for another has been the guiding conviction throughout this book. Our life, whatever it may consist of, and no matter the sincere desire to exchange less desirable aspects of it for more desirable ones, has been built on the sum total of every event and thought, now woven densely together to form "My Life." Finding the exact and giving seam in this fabric, extracting the element to be modified, preparing the whole organism for the introduction of a new element, selecting, shaping, and then introducing this new element into the ongoing river of our life,

requires a holistic approach addressing mind, body, and spirit, because it is the whole mind, body, and spirit that must be and will be changed.

The seam of life that this text has focused upon has been the one where the practice of our art and the ideational and behavioral relation we have with Nature touch. I would like to propose that this seam, primary as it is to the particular purposes of this text, not be the only seam in the web of life that we address in our efforts to draw closer to Nature. The reader of this book is more than likely already engaged in some form of Nature conservation or ecological activism, and I would like to affirm the importance of such engagements in their own right and as a significant complement to artistic endeavors. The many cases for active engagement in the conservation of Nature have been made many times by many authors and much literature; this author can add little of significance or urgency to this vital call.

What I may offer derives from within the slim portion of expertise that I do claim as an artist. It is this: political, social, and financial activism on behalf of Nature deepens the central sources of our artistic projects and reveals features of Nature that remain unavailable to those who do not devote significant energy and resources to the well-being of Nature. Art requires physical embodiment of inner intellectual and emotional life. To the degree that our artwork is on the forefront of our inner life, so does our art take on the dynamics, powers, and authority of convictions closely held. Convictions inform effort; cherished values impart structural dynamics to effort. Ideas matched with words, linked to deeds, create an arc of great tensegrity.

Many people are hard at work calling attention to the plight of the earth and all its inhabitants, and, by caring for the fate of others, making a difference in the quality of their own life. You can only enhance the likelihood of your drawing closer to Nature by doing likewise. For example, I find close affinity with the aims of the Orion Society and am thus a subscriber to their publications. One of their aims is "to heal the fractured relationship between people and nature by undertaking educational programs and publications that integrate all aspects of the relationship: the physically immediate, the analytical and scientific, the inspirational and creative." That is my aim too, and I am glad to be part of the same enterprise. The Sierra Club, the National Audubon Society, the Nature Conservancy, the Wilderness Society, EarthJustice, Greenpeace, Environmental Defense Fund, and

local environmental conservancies are some other environmental agencies whose goals I share and to which I am pleased to be able to be a contributor.

Our culture has spawned a number of profound revolutions these last one hundred years, as if a series of shock waves have concussed the entire planet, requiring each person and each society to pause, take a step back, reflect upon the pattern of their life to date, and then boldly—if they are able—to create a new agenda fit into a new, more detailed and expanded cosmology. All of these revolutions have taken great tolls, only some of which seem to offer more palatable and available rewards than the ones they replaced. Certainly, the environmental movements have been among these great revolutions, and most certainly they promise the largest rewards for the largest constituency: viable and sustainable earth, air, fire, and water for everyone and everything.

With such a universal agenda comprised of so many facets necessary to address, a plethora of initiatives are welcome. The Island Press, a nonprofit environmental publishing house, lists a number of categories of environmental initiatives, each one indicative of a contributing environmental movement. Following is a list of such, and, if you are not otherwise engaged, they are offered as invitations to do so· biodiversity; wildlife micro- and macro-ecosystems; the politics, biology, planning, and management of ecosystems; conservation; forests; oceans; coastal systems; rivers and water quality; ecological restoration; landscape design and architecture; land use planning; rural development; urban parks; zoos and recreation; eco-tourism; sustainable development; science/politics/society; environmental law and policy; human impacts; energy; business and industry relative to environmental concerns, environmental education; environmental protection; history; photography; visual and performing arts.[1] Within any of these communities of discourse and other local, regional, national, and global environmental enterprises, good people of many talents are enabling themselves and others to draw closer to Nature. The particular genius that resides within you, joined with the company of like-minded others, will enable your common enterprise.

I am best at working at making art, teaching, writing, and participating in local civic and environmental initiatives. But I know that the particular constellation of gifts and predispositions I possess are far

from all that is required to advance my personal values in the world. By familiarizing myself and sharing my financial resources with the agendas and activities of organizations with which I share core values, I believe my personal efforts to draw closer to Nature are underwritten while, at the same time, the same agenda is advanced in larger domains.

When we bring our artistic sensibilities and talents to bear upon an enterprise of such profound proportions as drawing the human enterprise closer to that of all creation, we position ourselves in an arena of concern that is the highest motivation for art. For we desire an art that issues from our central being in the world. An art that is informed by the entire cloud of our life, an art that is informed by principles, beliefs, and convictions tested in the bang-'em-up world. We want an art that is unhesitant because its agenda is clear, its hand already dirty with Nature's loamy body. We want artistic enterprises that we are unembarrassed to claim as our own, chosen from the midst of the infinite choices set before us. We want an art that is necessary, is unafraid to pay a steep price for what it holds in high regard. We want an art that calls for a full-court press, because this is a full-court life: mind, body, spirit. It also consists of political, social, and financial structures and forces that willy-nilly enmesh every cogent person. Artists who are oblivious to these forces that affect the state of Nature, that affect the quality of all human existence and that of one's own self, that inflect the very possibility of drawing closer to Nature, deny themselves a major source of authority to declare on their subject. We want to draw closer to Nature in every aspect of our Selves and in every aspect of Nature; otherwise it would be not our true Self or actual Nature that might meet. We want everyone to have the opportunity to so choose and to do so. We want an art that flows from this kind of first-hand knowledge and unequivocal commitment to being a member in good standing of this world.

Time's up. Get to work.

❧ *EVERYBODY IS WAITING FOR A MIRACLE*

Everybody is waiting for a miracle.
A real miracle.
One in which God appears.
Angels are also good, but not the same thing as God.
We want God (preferably) to say something,
do a trick.
We want to see for ourselves that God is God.
Why?
To believe in a modern way,
to believe as a result of knowing.

But the end of knowing, or even belief, is neither belief nor
 knowing.
The end of both belief and knowing is doing.
Now we already know what to do, what we should do.
Everyone knows that.
It's written all over the place.
It's been drummed into our heads since the day we were born
 by everyone.
However, we are still waiting for proof.
We are still waiting for direct knowledge right from God
to actually do what we are supposed to do.

For example: to act nice.
To act nice to everyone
and everything.
Everybody knows this.
But everyone, including this writer,
is waiting for direct orders from God
to act nice.
Otherwise, why bother.

Now I'd like to have you try an experiment.
It's about knowledge
and, in a way, about how much you know.
And about the connection between knowing and doing.

Get a piece of bread.
It doesn't have to be whole grain or anything,
any piece of bread.
(If you are still reading this without a piece of bread
you are not taking a test, you are just reading something
and it would be better if you got some bread.)
Now take a bite, chew it, and swallow it.
The second step in the experiment is this:
Say out loud what you see in front of you.
Don't look around for anything special,
just what's in front of you will do.
A sofa with a few pillows, perhaps, a glass of something on the
 table,
a cat, a dog, and so on.
Say it out loud.

Now comes the test of your knowledge.
How did you transform the bread into sight?
When you get that answer, answer this:
How did you transform seeing into saying?
Take as much time as you need.

Here is another test.
This one starts the same way.
Take another bite of the bread, chew, and swallow.
(You could of course take a bite out of anything.)
This time say out loud
(here again, you could say this to yourself, but that would be
 another test)
This time say out loud a dream that you had recently.

The test question is this: How did you transform this bread
 into a dream?
For extra credit: How did you transform this *memory* of a *dream*
 into *saying*?

We could do a number of tests of your knowledge that are like
 this.

For instance, take a slug of milk
and write down, you can do this in outline form if you wish,
how you transform that milk
into the tip of your left foot's pinkie toe.

Or let's try the subject of hair and see what you know about
 that.
We'll start with how you manage to grow all of your ten
 million hairs at the very same rate,
or how you make them each the same width,
or what you do to make different hair on your head from that
 on your cheeks from that on your forearms from that under
 your arms from that along the top lid of your eye from that
 of the bottom lid from that in your crotch from that in your
 ears from that in your nose.

My guess is you are much like me;
You don't know how you do anything.
But that doesn't stop you from doing everything.

Unless of course it comes to being nice.
For this we wait for God.
Or one of His miracles,
something a bit more gaudy than,
you know,
seeing, dreaming, saying.
Or growing hair.

———

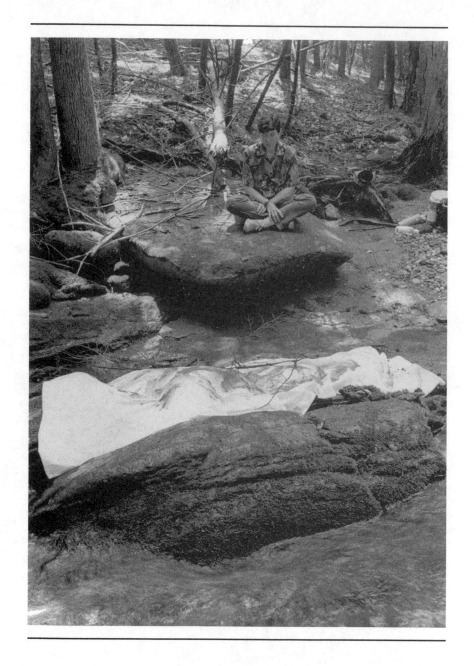

N O T E S

Part One: PERSONAL ENCOUNTERS WITH NATURE

1. Mitchell, *The Book of Job*, p. 88.
2. Heschel, *Man Is Not Alone*, p. 13.
3. Ibid., p. 38.
4. Ibid., pp. 40–41.
5. Ibid., p. 40.
6. *The Holy Scriptures, Masoretic Text.* Genesis p. 3
7. Ibid., p. 4
8. Ibid.
9. Ibid.
10. Ibid., p. 5.
11. Ibid., p. 6.

Part Two: NOTES TO AN ARTIST

1. Dillard, *Pilgrim at Tinker Creek*, pp. 31–34.
2. Shepard, *Man in the Landscape*, p. 35.
3. Shepard, *Nature and Madness*, p. 22–26.
4. Thomas Berry, in "Belonging: An Interview with the Editors of *Parabola*." *Parabola* 24, no. 1 (1999).
5. Buber, *I and Thou*.
6. Marc, *The Animal in Art*.

7. Klee, *Diaries*, July–August.

8. Stein, *Lectures in America*, pp. 212–213.

9. Gelber, *A Sense of Place*, p. 103.

10. Burchfield, in Gelber, *A Sense of Place*, p. 134.

11. *The Portable Thoreau*, p. 351.

12. Ibid., pp. 350–51.

13. See Gitta Mallasz, *Talking with Angels,* the true story of encounters with spiritual beings experienced by four young artists in Nazi-occupied Hungary.

14. Poem by Peter London.

15. Shepard, *Nature and Madness*, p. 9.

16. Mitchell, *The Book of Job*, p. 84.

17. James, *The Varieties of Religious Experience*, p. 53.

18. Carse, *Finite and Infinite Games*, p. 3.

Part Three: THE STRUCTURE OF AN ENCOUNTER

1. London, *No More Secondhand Art*, pp. 78–79.

2. *Tensegrity* is a word coined by Buckminster Fuller. It is a conjunction of *tensional integrity*, the system of mechanics that produces a geodesic dome (hence "the arch of a tensegrity"). Fuller "helpfully" explains the term as "islanded compression and omnicontinuous tension." Helpful? R. Buckminster Fuller, *Synergistics 2* (New York: Macmillan, 1979), p. 177.

3. Storr, *Solitude,* p. 69.

4. Shepard, *Nature and Madness*, p. 9.

Part Four: ENCOUNTERS WITH NATURE

1. Koren, *Wabi-Sabi*, pp. 46.

2. Arunima Orr, personal correspondence, 1987.

3. Teilhard de Chardin, *The Phenomenon of Man*, pp. 244–45.

4. Levine, *Healing into Life and Death*, p. 89.

5. McLuhan, *Touch the Earth*, p. 40.

Part Five: MEDIA AND TECHNIQUE

1. Goldsworthy, *A Collaboration with Nature*, introduction, n.p.
2. Ibid., n.p.
3. Daniel Ladinsky, *I Heard God Laughing: Renderings of Hafiz*, p. 89.

Part Six: NOTES TO A TEACHER

1. Michael, *The Lowenfeld Lectures*, pp. 331ff.
2. Eugen Herrigel, *Zen in the Art of Archery*, pp. 58–61.
3. Daniel Ladinsky, *I Heard God Laughing: Renderings of Hafiz*, p. 57.

Epilogue: DRAWING TOGETHER

1. The Island Press, *2001 Catalogue*.

WORKS CITED

ABRAM, DAVID. *The Spell of the Sensuous*. New York: Vintage Books, 1997.

ARMSTRONG, KAREN. *The Battle for God*. New York: Alfred A. Knopf, 2000.

ARNHEIM, RUDOLF. *The Genesis of a Painting: Picasso's Guernica*. Berkeley: University of California Press, 1962.

BATESON, GREGORY. *Mind and Nature: A Necessary Unity*. New York: E. P. Dutton, 1979.

BERRY, THOMAS. "Belonging: An Interview with the Editors of *Parabola*." *Parabola* 24, no. 1 (1999).

BUBER, MARTIN. *Between Man and Man*. Translated by Ronald Gregor Smith. New York: Collier Books, Macmillan Publishing Company, 1965.

———. *I and Thou*. 2nd ed. Translated by Ronald Gregor Smith. New York: Charles Scribner's Sons, 1958.

CARSE, JAMES. *Finite and Infinite Games*. New York: Ballantine Books, 1987.

CASTANEDA, CARLOS. *The Teachings of Don Juan: A Yaqui Way of Knowledge*. New York: Pocket Books, 1998.

DEWEY, JOHN. *Art As Experience*. New York: Berkeley Publishing Group, 1959.

DILLARD, ANNIE. *Pilgrim at Tinker Creek*. New York: Harper & Row, 1974.

FINDHORN COMMUNITY. *The Findhorn Garden.* New York: Harper & Row, 1975.

FORSTER, E. M. *Howards End.* New York: Viking Penguin, 2000.

FULLER, BUCKMINSTER. *I Seem to Be a Verb.* New York: Bantam Books, 1970.

GELBER, SAM. *A Sense of Place: The Artist and the American Land.* San Francisco: Seabury Press, Friends of the Earth, n.d.

GOLDSWORTHY, ANDY. *A Collaboration with Nature.* New York: Harry N. Abrams, 1990.

HALL, EDWARD T. *The Hidden Dimension.* New York: Doubleday, 1990.

HERRIGEL, EUGEN, *Zen in the Art of Archery.* Translated by R. F. Hull. New York: Vintage Books, 1971.

HESCHEL, ABRAHAM JOSHUA. *Man Is Not Alone: A Philosophy of Religion.* New York: Farrar, Strauss and Giroux, 1951.

HILES, MARV. *The Day Book: A Contemplative Journal.* Healdsburg, Calif.: Iona Center, 2000.

Holy Bible: According to the Masoretic Text. Philadelphia: Jewish Publication Society of America, 1955.

HOUSE, JOHN. *Monet: Nature into Art.* New Haven: Yale University Press, 1986.

JAMES, WILLIAM. *The Varieties of Religious Experience.* New York: New American Library, 1958.

KOREN, LEONARD. *Wabi-Sabi: For Artists, Designers, Poets, and Philosophers.* Berkeley: Stone Bridge Press, 1994.

LADINSKY, DANIEL. *I Heard God Laughing: Renderings of Hafiz.* Walnut Creek, Calif.: Sufism Reoriented, 1996.

LAO TSE. *Tao Te Ching.* Translated by Gia-Fu Feng and Jane English. New York: Alfred A. Knopf, 1977.

LEVINE, STEPHEN. *Healing into Life and Death.* New York: Anchor Books, Doubleday, 1987.

LONDON, PETER. *No More Secondhand Art: Awakening the Artist Within.* Boston: Shambhala Publications, 1989.

LOWENFELD, VIKTOR. *Creative and Mental Growth.* 3rd ed. New York: Macmillan Company, 1952.

MALLASZ, GITTA (transcriber). *Talking with Angels.* English rendition by Robert Hinshaw. Zurich: Daimon Verlag, 1992.

McLUHAN, T. C. *Touch the Earth: A Self-Portrait of Indian Existence.* New York: Pocket Books, 1972.

MICHAEL, JOHN A. *The Lowenfeld Lectures: Viktor Lowenfeld on Art Education and Therapy.* University Park: Pennsylvania State University Press, 1982.

MITCHELL, STEPHEN. *The Book of Job.* New York: HarperCollins Publishers, 1992.

Monet's Years at Giverney: Beyond Impressionism. New York: Harry N. Abrams, 1978.

NERUDA, PABLO. *Selected Poems.* Edited by Nathaniel Tarn. New York: Dell Publishing Co., 1970.

PASCAL, BLAISE. *Pensées.* Translated by A. J. Krailsheimer. Harmondsworth: Penguin Books, 1972.

RICHARDS, M. C. *Centering: In Pottery, Poetry and the Person.* 2nd ed. Hanover: University Press of New England, 1989.

SHEPARD, PAUL. *Man in the Landscape: A Historic View of the Esthetics of Nature.* College Station: Texas A&M University Press, 1991.

———. *Nature and Madness.* San Francisco: Sierra Club Books, 1982.

SOLZHENITSYN, ALEKSANDR. *The Gulag Archipeligo.* New York: HarperCollins Publishers, 2002.

STEIN, GERTRUDE. *Lectures in America.* Boston: Beacon Press, 1957.

STORR, ANTHONY. *Solitude: A Return to the Self.* New York: Free Press, 1988.

TEILHARD DE CHARDIN, PIERRE. *The Phenomenon of Man.* New York: Harper Colophon Books, 1965.

THOREAU, HENRY DAVID. *Henry David Thoreau: An American Landscape.* Edited by Robert L, Rothwell. New York: Paragon House Publishers, 1991.

———. *The Portable Thoreau.* Edited by Carl Bode. New York: Viking Press, 1959.

TILLICH, PAUL. *The Courage to Be.* New Haven: Yale University Press, 1952.

WESSELS, TOM. *Reading the Forested Landscape: A Natural History of New England.* Woodstock, N.Y.: Countryman Press, 1997.

WOOLF, VIRGINIA. *A Room of One's Own* (1929). Cambridge: Cambridge University Press, 1996.

ACKNOWLEDGMENTS

In a book such as this, ranging as widely as it does—and must in support of the argument for a holistic approach to our subject—I have had occasion to draw upon many kinds of sources. The first and primary one has been Nature itself, first as a young boy wandering off from picnicking family to turn over stones looking for whatever may have sought shelter there, hopefully snakes, through to the present, in which I do much the same thing. From these small but many adventures, my artistic endeavors, the work of other artists in many art forms, students and colleagues, have provided me with the opportunity to consider the meanings of my own tropism with Nature. In addition to the authors cited in the bibliography, I am particularly indebted to the many students and colleagues with whom I have worked these several decades, notably Seymour Segal, with whom I taught a number of early versions of *Drawing Closer to Nature* courses. In the give and take of working closely together with these good people, the extent and detail of the premises of the book became clearer and more compelling, hopefully sayable. Their contributions to what has been a long and colorful conversation have been essential. Most of the photographs were taken by David Allen; others by Evelyn Vipons-Schmidt, Ellen Robinson, and the author. Special appreciation must be recognized to my editor, Kendra Crossen Burroughs, who from the first thought the book had merit and whose wise counsel and careful reading helped me to write what I meant, nothing less, nothing more.

CREDITS

Part Two

Excerpt from *Pilgrim at Tinker Creek*, © 1974 by Annie Dillard. Reprinted by permission of HarperCollins Publishers, Inc., and Blanche C. Gregory, Inc.

Excerpt from *Tao Te Ching* by Lao Tsu, translated by Gia-Fu Feng and Jane English, copyright © 1977 by Jane English. Copyright © 1972 by Gia-Fu Feng and Jane English. Used by permission of Alfred A. Knopf, a division of Random House, Inc.

Part Five

Excerpt from Daniel Ladinsky, *I Heard God Laughing: Renderings of Hafiz*, p. 89. Copyright © 1996 by Daniel Ladinsky. Reprinted by permission of the author.

Part Six

Excerpt from *Zen in the Art of Archery*, pp. 58–61, by Eugen Herrigel, copyright 1953 by Pantheon Books and renewed 1981 by Random House, Inc. Used by permission of Pantheon Books, a division of Random House, Inc., and of Penguin Books, Ltd.

ABOUT THE ARTWORK

All the drawings shown in this book are part of a series by the author titled "Notan." They are all in charcoal oil pastel on paper, with dimensions of 42 x 54 inches, and they were created in 2001–2002.

ABOUT THE AUTHOR

Peter London is a painter, art therapist, and art educator, and the author of *No More Secondhand Art*. He has taught the approach presented in this book over the past seventeen years in colleges, art schools, holistic centers, and teachers' institutes, and has given dozens of keynote addresses in Art Education conferences throughout the United States. He is Professor Emeritus at the University of Massachusetts, Dartmouth, and a 2002 Distinguished Fellow at the National Art Education Association. He lives in Fairhaven, Massachusetts.

For lecture and course information Peter London can be reached at plondon@umassd.edu or www.peterlondon.com.